SPECIAL EFFECTS

SPECIAL EFFECTS:
Creating Movie Magic

by CHRISTOPHER FINCH

Abbeville Press · Publishers · New York

For Susan Brockman

Editorial Director: Walton Rawls

Editor: Don Goddard

Art Director: Philip Grushkin

Designer: Marilyn Marcus

Production Manager: Dana Cole

Library of Congress Cataloging in Publication Data

Finch, Christopher.
 Special effects.

 Includes bibliographical references and index.
 1. Cinematography—Special effects. I. Title.
TR858.F56 1984 778.5′345 84-9180
ISBN 0-89659-452-1

ILLUSTRATION CREDITS

The diagrammatic illustrations that explain procedures discussed in the book are the work of the author.

Contents

PART I: THE ART OF DECEPTION

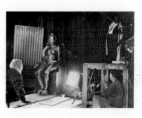

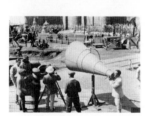

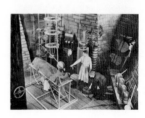

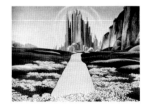

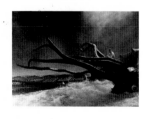

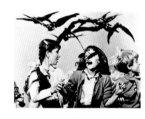

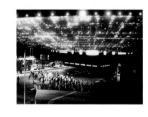

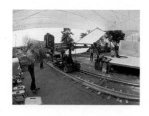

ACKNOWLEDGMENTS

I first thought of writing a book on special effects after a casual conversation with Gary Kurtz at Elstree Studios in 1981. I asked a single question about *Star Wars* (which Mr. Kurtz co-produced), and he talked for an hour about motion-control cameras and matte shots—about the magic of conjuring up another universe with the aid of technology and pure imagination. It was his enthusiasm that whetted my appetite.

Sometime later, when I formally embarked on this project, it was my friend Peggy Weil who pointed me in the right direction, and both she and Richard Hollander provided invaluable guidance throughout the course of my research.

Despite back-breaking work schedules, many top effects experts and producers found the time to talk with me, often at length and in some instances on several occasions. These include Robert Abel, Mat Beck, David Dryer, Linwood Dunn, John Dykstra, Richard Edlund, Harrison Ellenshaw, Richard Greenberg, Robert Greenberg, Jim Henson, Greg Jein, Bill Kovacs, Sherry McKenna, Mike Middleton, Virgil Mirano, Lester Novros, Robert Swarthe, Richard Taylor, Douglas Trumbull, John Whitney, Jr., and Richard Yuricich.

I also received many courtesies from the staffs of various effects houses and production companies including Walt Disney Studios, Lucasfilm, Apogee, Inc., Digital Productions, Robert Abel and Associates, R/Greenberg Associates, and EEG (Entertainment Effects Group). Among individuals I would like to single out David Smith, Bob King, Wendall Mohler, Wayne Morris, Stephanie Mardesich, Mariko Fukuda, and Sandra Payne for special thanks.

The manuscript was read by Don Shay and Stan Hirson, both of whom made valuable suggestions. Mr. Shay, publisher and editor of *Cinefex*, was also of great assistance in supplying rare photographs and making hard-to-find research materials available.

Mary Corliss of the Museum of Modern Art film-stills library provided much help, as did Ron Haver and Joan Cohen of the Los Angeles County Museum's film department. My California research was greatly facilitated by the kindness of Judy Harris, Tom and Joan Dunsmuir, Kip Niven, and Linda Lavin. In New York Amy Jones and Suzanne Bodden performed often frustrating tasks with unfailing good humor.

Finally, thanks to my wife Linda, who, as usual, has contributed to the success of this enterprise in a hundred different ways.

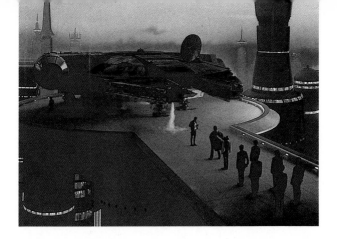

Prologue

Special effects is a discipline that sets itself the task of putting on screen *anything* a writer or producer can imagine. If you want a giant ape to climb the Empire State Building, you will have to rely on the ingenuity of special effects men. If you need to evoke Atlanta as it looked before Sherman's army burned it down, or if the script calls for an earthquake to destroy downtown Los Angeles, the special effects department will oblige. Effects can be used to transpose an actor on a Hollywood sound stage to the middle of Times Square, the Kalahari Desert, one of Jupiter's moons, or another galaxy; they can invisibly enhance a movie's naturalism, or they can be used to create spectacular new worlds.

Increasingly, in recent years, effects crews have been asked to sustain an audience's belief in totally imaginary environments, such as the deep-space settings of *Star Wars*, or the sinister futureworld of *Blade Runner*. There are only a handful of places anywhere capable of effects work on that scale and of that quality. Much of the most dramatic footage in *Star Wars* was shot not at a movie studio but on smallish, black-walled stages in a vine-covered industrial building next to a tuxedo outlet in the San Fernando Valley. *Blade Runner*'s mile-high buildings and busy skies were conjured up in another industrial plant located half-an-hour's drive away, in Marina del Rey. In these facilities the cameras do not look like ordinary motion picture cameras. They are mounted on elaborate servomechanical rigs that move slowly on metal tracks, obeying instructions called up from a computer's memory banks. In this world of space-age technology, a shot that is on screen for just a few seconds may cost upwards of $100,000.

The beginnings were more innocent.

Within a few miles of the spot where Han Solo's Millenium Falcon was first made to speed through hyperspace, Hollywood cowboys once shot it out on the Ince Ranch or in the Simi Hills. One reason that Westerns were so popular in the early days of Hollywood was that they could be made on a shoestring. All you needed was a camera, a leading man, a heavy, a leading lady (optional), stunt riders and wranglers, horses, and a stretch of open country—items that were easily come by in Southern California. If you needed a mine shaft or an authentic ghost town, those were available too.

Even these simple movies, however, called for an occasional special effect. No two-reel Western was complete without an equestrian chase sequence, during the course of which the director would want to insert a couple of tight shots of the

1. One of the earliest special effects devices, used at the beginning of the silent era, was a motor-driven carousel to which panoramic background paintings could be affixed. If an actor was placed in front of the rotating carousel, the illusion created, on film, was that he was moving through the painted landscape.

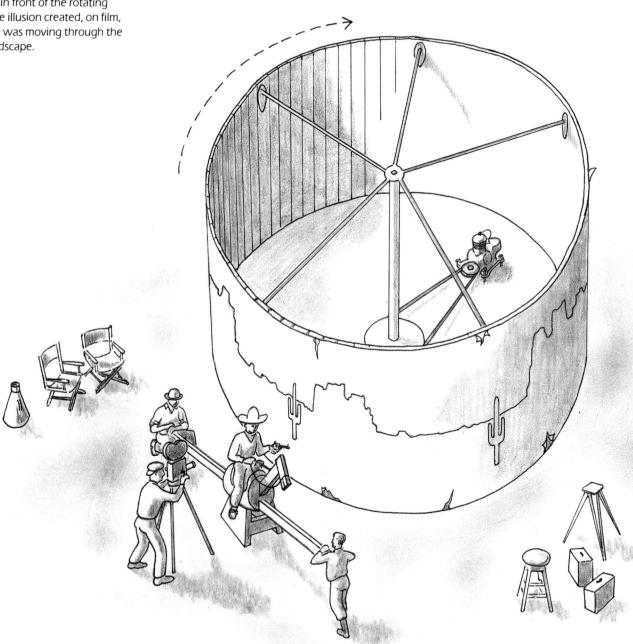

hero emptying his six-gun in the general direction of Black Bart and his dastardly band of hornswoggling varmints. The problem was, how could the director get his camera close enough to the hero on his faithful and fleet-footed steed to obtain these shots?

It was possible, of course, to mount a camera in an open touring car, but that approach was seldom effective. The shock absorbers supplied with even the most luxurious pre-World War I cars were not up to ironing out the bumps sufficiently to provide cinematographers with a reliable camera platform at speeds above five miles an hour. Your Hupmobile might have the chops to keep pace with Bronco Billy's charger, but every time the wheels made contact with an obtrusive clump of sagebrush, Billy's head would bounce from view.

There was a simple alternative to this, thought up by an unsung special effects technician (who would not have known the meaning of the term "special effects"). First a kind of carousel device was built on the studio's back lot, a motorized turntable perhaps twenty feet in diameter. A suitable mural painting—canyon walls and cactus—could be wrapped around its circumference so that, when the carousel was rotated, the landscape would appear to be in movement. Bronco Billy would now be placed in front of this moving landscape astride a "horse" that was actually a saddle and harness strapped to a barrel mounted on rockers. A couple of prop men would cause the "horse" to bob up and down on the rockers, while a stationary camera on a solid tripod made a record of the man in the white hat "pursuing" the bad guys. On screen the illusion would be tolerable (presuming the background painting was sufficiently skillful) so long as the shot was not held too long, allowing the same Joshua tree to come by once too often.

The early trick artists knew that you could get away with murder so long as the audience was caught up in the story. Audiences and technologies have changed, but the modern special effects man works with the same basic set of assumptions. Like a conjurer, he is bent on deceiving the eye and, like

a conjurer, he uses the context of a theatrical event to disguise his sleight of hand.

The term "special effects" is, in fact, something of a euphemism, equivalent perhaps to describing garbagemen as sanitation engineers. What, after all, would non-special effects be? Until the end of the silent era this dubious line of work was generally described as trick photography, and old timers still habitually use the term. ("Back then, when Mr. De Mille gave me a call, I was working in the trick department at Paramount . . .") No one seems certain who first spoke of special effects, but the phrase appears to have been coined as a way of giving trick departments instant respectability. Special effects people tend to be mavericks, however—mild-mannered for the most part but a little outside the mainstream of movie society—so that, even though it is no longer au courant to talk of trick work, today's practitioners refer to the most elaborate computer-assisted illusion as a "gag."

In the early days, the charm of special effects lay in the fact that the field offered men the opportunity to display great ingenuity within severely restricted technical limits. In the 1980s special effects provide the very different but equally fascinating spectacle of the microchip-based technology of the space age being bent to serve the frivolous requirements of the entertainment industry. The time has come when computers can be used to "paint" certain effects directly onto film.

Occasionally the old innocence prevails. George Lucas's *Return of the Jedi* features many effects shots of almost unbelievable complexity, amongst them the scenes showing the massed forces of the Rebel Fleet. Each of these scenes involved hundreds of hours of work with the most modern and sophisticated electronically controlled camera equipment. Filling these shots with a sufficient variety of space vehicles, however, was a challenge that called for plain, old-fashioned ingenuity. The ships in the foreground, needless to say, are large, highly detailed models. Those in the background are reported to include a pair of sneakers and several sticks of chewing gum.

PART I

THE ART OF DECEPTION

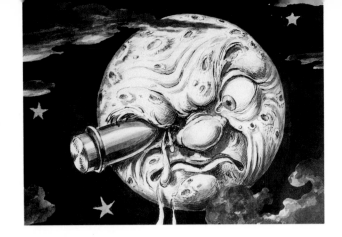

1. Tricks and Treats

It is less than one hundred years since the public was first exposed to photographed moving pictures, less than a century since the movies began to change the way we perceive the world and concurrently to alter the world we perceive. During the last decade of the nineteenth century a generation of inventors brought the modern cinema into existence. By and large they were a high-minded bunch who saw themselves as scientific innovators rather than as purveyors of entertainment to the masses. That did not prevent the Lumière brothers—Louis and Auguste—from opening the first real movie theater, the so-called Salon Indien, in a basement on the Boulevard des Capucines, in Paris, on December 28, 1895.

Entry to the Salon Indien cost one franc, and by the middle of January moving pictures were the sensation of the hour.

The Lumière *cinématographe* differed from the Edison kinetoscope, which had made its public debut in 1894, in several important respects. The kinetoscope was a peep-show device which could only be enjoyed by one viewer at a time. At the Salon Indien the *cinématographe* was used to project images onto a screen, just as in any movie theater today, so that for the first time watching motion pictures became a communal experience. Louis Lumière had designed the *cinématographe*

to be a projector, a printer, and a camera all in one. Moreover, he had managed to make it so light in weight that it could be taken anywhere. The first Edison camera, by contrast, weighed almost a ton and could only function as a permanent installation in Edison's famous tar-paper studio, "The Black Maria." The fifty-foot kinetoscope film strips had necessarily been limited to subjects, such as vaudeville acts, which could be brought into the studio. Each of these films ran just thirteen seconds.

The first offerings of the *cinématographe* ran approximately a minute, and they took the viewer out into the world. Subjects included a train arriving at a station, workers leaving the Lumière factory, card players, a gardener at work, and, inevitably, the ocean. Soon humorous subjects, such as a man wrestling with a folding bed, were added, but these too were given naturalistic settings and differed greatly from the photographed stage acts that had become the staple of the kinetoscope.

One of these early Lumière shorts capitalized on a primitive special effect. At the conclusion of a film descriptively titled *Demolition of a Wall*, the footage was run in reverse so that the wall appeared to rebuild itself, brick by brick. This particular squib is said to have remained popular at country

2. Designed by Louis Lumière, the **cinématographe** (below) was a movie camera, film printer, and projector all in one. Beautifully engineered, the prototype was in perfect running order half a century after it was built.

3. The Arrival of a Train (1895) was one of the Lumière brothers' first successes. Audiences are said to have displayed signs of panic when the locomotive appeared about to leave the screen and invade the theater.

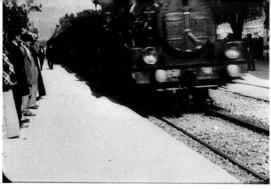

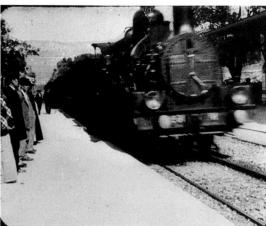

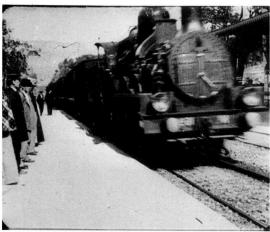

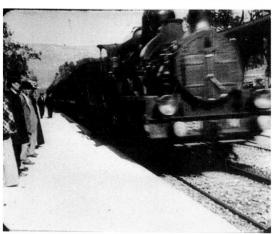

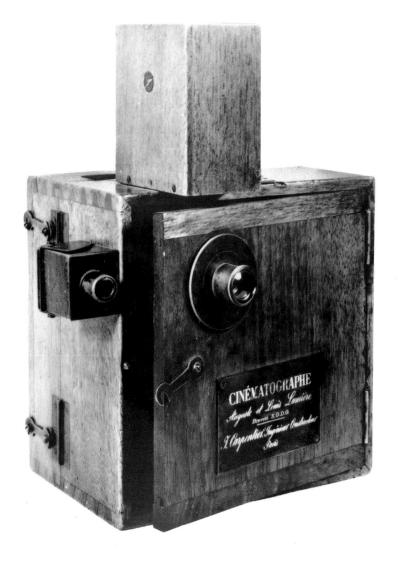

carnivals and the like for a decade or more after it was first shown, but, in general, the Lumières did not lean much toward camera trickery. They had no need for it since the magic of the *cinématographe*, for early filmgoers, lay in its ability to conjure up moving images of the real world. When he photographed the mail train arriving at La Ciotat, Louis Lumière can hardly have imagined that audiences would actually panic, thinking the locomotive was about to leave the screen and invade the auditorium, yet contemporary reports insist that people screamed and fainted. Clearly, however—as with 3-D films in the 1950s—the alarm caused was not sufficient to keep the next group of patrons away.

Louis Lumière was not an artist, but he did have a certain gift for mise-en-scène and, even in less dramatic shots, displayed a knack of crowding the screen with the kind of detail that held an audience's attention and added to the illusion of reality (or to the reality of illusion). It is recorded that early movie patrons were especially impressed by the way the *cinématographe* was able to reproduce nature, as if there were some special virtuosity involved in capturing a patch of shrubbery on film. A shot of leaves blowing in the wind could be counted upon to produce a burst of spontaneous applause.

The potency of these images can be gauged from the fact that within twelve months of the *cinématographe*'s Paris debut, it had enjoyed triumphant engagements on every continent, thrilling audiences from New York to Tokyo. (And everywhere they went, the Lumière cameramen brought back fresh and exotic footage for the European public.)

In the beginning, then, it was enough that images were up there on the screen. The camera did not move. There were no edits. The magic derived from the simple fact that snapshots had been brought to life. Almost immediately, however, there were men who realized that the magic could be manipulated in a variety of ways. This was hardly surprising. The principles of cinematography were well known. Little groups of enthusiasts had been delivering lectures to one another for years, and building experimental equipment. Not a few of the pioneer filmmakers were professional photographers who

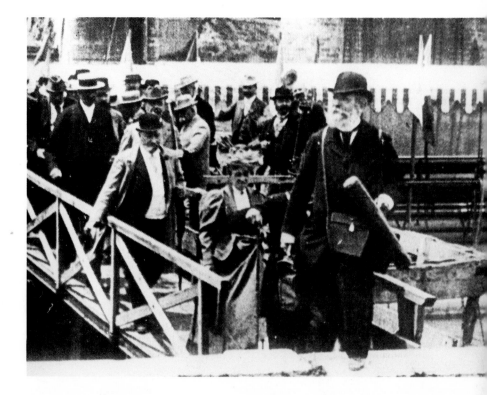

4–5. The early **cinématographe** films ran approximately sixty seconds apiece and were little more than moving snapshots portraying such scenes as the disembarkation of a camera club from a pleasure boat (above right), or casual domestic vignettes. At the end of the Victorian era, the simple fact that the pictures moved was the ultimate special effect and quite sufficient to guarantee the public's attention.

were completely conversant with such techniques as double-exposure and multiple-exposure.

One such was an Englishman named G. A. Smith, a Brighton portrait photographer who began to produce motion pictures in 1897 with a camera that he designed and built himself. That same year he took out a patent for double-exposure and used the technique to produce phantoms and visions in such films as *The Corsican Brothers* and *Photographing a Ghost*, which date from no later than 1898. That same year another British pioneer, R. W. Paul, made a film titled *The Railway Collision*, which seems to have used miniature landscapes and model trains to create what appears on screen to be a tragic accident, thus introducing to the filmmaker's vocabulary a kind of special effect that is as popular today as ever.

Both Smith and Paul went on to make elaborate fantasy movies, using both photographic and stage tricks, but, unfortunately, most of these have been lost. Those few examples that have survived—such as Paul's oddly titled *The ? Motorist* (1905)—indicate a considerable level of technical achievement, but the evidence is thin, and so in most film histories these pioneers (and there may be others still more obscure) have been overlooked as originators of the trick film in favor of the better known Georges Méliès.

Not that Méliès should be begrudged his honorary title as the father of special effects. It may well be that his films have survived precisely because they were the finest examples of the genre, and undoubtedly they were among the most successful. It is worth keeping in mind that he was not a unique figure—others were working in the same idiom—but a substantial body of his work is still available to us, and it provides the best catalogue we have of early trick-film techniques, techniques that included multiple exposures, split-screen mattes, and a variety of mechanical devices.

Tricks aside, Méliès has been described as the first real director, in the sense of being the first person to use moving pictures to tell a story. This is another of those assertions that should be tempered with caution, though Méliès's claim is probably as good as any of a dozen other pioneers. In any case, when the Lumières launched their revolution, Méliès was a magician—a successful one—and proprietor of the Théatre Robert-Houdin, the Parisian home of the illusionist's art. For decades illusionists had made use of techniques that would become staples of the special effects arsenal. Relatively sophisticated forms of front projection and rear projection, for example, were already commonplace at theaters like the Robert-Houdin. When Méliès was first exposed to the *cinématographe*, though, he reacted like everyone else. No trick photography

was needed to arouse his interest in the movies. The mere fact of their existence was magic enough.

Méliès attempted to purchase *cinématographe* equipment from the Lumières, but they (perhaps scenting a worthy rival) refused to sell to him. Undaunted, Méliès bought a projector from R. W. Paul, then acquired a Bioscope camera and began to make his own movies. Like other illusionists who became fascinated with the cinema, he made some films of himself performing conjuring tricks, but mostly he concentrated on straightforward, everyday scenes of the Lumière type, and these were shown at his theater as part of the regular programs there. According to unsubstantiated but plausible tradition, his interest in trick photography came about because of an accident when he was shooting one of these short subjects in the Place de l'Opéra in 1898. As he filmed the traffic that circulated in front of the opera house, his camera jammed, but he was able to restart it. When he developed and projected the film, he found that a wonderful transformation had taken place: a horse-drawn omnibus seemed to turn into a hearse before his eyes.

Or so the story goes. Certainly something prompted Méliès to realize that by deliberately stopping a motion picture camera and then restarting it, all kinds of interesting effects could be achieved. He was not, in fact, the first to take note of this phenomenon. As early as 1895, Alfred Clark, an employee of the Edison Kinetoscope Company in New Jersey, had made a film titled *The Execution of Mary Queen of Scots*, which capitalized upon the marvelous ability of the camera to make discontinuous action seem continuous. A male actor dressed as Mary walked up to the block and placed his bewigged head upon it. At this juncture Clark stopped cranking his camera, the actor was replaced by a lifelike dummy, action was called again, and the camera recorded the ax-blade severing the queen's head from a body which the viewer had seen living and breathing only seconds earlier.

Since this mini-epic was shown only in peep shows, however, and at a time when the genre was losing favor, it had little influence. There is no reason to suppose that Méliès ever saw it, and, in any case, had he done so it would hardly detract from his achievement. Alfred Clark invented a trick but apparently failed to see that it had applications beyond the specific situation. Méliès stumbled upon the same trick and recognized that it was actually a basic cinematic technique that could be exploited in dozens of different situations. It led him to explore other ways in which the motion picture could be used to manipulate the illusion of reality, and, with his conjuror's ingenuity, he quickly evolved a vocabulary of crude

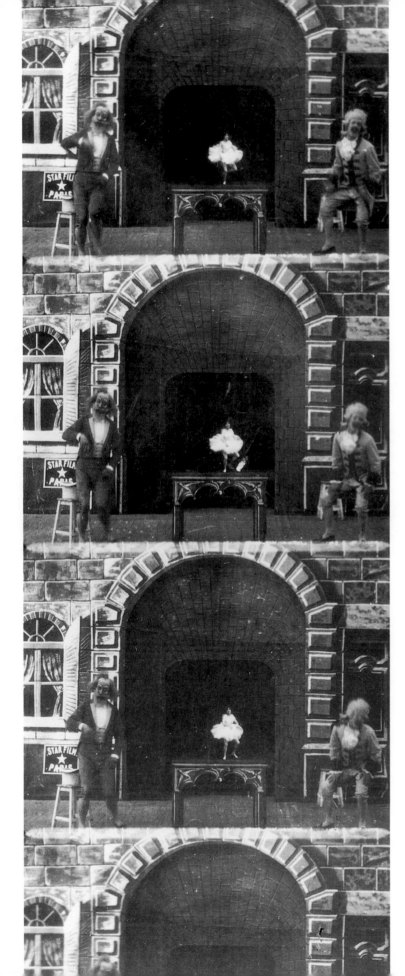

devices that permitted him to put on screen a novel kind of fantasy film.

The timing was propitious. The public was becoming accustomed to the simple magic of the *cinématographe* and was ready for something new. It is probable that simple demonstrations of trick photography would have won audiences over, but Méliès went one better. He used his camera tricks as building blocks for a kind of storytelling that struck the technically naive theatergoers of the day as quite amazing.

His first efforts in this direction were relatively simple and often involved decapitation, or some other form of mutilation, presented in a comic light. (Turn-of-the-century audiences seem to have relished mayhem every bit as much as the crowds who today flock to *Halloween* and *The Texas Chain Saw Massacre*.) Shrinking men and disappearing women were among his other staples, but he quickly began to weave these elements together into narratives that, by the standards of the day, were extremely complex. By 1899 he was able to take on subjects such as *Cinderella* (in twenty scenes), which was a considerable success on both sides of the Atlantic, immediately engendering imitations in the United States. (In fact, Méliès's *Cinderella* may itself have been inspired by G. A. Smith's *Cinderella and the Fairy Godmother*, which had been produced in England the previous year.)

Like Méliès's later story films—*Joan of Arc, Blue Beard, Robinson Crusoe,* and *The Damnation of Faust* are some titles —*Cinderella* was shot as if it were being performed on a stage and the camera was stationed in the auditorium. In fact, some film historians believe that most of these movies were actually shot at the Théatre Robert-Houdin to take advantage of the trapdoors and other devices used by the illusionists who performed there. If this is so, then Méliès must have been a pioneer in the use of artificial lighting in the movies. So far as is known, no movie studios were equipped with arc lamps be-

6. Georges Méliès's early films capitalized on the fact that moviegoers of the day were likely to be mystified by even the simplest of tricks. Ironically, modern scholars cannot always be sure what kind of trick he was employing in a given instance. This scene from **The Dancing Midget** (1902) might conceivably have been achieved with a primitive in-the-camera matte, meaning that the foreground figures and the ballerina would have been shot separately. More likely, however, the dancer was placed on a platform that was lined up with the foreground table but stood thirty or forty feet behind the set. The differences in scale, then, are probably due to nothing more complex than a clever exploitation of natural perspective.

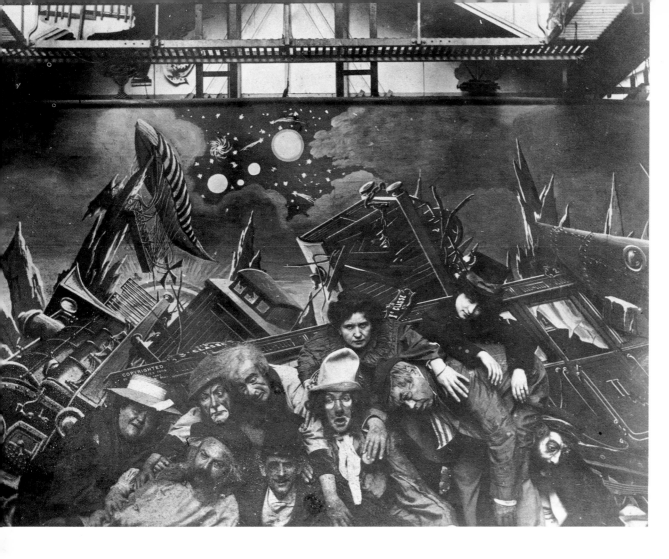

fore 1903 (though they had been used during the filming of a prizefight four years earlier), but it may well be that stage lights at the Robert-Houdin did provide Méliès with sufficient illumination even for the slow film stocks of the day. Elsewhere, though, it has been stated that he built one of the first glassed-in studios as early as 1897.

Certainly his films are inescapably "stagey," complete with painted backdrops and two-dimensional props. In fact, it is sometimes impossible to tell whether the special effects seen on screen are actually filmed stage illusions or camera tricks, making Méliès a pioneer of both mechanical effects and optical effects.

The most famous of these movies is *A Trip to the Moon* (1902), which is derivative of both Jules Verne and H. G. Wells but has, as translated to the screen, a distinctive life and character of its own, thanks to Méliès's tongue-in-cheek penchant for a kind of dreamlike continuity which would earn him, two decades later, the admiration of the Surrealists. *A Trip to the*

Moon is the first science fiction film, but it is not one that takes its science very seriously (certainly not by the standards of a writer like Wells). Méliès seems, in fact, to have set out to create a kind of humorous fantasy that verged on parody. The moon men who explode when knocked to the ground, the stars that turn into women's heads, are not sophisticated effects by today's standards, but they were probably not taken very seriously by Méliès at the time. Like many who have followed him in the field, he was primarily a showman who—for a few years at least—had his finger on the pulse of the filmgoing public.

Many historians have regretted the fact that Méliès never developed into a true cinéast, that he remained entrapped by the conventions of the proscenium arch and bound by the low-kitsch tastes of the time. The fact is, however, that he probably did more than any other individual to establish the manipulation of reality as a viable form of moviemaking. The developing language of the cinema would quickly leave

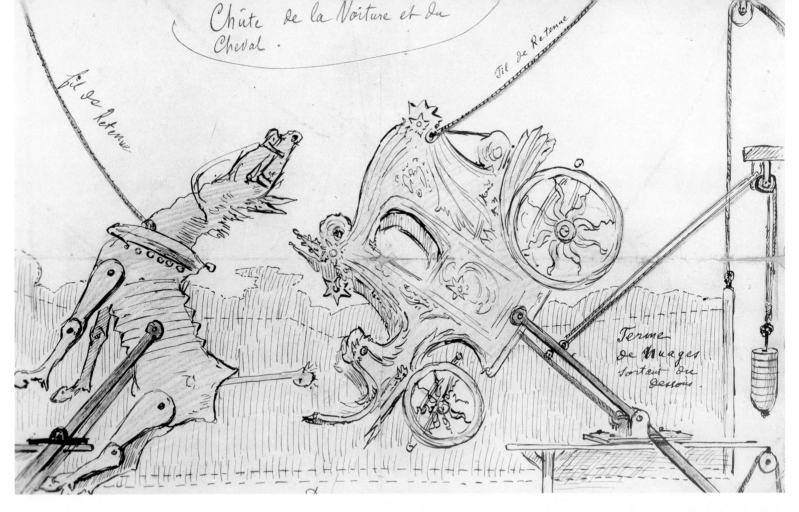

Chûte de la Voiture et du Cheval.

him behind, but not before he planted seeds that would result in a rich harvest of varied exotica.

In a sense, Georges Méliès was the Douanier Rousseau of the movies. Henri Rousseau, "le Douanier," was an older contemporary of Méliès who, like Méliès, produced the work by which he is remembered in the last decade of the nineteenth century and the first decade of the twentieth century. A customs official turned painter, Rousseau was much admired by Picasso and other artists who forged the revolution of modern art. He has been justly described as "a folk artist of genius," a phrase that could equally be applied to Méliès, who, like his fellow Parisian, had the knack of conjuring up innocent, dreamlike images. (It seems unlikely that Méliès would have known Rousseau's work, though as a painter manqué he may have stumbled upon it at the Salon des Indépendants. It is much more likely that Rousseau would have been familiar with Méliès's well-publicized presentations at the Robert-Houdin.)

Neither Rousseau nor Méliès lacked for admirers among their peers, and one of Méliès's most enthusiastic followers was Edwin S. Porter, a young American who had had considerable experience as a barnstorming projectionist before, at the turn of the century, he joined the Edison Company as a producer-director-cameraman-scenarist. (The ultimate hyphenate, he also designed and built the cameras and managed Edison's skylight studio on East 21st Street in Manhattan.) Initially, Porter expressed his admiration in the form of plagiarism, making trick films in the Méliès vein. In 1903, however, he took some of the Edison films that dealt with fire and firemen—one-shot subjects of the Lumière kind—and edited them, with the addition of a few snippets of footage

10. Méliès's most famous film, **A Trip to the Moon** (1902), presents the adventures of a group of Edwardian scientists who make the first space flight aboard a shell-like vehicle of the sort envisioned by Jules Verne about thirty years earlier.

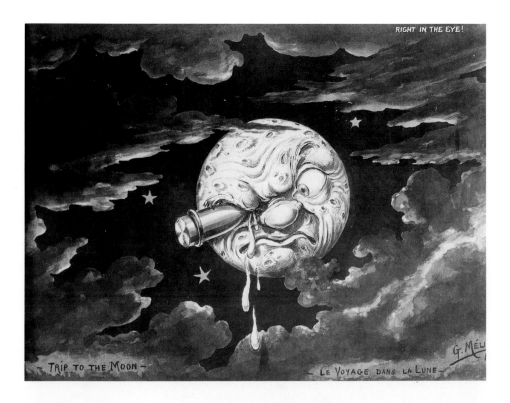

RIGHT IN THE EYE!

TRIP TO THE MOON

LE VOYAGE DANS LA LUNE

G. Méli

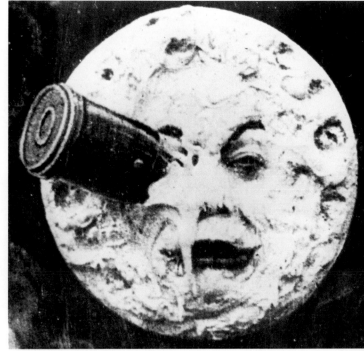

THE SHELL REACHES THE MOON

G. Méliès
1902
LE VOYAGE DANS LA LUNE

11–13. Méliès, a frustrated cartoonist, seems to have initiated the idea of production sketches, planning many of his key scenes on paper before committing them to film. It will be noted that the drawings were captioned in English as well as French, reflecting the importance of the American market to European filmmakers, even at this early date.

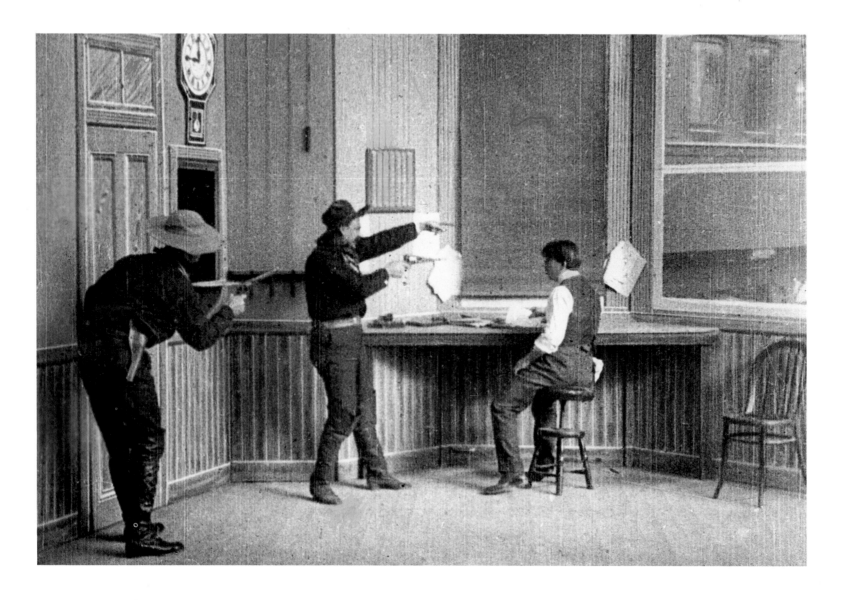

shot specially for the occasion, to create a little drama, *The Life of an American Fireman*. It derived, according to Porter himself, from Méliès insofar as it consisted of a series of short scenes placed end to end to tell a story, but it was Méliès with stage props and proscenium arch discarded, Méliès without obvious tricks and gimmicks.

Porter's progress toward naturalism, and toward film montage in the modern sense, culminated that same year in *The Great Train Robbery*, one of the most famous films of all time. Running 740 feet, or a little over twelve minutes, and shot in the wilds of New Jersey, this proto-Western tells, in fourteen scenes, the story of the robbery of a mail train, the bandits' flight, and their eventual capture by a hurriedly assembled posse. Shifting viewpoints, casual, nontheatrical setups, and a dramatic close-up stunned the audiences of the day and paved the way for D. W. Griffith's triumphs, which were just a few years away.

The Great Train Robbery also contains what may well be the first instance of an optical effect used for the purpose of adding to the naturalism of a shot. In the opening scene, set in the interior of a railroad telegraph office, a train can be seen through the window. This train was composited into the image

14. In his classic **The Great Train Robbery** (1903), Edwin S. Porter made the first known use of an in-the-camera matte shot outside the context of the blatant trick film. When the foreground action was shot, the window area was masked off so that this portion of the film would not be exposed. The film was then rewound to the starting point, and the foreground action was masked off while the train was shot so that, in the resulting composite image, the train seems to be beyond the glass panes of the window.

15. In his 1906 film **The Dream of a Rarebit Fiend**, Porter returned to the Méliès fantasy genre and used a horizontal split-screen matte to create this illusion of a man and his bed sailing above the Brooklyn Bridge.

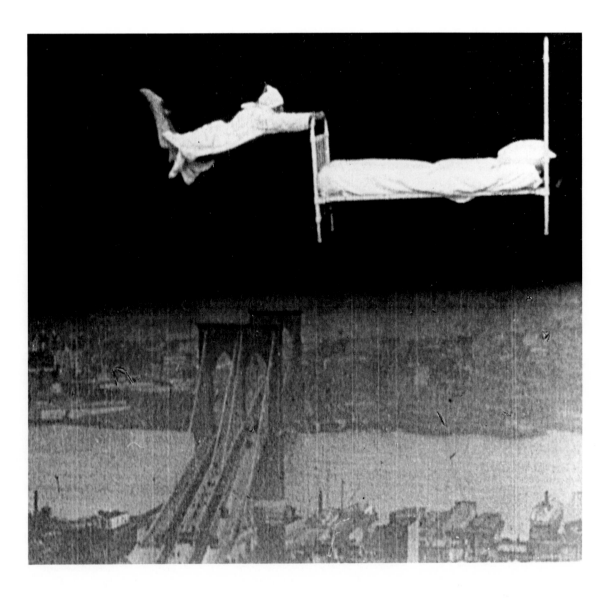

by means of an in-the-camera matte, a technique that was familiar to still photographers and had been adapted by Méliès and others to enliven their trick films.

Porter himself failed to build on the success of *The Life of an American Fireman* and *The Great Train Robbery*, returning to more conventional films, including such trick subjects as *The Dream of a Rarebit Fiend* (1906), an evocation of a nightmare brought on by indigestion, and *The "Teddy" Bears* (1907), an early exercise in stop-motion animation. He would remain a respected figure in the industry for several more years, but it was left to others to develop his innovations. Méliès, for his part, found himself left behind by shifting tastes and a changing distribution system that, after 1908, was controlled by giant companies like Pathé and Gaumont. Méliès signed with Pathé—an affiliation that was to prove disastrous—then suffered a further setback when the Théatre Robert-Houdin was closed during World War I.

After the Surrealists rediscovered him, in the 1920s, Méliès became a minor cult personality once more but, despite efforts on the part of his new patrons, he never reentered film production. Instead he continued to work for his second wife at her kiosk in the Gare Montparnasse, selling candy and toys.

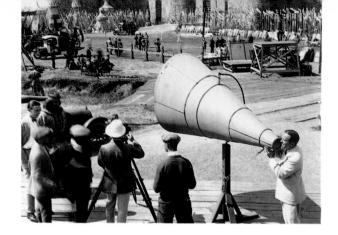

2. Masks and Mirrors

By 1908, when D. W. Griffith directed his first one-reeler, the neolithic era of special effects—the age of the trick film—was essentially over. Audiences were no longer so easily amazed, and directors and producers were forced to pursue new goals. Special effects did not disappear; they simply began to play a legitimate role in shaping the rapidly evolving language of the movies. Between 1909, when Griffith hit his stride, and 1916, when *Intolerance* was released, the cinema developed from a crude form of entertainment into a complex medium, capable of transporting the viewer convincingly into almost any world the director was capable of imagining.

As already noted, filmmakers like Méliès used both camera tricks and traditional stage effects in their movies. These now began to evolve into separate but allied specialties with expanding applications. From the prop departments at various studios emerged a group of men with a particular knack for handling explosives or rigging buildings to collapse on cue; and so the discipline of practical effects (later to be known as physical effects or mechanical effects) came into being. Meanwhile, until the coming of sound, the field of photographic or optical effects remained almost exclusively the responsibility of the cinematographers.

In the hands of someone like Billy Bitzer, Griffith's cinematographer, the silent-movie camera was a wonderfully flexible tool. Whether Vitagraph, Pathé, or some other make, the silent camera was hand-cranked, a fact which both imposed severe responsibilities on the operator and allowed for all kinds of variables and subtleties. Thirty-five millimeter silent film was normally projected at sixty feet per minute, sixteen frames per second. For comedy purposes the cameraman would often undercrank, so that the film would be speeded up when projected, while overcranking would produce slow motion. Even when shooting at standard speed a skillful cameraman could subtly alter the mood of a scene by minutely adjusting the rate at which the film passed through the gate of the camera. It has sometimes been suggested that a silent movie cameraman needed a metronome in his brain. Actually what was called for was something more like the Count Basie rhythm section.

Fades and dissolves were considered extraordinary effects when they first appeared on the screen. There is no way of knowing which cameraman invented the fade, but he achieved it by slowly closing the aperture of his camera as he continued to crank, a method that remained current for twenty years. To

create an in-camera dissolve, the operator faded out on one scene, as described above, wound back the film to the point at which the fade began, then gradually opened the aperture as he began to shoot the next scene. Smoothly executed, this produced an exquisite dissolve, but it had its drawbacks. There was only one chance to shoot the second scene. If anything went wrong, then both scenes would have to be reshot.

Simple masking effects had been known almost since the beginning of the movies, and during the Méliès period these began to evolve into matting techniques that proved to have an almost limitless range of application.

The most basic kind of mask hardly needs explanation. A character in a movie is seen spying on someone through a key-hole. The next shot shows what the character sees, dramatized by having the image framed by a keyhole-shaped mask, actually just a cutout form placed in front of the lens. Directors and cameramen found countless situations for this type of effect. Whenever a character looked through binoculars, a gun-sight, or a periscope, the appropriate mask would be suspended in front of the lens, or inserted into the camera's intermittent movement at the focal plane.

The in-the-camera matte shot also utilized a mask of some sort, but combined it with carefully controlled double or multiple exposure. One of the first matte effects, well known to the trick filmmakers, was the split screen, commonly applied when the same actor was to appear with himself in a scene (as his own twin brother, for example). For this the camera was set up on as solid a base as possible—to minimize movement and vibration—and half the lens was masked off with some form of matte, which could be as crude as tape applied directly to the lens, though more commonly it was a thin sheet of board, painted flat black, which slotted into the matte box, a hood-type attachment in front of the lens. Thus only half of each frame would be exposed when the camera was cranked, and only half the scene would be recorded.

The performer, of course, would be in the exposed portion of the scene, playing the banjo, perhaps, for an unseen audience. This completed, the cameraman would wind the film back to the starting point, reverse the matte so that it would mask the other half of each frame, then shoot the scene again with the performer seated in an armchair in the portion of the set that was now being recorded. When the film was developed and projected, the two portions, exposed separately, would (if all had worked as planned) come together as a single "take" with the performer admiring his own banjo-playing.

This kind of split-screen device reached a peak in 1921 in Buster Keaton's First National comedy *The Playhouse*. In this film about a minstrel show, Keaton played every role: theater manager, stage director, stagehands, members of the orchestra, the entire audience, and, of course, all the performers. Shot by Keaton's regular cameraman, Elgin Lessley, the movie is full of split-screen shots, but the one that caps them all is the scene in which no fewer than nine Buster Keatons, all in blackface, all perfectly synchronized with each other, appear on stage at the same time. For this shot Keaton had a special lightproof box built that fitted over the front of the camera. In this box were nine "gates" that could be opened one at a time. The device worked perfectly, but even so the scene provided cameraman Lessley with plenty of headaches, as Keaton described

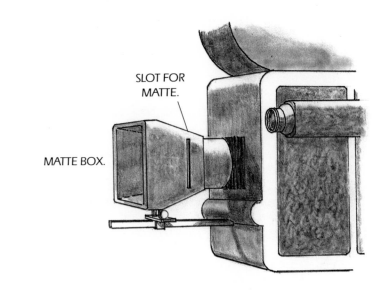

SLOT FOR MATTE.

MATTE BOX.

MATTES FIT INTO SLOTS IN WALLS OF MATTE BOX. THIS MATTE IS CUT TO PRODUCE THE EFFECT OF LOOKING THROUGH BINOCULARS.

16. A matte box is a hood-type attachment which fits in front of the camera lens. The box is equipped with slots into which mattes can be slipped, either vertically or horizontally. The matte masks off some of the light entering through the lens so that corresponding portions of the negative film stock in the camera are left unexposed.

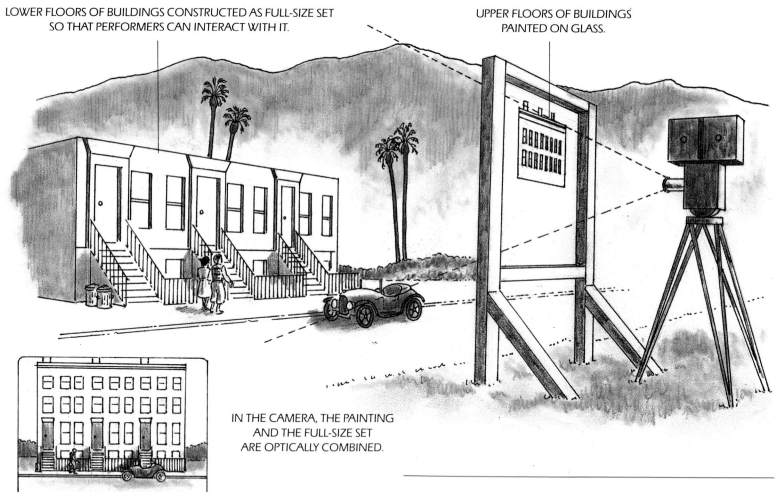

LOWER FLOORS OF BUILDINGS CONSTRUCTED AS FULL-SIZE SET
SO THAT PERFORMERS CAN INTERACT WITH IT.

UPPER FLOORS OF BUILDINGS
PAINTED ON GLASS.

IN THE CAMERA, THE PAINTING
AND THE FULL-SIZE SET
ARE OPTICALLY COMBINED.

17. The glass shot is a simple but effective kind of trick shot that has been used since early in the silent era. A painting on glass is placed between the camera and a partial full-scale set. If everything is lined up perfectly, the painting and the full-size set will appear to be continuous parts of a single image.

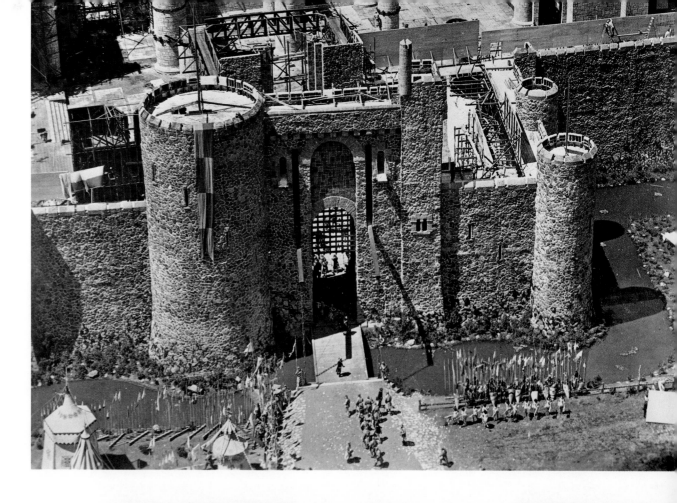

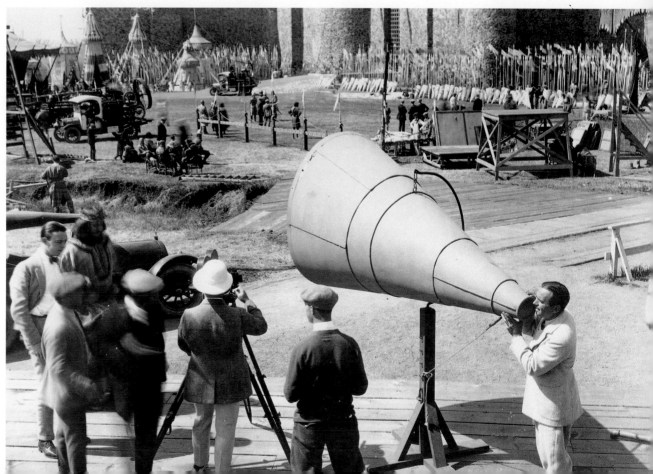

18. The castle built for Douglas Fairbanks' version of **Robin Hood** (1922) was the largest set constructed in Hollywood up to that time, but even so—and the scale is evident from this aerial view—glass shots were used to give the structure additional height on screen.

19. In front of the **Robin Hood** castle, Douglas Fairbanks poses with the giant megaphone he used to control movements during crowd scenes. Wind machines, mounted on trucks, have been drawn up onto the forecourt to ensure that pennants can be made to flutter on cue.

years later: "He had to run the film back eight times, then run it through again. He had to *hand-crank* at *exactly* the same speed *both* ways, *each* time. . . . If he were off by the slightest fraction, no matter how carefully I timed my movements, the composite action could not have been synchronized." (R. Blesh, *Keaton*, p. 168.)

Keaton, incidentally, used an off-screen banjoist (who took his beat from the cameraman), to synchronize his own movements from take to take.

In the early days, in-camera mattes tended to be rather hit or miss. It was Norman Dawn, an important special effects pioneer, who introduced a more controllable version of the technique. To understand it in context, though, we must first take a look at another of Dawn's innovations, the glass shot.

Still photographers (Dawn included) had long made use of glass shots, but Dawn seems to have been the first to use it in professional cinematography. His specialty at the time was filming picturesque sights for theatrical exhibition. Many of the buildings he shot were ruins—or at least in a state of advanced disrepair—and Dawn began to use the glass shot as a means of restoring them to their former glory. The first application he found for the technique was in a 1907 film called *Missions of California*. At one mission a row of arches had been reduced to a few piles of broken masonry. Dawn simply painted the missing arches on a sheet of glass, set the glass up in front of his camera, and, through the viewfinder, lined up the painting with the actual building, which was miraculously made whole again.

From 1911 on, Norman Dawn worked within the Hollywood film industry, where he became one of the first special effects consultants. There was some resistance to his methods at first, but soon the studios—producers and art directors in particular—came to see the advantage of the techniques he introduced. The glass shot, for example, meant that it was possible to get away with building half a set—the lower half, in most instances, where the actors would appear. The upper stories of a building could then be painted on glass at a considerable saving of time, energy, and dollars.

The glass shot remained in favor for at least two decades and has found occasional applications more recently than that, but it was gradually supplanted by Dawn's own variation on the in-the-camera matte and its many derivatives.

Around 1911, Dawn hit on another of the simple ideas which are the essence of so many special effects. He set up his camera to shoot through a sheet of glass, just as in a regular glass shot. Instead of painting an image—say, the steeple of a church and surrounding sky—directly onto the glass, he blacked out the area where the steeple and sky would be, using opaque, flat paint, thus creating a matte. The live-action scene would then be shot in the normal way, but those areas of the negative blocked out by the matte would not be exposed. This partially exposed but undeveloped film would be transferred to another camera, set up—again on a heavy, vibration-proof base, typically a lathe-bed—in front of an easel (or "matte-board") on which a painting of the steeple and sky had been mounted. The area that had already been exposed during the live-action take was blacked out to form a "countermatte." Now the film was run again, this time with the live-action footage masked out and the painting of the steeple and sky exposed. The result, if registration and everything else were perfect, would be a beautiful in-the-camera composite of the action and painted image.

The advantages of this system over regular glass shots are obvious enough. The time needed, on set, to paint a black matte would be just a fraction of that involved in painting an illusionistic steeple (or something more complex, always remembering that the artist would have to take perspective, parallax, shadows, and many other factors into account). Dawn's new system enabled this artist, soon to become known as a matte painter, to work at his own pace, carefully matching his work to the live-action footage already exposed. (Extra footage would always be shot for test purposes.)

There were problems too. For example, special process cameras, with registration pins (known as pilot pins) to keep each component of the image steady, were still years away. But the system worked well enough to establish stationary mattes as a standard tool of the filmmaker's craft, and to make the skilled matte painter a fixture at every major studio.

Looking at silent movies now, it is virtually impossible, in the absence of documentation, to tell a glass shot from an in-the-camera matte shot. Both have the same general appearance, are used in similar situations, and, when properly executed, are undetectable to the untrained eye. It is reported, for example, that the height of the castle in the Douglas Fairbanks 1922 version of *Robin Hood* was boosted with the aid of glass shots, but in most instances we can only guess at the technique used. (The basic patent for glass shots was not granted until 1925.) As a rule of thumb, the earlier the date the greater the likelihood that the glass shot was the technique used. Matte systems gained favor as the 1920s progressed, suffered a brief setback at the advent of sound, then became dominant as reliable process cameras became available (though the glass shot enjoyed popularity in Europe well into the sound era).

Another technique much utilized by European special

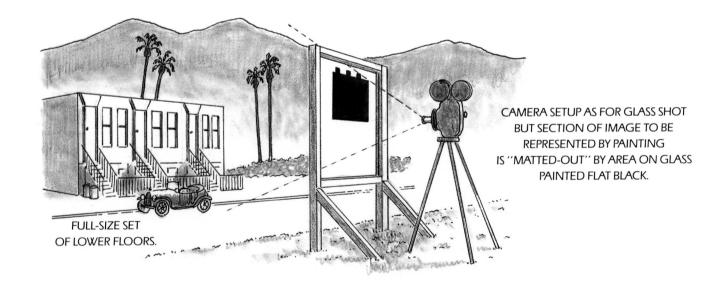

1

CAMERA SETUP AS FOR GLASS SHOT
BUT SECTION OF IMAGE TO BE
REPRESENTED BY PAINTING
IS "MATTED-OUT" BY AREA ON GLASS
PAINTED FLAT BLACK.

FULL-SIZE SET
OF LOWER FLOORS.

2

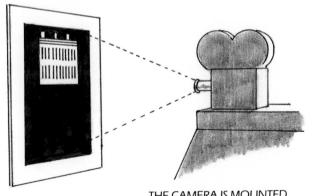

ARTWORK REPRESENTS
UPPER FLOORS OF BUILDINGS.
ALREADY SHOT LIVE-ACTION ELEMENTS
NOW "MATTED OUT" WITH
FLAT BLACK PAINT OR INK.

EXPOSED NEGATIVE
OF LIVE-ACTION ELEMENT
REWOUND TO BEGINNING
THEN RELOADED INTO
A PROCESS CAMERA IN THE LAB.
THE CAMERA IS NOW USED
TO COMBINE THE ALREADY EXPOSED
ELEMENTS WITH THE ARTWORK
ON THE MATTE EASEL.

THE CAMERA IS MOUNTED
ON A SOLID LATHE BED
TO MINIMIZE VIBRATION.

20. One primitive kind of matte shot used a camera setup that was identical to that employed for glass shots. Instead of painting a representation of the upper part of the building (or whatever) on the glass, however, the matte artist simply blanked out the equivalent area with flat, nonreflective black paint. This would leave an unexposed "window" in each frame of film. The negative could then be taken back to the process laboratory and reloaded into a camera focused on artwork representing the parts of the set that had not been built. When the negative was run through the camera again, the artwork would (in theory, at least) be slotted exactly into the previously unexposed "window." Thus a painted image could be combined with live action that might have been shot weeks earlier, and the on-set delays associated with glass shots could be avoided.

effects people was the so-called Shuftan process, a clever kind of mirror shot devised in Germany in 1923. Eugene Shuftan (born Eugen Schüfftan) was to become an important Hollywood cinematographer, eventually winning an Academy Award for his work on Robert Rossen's *The Hustler*. In the early 1920s, however, he was a young artist turned animator with an interest in trick photography. The process named after him was a remarkably elegant way of compositing live-action elements with painted images, miniatures, or back projection in a single in-the-camera operation.

Imagine that a producer is making a period movie in which there is a scene calling for the actor who plays Socrates to appear on the steps of the Parthenon. If the Shuftan process is to be used, the art director will be asked to prepare a detailed model of the Parthenon and a matching full-scale set of that portion of the building—a couple of Doric columns and a stone platform—in which Socrates is to stand. The camera will be set up to shoot the miniature Parthenon through a sheet of glass, part of which is mirrored. (In fact, a technician

will have started with a front-silvered mirror and scraped away the silvering except in the area where it is needed.) This glass will be angled so that the mirrored area reflects the full-scale partial set in such a way that it appears, through the viewfinder, to be an integral part of the miniature. Socrates is placed on the set and is able to stand "inside" the model Parthenon.

The Shuftan process used in this way—to combine live action with miniatures—was employed most effectively during the silent era for Fritz Lang's great futuristic fantasy *Metropolis* (1927). It was also particularly useful, in the early days, when combining live action with rear projection.

Rear projection had apparently been utilized by Norman Dawn as early as 1913, but with disappointing results. The problem was that in those days, and for almost twenty years afterwards, rear-projection screens did not transmit an intense enough image to combine effectively with the live action staged in front of them. The smaller the screen, however, the more intense the projected image. Since the Shuftan process

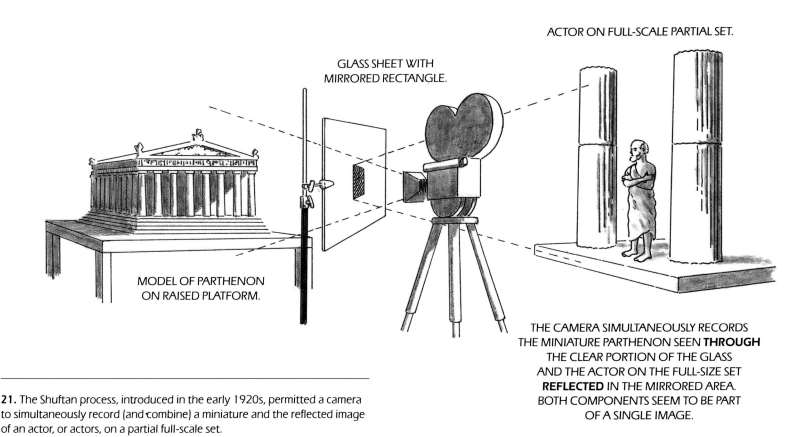

GLASS SHEET WITH
MIRRORED RECTANGLE.

ACTOR ON FULL-SCALE PARTIAL SET.

MODEL OF PARTHENON
ON RAISED PLATFORM.

THE CAMERA SIMULTANEOUSLY RECORDS
THE MINIATURE PARTHENON SEEN **THROUGH**
THE CLEAR PORTION OF THE GLASS
AND THE ACTOR ON THE FULL-SIZE SET
REFLECTED IN THE MIRRORED AREA.
BOTH COMPONENTS SEEM TO BE PART
OF A SINGLE IMAGE.

21. The Shuftan process, introduced in the early 1920s, permitted a camera to simultaneously record (and combine) a miniature and the reflected image of an actor, or actors, on a partial full-scale set.

could be used to "miniaturize" the live-action components, it provided a useful way of bringing actors together with the smaller and brighter rear-projected images.

Much more important than rear projection at this period was the use of models and miniatures. Although they had been used occasionally in the primitive movies of the 1890s, it was as the industry began to grow that their value became more apparent. One reason for this was the public demand for historical dramas. Transporting an audience to, say, fourteenth-century Florence might require a few full-scale sets, supplemented by glass shots or in-camera mattes. But miniatures would provide another dimension. The camera could fly above the rooftops of a model city, for example, like a bird.

Miniatures have been central to the craft of special effects

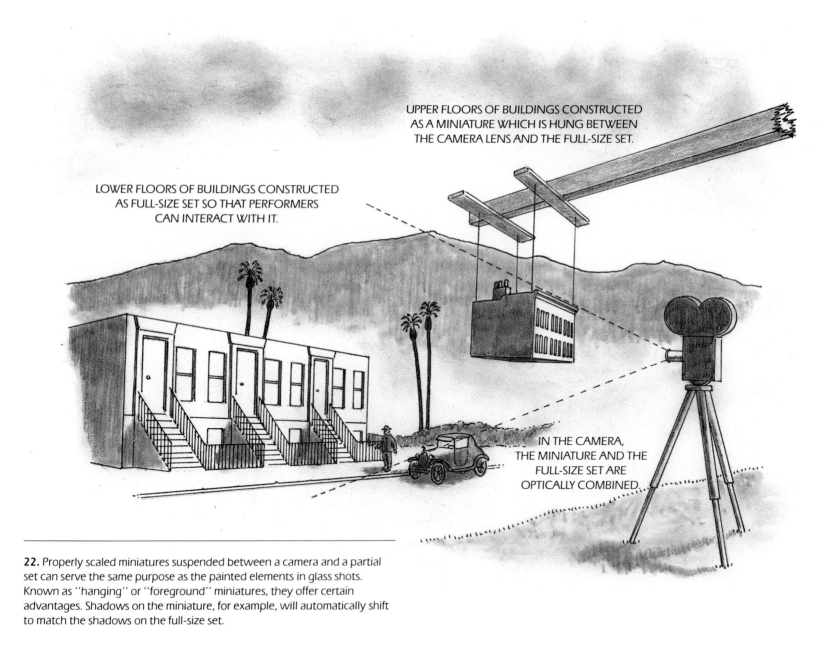

UPPER FLOORS OF BUILDINGS CONSTRUCTED AS A MINIATURE WHICH IS HUNG BETWEEN THE CAMERA LENS AND THE FULL-SIZE SET.

LOWER FLOORS OF BUILDINGS CONSTRUCTED AS FULL-SIZE SET SO THAT PERFORMERS CAN INTERACT WITH IT.

IN THE CAMERA, THE MINIATURE AND THE FULL-SIZE SET ARE OPTICALLY COMBINED.

22. Properly scaled miniatures suspended between a camera and a partial set can serve the same purpose as the painted elements in glass shots. Known as "hanging" or "foreground" miniatures, they offer certain advantages. Shadows on the miniature, for example, will automatically shift to match the shadows on the full-size set.

THE FOREGROUND ELEMENT—IN THIS CASE
A MODEL PLANE "FLOWN" ON WIRES—IS FILMED
AGAINST A BLACK SCREEN.

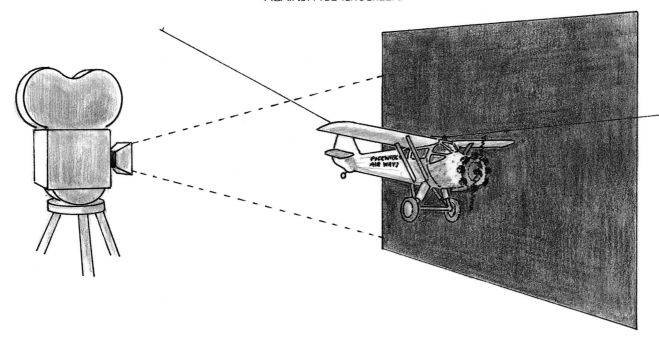

HIGH-CONTRAST PRINTING
IS USED TO CREATE
A SILHOUETTE MATTE OF
THE MODEL PLANE.

THE SILHOUETTE OF THE
MODEL PLANE IS USED TO
PUNCH A HOLE—A MATTE
WINDOW—IN EACH FRAME
OF THE BACKGROUND PLATE.

FINALLY, THE LIVE ACTION
OF THE MODEL PLANE IS
FITTED INTO THE MATTE
WINDOWS. THE RESULT IS
THE ILLUSION OF A PLANE
FLYING OVER A
MOUNTAINOUS LANDSCAPE.

from the beginning, and their value is undiminished today. Photographing models can be tricky, but already in the silent era cinematographers and art directors understood all the key principles involved. To give one basic example, a miniature set must often be built in forced perspective to accommodate a particular camera angle and lens. Again, shooting moving models—automobiles or boats, for instance—calls for all kinds of adjustments on the part of the cameraman because the model lacks the mass of the full-scale vehicles and thus responds differently to gravity and other forces. Cameramen soon learned that they could compensate for such variables by, for instance, shooting in slow motion (which creates an illusion of greater mass).

If the use of miniatures was rather sophisticated in the silent era, another component of special effects work—traveling-matte photography—was still at a very primitive stage.

The traveling-matte technique is a way of placing an actor filmed on a sound stage into a scene shot on location (or of combining a model of a spaceship with a background painting of a planet and distant galaxies). The trick, at its most basic, is to photograph the foreground element—a running man, perhaps—against a flat monochrome backing of some kind. The man, whose image and position will, of course, change from frame to frame, must then be reduced to a series of silhouettes which will be introduced into the background plate as unexposed elements. If all goes well, this matted background plate can be combined with the original film of the running man so that his photographed image slots precisely into the "windows" left by the silhouette mattes.

There have been dozens of traveling-matte systems over the past seven decades, but only two were available in the silent era, and both had severe limitations. One method involved making mattes by hand, carefully tracing the outlines of the foreground live-action elements and in effect reducing them to a series of animated drawings which could be introduced, as mattes, into the background plates. This system, called roto-scoping (after a piece of equipment that facilitates this kind of animation) is still employed today under certain circumstances. Unfortunately, it is laborious, time-consuming, and, therefore, expensive.

The only alternative to rotoscoping available in the silent era was the Williams system, sometimes called the black-backing system. Patented in 1916 by Frank D. Williams, a one-time Keystone cameraman, it capitalized upon the idea of photographing actors against a black (or sometimes white) background so that, by deliberate overexposure and high-contrast printing, moving silhouettes, and hence mattes, could be recorded. The system worked, but it was crude. Imperfect registration in cameras and printers, combined with other problems like film shrinkage, meant that foreground image and matte window did not always match perfectly, so that on screen an actor was likely to be surrounded by a so-called matte line, as if an etcher had decided to emphasize the outline of the figure with his needle.

Such shortcomings meant that the Williams system was not as popular as it might have been, but it was the legitimate progenitor of all succeeding traveling-matte systems. Frank Williams, if he were alive, might take satisfaction in the fact that present-day special effects artists still have not eliminated completely the nightmare of matte lines.

23. Filmmakers have always sought methods of combining moving foreground elements shot one place (usually in the studio) with backgrounds filmed elsewhere. The Williams process was an early method for generating so-called traveling mattes which, like most later systems, capitalized on shooting the foreground elements against a monochrome backing screen. In this diagram, some stages have been eliminated for the sake of clarity, but it illustrates a principle that is fundamental to almost all traveling-matte systems. First, the foreground elements are reduced to silhouettes, and then these silhouettes are used to punch holes ("matte windows") into the background. Finally, the foreground elements, as originally filmed against the backing screen, are slotted into the matte windows, thus creating a composite image.

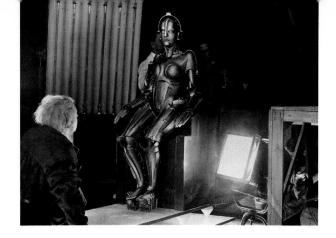

3. Silent Magic

For almost twenty years the movies managed to get by without any kind of formal art direction. Prop men dressed the interiors, and when an exterior was needed the responsibility was handed over to the head carpenter. If he did not know what the Taj Mahal looked like, he could always make a trip to the local library. Even the mammoth Babylon sets for *Intolerance* were conceived and built in a somewhat haphazard and piecemeal way. Griffith assigned Joseph Henaberry—one of his assistant directors, who also played several roles in the film—to do some basic research, which consisted of purchasing books on the ancient Near East and cutting out illustrations and gluing them into a scrapbook. Griffith then used this scrapbook to show Frank "Huck" Wortman, his chief set-builder, what he wanted. Wortman and his crew then went ahead and built it. It was as simple as that.

In the mid-1910s, however, production designers began to enter the film industry, initially arriving from the legitimate theater. Wilfred Buckland was one of the first. Celebrated for the realistic stage sets he had created for David Belasco, he joined Famous Players-Lasky in 1914. Others, like Joseph Urban, who had made his reputation with the Ziegfeld Follies, followed, and it was only a short while before designers like

Cedric Gibbons and A. Arnold Gillespie, who would dominate the field for almost half a century, became active.

Significantly, both Gibbons and Gillespie, who worked together at MGM, were special effects experts. Gillespie in particular was to combine his career as an art director with an equally distinguished career as a special effects supervisor. In general, it was the art directors who did the most to popularize special effects in the silent era, if only because it was they who were given impossible tasks like reconstructing the Seven Wonders of the World on the back lot at a week's notice.

Gillespie and Gibbons worked on one of the most notorious productions of all times, the 1925 version of *Ben-Hur*. The story of the disasters that beset the filming of this epic has been told many times. Started in Italy, *Ben-Hur* encountered everything from labor disputes between Fascists and anti-Fascists to a chronic lack of competent electricians. During the filming of the chariot race, dozens of horses and at least one stunt man were killed, and it is still a matter of conjecture as to whether extras drowned during the sea battle between Roman triremes and pirate galleys. In a move that was to have long-term consequences, Louis B. Mayer and Irving Thalberg —who had inherited what threatened to be a fiasco from the

Goldwyn Company—brought *Ben-Hur* back to California for completion and salvaged it with considerable aid from MGM's special effects team.

The sea battle, for example, was completed with the aid of model shots made in a studio tank, and Frank Williams' traveling-matte system was given one of its most successful outings in the sequence depicting the destruction of the Senate building. (Actually, the Williams system was used in conjunction with hand-drawn mattes, which were needed in shots where chunks of masonry appear to fall between the actor and the camera.) More impressive still are the shots involving the most famous miniature of the silent era, the model devised by Cedric Gibbons and Arnold Gillespie to represent the upper levels of the Circus Maximus in which the climactic chariot race takes place.

The main arena of the Circus Maximus had first been built on the outskirts of Rome, where some footage was shot by "action" director Breezy Eason. When the entire unit was brought back to California, Eason had to wait four months until a new arena was built for him at the corner of La Cienega and Venice boulevards, a short drive from the MGM lot. This set was gigantic—three thousand feet long according to *The New York Times*—but, for obvious reasons, it was only built up to the level of the first tier of seats. In long shots, the upper tiers of the stadium were represented by a large model—a so-called "hanging miniature"—which was suspended in front of the camera, rather like the painted portion of a glass shot, so that the cameraman filmed the model and the full-size set simultaneously. A glass shot would not have worked in this instance, or would not have worked as well, because Gibbons and Gillespie designed the miniature so that it would stay in register with the set as the camera panned across it. Moreover, they furnished the model with ten thousand minute spectators, operated by a system of rods, who could be made to stand and cheer in unison with the live extras (many of them Hollywood celebrities) in the full-size stands.

Ben-Hur cost $4,000,000, was a great popular success, still lost money, and helped change the face of Hollywood filmmaking for the next thirty years. Griffith had made the movies a director's medium, and films like *Birth of a Nation* had led directors to search for realism. In many cases this meant location work, so that when Erich von Stroheim made *Greed* he went to Northern California, found real houses that suited his purposes, and tore down walls so that he could shoot inside

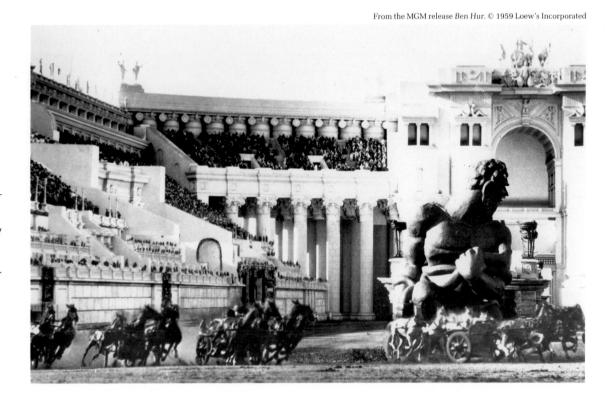

24. This publicity composite for **Ben Hur** (1925) shows approximately how the Circus Maximus appeared on screen. The lower levels of the stadium were built full size, but the upper tiers were constructed as a miniature which could be suspended between the camera lens and the full-scale set, positioned in such a way as to make the two components appear to the camera to be continuous parts of a single giant structure.

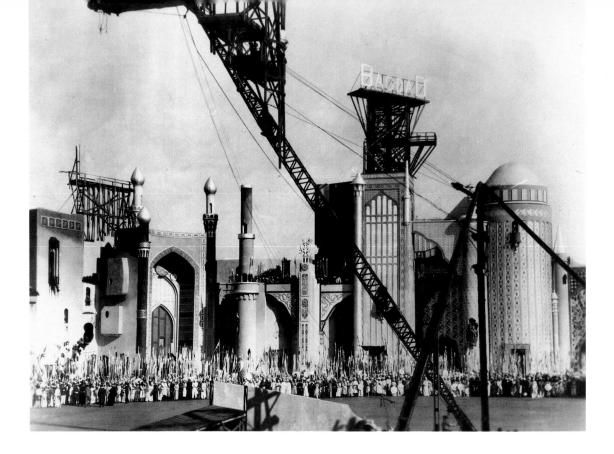

25. This huge exterior set was built for Douglas Fairbanks' **The Thief of Bagdad** (1924). The Bagdad sign mounted on scaffolding is there for the benefit of motorists on Santa Monica Boulevard. On film, it was eliminated by means of a glass shot. The giant crane in the foreground was used to "fly" Fairbanks on a magic carpet, one of the most famous effects of the silent era.

26. The Thief of Bagdad includes a spectacular undersea sequence for which glass foreground miniatures were used to enhance the scale of the sets. Cinematographer Arthur Edeson overcranked his camera so that the on-screen action is seen in subtle slow motion that contributes to the underwater effect.

them. Other directors traveled farther afield. *Romola* was set in Italy, so Henry King went abroad to shoot it. The same logic took the filmers of *Ben-Hur* to Italy, but the logic that brought them back to California was even more powerful.

Mayer and Thalberg were able to muster a formidable array of arguments to justify their decision. The film industry had moved to Southern California in the first place to take advantage of its almost ideal climate and its limitless variety of locations. As a consequence of this, Hollywood provided the world's greatest pool of technical talent for the production of motion pictures. There was no language barrier to contend with, no shortage of skilled electricians, and certainly no vendetta between Fascist and anti-Fascist groups. Under the circumstances, who needed Italy?

Unspoken was a still more potent argument. Mayer and Thalberg were keenly interested in reestablishing the producer's eminence in the movie field. Shooting films on a Hollywood lot, with occasional forays to nearby locations, a producer, through his informants, could keep close tabs on a given project on a day-to-day basis. Temperamental stars could be dealt with before grievances were blown out of proportion, and uppity directors could be kept in line. All of which meant savings.

Many film historians date the swing back to in-studio production from the advent of sound, which did undoubtedly accelerate the process. The evidence suggests, however, that the trend began three or four years earlier and that the original impetus was the desire of studio heads to bolster their power bases. The impact this had on the development of the American film is arguable. One thing is certain, however. Studio-based films meant more special effects, and it is at about this time—the mid-1920s—that the major studios began to develop their special effects departments in a systematic way.

Although many Hollywood movies of the '20s relied heavily on effects—Fairbanks' flamboyant spectacles immediately come to mind—it must also be admitted that at this period leadership in the field was to be found in Europe, especially in Germany, where, at studios like Decla-Bioscop and UFA, extraordinary visions were being committed to film.

America became aware of German cinema in 1921, when *The Cabinet of Dr. Caligari* was shown in New York, Los Angeles, and other American cities. With its stylized expressionistic set, *Caligari* caused immediate controversy—even provoking a riot by American Legionnaires—and was a commercial flop. But people took notice of these German productions. Paul Wegener's *The Golem*, released later that year, enjoyed much more success, and soon a steady stream of German films began to cross the Atlantic. To speak of a German

school would be an exaggeration—directors like Fritz Lang, G. W. Pabst, and F. W. Murnau had highly personal approaches —but still there were definite characteristics that made almost any German film look different from an American film. In particular, the German movies benefited from highly imaginative and dramatic art direction. Many German production designers eschewed location work entirely, often shooting exteriors on enclosed stages (in part this may have been due to the climate). The inevitable consequences involved innovative sets, inventive approaches to cinematography, and an extensive use of special effects.

In 1921, Fritz Lang made an ambitious film titled *Der Müde Tod* (*Weary Death*). A young woman (Lil Dagover) bargains with Death (Bernhard Goetzke) for the soul of her lover. Beginning in a small German town, the film also travels to Renaissance Venice, ancient China, and Baghdad. Douglas Fairbanks

27. Paul Wegener's **The Golem** (1921) was one of the first German films to enjoy a substantial degree of success in the United States. (Since the silent film presented no language barrier, audiences were able to enjoy foreign movies without difficulty.) The sets for the movie, by Hans Polzig, caused a considerable stir, and Wegener himself, in the title role, brought the clay giant to life with the aid of what could now be called effects makeup.

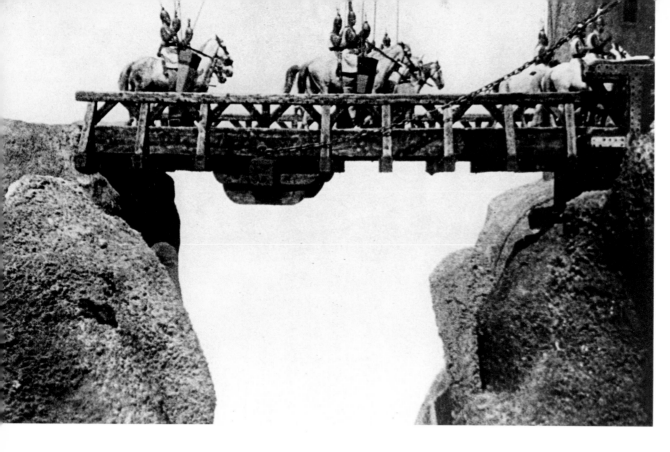

28–30. During the silent era, German special effects artists were among the finest anywhere. The two photographs on this page show how, for Fritz Lang's **Siegfried** (1925), the effects crew was able to use in-the-camera mattes and foreground miniatures to transform a shallow moat into a gaping chasm. The dragon built for **Siegfried** (opposite) was seventy feet long and was operated by seventeen concealed technicians. Even by today's standards it was remarkably lifelike.

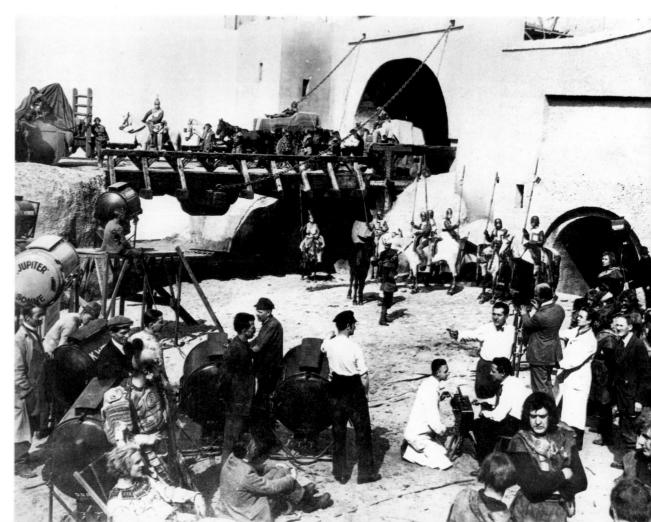

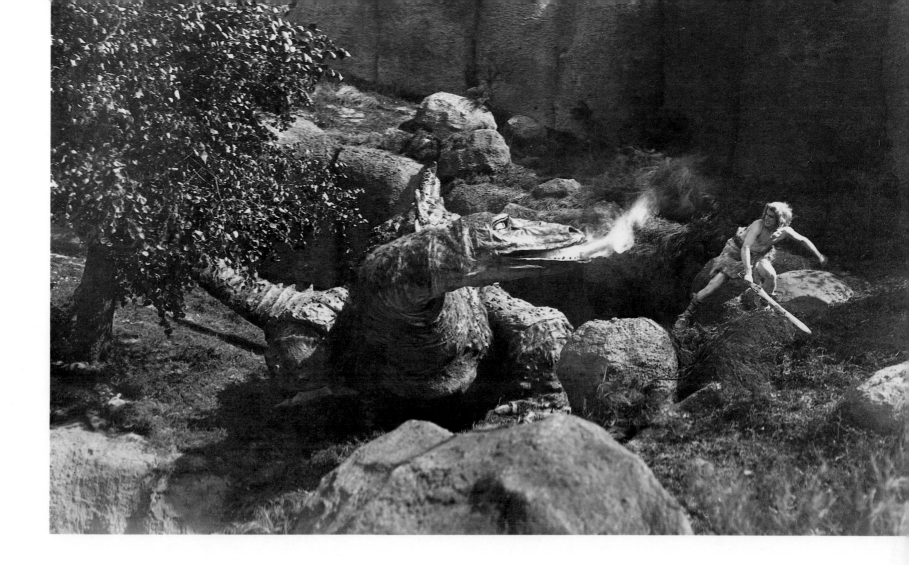

was so taken with the movie that he purchased the American rights. He had no intention of releasing it at that time, however; rather, he wanted to suppress it, giving his technical people the leisure to study the German photographic tricks so that he might incorporate them into his forthcoming spectacle, *The Thief of Bagdad.*

Some of Lang's later silent movies, such as the two halves of *Die Nibelungen* (1924) and *Metropolis* (1927), are especially rich in effects. The *Siegfried* segment of *Die Nibelungen* boasts a spectacular mechanical dragon, seventy feet long, which could breathe fire, drink water, and, when wounded by Siegfried's sword, bleed. Devised by Lang's art director, Karl Volbrecht, the dragon had an articulated skeleton and a scaly outer skin coated with vulcanized rubber. Its mechanical controls were operated by seventeen technicians, some concealed within the body itself and some in a trench containing tracks on which the dragon ran.

If *Die Nibelungen* evoked a mythical past, *Metropolis* conjured up a terrifying future. Supposedly inspired by Lang's first glimpse of Manhattan from the deck of the *S.S. Deutschland,* the movie is set in a city of the twenty-first century where the ruling class lives in soaring skyscrapers while the workers subsist underground in man-made caverns filled with spidery catwalks and throbbing machinery. Mixing the cinematic equivalent of metaphysical rhetoric with gothic clichés and cybernetic fantasy, *Metropolis* was about as far removed from the Hollywood silent-movie norm as could be imagined, yet Americans were awed by its visual delights, many of which were provided by the special effects team. At least a dozen scenes made use of the Shuftan process (under the inventor's personal supervision), and others employed miniatures of various kinds, glass shots, large-scale mechanical effects, animation—in short, every tool that was available to the imaginative filmmaker of the period.

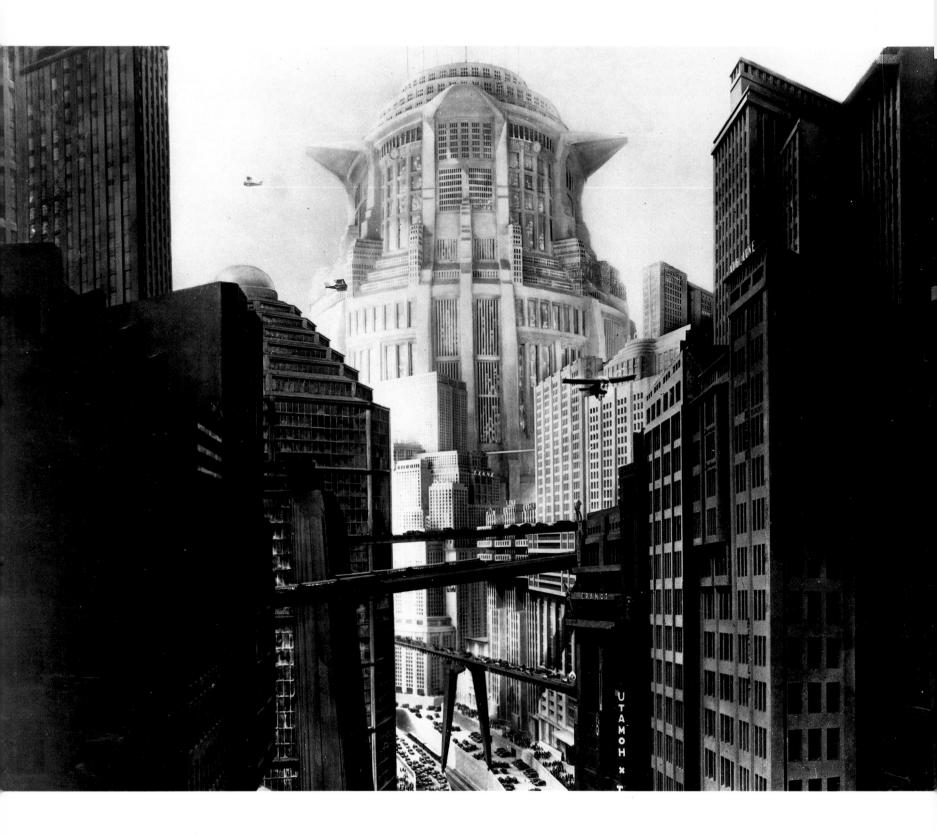

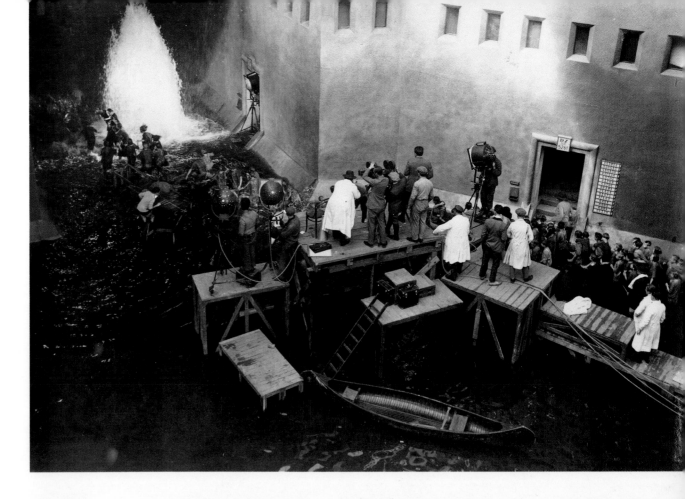

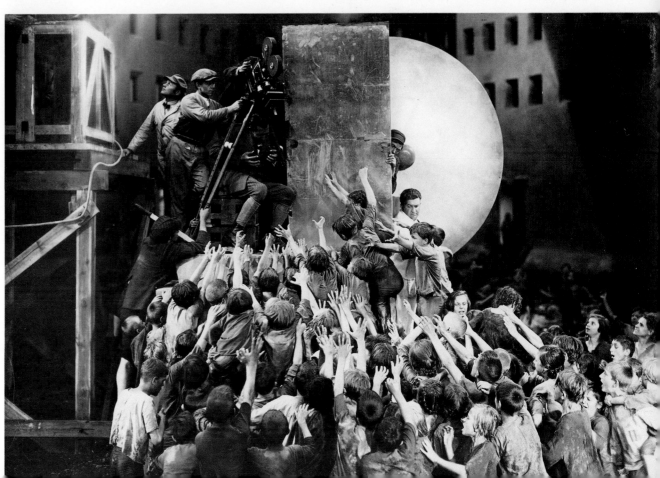

31. Inspired by the director's first glimpse of New York, Fritz Lang's **Metropolis** (1927) is a stunning evocation of a future world that drew upon the entire arsenal of visual and practical effects. The surface city, with its baroque skyscrapers, busy flyovers, and aerial traffic, was conjured up with the help of detailed miniatures.

32–33. One of the many impressive physical effects in **Metropolis** is the flood that engulfs hundreds of children in the underground city. Here Lang, positioned directly beneath the camera lens in the lower photograph, directs scenes on the flooded set.

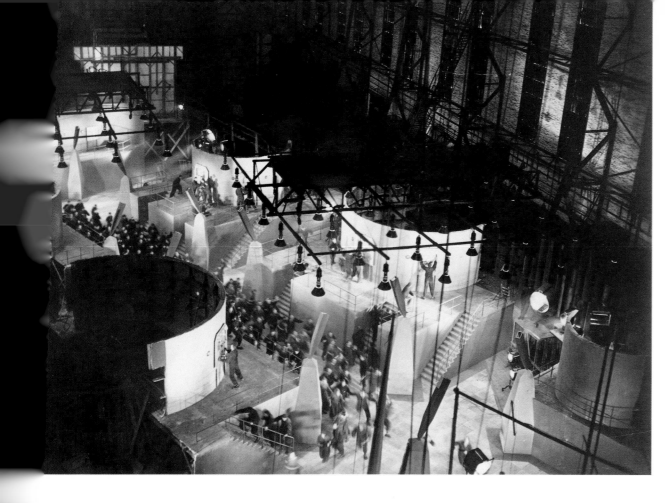

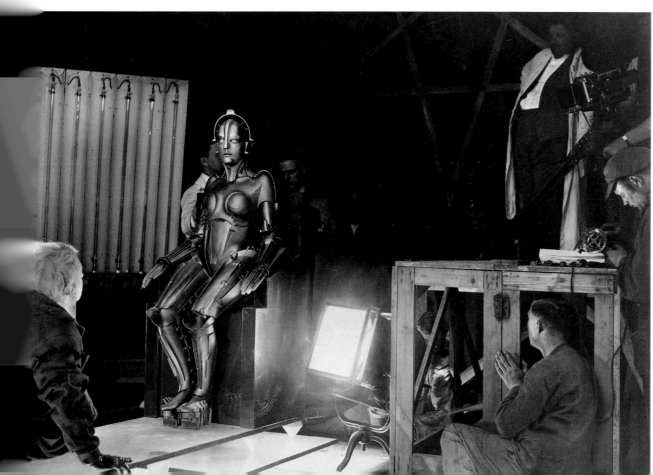

34–35. In order to conjure up his Malthusian vision of the future, Lang packed **Metropolis** with busy crowd scenes. Here (left), seen from a cat-walk high above a stage at UFA's Neubabelsberg studios, extras portraying slave workers rush to their posts. **Metropolis** was also one of the first movies to feature a robot. Consisting of a jointed metallic costume with an actor inside, this automaton was re-markably elegant and effective, its appearance anticipating that of **Star Wars'** C3PO, who did not reach the screen until almost half a century later.

36. Lang's **Woman on the Moon** (1928) maintains a decent degree of scientific plausibility until its cosmo-nauts reach the lunar surface. The director was no doubt aware that the moon was likely to lack a breathable atmosphere, but decided to dispense with this knowledge in the interest of narrative considerations.

At the end of the silent period—on the cusp of the sound era, actually—Lang made *Frau im Mond* (*Woman in the Moon*), a science-fiction movie that anticipated Stanley Kubrick's *2001: A Space Odyssey* in one interesting respect. The special effects for *Frau im Mond* are only moderately interesting, but, just as Kubrick was to attempt to base his space movie on informed scientific speculation, so Lang sought out the advice of experts like astronomer Willy Ley and Professor Herman Oberth, progenitor of the German rocketry program that produced the V-1 and V-2 missiles. Their input enabled Lang's art director to design a very plausible space vehicle, by the standards of 1929. In fact, the movie contains much sound scientific detail, though, curiously, no precautions are taken on this particular expedition against the moon's lack of atmosphere, so that the adventurers are shown cavorting around the lunar surface in plus-fours and Norfolk jackets.

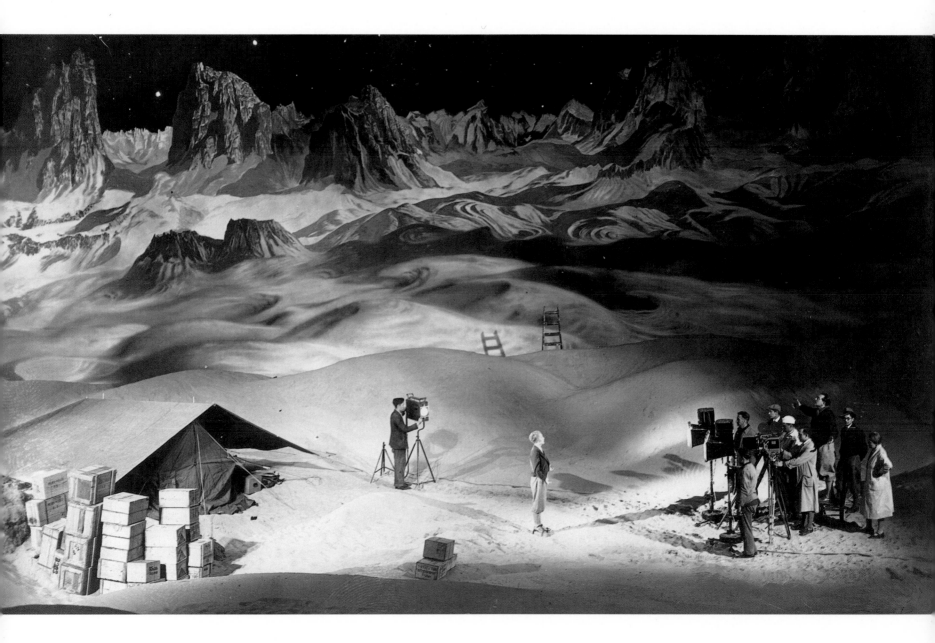

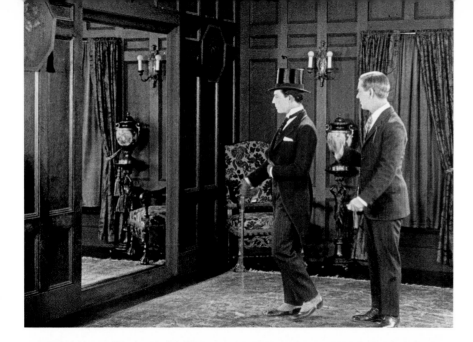

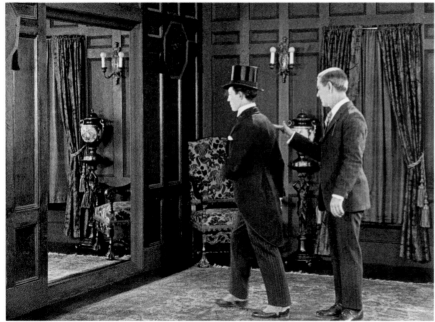

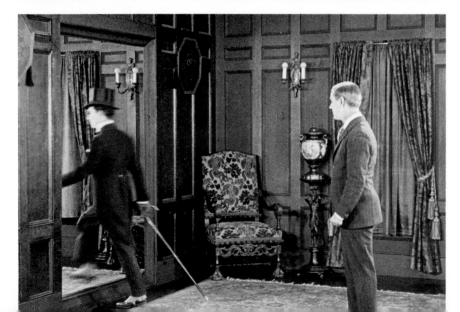

37–39. As a director, Buster Keaton had a sure sense of how to use cinematic sleight of hand, sometimes employing very sophisticated visual and mechanical effects, many of which he devised himself. Some of his most complex tricks are to be found in **Sherlock, Jr.** (1924). In this scene from that movie, however, the ''mirror'' is simply an opening in the wall and the ''reflection'' a set of reversed props. The devise is elementary, but the illusion is wonderfully effective.

Needless to say, Lang was not the only German director to make use of special effects. In *The Last Laugh* (1924), for example, Murnau used matte shots and multiple exposures to convey pathological delusions from the point of view of the character suffering them. In E. A. Dupont's *Variety* (1926)—an Emil Jannings vehicle—the camera itself, in the hands of the great Karl Freund, became a kind of special effect. One scene, for example, called for a character to fall from a trapeze. The fall was recorded from the victim's subjective viewpoint by having Freund lowered on a cable, twisting and turning, undercranking his camera as he made his descent.

In the area of physical effects, however, Hollywood held its own, with much of the best work in the field expended on comedy films. Mack Sennett was a pioneer of camera trickery, and Buster Keaton was himself a genius at devising mechanical gags, usually worked out in collaboration with his "technical" man, Fred Gabourie, who was responsible for rigging some of the most dangerous stunts a movie star has ever been subjected to. In *Steamboat Bill, Jr.*, for example, Keaton finds himself in the middle of a town that is being blown away by a hurricane. Automobiles and houses fly through the air (actually they were suspended from a giant crane) while Keaton stands in front of a two-story building, wondering where he can seek shelter. Suddenly the front of the building—two tons of heavy beams, wood lath, and plaster—is torn loose by the fierce wind and begins to fall on the oblivious Buster. Keaton does not flinch, does not move a muscle as the facade falls, engulfs him, and appears to have crushed him. When the dust settles, however, we see that he is still standing there, slotted into a small open attic window, like a sprocket into a sprocket hole.

Keaton was an endlessly inventive filmmaker. In *Sherlock, Jr.*, he plays a movie projectionist who falls asleep and dreams that he is able to enter the two-dimensional world on screen. The screen Keaton invaded was actually a stage furnished with a cutout "frame" the shape of a projected movie image and lit in such a way that whatever happened on it would have the appearance of a film being projected. Once Keaton had entered the "movie," however, the camera cut away from the fake screen to a series of location shots that cause the sleepwalking Keaton no end of confusion. Walking on the mountains, he almost falls over a cliff. As he peers down, he suddenly finds himself in a jungle, confronted by lions. As the lions threaten him, there is another cut and he is alone in the desert. An express train appears from nowhere, and he throws himself onto a sand dune which, the instant he hits it, turns into a rock on the seashore. A wave breaks over him, he dives into the ocean and ends up in a snowdrift.

This magic, which is as astonishing to contemporary audiences as it was to theatergoers in 1924, was accomplished with a simple enough trick, though one that demanded great precision on the part of Elgin Lessley, the cameraman. At the end of scene A, Keaton would remain frozen while the distance between the camera and himself was precisely measured. Before scene B was shot, scene A would be hurriedly developed (often in a portable darkroom), and a few frames would be clipped and inserted in the camera gate. At the start of scene B, the camera would be placed at the exact same distance from Keaton, and Lessley would use the clip in the camera to line Keaton up. The result is that the backgrounds change, as if cut in the editing room, while Keaton's actions appear to flow seamlessly from scene to scene.

Sherlock, Jr. is packed with clever devices, both optical and mechanical, and, like the earlier *Steamboat Bill, Jr.*, deserves to be considered among the all-time classics of the special effects film.

Some of Hollywood's more pretentious productions in the '20s had their moments, too. For Cecil B. De Mille's 1923 version of *The Ten Commandments*, the task of parting the Red Sea was assigned to Paramount's Fred Moran and Roy Pomeroy. The moment when the waters part was relatively easy to achieve. Moran and Pomeroy had huge dump tanks deposit water into a U-shaped trough. When film of this was run in reverse, it looked like a body of water being separated into two entities by divine intervention. More problematic was the need to keep the two walls of water apart while the Israelites crossed to safety. Pomeroy solved this by filming a slab of Jell-O that had been sliced down the middle and then matting a live-action shot of fleeing Israelites into this quivering miniature. On screen the result is surprisingly convincing.

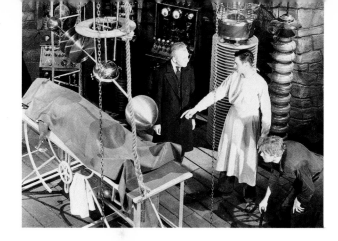

4. The Coming of Sound

It is difficult for us to grasp, at this remove in time, why such astute showmen as Irving Thalberg and Adolph Zukor were so reluctant to take the leap into the sound era. Partly, of course, it was a matter of economics. At a time when the production companies also controlled huge theater chains, the switch to sound meant not only rebuilding studio facilities but reequipping every projection booth and every auditorium— a huge capital outlay. In addition, it meant being in thrall to giant companies like Western Electric and RCA (controlled respectively by the Morgans and the Rockefellers) who held the sound patents.

But that was only part of the story. The fact is that, by the time Warner Brothers released *The Jazz Singer* in 1927, sound film had been around for a quarter of a century; for two decades the public had been intermittently subjected to such ballyhooed systems as the Chronophone, the Cameraphone, the Cinephone, the Vivaphone, the Synchroscope, the Kineto-phone, and Phonofilm. Since none of these had caught on, it is hardly surprising that the conventional wisdom within the film industry was that Warner Brothers' initial success with Vitaphone was merely a fluke.

This delusion was quickly dispelled, however, and before long Hollywood was full of self-appointed sound experts, vo-cal coaches, dialogue directors, and actors trying to imperson-ate Alfred Lunt and Judith Anderson. Overnight, the fundamen-tals of filmmaking changed. The great silent-film directors had sent their cameras probing and soaring. Now suddenly those cameras, running at a precise, mechanically controlled twenty-four frames per second, were housed in soundproof blimps that looked like refrigerators, while directors were reduced to the expedient of shooting static stories that were little better than filmed stage plays. And, although before long sound re-cording equipment became less cumbersome and the camera was free to move again, some of the changes were permanent. The days when you could ignore traffic noises and the hum of low-flying aircraft were gone forever, and for twenty-five years location shooting would be a luxury reserved for subjects that absolutely demanded it, and for directors who had proven to the front office that they could be trusted to cross the street. Sound meant that the majority of films were made in the studio, and this meant more work for the special effects departments.

Sound dictated that many in-the-camera tricks were no longer practical (unless the sound was to be dubbed in later). At the same time, the emphasis on studio production increased

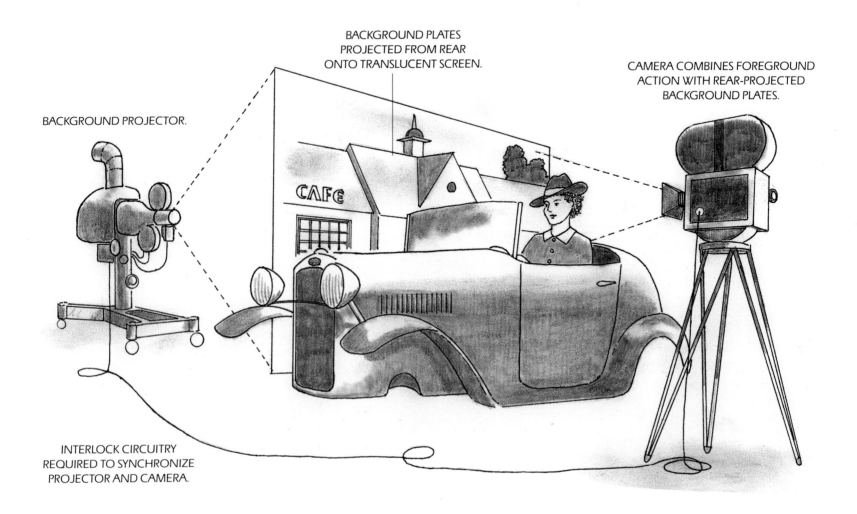

BACKGROUND PLATES
PROJECTED FROM REAR
ONTO TRANSLUCENT SCREEN.

CAMERA COMBINES FOREGROUND
ACTION WITH REAR-PROJECTED
BACKGROUND PLATES.

BACKGROUND PROJECTOR.

INTERLOCK CIRCUITRY
REQUIRED TO SYNCHRONIZE
PROJECTOR AND CAMERA.

the need to composite stage-shot live action with artwork or background plates filmed elsewhere. The prime need, then, was for improved rear-projection techniques, new matting systems, and for printing devices that could duplicate what had previously been done in-camera.

Rear projection, as has been mentioned, was not a novelty, but its efficacy began to improve sharply in the early 1930s largely due to the efforts of men like Ralph Hammeras, then at First National, and Farciot Edouart of the Paramount special effects department. Good quality rear projection requires a specially constructed projector equipped with powerful arc lamps (to provide a bright process-screen image), and a pilot-

40. Rear projection began to enjoy some popularity during the early 1930s, and by the end of the decade had become a standard special effects tool. A powerful projector projects the background image, from the rear, onto a special translucent screen. The camera, synchronized with the projector, films foreground elements and the projected background plates simultaneously. The system was especially popular for shots that involved people traveling in cars or other vehicles. Every studio kept special car bodies—wheelless and sometimes with part of their superstructure cut away—on hand for such shots. Often these vehicles were mounted on springs or rockers, so that naturalistic movement could be simulated.

pin intermittent movement that exactly matches the movement in the camera it is working with. Camera and projector are linked by interlocking controls, since the shutters of both machines must be synchronized so that each frame of negative raw stock is registered in the camera just as a frame of the background plate is registered in the projector.

Poorly executed rear projection is the kind of special-effects shortcoming that the least sophisticated filmgoer can spot without difficulty. If the director and his production designer fail to match the perspective of the foreground elements to that established by the background plates, the discrepancy will be immediately apparent. An even more serious problem

in the early days was the inadequacy of the projected image itself, which often appeared washed out or grainy. Process screens were inadequate, and projectors were simply not powerful enough. Edouart eventually solved (or at least minimized) this latter problem by using three of them, all running

41. The Dunning-Pomeroy process enjoyed a brief heyday in the early sound era. Foreground elements, shot against a blue screen, could be composited in a bipack camera with backgrounds shot earlier. The system had some severe disadvantages, however, and fell into disfavor as rear-projection techniques improved.

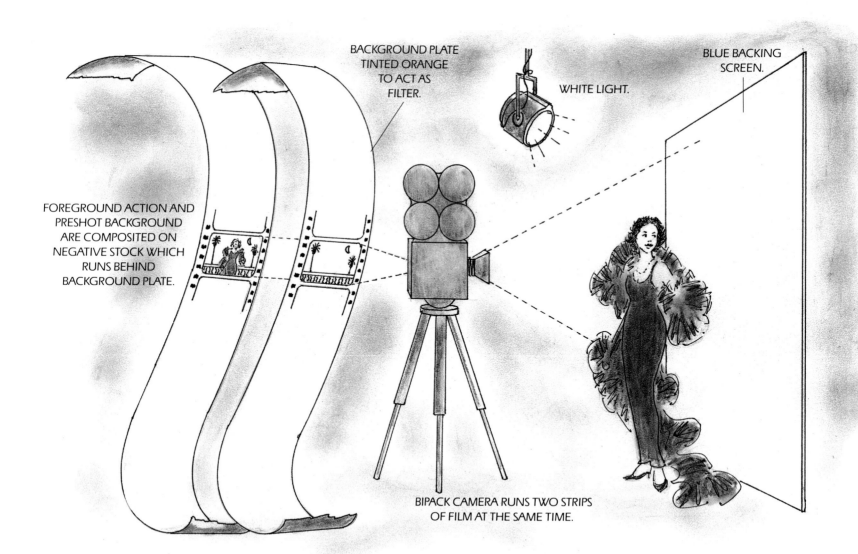

BACKGROUND PLATE TINTED ORANGE TO ACT AS FILTER.

WHITE LIGHT.

BLUE BACKING SCREEN.

FOREGROUND ACTION AND PRESHOT BACKGROUND ARE COMPOSITED ON NEGATIVE STOCK WHICH RUNS BEHIND BACKGROUND PLATE.

BIPACK CAMERA RUNS TWO STRIPS OF FILM AT THE SAME TIME.

the same background plate, in conjunction with one another, building up a far more brilliant image on the process screen.

Hardware improvements of this sort made rear projection increasingly popular as the '30s progressed, but for much of the decade filmmakers preferred to use a traveling-matte system known as the Dunning-Pomeroy self-matting process. Patented in 1927 by C. Dodge Dunning, and developed by Roy Pomeroy (the man who parted the Red Sea), it capitalized upon the way black-and-white film stock responds to different wavelengths of light.

Background plates were shot first, then a positive print of this footage was dyed orange (so that you had an orange-and-white record of the background scene, instead of a black-and-white one). This dyed positive would then be loaded into a bipack camera (one capable of handling two reels of film simultaneously) with raw negative stock running behind it. Actors and foreground props were lit with orange light and placed in front of a blank Dunning screen saturated with blue light. In the camera, the dyed stock acted as a filter. The orange light reflected from actors and props passed through this filter and was recorded as a black-and-white image on the raw stock behind. Meanwhile, the blue light reflected from unobscured portions of the Dunning screen was simultaneously used to print background detail from the dyed positive onto the same raw Panchromatic stock (film sensitive to all visible wavelengths) so that a fully composited image was produced in a single operation.

In short, the actor served as his own matte, which gave the Dunning process considerable advantages over earlier traveling-matte systems, not the least of which was that composited rushes would be available for viewing the next morning. Among its drawbacks were the fact that the background plates sometimes "ghosted" through the foreground imagery, producing a transparent effect. Also, the director and cameraman had no practical way of lining up their foreground components with the background plate, so that composition and perspective were left largely to guesswork. As rear-projection systems improved, so the Dunning-Pomeroy process slipped into disuse.

The bipack cameras used for Dunning shots retained another use, however, in the process known as bipack contact matte printing.

The in-the-camera matte shots described in Chapter Two registered all their manipulations and replacements of imagery on the original negative. This had one tremendous advantage. It was capable of producing the most exquisite composites imaginable (never having to go through extra generations of film with the inevitable loss in quality that implies). It also had a critical disadvantage. If one exposure was botched, the whole thing was ruined.

Bipack contact printing allows mattes to be made from a master positive struck from the original negative. This master positive (not dyed) is loaded into the camera with raw negative duplicating stock running behind it, as in the Dunning process, but with the emulsion of one strip in contact with the emulsion of the other. When these two strips of film are run together with the camera lens focused on a properly illuminated white matte-board, the camera becomes a step-printer and produces a dupe negative of each frame of the master positive. If an area of the matte-board is blacked out with ink or paint, however, that area will not transmit light into the lens, and the corresponding part of the master positive will not be exposed onto the dupe negative. Mattes

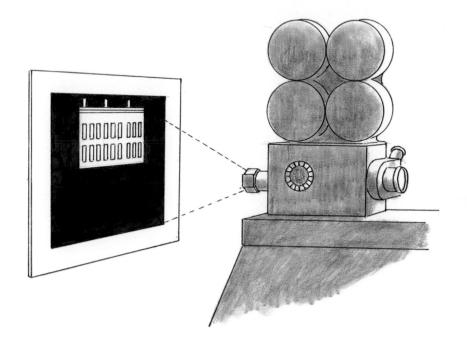

42. Bipack printing is a system that permits artwork to be combined with, for example, live-action footage shot on a sound stage or on location. Mattes are generated and images composited in a camera equipped to run two strips of film simultaneously.

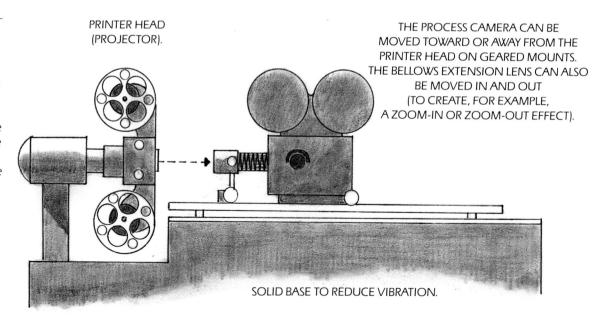

43. An optical printer consists, at its most basic, of a projector (the printer head) and a mounted camera facing one another, so that the projector can throw a focused image directly into the camera lens. The optical printer is probably the most flexible tool available to special effects workers. It is capable of a wide variety of tasks, from simple wipes and fades to the most elaborate compositing work.

PRINTER HEAD (PROJECTOR).

THE PROCESS CAMERA CAN BE MOVED TOWARD OR AWAY FROM THE PRINTER HEAD ON GEARED MOUNTS. THE BELLOWS EXTENSION LENS CAN ALSO BE MOVED IN AND OUT (TO CREATE, FOR EXAMPLE, A ZOOM-IN OR ZOOM-OUT EFFECT).

SOLID BASE TO REDUCE VIBRATION.

and countermattes can be generated in this way so that the live action on the master positive can be composited with a matte painting, a photograph, or other live-action footage.

What made bipack matte printing viable was the improved fine-grained duplicating stocks that became available in the sound era. These also helped make a success of an even more flexible tool that appeared at about the same time: the optical printer. Linwood Gale Dunn, who was to become one of its virtuosi, says that he first heard of the optical printer around 1926. As he recalls, a place called the Roy Babbitch Laboratory had built one which they kept under wraps in a locked room. But before long every major studio would have its own, though it was almost twenty years before the optical printer was produced in quantity.

The basic principle of the optical printer had been employed by still photographers long before 1926. Essentially, a projector (known as the "printer head") is set up facing a camera. The projector is loaded with a master positive, the camera with raw negative stock. The projector throws an image literally *into* the camera, and the camera records it on the negative stock. As with rear-projection systems, projector and camera must be synchronized by means of interlocking controls. The advantages that the optical printer provides over contact printing are many. Fades and dissolves, for instance, are no challenge to the optical printer; nor are such other optical transitions as wipes and "push-offs" (the effect achieved when the

incoming shot appears to push the outgoing shot off screen). An optical printer can skip frames—say, every other one— so that the action will be speeded up, as if the camera had been undercranked. Just as easily a slow-motion effect can be achieved by repeating frames, or a single frame can be photographed again and again to produce a freeze-frame effect.

If the camera is moved closer to the printer head, it can record (or enlarge) part of each frame: a magnification effect. If the camera moves closer to the printer head in regular increments, from frame to frame, a zoom effect is produced. Diffusion, day-for-night, and split-screen can also be achieved with the optical printer, and if, as is normal, the printer head and/or the process camera are equipped to run bipack, all kinds of elaborate matte work can be handled. From the beginning, the optical printer, in the hands of an expert, routinely worked miracles, and still does today.

Many of the same miracles can be wrought with the aerial-image printer, which also began to enjoy some currency in the 1930s. One form of aerial-image printer is, in fact, a modified optical printer. The more common kind is a modified animation stand.

An aerial image is an image that is focused in thin air. The projectors at your local Multiplex are automatically set (often with dismal results) to throw a focused image onto a screen which is, say, one hundred feet from the projection booth. The screen allows that image to be seen. Remove the screen and

the image becomes invisible to the audience, but in a real sense it is still there. In theory, if you place a camera, with the same focal length as the projector, one hundred feet behind the place formerly occupied by the screen, that camera will be able to pick the image, perfectly focused, out of thin air. That is how an aerial-image printer works, except that instead of a theater screen, the critical focal plane is represented by the

upper surface of the transparent "window" in the table of an animation stand.

Animated films are made by photographing artwork painted on "cels," transparent sheets held in place on the table of an animation stand by means of registration pins. When the animation stand is modified to serve as an aerial-image printer, the camera simultaneously records, for example, artwork and,

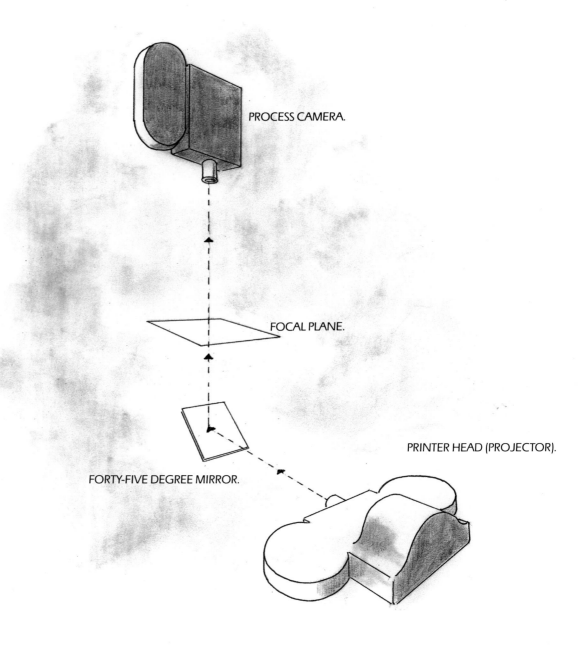

PROCESS CAMERA.

FOCAL PLANE.

FORTY-FIVE DEGREE MIRROR.

PRINTER HEAD (PROJECTOR).

44. The aerial-image printer can perform many of the same tasks as the optical printer. Like the optical printer, it consists of a projector and a camera positioned in such a way as to permit interaction between the two optical systems. In principle, the configuration employed allows the camera to snatch a focused image out of thin air (hence the term aerial-image). In practice, the equipment used is a modified optical printer or, more commonly (as in the configuration shown here), a modified animation stand.

in the surrounding areas, background plates (or whatever) cast into the same focal plane by a projector synchronized with the camera.

It can easily be seen how such a method can be used to combine live action with animation, as in *Hollywood Party* (1934) when Mickey Mouse and Jimmy Durante share the screen for a few memorable moments. The aerial-image system can be used with equal effect to produce fades, dissolves, skip-frames, superimpositions, and the majority of effects that can be generated with a standard optical printer.

With these new tools coming into general use, studio special effects organizations began to settle into their final form, though there was no uniformity from one lot to the next. At Paramount, for example, Gordon Jennings became head of special effects, but under him were a number of semi-autonomous subdepartments. Farciot Edouart had his own rear-projection unit, while Paul Lerpae was the optical supervisor. Ivyl Burks was in charge of miniatures, and Jan Domela was the chief matte painter. At some studios the term special effects was used strictly to describe physical effects, while matte photography, optical printing, and the like were consigned to a separate department known as visual effects or photographic effects.

Some people came to the departments by choice and temperamental inclination, others by chance. Linwood Dunn, for example, arrived in Hollywood in 1926 as a production cameraman with a Pathé serial unit. In the normal course of events he learned to do in-the-camera fades, dissolves, split-screens—techniques that every silent-era cameraman had to be familiar with—but he entertained no thought of entering the effects field. In 1928, however, he was out of work, playing in a dance band, when he got a call from the union offering him a couple of days work at RKO. RKO was at that time a brand new company, set up by RCA to capitalize on its Photophone sound system. Dunn found himself working on a matte shot for a movie called *Ringside*. Evidently he acquitted himself well at this task because he was soon permanently employed as a camera operator in the fledgling RKO special effects department.

"I really lucked out," he explains. "RKO was the smallest of the majors, and, because it was smaller, we did all the various types of effects in the one department. The big studios like Fox and Metro had a separate department for everything—one for matte paintings, one for optical printing, one specially for miniatures, another for background projection—but at RKO everything came through the one department. I got on the optical printer mostly, but my experience has been pretty broad."

In the opinion of many people Dunn was in fact the first master of the optical printer, and certainly he contributed greatly to the refining of that particular tool. During World War II Dunn was asked by the U.S. government and Eastman Kodak to design a standard optical printer for Armed Services Photographic Units. The outcome of this was the Acme-Dunn Special Effects Optical Printer, for which Dunn and his colleague Cecil Love received an Academy Award. (Dunn also received an Oscar in 1981 for his further contributions to optical printing.)

In the meantime, however, Linwood Dunn had become head of the photographic effects department at RKO and had contributed his skills to dozens of productions, including such classics as the 1931 version of *Cimarron*, *Flying Down to Rio*, the Astaire-Rogers musicals, *Citizen Kane*, and, of course, *King Kong*.

5. King Kong

Hollywood has never succeeded in producing a movie with more compelling mythic undercurrents than the original *King Kong*, which RKO unleashed on an unsuspecting world in March of 1933. The story of the giant ape and the beautiful girl, which has gripped audiences for more than half a century, seems to have the power of an archetypal legend dredged up from the collective unconscious. Perhaps, indeed, the collective unconscious was lurking in a corner of the old RKO lot, but the evidence suggests that the film was actually the result of a series of compromises which, while typical enough of the motion picture industry, could hardly have been expected to produce a cinema classic.

The two men chiefly involved in shaping *King Kong*, Merian C. Cooper and Willis O'Brien, were drawn from very different backgrounds and had very different aspirations. Each of them, in 1931, was nursing a pet project.

Willis O'Brien is one of the greatest names in the history of special effects, a pioneer of stop-motion animation and a masterful coordinator of the entire arsenal of special effects that was available during the early sound era. After a restless adolescence, which had seen him employed as a cowboy, a prizefighter, and a railroad brakeman, he began to experiment with model animation, one of the most trying and time-consuming ways of making a movie that has yet been devised.

On the set of a live-action film, such as *Top Hat*, the camera records the movement of the performers by breaking it down into twenty-four still images every second. When the film is projected at the same speed, Fred Astaire and Ginger Rogers are brought back to life thanks to the phenomenon known as "persistence of vision," which causes our brains to run the succession of images together to produce the illusion of movement. It is possible to create this illusion from scratch by photographing a series of carefully related still images—drawings, for example—one frame at a time, with a special movie camera designed for this purpose. Animated cartoons are made this way, and such "flat" animation has its place in special effects, too.

Model animation, as practiced by Willis O'Brien, simply carries the same principle into the third dimension. Flexible figures with articulated skeletons are made to move in tiny increments. (The animator simply moves them by hand, causing an elbow or a knee to bend a fraction of an inch at a time.) After each minute move, the animation camera exposes one frame of film. When the exposed strip of film is developed and

projected, the figures appear to move on their own. If the animator possesses the skills of a Willis O'Brien, the figures actually seem to be alive, but the work is maddeningly slow and demanding.

This technique has been known at least since 1897 (nearly a decade before the first recorded animated cartoon), but it was still no more than a novelty when Willis O'Brien, in his twenties, began to experiment with it. His first serious effort was a short titled *The Dinosaur and the Missing Link*, which he completed in 1915. This prehistoric comedy announced O'Brien's predilection for movies about the age of dinosaurs. Both of his major successes of the silent era—*The Ghost of Slumber Mountain* (1918) and *The Lost World* (1925)— feature confrontations between man and prehistoric monsters. The set of the latter film, produced by First National, was visited by Fritz Lang on his first trip to America. He pronounced the film "a technical masterpiece," while Sir Arthur Conan Doyle premiered clips from it before the Society of American Magicians in New York. Newspaper reports of this occasion suggest that some of those present believed that the dinosaurs they saw on screen were "real."

As the 1920s came to a close, O'Brien was at RKO developing *Creation*, another picture in the same vein. But when in October of 1931 David O. Selznick was appointed vice-president in charge of production at the studio, one of the first things he did was to place *Creation* on hold, suspecting, perhaps, that O'Brien had gone to the well once too often. Selznick might have killed it outright if it had not been for the fact that a considerable sum had already been spent on development and preproduction. As things stood, he had to go through the motions of evaluating the project, appointing Merian C. Cooper to look into its potential.

Cooper was a hero of the War to End All Wars—a flying ace—who had drifted into filmmaking as an adjunct to his adventurous lifestyle. With an ex-combat cameraman, Ernest B. Schoedsack, Cooper had made innovative documentaries and quasi-documentaries in exotic locations such as Persia and Siam. While shooting in Africa he had become fascinated with gorillas and had conceived the idea of making a movie with an ape as the central character. The idea he was hawking around the studios in 1930 and 1931 was for a film that would feature a real gorilla, but no one was buying, apparently thinking that in the changed conditions of the sound era the cost of location

45. Producer Merian C. Cooper indulges in a profitable pipe dream for the benefit of the RKO publicity department.

shooting would be prohibitive. At the time he signed on as a Selznick aide, Cooper was still committed to his gorilla idea and presumably looked on his RKO duties as interim chores.

When Cooper was called in to assess the *Creation* project, Willis O'Brien saw the writing on the wall but took note of the fact that Cooper seemed impressed with his skills as a model animator and special effects artist. (Extensive tests had already been shot for *Creation*.) O'Brien decided to gamble. He had heard about Cooper's gorilla idea and set out to convince the producer that, with the aid of photographic effects and his stop-motion miniatures, he could place on screen an ape that would appear far more imposing than any live gorilla. Moreover, with a little imagination on the part of the scenarist, many of the expensive miniatures prepared for *Creation* could be worked into the story line.

Cooper immediately saw that a giant ape would give his proposal a new dimension and decided to persuade Selznick of its feasibility. He concocted the barest outlines of a story, then hired the British thriller writer Edgar Wallace to flesh it out. Wallace's name appears on the credits, though apparently almost nothing of the treatment he prepared found its way onto the screen. (He died shortly after delivering the first draft.) Meanwhile, O'Brien's top modelmaker, Marcel Delgado, began work on a miniature Kong. For a while Cooper insisted that Kong should be given some human characteristics, but this notion was quickly abandoned, and Delgado soon produced the prototype of the ape that was to sweep the world. Footage of the *Creation* models and of Kong himself was edited into a trial reel which, when it was shown at the next RKO sales meeting, was greeted with unstinted enthusiasm.

Only at this point was Cooper given the official go-ahead for the production and assigned a budget of $500,000—high for the period. Despite the fact that the film was slated to be a major release, however, the cast was drawn entirely and appropriately from the kings and queens of the B-movie. Robert Armstrong, often cast as a tough cop or private eye, was selected to play Carl Denham, the adventurous film producer who might be taken for a caricature of Cooper himself. Frank Reicher, a one-time silent-film director and veteran character actor, was chosen to play Englehorn, captain of the tramp steamer that carried Denham to Kong's island. As first mate Jack Driscoll, the film's nominal hero, Cooper hired a relative newcomer, Bruce Cabot.

The crucial role of Ann Darrow—love interest for both Driscoll and Kong—was assigned to the splendid Fay Wray, who had been seen most recently in such memorable programmers as *Dirigible* and *Doctor X*.

King Kong would bring all these performers, in particular Fay Wray, a measure of immortality. In her case, and Armstrong's, it also brought a heavy work load, since Cooper hit on the idea of defraying costs on *Kong* by simultaneously shooting another movie on the full-sized jungle sets that were being

46. A publicist dreamed up this image to show how large King Kong was in comparison to garden variety gorillas. In reality, the puppet Kong that was animated by Willis O'Brien was only eighteen inches tall.

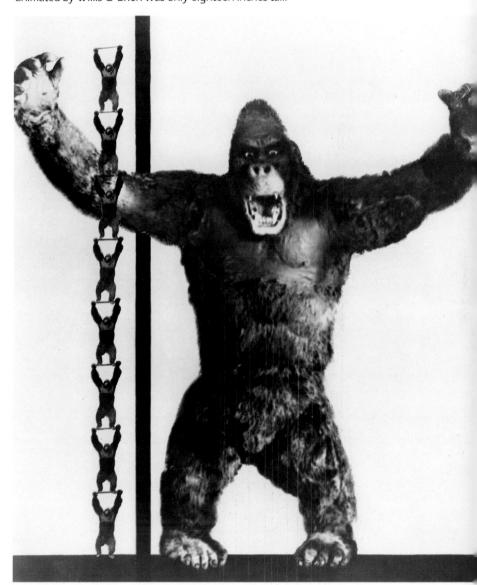

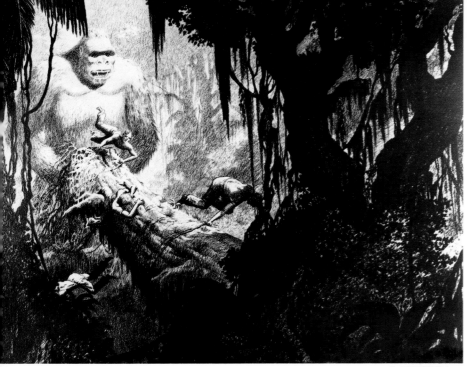

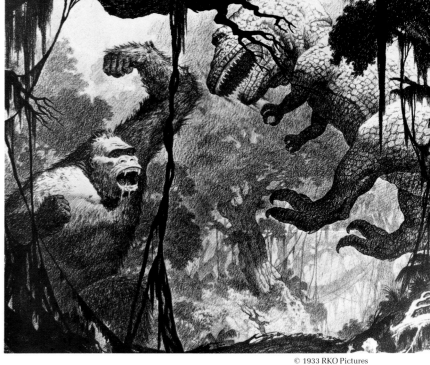

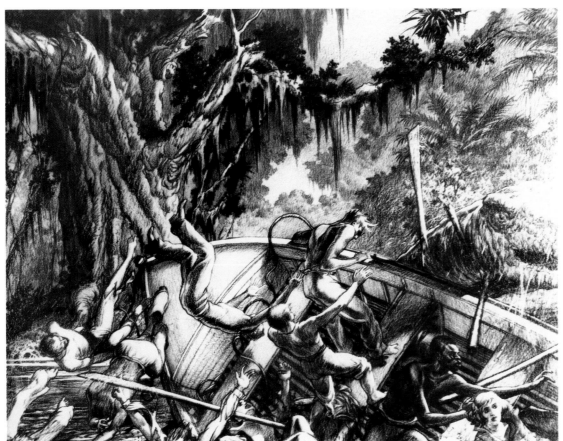

47–49. Detailed production sketches were prepared both to help visualize the story of King Kong and as an aid to selling the project to the RKO front office. These drawings were particularly useful in planning the model animation sequences, where mistakes would have been especially costly. In the 1930s, such an approach was something of a novelty. Today, every effects sequence is planned out as a series of storyboard sketches well before production begins.

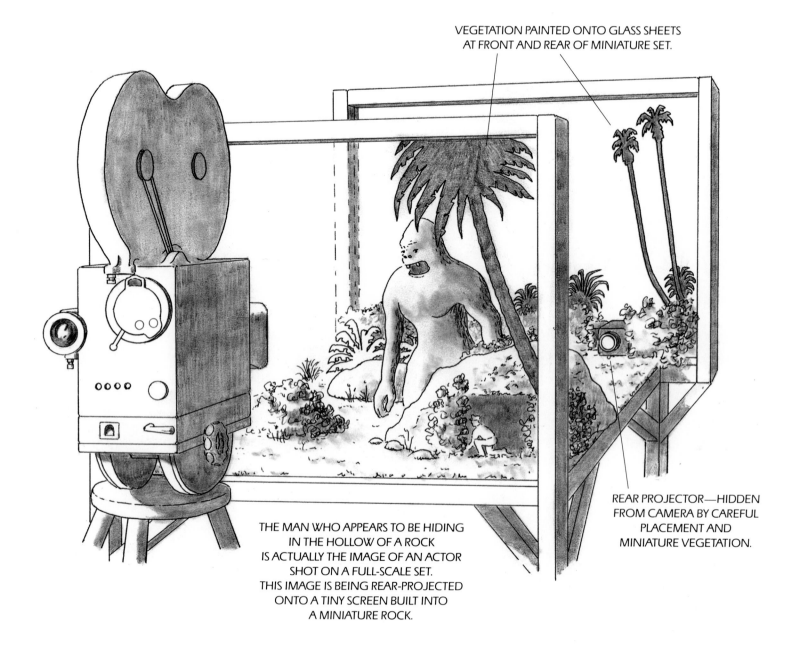

VEGETATION PAINTED ONTO GLASS SHEETS
AT FRONT AND REAR OF MINIATURE SET.

REAR PROJECTOR—HIDDEN
FROM CAMERA BY CAREFUL
PLACEMENT AND
MINIATURE VEGETATION.

THE MAN WHO APPEARS TO BE HIDING
IN THE HOLLOW OF A ROCK
IS ACTUALLY THE IMAGE OF AN ACTOR
SHOT ON A FULL-SCALE SET.
THIS IMAGE IS BEING REAR-PROJECTED
ONTO A TINY SCREEN BUILT INTO
A MINIATURE ROCK.

50. What made Willis O'Brien's contribution to **King Kong** so remarkable, from a technical viewpoint, is the fact that he placed his stop-motion figures in miniature landscapes. (Later practitioners of model animation, such as Ray Harryhausen, have generally matted their stop-motion figures into full-scale sets or landscapes.) O'Brien occasionally used split-screen mattes to introduce figures shot on full-size sets into his miniature environment. He also achieved the same ends with a system of his own invention, shown here, which allowed actors shot earlier and elsewhere to be rear-projected onto tiny process screens built into the miniature landscape and suitably camouflaged with props and vegetation.

built. The outcome of this decision was *The Most Dangerous Game* (1933), itself a minor genre classic, which Wray and Armstrong labored on by day while they worked in *Kong* by night.

To direct both these movies, Cooper brought in his old associate Ernest Schoedsack. In practice, however, Cooper directed much of *King Kong* himself, especially the key action sequences, while Willis O'Brien, of course, was in charge of all the many animation episodes. To all intents and purposes, then, the picture was the work of three directors.

Another unusual feature of the film was that it went into full production without anything remotely resembling a finished script. James Creelman had been given the job of reshaping Edgar Wallace's treatment, and Schoedsack's wife, Ruth Rose, later did extensive rewrite work. In the meantime Cooper went ahead with the picture, improvising on the sketchy story line he was carrying in his head. O'Brien's special effects crew displayed a capacity for improvisation of its own, and so the movie began to evolve in a curiously informal and organic way that may well have contributed something positive to its eventual texture.

To say that *King Kong* is one of the all-time masterpieces of stop-motion animation is to state the obvious. Less obvious is the fact that the film offers a textbook example of the state of the art in special effects as it stood in the early sound era. No movie until that time, for example, had attempted to combine live action shot on full-scale sets with model animation filmed on miniature sets in so elaborate and ambitious a way. To achieve this end, O'Brien's crew used almost every technical device known to filmmakers of the period, including quite a few they had to invent for themselves.

O'Brien himself had developed a miniature rear-projection system which proved of enormous value. A typical setup might involve the following elements. Nearest the camera, foreground vegetation painted on glass. Beyond this, a miniature jungle set, built in forced perspective, consisting of real and man-made plants and rocks. In the middle ground of this set, articulated puppets representing Kong and a prehistoric reptile locked in mortal combat. Beyond this miniature set, another glass painting representing background vegetation. Finally, and most unusual, a miniature rear-projection screen set into the rocks, its hard edges disguised with creepers and lichens.

By projecting live action of an actor, shot on a matching full-sized set, onto this rear-projection screen, O'Brien could introduce human protagonists right into his miniature world. (The live-action footage would, of course, be projected a frame at a time to synch up with the stop-motion work.) Because the

process screens he used were so small, the quality of the back projection was excellent, and when the composite footage is shown in a theater, what the audience sees is a tiny human watching from cover as the two giant creatures fight to the death.

Other methods of compositing miniature and full-scale elements included regular rear projection (used sparingly) and traveling-matte work employing both the Dunning-Pomeroy process and an improved version of the older Williams process. The Williams process lent itself well to manipulation by RKO's optical printer, which Linwood Dunn, Cecil Love, and their associates now had on line.

In the end, though, it was the stop-motion miniatures that made *King Kong* a sensation in its day. The Kong figures and the dinosaurs built by Marcel Delgado set a standard by which all such models would be judged for decades. An articulated steel skeleton, designed by O'Brien, was made for each creature, then latex rubber "sinews" were stretched between tendon points to create a convincing musculature. Next, Delgado stuffed this armature with cotton, to produce a feeling of bulk, then he applied latex to the figure, sculpting detail into it as it dried. In the case of the Kong miniatures, the entire figure was covered with rabbit pelts.

In addition to the miniature Kongs, a full-size head-and-shoulder assembly was built, also a paw and a foot, as well as the talons of the pteradactyl that attempts to snatch Fay Wray from Kong's grasp. The full-scale bust of Kong was so huge that the skins of eighty bears are said to have been needed to cover it, and six men concealed within the figure were required to operate the mechanical controls.

These full-scale props saw only limited service, however, in scenes where it was necessary to show the real Fay Wray and compositing could not provide a solution. In many other scenes the Ann Darrow character was actually represented by a six-inch-long articulated figure held by a Kong miniature. Similar male figures were made to be mauled by the prehistoric creatures. The great bulk of the effects work was in fact done with the stop-motion models, and animating these was the special sphere of Willis O'Brien and his assistant, Buzz Gibson.

Like all animators, the stop-motion artist is a frustrated actor who has found a special way to utilize his dramatic talents. Also like all animators, he must break each gesture down into twenty-four tiny movements for every second of film. The animator who works with two-dimensional drawings, however, has one enormous advantage over the model animator. He can break a gesture down into "key poses"—the

crucial positions that will bring a character's movements to life—and have an assistant fill in the in-between drawings later. The stop-motion animator enjoys no such luxury. He must start at A and proceed to Z, using what old-time cartoonists called the "straight-ahead" method, which was the only one known until Disney artists developed the "key-pose" system. In other words, Willis O'Brien had to be able to visualize

an entire shot, from beginning to end, as a sequence of tiny incremental changes. He had to, in effect, place himself "inside" the puppet he was animating and "live" the scene in excruciatingly slow motion. A fifteen-second shot might involve days of work, and it has been said that Kong, not surprisingly, perhaps, acquired quite a few of O'Brien's own mannerisms.

Nor was O'Brien the type of person to make things easy for himself. By deciding to shoot the brontosaurus sequence in water, for instance, he invited all kinds of technical problems that could easily have been sidestepped, and the fact that the

51. *The cameraman in this still is an actor playing a member of the Carl Denham film crew that is supposedly making a movie within the movie.*

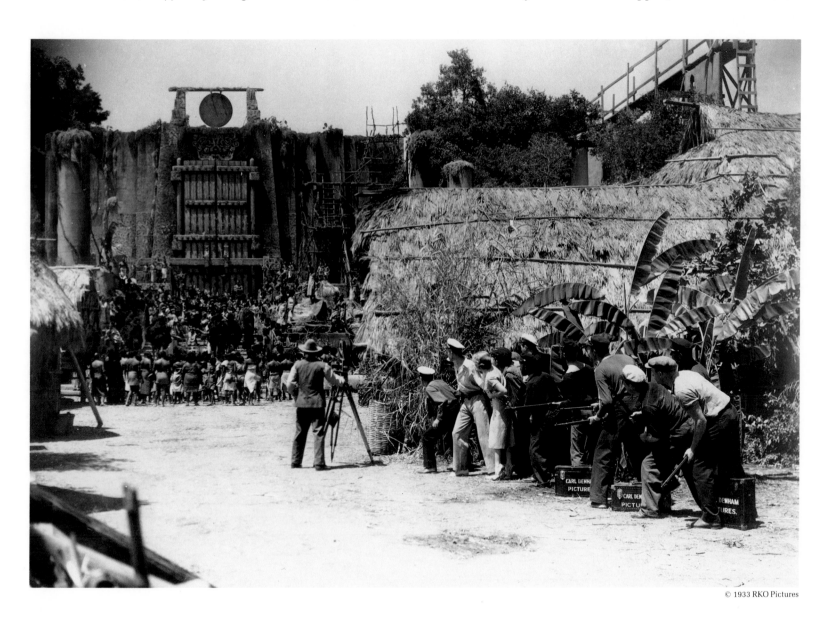

stop-motion footage would have to be matched (in terms of lighting and everything else) to live-action footage made many scenes incredibly difficult.

The climactic sequence of *King Kong* provides a good example of the kind of meshing of elements that was involved. First, Ernest Schoedsack went to New York and shot live-action footage of full-scale biplanes making mock attacks on the Empire State Building. More live-action footage, shot back in Hollywood, provided glimpses of Fay Wray helpless in the full-size ape paw and cowering on a ledge that was part of a mock-up section of the Empire State Building, built in the RKO carpentry shops. O'Brien, meanwhile, was animating an

eighteen-inch-high Kong puppet, and the miniature Fay Wray figure, on top of a model skyscraper which was shot against glass paintings representing a panorama of New York City. While he did so, another member of the effects team, Orville Goldner, "flew" miniature biplanes, one frame at a time, on piano wires, matching their maneuvers to the stunts of the actual planes Schoedsack had filmed in New York and to the desperate gestures of the miniature Kong. Goldner also rigged up an animation camera on a wooden track so as to provide a pilot's-eye view of the action. There was still plenty of compositing work left for Linwood Dunn and his optical printer, and it became the responsibility of film editor Ted Cheesman

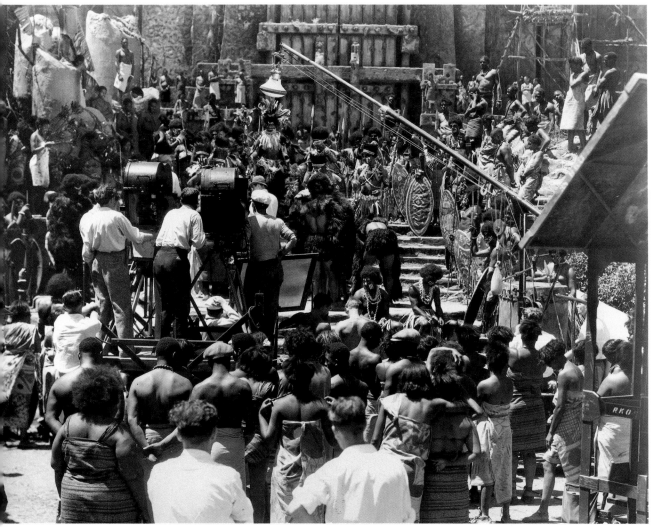

© 1933 RKO Pictures

52–53. These production photographs show the real-life RKO film crew working on the same set that is seen in plate 51. Note the huge sound-proofing "blimps" on the early talkie-era cameras, designed to prevent the noise of the camera motors and drive mechanisms being picked up by the microphones. The huge wall built for **King Kong** was one of the sets deliberately torched, a few years later, to represent the burning of Atlanta in **Gone With the Wind**.

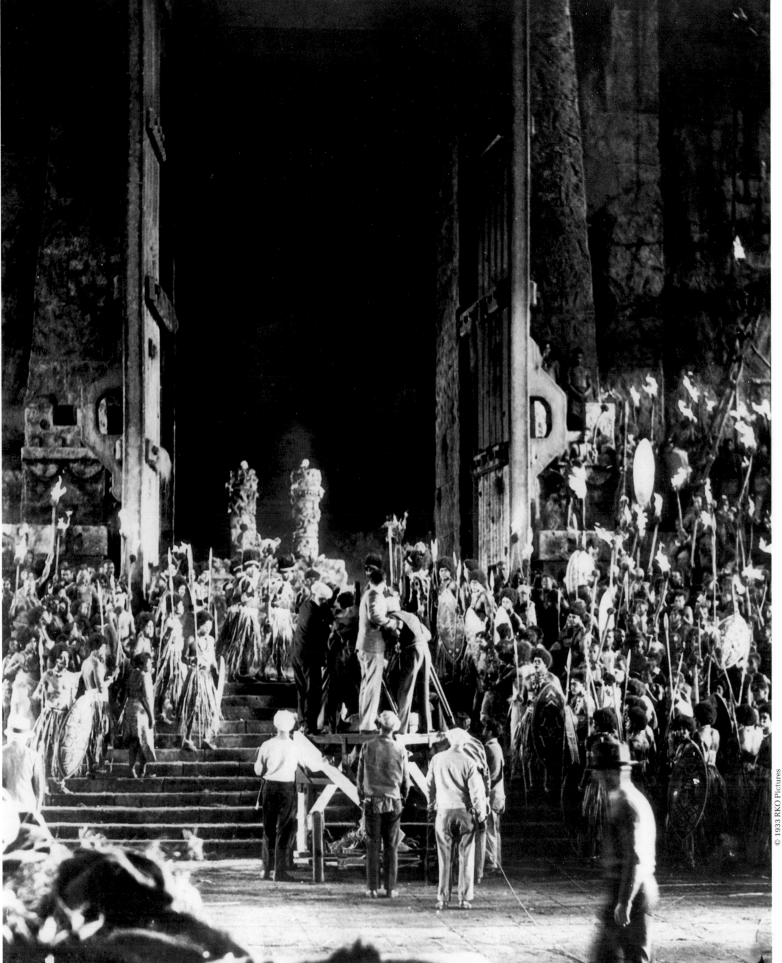

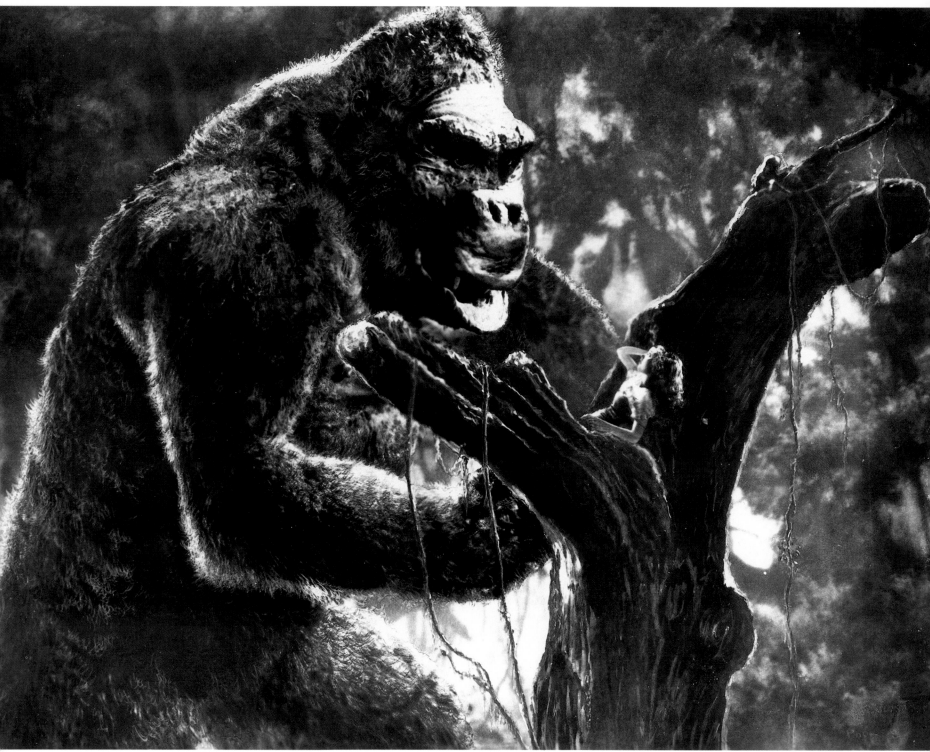

64

54–55. Having deposited Fay Wray in the fork of a tree, Kong battles with a healthy specimen of *Tyrannosaurus rex*. In some scenes the actress was filmed on a full-scale set in such a way as to allow this footage to be composited, by means of traveling mattes or rear projection, with footage of the eighteen-inch-tall Kong shot on a miniature set. In other scenes this model Kong was made to carry a tiny, articulated Fay Wray figure.

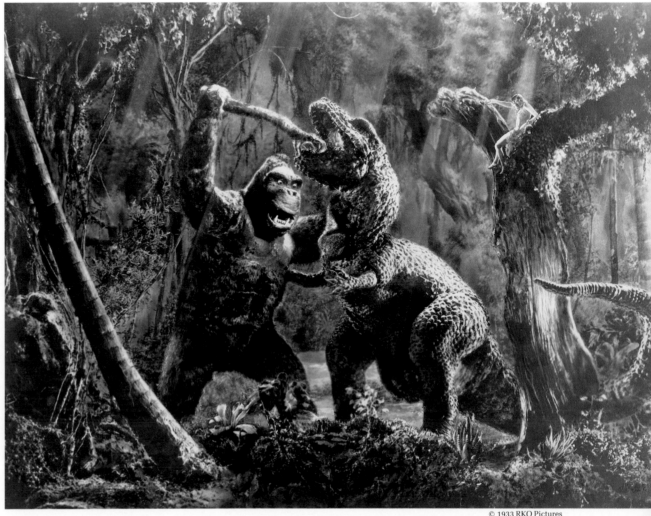

to piece all the elements together. But if O'Brien and his team had ever lost sight of how these elements would blend on screen, Cheesman's task would have been impossible.

It is hardly surprising that the special effects on *King Kong* took over a year to complete. There must have been times when the principals wondered if the picture would ever be released, since RKO was teetering on the brink of bankruptcy and the deepening Depression was making the studio's future more uncertain by the day. As things turned out, the extraordinary success of the movie was instrumental in restoring RKO's fortunes. The crowds who flocked to see *Kong* at Radio City Music Hall, the Roxy, and Grauman's Chinese helped make Merian C. Cooper—whose story sense and flair for drama were key elements in the movie's triumph—the golden boy of the hour. On Selznick's departure, he became RKO's head of production, and later he was one of the promoters of Cinerama and other technological wonders of the postwar era, for which he received a special Academy Award in 1952.

As for Willis O'Brien, a man whose life was soon to be touched by tragedy (his first wife went mad and killed their two sons), he received his own Academy Award in 1950 for his effects work on *Mighty Joe Young*, another collaboration with Cooper and Schoedsack. For bringing Kong to life, however, and coordinating the effects on this his greatest triumph, he received only the billing of Chief Technician and the princely salary of three hundred dollars a week.

6. Invisible Effects

King Kong was one of the great success stories of the 1930s, but it hardly set a bandwagon rolling. (*Son of Kong*, rushed out by RKO before the end of 1933, was a rather feeble spin-off.) It might be said, in fact, that between *Kong* and *Mighty Joe Young*, seventeen years later, very few movies were made, in Hollywood or elsewhere, that can be classified as special-effects films.

Univeral had begun its great horror-film cycle with the Tod Browning version of *Dracula*, released in 1930, and its successor, James Whale's *Frankenstein*, brought out the following year, was larded with effects. In turning Boris Karloff into Frankenstein's monster, Jack Pierce devised a classic example of what we would now call effects makeup. Frankenstein's laboratory, meanwhile, was alive with electrical effects—mysterious rings of light and miniature lightning bolts—devised by Ken Strickfaden. (When Mel Brooks made *Young Frankenstein* nearly half a century later, he found Strickfaden's Faustian devices still in perfect working order and available for lease.) Scenes such as the burning windmill were handled by John Fulton, who received an even more challenging opportunity the next year when he supervised the effects on another James Whale movie, *The Invisible Man*.

Based on an H. G. Wells story, *The Invisible Man* presented Claude Rains as a mad scientist who is literally invisible until, at the film's end, death makes him visible. Fulton devised many ingenious tricks for this film and its several sequels. Toward the climax of *The Invisible Man*, for example, the scientist's presence is betrayed by footprints appearing in a fresh fall of snow. Before the scene was shot, artificial snow was spread onto a wooden platform in which foot shapes had been cut with a jigsaw. Each of these cutouts was rigged so that a technician could cause it, on cue, to drop down an inch or so below the surface of the platform. The result of this was footsteps appearing in the artificial snow as if by magic.

In scenes which required the invisible scientist to walk around clothed, but with his head and hands uncovered (and hence invisible), a stand-in for Rains was used. His head was covered with a black velvet hood, his hands with black velvet gloves, and he was filmed in front of a black backdrop. Carefully staged, this resulted in the illusion of a suit of clothes walking around by itself against a black background. It was then a matter of generating mattes from this "clothes" footage so that these foreground elements could be composited with a background plate.

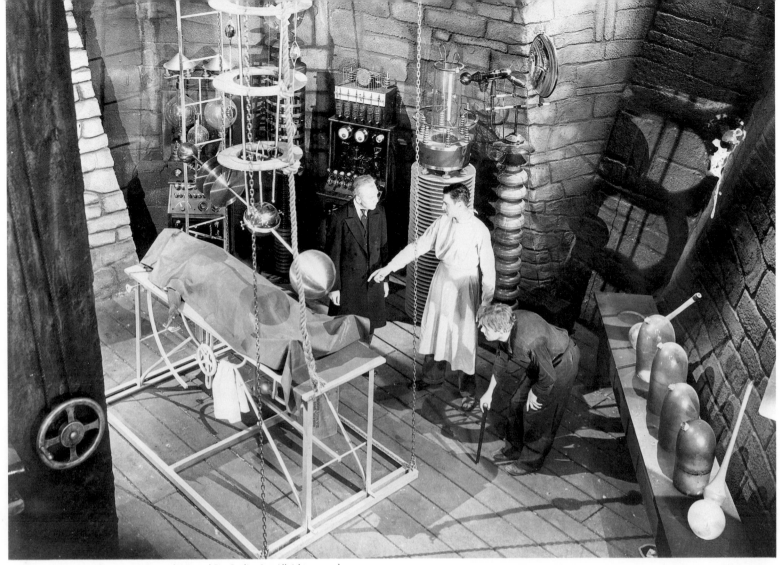

56. For **Frankenstein**, Ken Strickfaden devised an array of bizarre ''scientific'' gadgets. When Mel Brooks began work on **Young Frankenstein**, more than forty years later, he found this laboratory full of equipment intact and in perfect working order.

57. Most Hollywood makeup men spent their career helping stars like Carole Lombard and Jean Harlow look more beautiful. Universal's Jack Pierce (left) specialized in creating monsters. Here, with an assistant, he prepares Boris Karloff for his role in **Frankenstein** (1931).

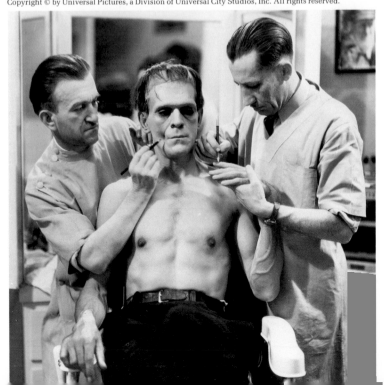

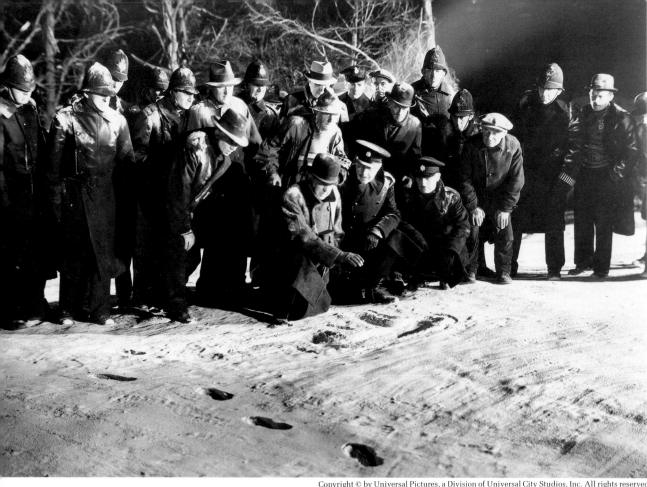

58. For **The Invisible Man** (1932), John Fulton was confronted with the problem of making footprints appear, as if by magic, in freshly fallen snow. Foot-shaped cutouts in a wooden platform were covered with artificial snow. Each cutout was rigged to be pulled from below, on cue, so that it dropped an inch or two beneath the level of the platform. As it dropped, an indentation appeared in the snow.

Universal continued its cycle of macabre fantasies with films like *The Black Cat* (1934), *Bride of Frankenstein* (1935), and *The Devil Doll* (1936), all of which contained interesting effects work, even if it was sometimes done on the cheap. *The Devil Doll*, for example, is one of that genre of pictures, like *Dr. Cyclops* and *The Incredible Shrinking Man*, which deals with the miniaturization of human beings. Directed by Tod Browning, *The Devil Doll* may not have been the first film to take on this theme but it is one of the most amusing, with Lionel Barrymore—an escaped convict disguised as a woman —taking revenge on his enemies and the world by shrinking people to the size of kittens, then, through telepathy, using these tiny creatures to carry out his nefarious deeds. The illusion of lilliputianism was sustained with the aid of oversize sets and props, rear projection, and matte shots of various kinds.

In films like these one senses special effects men flexing their creative muscles, longing to break free of the established genres as O'Brien had done with *King Kong*, but that moment was still many years away, at least for Hollywood. In England, however, the decade did produce one remarkable film that was virtually dependent on special effects: Alexander Korda's production of *Things to Come*, directed by William Cameron Menzies and released in 1936.

Based on H. G. Wells' novel, *Things to Come* tells the story of the collapse of civilization due to a world war, and the rise of a new culture based on the rational use of science and technology, a vision of the future that called for everything from giant "flying-wing" aircraft to a city that was a cross between a Bauhaus dropout's megalomaniacal dream and an overgrown Mighty Wurlitzer. Menzies, although Scottish born, had long been one of Hollywood's top production designers and was up to visualizing all this, but it could not be brought to the screen without a great deal of help from London Films' talented special effects department, whose head, Ned Mann, brought in American reinforcements, including Lawrence Butler (mechanical effects), Jack Thomas (opticals), Harry Zeck (rear projection), and Ross Jacklin (miniatures).

Among the Europeans on the production were Percy "Pop" Day—a highly regarded matte painter who had worked for Abel Gance, among others—and two apprentice effects men, Wally Veevers and Tom Howard, who were to be key figures

59. In **The Devil Doll** (1936), Lionel Barrymore played an escaped convict, disguised as an old woman to escape justice, who has the power to shrink animals and humans to a fraction of their normal size.

60. Ernest B. Schoedsack's **Dr. Cyclops** (1940) is another film that capitalizes on the notion of miniaturization. Here giant props provide the necessary dislocation of scale. In other scenes, matte paintings, traveling mattes, and rear projection were used to the same ends.

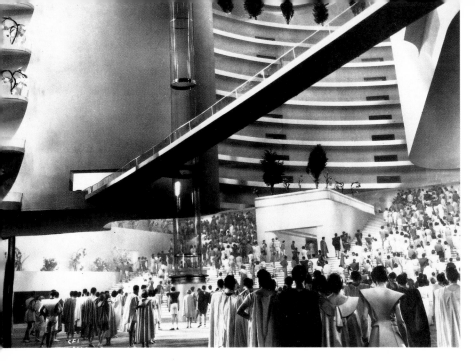
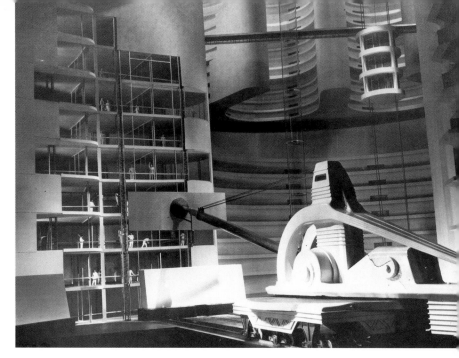
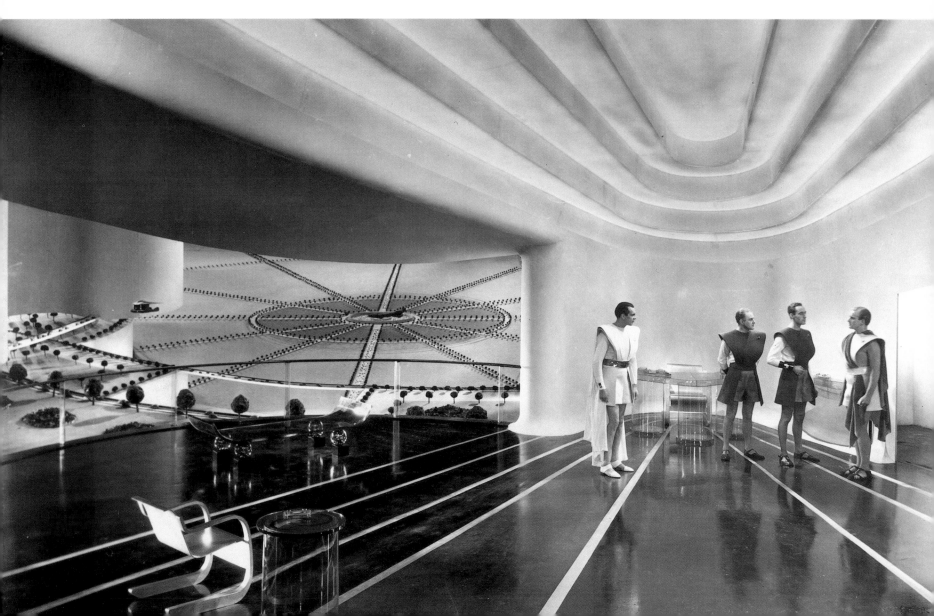

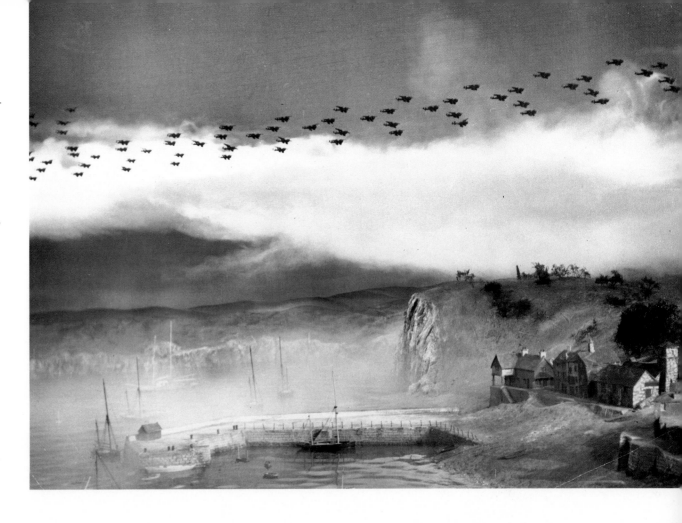

61–63. Things to Come (1936) conjured up the future (opposite) with the aid of miniatures, matte paintings, Shuftan-type mirror shots, and the entire spectrum of special effects.

64. The futuristic scenes in **Things to Come** were evoked, for the most part, with great skill. Mid-twentieth century reality proved more intractable, however. This landscape is clearly a miniature, a fact that is obvious to the most casual observer. Better model-making might have minimized the problem, but nobody has yet devised a way of miniaturizing water.

on another Anglo-American team thirty years later, the effects crew that worked with Stanley Kubrick on *2001: A Space Odyssey.*

Things to Come was, in a sense, the *2001* of its day, drawing on the whole spectrum of special effects techniques, from the Shuftan process to movable matchstick figures reminiscent of those that populated the upper decks of the Circus Maximus in *Ben-Hur*. It was the kind of project where the visual novelties could not help drawing attention to themselves. Effects artists always seem to jump at this kind of job when it comes along: in those days, though, most of them spent the great bulk of their time making their work invisible. Indeed, the effects man's slogan had become, "The best effects are the ones you don't notice." Whether or not they really believed this, it was what the studios were demanding.

Once you start looking for special effects in Hollywood movies of the '30s and '40s, you find them everywhere—in gangster films, Westerns, war pictures, comedies, tearjerkers, and even musicals. *Flying Down to Rio*, for example, is full of process shots and composites achieved with the help of the

optical printer. A film crew was sent to Brazil to shoot background plates to be combined with footage shot on the RKO lot. At the climax of the film—one of the most famous moments in the history of the musical—the title song is performed by Fred Astaire and the RKO Chorus and Orchestra, while dozens of chorus girls, directed by Dave Gould, dance on the wings of biplanes which appear to be in flight several thousand feet above Rio Bay. In fact, the planes were suspended from the roof of a hangar, just high enough to provide all the camera angles called for, while wind machines were used to dishevel the hoofers' hair enough to simulate the effect of slipstream. This footage was then composited with aerial views of Rio, the Malibu coastline, and an airfield not far from the studio.

Flying Down to Rio was intended as RKO's answer to the Busby Berkeley films, *42nd Street* having provided Warners with a sizable hit earlier that year. Berkeley's own musical numbers were often full of effects, both photographic and mechanical. In *42nd Street*, for instance, the "Shuffle Off to Buffalo" number featured a Pullman coach that could split open

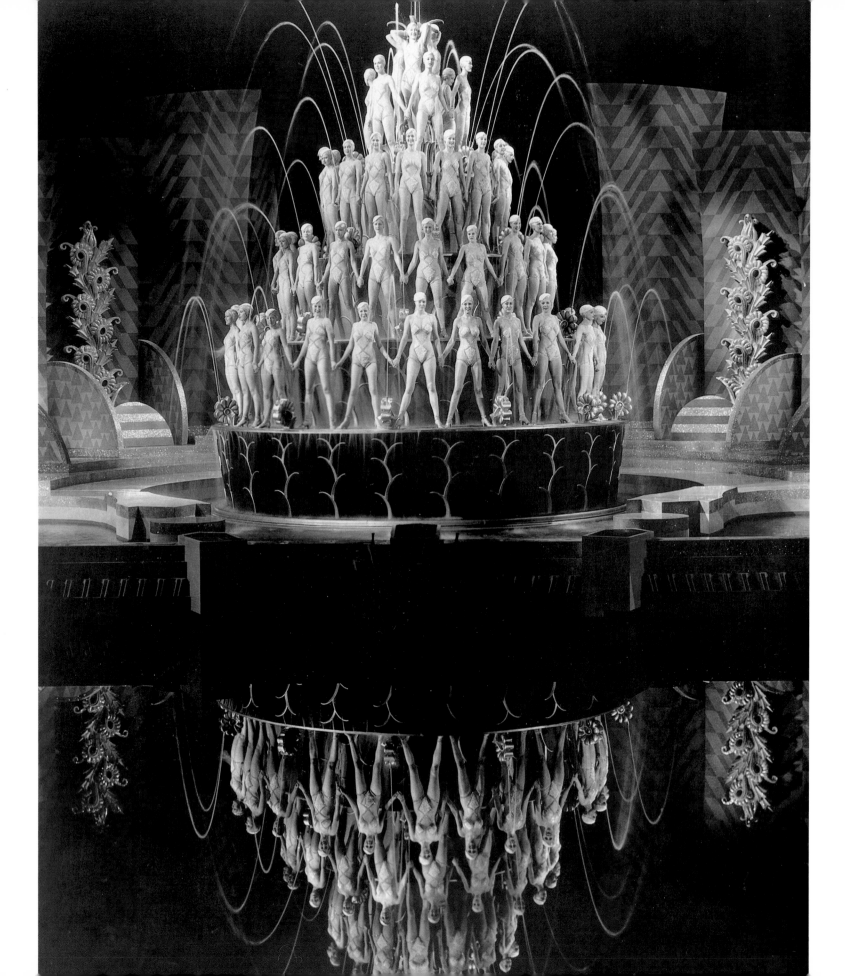

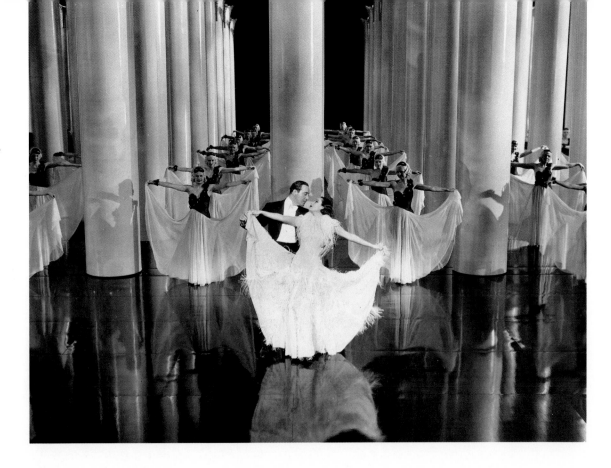

65. Busby Berkeley often enhanced musical numbers with elaborate mechanical effects. For **Footlight Parade** (1933), Berkeley had the Warner Brothers shop build this spectacular, multilevel, hydraulically powered fountain.

66. In this dance routing for **Wonder Bar** (1934), stylized columns—running on rails that are quite visible in this photograph—were choreographed to mesh with the Berkeley girls.

at the crucial moment, allowing the camera to penetrate into the interior in a single, fluid tracking movement. In *Footlight Parade*, the "By a Waterfall" set was, in actuality, one huge mechanical effect with 20,000 gallons of water a minute pouring over artificial falls into a huge pool from which multilayered wedding-cake fountains, dressed with show girls, rose on hydraulic lifts. The "Don't Say Goodnight" sequence of *Wonder Bar* featured dancers weaving among motorized Greek columns which moved on hidden tracks, and the great "Lullaby of Broadway" feature in *Goldiggers of 1935* was introduced with an evocative montage that capitalized on skillfully executed opticals.

It was left for MGM, however, to produce the ultimate special effects musical, *The Wizard of Oz* (1939). When Dorothy takes the Munchkins' advice and follows the Yellow Brick Road, she skips off into a landscape that was conjured up on sheets of glass by artists in the matte-painting shop. (Nor was this a routine task. Three-strip technicolor was still a novelty, and matching matte paintings to color films was a new skill that had to be mastered by trial and error.)

The most famous special effect in the film occurs in the opening black-and-white segment, for which Arnold Gillespie was asked to provide a convincing tornado to sweep across the Kansas plains. This particular effect has been the subject of a good deal of rumor over the years. As far as can be ascertained, at least three major components were involved. Seen in the far distance, the tornado was stock footage of an actual twister. In the middle distance, however, the funnel cloud was created by a silk stocking twisted by the breeze from a fan. There was also a much larger synthetic tornado consisting of a ragged burlap "sock," thirty feet long, suspended from a truck running along an overhead monorail—the dangling fabric lashed by wind machines and throwing off Fuller's earth as it spun. Beyond this, it can safely be assumed that each of these artificial cyclones was subjected to a good deal of manipulation in the optical printer.

Of the innumerable examples of effects achievements that could be drawn and dissected from a film that contains flying monkeys, a horse which changes color, and a witch who melts into thin air, let us select one more. It will be recalled that the good witch Glinda is transported to Munchkinland by means of a translucent, glistening sphere, like a giant soap bubble. Gillespie had some difficulty coming up with something to represent this bubble, but eventually discovered the ideal surrogate: a brass ballcock from the tank of an ordinary toilet. This object, optically composited with Billie Burke as the

fairy, a matte painting, and live action on the foreground set, provided the movie with one of its magical moments.

Released that same year, *Gone With the Wind* is full of the kind of "invisible" effects that were much in demand in those days. Scenes like the evacuation and burning of Atlanta relied heavily on physical effects (supervised by Lee Zavitz). A variety of optical devices was also employed—to give a single example, the crowd outside the newspaper office, waiting for news of the Battle of Gettysburg, was doubled in size by means of an in-the-camera split-screen that harked back to the silent days.

More than anything, though, *Gone With the Wind* is a triumph of the matte painter's art. Selznick's photographic effects supervisor was Jack Cosgrove, who had been a top effects man at Paramount, Pathé, and RKO. A superb cinematographer, he was also an expert matte artist (having started life as a portrait painter). Unlike his counterparts at MGM, Cosgrove had already had considerable experience working with Technicolor. He had painted mattes for *The Garden of Allah* (1935) and the Janet Gaynor version of *A Star is Born* (1936), sharing his chores on the latter with Byron Crabbe, one of the early masters of the discipline. Crabbe, with Mario Larrinaga, had contributed paintings to *King Kong*. Cosgrove's associate, Clarence Slifer, had built a special matte-box for the bulky Technicolor cameras of the day and had also been instrumental in putting together an optical printer and an aerial-image printer, both

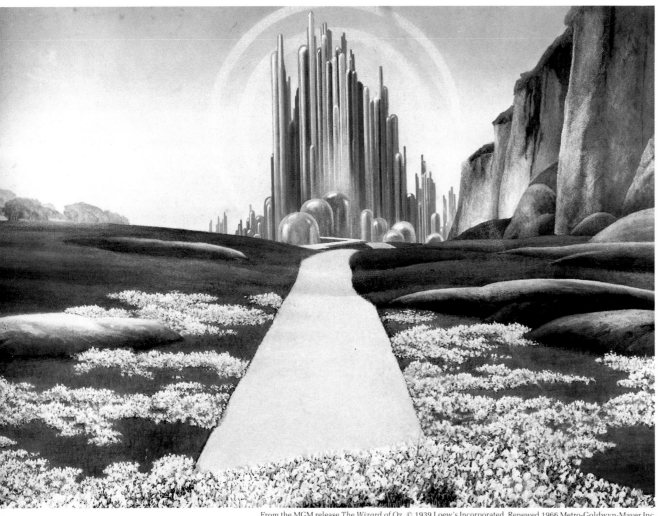

67. The Wizard of Oz (1939) was full of effects work. The MGM matte department contributed much to the film, including this pastel matte of Emerald City by Warren Newcombe. The challenge of re-creating L. Frank Baum's fantasy world was complicated by the fact that this was one of the studio's first three-strip Technicolor productions.

68. On the evening of December 10, 1938, dozens of Hollywood sets —including the great wall from **King Kong**—were burned, under the supervision of Selznick effects director Lee Zavitz, to represent the destruction of Atlanta for **Gone With the Wind** (1939). Hundreds of movie personalities came to view the blaze, and it was on this occasion that David O. Selznick first met Vivian Leigh, which led to her being selected to play Scarlett O'Hara. The Rhett and Scarlett seen in this shot are stunt doubles.

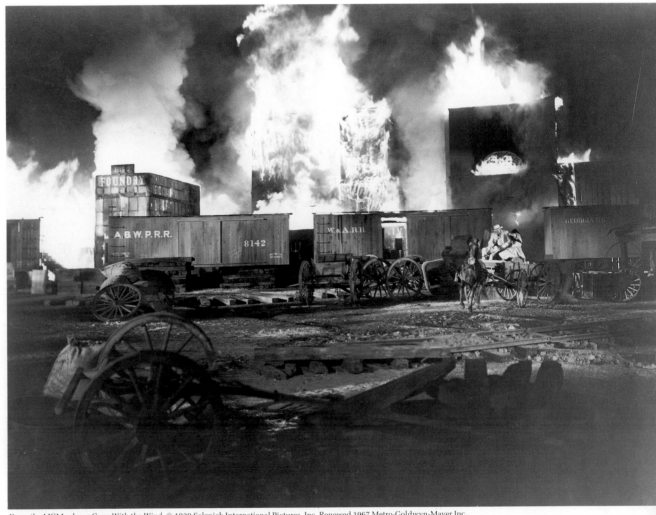

From the MGM release *Gone With the Wind*. © 1939 Selznick International Pictures, Inc. Renewed 1967 Metro-Goldwyn-Mayer Inc.

adaptable to the Technicolor camera, so that the Selznick visual-effects department was well equipped to meet the challenges of *Gone With the Wind*. By then, Cosgrove was no longer painting mattes himself, but he had the veteran matte artist's eye for when they would work, and he collaborated closely with art director William Cameron Menzies on planning the sets with this in mind. Byron Crabbe had died, and the Selznick matte-painting team now consisted of Fitch Fulton (a one-time vaudeville set painter and the father of John Fulton), and Albert Simpson, who was particularly skilled at blending mattes with live-action components.

Clarence Slifer (writing in *American Cinematographer*, August 1982) has described how, working on thirty-by-forty-inch masonite boards painted Technicolor gray, Simpson and Fulton provided Tara with walls that were never built, helped bring old Atlanta back from the flames, made giant sets seem even more gigantic, and generally contributed many realistic details that brought the Civil War era to life on screen. More than one hundred shots in *Gone With the Wind* incorporated matte paintings, a fact that can have occurred to very few of the millions who have seen the film, since these mattes are virtually undetectable to the untrained (and often the trained) eye.

One of the most sparkling comedies of the late '30s was *Bringing Up Baby* (1938), which starred Katharine Hepburn, Cary Grant, and a leopard sent to the Hepburn character as a

gift. A number of scenes show Hepburn on screen with the animal, but Linwood Dunn, who worked on the movie, reports that, except in a couple of early shots, Hepburn and the leopard were never on set together because the animal was simply too dangerous. It became Dunn's responsibility to devise ways of combining footage of the beast with footage of Hepburn, shot separately, in such a way as to make it appear that they were on camera together. There was no one "master" solution—one scene might call for rear projection, another for a traveling matte—but the net result was a textbook perfect set of invisible effects.

Dunn also worked on *Citizen Kane* (1941), which was also larded with invisible effects. "I don't think there's anybody else living today," says Dunn, "except maybe Bob Wise [the film's editor], who could pick out all the shots that are altered and changed and modified in that picture. Orson Welles got to know that there was such a thing as an optical printer and trickwork, and he'd just say, 'I want this, I want that.' He didn't care whether it could be done or not. I would say, 'You can't do that,' and he'd come back—very nice and very polite—and say, 'You mean it's impossible?' I'd say 'No—nothing's impossible. It's a matter of time and money and how good is it going to look?'

"He would want to take a scene that was already shot and make something else out of it. Like the scene with the gal in the library. It was shot with the camera pulling back from the woman sitting on the bench, and next to her is the base of the statue of Thatcher. Welles was already editing the movie and he said, 'No—I want to be on top of the statue and come down, then pull back.' Just like that, as if you could pick it off the shelf. Then he'd ask, 'Is it impossible?'

"As I say, nothing's impossible. It's a matter of time and money, so I went to the front office to get an OK for the expenses. Then I double-checked on that because I'm on salary and he's just a producer passing through. They told me, 'Go ahead and give him what he wants, until we see what's happening with the budget.' So the picture is loaded with effects, like that scene in the library, and in the Opera House, panning on up through the flies. That shot was extended with a miniature. Also at the very end, moving in on the Rosebud sled in the fire. The camera moved in as far as it could and stopped, then on the optical printer we continued the shot way, way in."

Six months after *Citizen Kane* was released, the United States entered World War II and Hollywood special effects men found themselves with a new set of challenges. Suddenly model shops were given over to building miniature battleships (some of them almost as large as full-size minesweepers, and

69–70. During the making of **Citizen Kane** (1941), Orson Welles quickly learned about the potential of special effects cinematography and pushed his effects crew to the limit, often asking for radical alterations to a scene long after it had been shot.

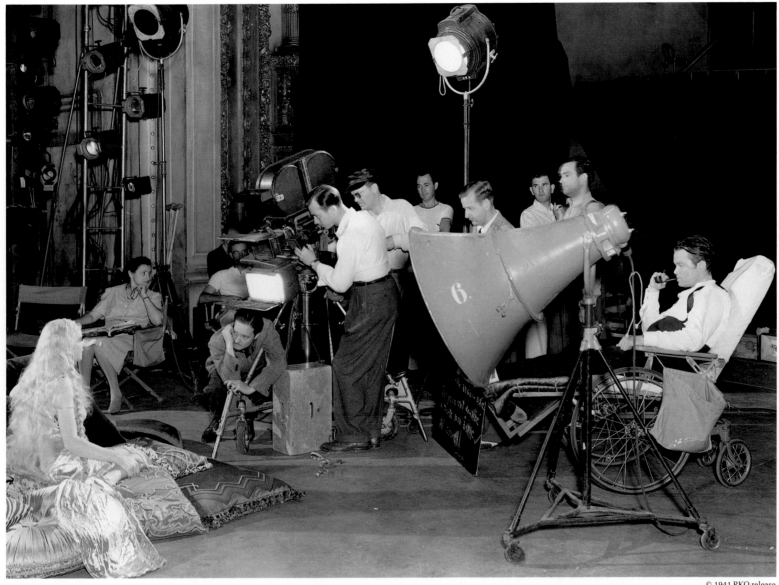

as lavishly equipped). War films brought plenty of employment to "powder men" (explosives experts) and pyrotechnicians, but photographic-effects specialists were kept just as busy blending live action of simulated assaults upon sound-stage beaches with matte paintings of Iwo Jima vegetation, or compositing flak bursts into shots of aerial armadas. At Republic Pictures, the Lydecker brothers—Howard and Theodore—switched from flying Captain Marvel to flying model P-47s on ingenious wire rigs, evolving a system that would catch the attention of Steven Spielberg thirty-five years later.

For Hollywood, the war years were a period of "business as usual," with a virtually captive audience ready to eat up every patriotic melodrama, every escapist musical turned out by the studio sausage machines. A few short years later, however, things began to change rapidly. In the late '40s the federal government forced the major production companies to divest them-

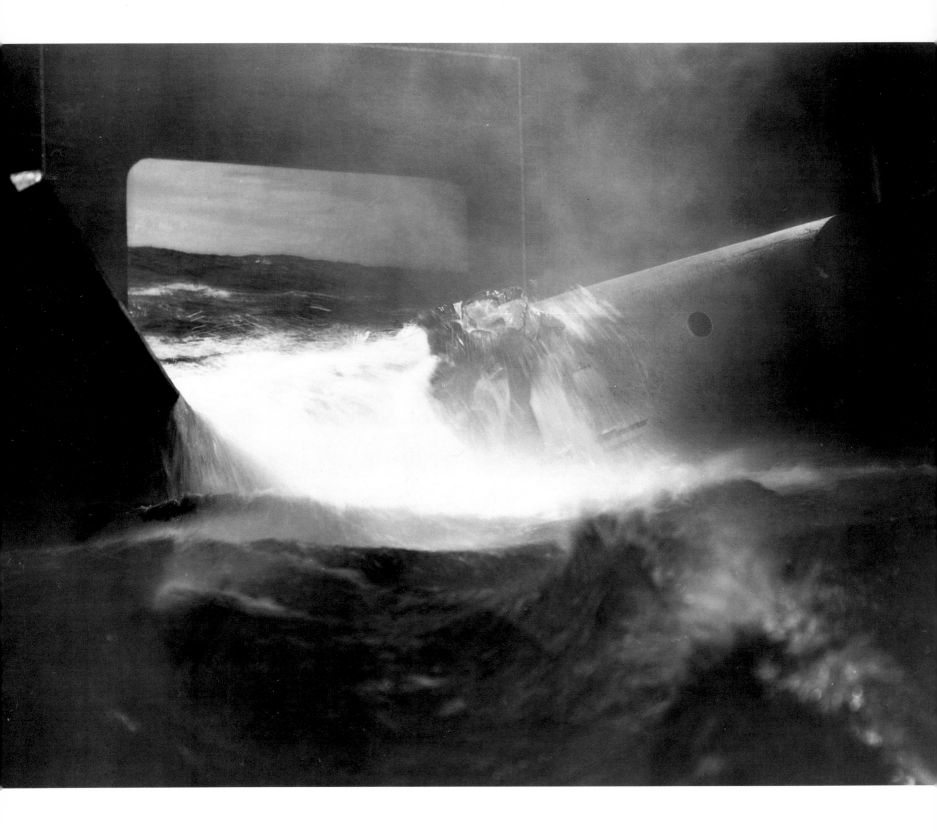

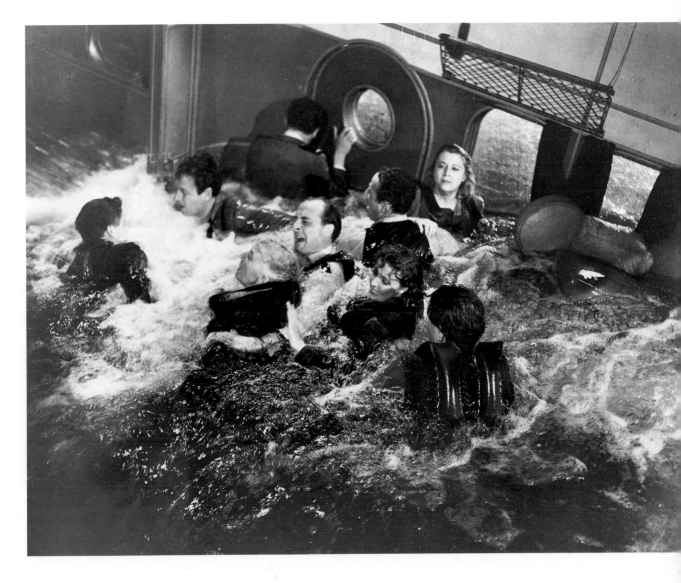

71–72. For **Foreign Correspondent** (1940), Alfred Hitchcock and his assistants devised a series of brilliant effects to heighten the reality of a scene in which a passenger plane crashes into the ocean. The rare photograph opposite shows how a key sequence of **Foreign Correspondent** was shot in a studio tank. Actors cling to a mock-up of the plane's fuselage which is lashed by machine-made waves. In the background is a process screen onto which film of actual ocean waves is being rear-projected. The movie camera, invisible here, combined actors, fuselage, tank waves, and rear-projected waves to create a single dramatic image.

selves of their theater chains, thus seriously weakening the power of the studios, and in 1948, Universal released Mark Hellinger's *The Naked City*, a film shot entirely on location in New York. *The Naked City* started a trend that would have an obvious impact upon special effects technicians. The government's blow to the oligarchic structure of the Hollywood establishment had less clear-cut but no less far-reaching consequences. Among other things, it led to the rise of the independent producer and the gradual erosion of the autonomy of the studios. Eventually this would lead to the disintegration of the special effects departments that had been evolving since the silent era.

For a while, though, nobody seemed to notice, and the veterans continued as before, turning out invisible effects for a variety of movies. All too often their work consisted of banal tasks—for instance, rear-projecting scenery onto a process screen set up behind the windows of a cutaway car, or providing matte-painted ceilings for studio sets—but once in a while they found themselves in league with a director who was aware of their capabilities.

Perhaps the most notable of these directors was Alfred Hitchcock, who had been fascinated with special effects ever since he visited the UFA-Neubabelsberg lot in Germany in

1924. As early as *Downhill*, made in 1927, Hitchcock was experimenting with optical effects, most notably in dream sequences. In 1929, for a scene in *Blackmail*, he made clever use of the Shuftan process in order to introduce a live actor into a miniature of the British Museum. By the time he moved to Hollywood in 1939, Hitchcock was a past master of all the technical aspects of filmmaking. In *Foreign Correspondent* (1940), for example, he collaborated with effects supervisor Lee Zavitz to produce one of the most spectacular and original rear-projection "gags" ever devised.

The scene, near the end of the movie, calls for a plane, in which Laraine Day and Herbert Marshall are passengers, to crash into the ocean. To show this from the pilot's point of view, the camera was placed in a mock-up of the cockpit in front of a special rear-projection screen made of paper. Behind this screen was a dump tank filled with hundreds of gallons of water. On the screen, the waves (photographed from a seaplane) came closer and closer. At the crucial moment, when it appeared that the plane was going to hit the ocean, Hitchcock gave a signal for the dump tank full of water to be emptied *through* the screen. The screen was destroyed and obliterated by the torrents which then flooded into the cockpit so that the transition from rear-projected water to real water was achieved without a cut.

In a subsequent scene, survivors are shown clinging to the wreckage. Here again, though in a totally different way, real water (in a studio tank) and rear-projected waves were blended with enormous skill.

Further examples of imaginative special effects are to be found in other Hitchcock movies—*North by Northwest*, for example, and *Vertigo*—but the Hitchcock film that uses the greatest variety of effects is probably *The Birds* (1963), in which mechanical birds and animated birds were supplemented by traveling mattes and process-screen shots of real birds. For the climactic scene when Tippi Hedren, alone in an attic, is attacked by flocks of seagulls, Hitchcock eschewed mechanical or optical effects and insisted on having live birds unleashed on the actress (who was subjected to their "attacks" for a week for the sake of two minutes of film). In a sense, this can be taken as an indication of the limitations of what special effects can achieve. In the world of invisible effects that Hitchcock understood so well, illusion gains its authority from the realities that give it context.

As Don Shay, editor of *Cinefex*, points out, however, Hitchcock seems to have become lazy later in his career, or at least out of step with advances in filmmaking technique, "continuing to use often wretched rear-process photography long after every other filmmaker in town had gone exclusively to location footage or, in the case of driving footage, to tow cars."

In these later works, Hitchcock seems to have fallen victim to his faith in his own ability to manipulate illusion and reality. This also points to both the importance and the limitations of invisible effects. Hitchcock's art depended on carefully guiding an audience through a story using, in every shot, a carefully selected point of view. With even one inept, outmoded effect, a viewer can be momentarily untracked. With several, he might begin to find the plushest theater seat distinctly uncomfortable.

7. New Aspects

The 1950s was a period of technical novelties that affected the motion picture industry in general and the special-effects worker in particular. 3-D movies had their brief moment of tinseled glory, but far more important was the advent of widescreen and large-screen formats such as Cinerama, Cinemascope, Todd-AO, and VistaVision and the introduction of new high-speed color film stocks. Each of these innovations was prompted by the same thing: the boom of "free" television entertainment and the consequent loss of revenue suffered by the theatrical movie business. Television screens in the '50s were small and black-and-white. Movie producers hoped that by stretching cinema screens, filling them with variegated imagery, and making the performers pop out into the theater-goer's lap, they could lure crowds back into picture palaces which themselves had lost much of the glamour and glitter they had possessed a quarter of a century earlier.

None of these innovations depended upon radically new technology. The principles of stereoscopic photography, for example, had been understood since the nineteenth century, and MGM had released 3-D shorts as early as 1935 (complete with the familiar throwaway Polaroid glasses). The 3-D features, such as *Bwana Devil* and *House of Wax*, released in 1952 and

1953 respectively, provided work for special effects men but had little impact on their methodology.

Big-screen formats were another matter, however. They too had been seen before (William Wellman's 1927 *Wings* is one of several films that were released with "magnascopic" sequences), but now they became the norm, driving directors and cinematographers to distraction with unfamiliar aspect ratios. (Aspect ratio defines the relative breadth and height of the screen. The standard ratio, until 1953, was 1.33 to 1—roughly the proportions of the dreaded television screen. Cinemascope, by contrast, has an aspect ratio of 2.35 to 1, or almost twice as wide in proportion to height as in the standard format.)

Certain of these large-screen systems, such as Todd-AO and Panavision's Camera 65, used special wide-gauge film stock—65mm or 70mm—meaning that, depending on the specific aspect ratio favored, each frame would occupy an area approximately three or four times that occupied by a frame of standard 35mm film. (VistaVision achieved a larger frame size by running 35mm film horizontally rather than vertically through the camera.) This was a boon for visual effects people. To begin with, the larger frame sizes provided a very sharp image, ideal for optical work. Secondly, the individual com-

ponents used to make up a composite of any kind—but especially a traveling-matte shot—would themselves be larger and therefore easier to manipulate. Nor was this advantage limited to use in films to be released in 70mm. The effects camerawork and compositing could be done in the large format and then transferred to 35mm stock by means of an optical printer (a relatively simple matter of mounting a 70mm projection head in tandem with a 35mm process camera). Even when the compositing is done in 35mm, as is still frequently the case, results will be better if the effects photography is done in a larger format.

For these reasons, top effects houses, to this day, use cameras that first found employment on movies such as Mike Todd's *Around the World in Eighty Days.*

That 1956 film was shot in Eastmancolor, one of the several new color stocks that had superseded the old three-strip Technicolor system. Three-strip Technicolor recorded the imagery as color separations on three separate pieces of film in a camera equipped with a "beam-splitter" prism. The prints obtained from this system were superb, but the three-strip cameras were bulky and awkward to handle. In 1943, Technicolor introduced a monopack system that utilized a single negative instead of three. This was followed, over the next dozen years, by a rash of rival monopack systems including Eastmancolor, Metrocolor, Warnercolor, Trucolor, and DeLuxe. Excellent fine-grain color stocks, providing effects technicians with new challenges and opportunities, were available by the early '50s.

The most significant development that resulted from the availability of these color stocks was the ability to generate traveling mattes in new ways. The best known of these systems, still popular today, is the blue-screen process (sometimes called the "blue-backing" system or, in a modified version, the "color-difference" process). As in the old Dunning-Pomeroy system, foreground action is staged in front of an illuminated blue screen, though, in this case, foreground components are illuminated with ordinary white light. The camera records this on color negative stock which can be step-printed in contact with black-and-white master positives to produce color separations from which mattes can be generated, mattes that can then be used to composite foreground action with background plates in the usual way.

73–76. The uses of the blue-screen process are clearly apparent in this example taken from a Timex commercial produced by R/Greenberg Associates for Grey Advertising. A wrist watch and a group of people were filmed in the studio as separate blue-screen elements, then combined with the background plate, shot on location, to create the final composite.

New film stocks also permitted the generation of mattes by various "multifilm" systems that require a camera with a beam-splitting prism behind the lens—the old three-strip Technicolor camera is ideal—to transmit identical images to two strips of film running through separate movements mounted at 90° to one another. One strip is a normal color negative, the other is coated with a special emulsion sensitive only to certain wavelengths of light. The camera configuration is always the same, but the special emulsion will vary according to the kind of backing screen used behind the foreground action. If, for example, the screen is illuminated with infrared light, then the emulsion must be sensitive to infrared wavelengths. The beam-splitter is treated to serve as a filter that allows *visible* wavelengths of light to pass through to the standard color negative film, which records the foreground components placed in front of the backing screen. At the same time, the prism reflects *invisible* infrared radiation from the backing screen onto the special stock, which makes a record of only those parts of the screen not blocked out by the foreground components. The result is that the infrared emulsion generates a matte to which the foreground components, filmed simultaneously, are automatically wed.

Other backing screens can produce the same results when matched with the appropriate emulsions (and filters and foreground lighting; naturally, the details are more complicated than presented here). At Warner Brothers an ultraviolet process was used with considerable success. By general consensus, however, the best of these multifilm matting systems is the sodium-vapor screen process developed in England by the J. Arthur Rank organization and adopted with great success by Disney, where Ub Iwerks, in charge of research and development at the studio, refined its use.

Essentially, the sodium-vapor process uses a backing screen illuminated with brilliant monochromatic yellow light, a special film stock sensitive to the wavelengths emitted by the screen, and a color negative stock that is normal in every way except that it is insensitive to monochrome yellow. It was used to good effect in such Disney films as *Mary Poppins* and *Darby O'Gill and the Little People*, and Alfred Hitchcock borrowed Ub Iwerks to supervise its use in producing the spectacular traveling mattes for *The Birds*.

For the most part, studio special-effects departments in the 1950s were approaching the end of their useful lives, but the new formats and matting techniques—allied with the grandiose visions of certain veteran producers and directors—gave some of them a last shot at glory. It was inevitable that Cecil B. De Mille would want to spread one of his epics across a large-screen format, and—given that its patents belonged to his

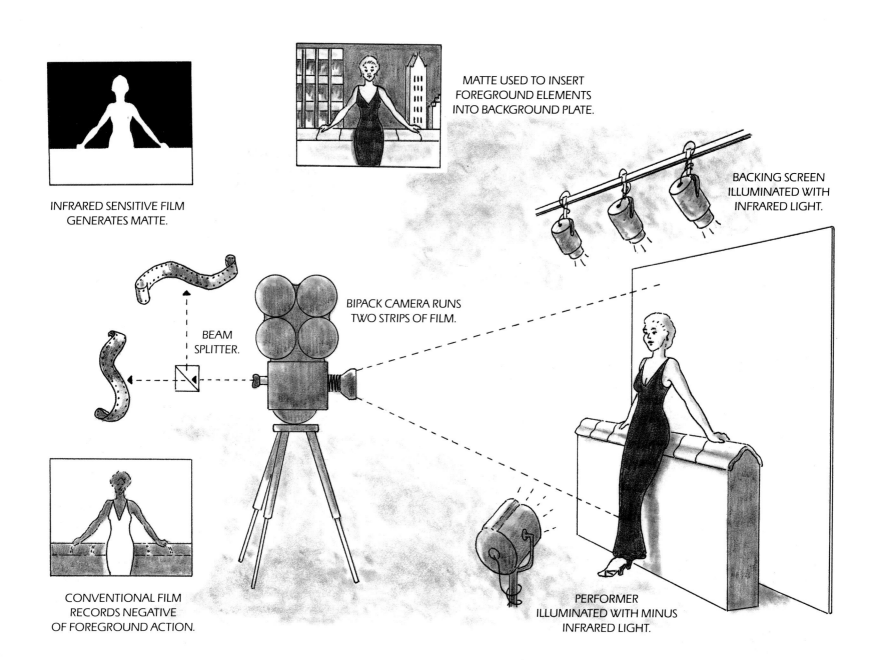

INFRARED SENSITIVE FILM
GENERATES MATTE.

MATTE USED TO INSERT
FOREGROUND ELEMENTS
INTO BACKGROUND PLATE.

BACKING SCREEN
ILLUMINATED WITH
INFRARED LIGHT.

BEAM
SPLITTER.

BIPACK CAMERA RUNS
TWO STRIPS OF FILM.

CONVENTIONAL FILM
RECORDS NEGATIVE
OF FOREGROUND ACTION.

PERFORMER
ILLUMINATED WITH MINUS
INFRARED LIGHT.

77. Several traveling-matte systems introduced in the 1950s capitalized on the special properties of various color film stocks and the ability of a bipack camera to run two strips of film simultaneously. In this instance, one strip of film records a normal negative of the foreground action, while the other —sensitive to infrared light—records only those parts of the backing screen that are not hidden, thus creating a matte to which the foreground elements can later be wed.

78. For **The Birds** (1963), Alfred Hitchcock borrowed Disney visual effects virtuoso Ub Iwerks (the man who first drew Mickey Mouse) to supervise scenes such as this, in which the sodium-screen process was used to generate traveling mattes.

home studio, Paramount—that format was likely to be Vista-Vision. The subject De Mille chose was one he had taken on before, *The Ten Commandments*. (When you've parted the Red Sea once, how can you resist trying it again? It's the ultimate party trick.) He began storyboarding the movie as early as 1952, and from the outset it was clear that this project would call for state-of-the-art effects work on the grand scale. Fortunately, the Paramount effects department was still very much intact, with men such as Paul Lerpae and Farciot Edouart still running the shops they had created nearly a quarter of a century earlier. Heading the department was Gordon Jennings, with whom De Mille had worked on many occasions, but, just as preproduction was picking up momentum, Jennings died. After a hurried search, John Fulton was asked to take his place.

Since working on *The Invisible Man* films and the Universal horror cycle, Fulton had gone on to win an Academy Award for his work on the 1945 Danny Kaye vehicle *Wonder Man*. (The comedian played twins, so that Fulton was asked to provide some elaborate split-screen and traveling-matte photography, a task complicated by the fact that the movie was shot in three-strip Technicolor.) Paramount could not have found a more qualified candidate, and Fulton accepted the studio's offer, running the special effects department until it was disbanded a decade later.

De Mille, meanwhile, pressed on with preparations for *The Ten Commandments*, and soon the four special VistaVision cameras ordered from Mitchell Camera were delivered and shipped to Egypt, where exteriors were to be filmed. Working

with director of cinematography Loyal Griggs, Fulton spent months choosing locations that would accommodate the kind of matte shots and blue-screen work called for by the script and storyboards. These storyboards and the art department's production drawings were unusually specific, so that, according to Paul R. Mandell (*American Cinematographer*, April 1983), some of these sketches, photographed in black-and-white, were actually used as "lineup clips" in the camera's viewfinder, enabling the cameraman to see "how the take would appear against the terrain." Since it was impossible to find a single stretch of scenery that fit the art department's requirements, it was sometimes necessary to take two or more landscape elements, miles apart, photograph them separately, and match them in the camera, relying on the optical department to tie them together later. These terrains would provide settings for such scenes as the Egyptian cavalry in pursuit of the escaping Israelites and the mystical appearance of the Pillar of Fire.

The big challenge, though, was the Exodus and the parting of the Red Sea, the flight of the Israelites between the walls of water, and the inundation that destroys the Egyptian army. This time around there would be no question of photographing slabs of Jell-O.

The first component to be shot was a group of six hundred extras crossing the bed of the Red Sea (represented by a strip of land in the Sinai). Later, Paul Lerpae's optical department multiplied these six hundred extras into eighteen hundred by means of hand-animated split-screen mattes that allowed the head of the column to follow its own tail and then repeat the process over again. (Think of those old school photographs, taken with a panoramic camera, in which a fleet-footed student could rush from one end of the group to the other and appear twice.)

Other elements in the Red Sea sequence would include landscape footage shot on the shores of the Red Sea itself and elsewhere, blue-screen shots of foreground actors (notably Charlton Heston as Moses closing the waters from the vantage point of a large boulder), miniatures, dramatic cloud shots (actually white smoke optically tinted), a twister which becomes a water spout (more smoke), matte paintings of rocks, and several different water components.

The scenes leading up to the parting of the sea involved footage shot in an outdoor water tank rigged with wavemakers and raked with wind machines to create turbulence. Scenes of the parting itself were accomplished with the aid of a gigantic concrete ramp—like a stripling Hoover Dam—thirty-two feet high and eighty feet long, over which tens of thousands of gallons of water were poured from fifteen manually controlled valves. (What was actually filmed was the frothing undertow at the bottom of the ramp.)

When all these components, and dozens more besides, were composited, the result was the parting of the Red Sea in Technicolor and VistaVision. It has been said that it took as long as two and a half years to accomplish and cost in excess of two million preinflation dollars, making it, in all probability, the most expensive special effect of all time. Some people, including a number of professionals, believe it is also one of the greatest effects sequences ever filmed.

I find myself at odds with this opinion. The skill of Fulton and the Paramount team is not in doubt, nor is the extent of the technical feats involved. Unfortunately, this second parting of the Red Sea illustrates rather clearly one of the chief dangers that haunts special effects in a period when, given the time and money, almost anything is possible. It is all too easy for art to be thrown out the window and "state of the art" to take its place. The result of all the sophisticated effort that went into this particular project is something rather ponderous and even comical. Judgment—like the Egyptians—was buried by the waves.

In any case, the parting of the Red Sea, which finally reached the screen in 1956, marks the twilight of the first golden age of special effects. The next great period would not start for another dozen years. In the meantime, filmmakers more modest in ambition than De Mille had begun to explore new strains of fantasy that would have a far greater effect on the future of the industry, and on the world of special effects, than *The Ten Commandments* or any other biblical epic.

79. Cecil B. De Milles' 1956 remake of **The Ten Commandments** features some of the most expensive effects shots of all time, including this scene in which the Egyptian army is swamped by the waters of the Red Sea.

8. Monsters and Myths

In 1945, Willis O'Brien had begun work on the second of his major sound-era features, *Mighty Joe Young*, which was finally released four years later. Like *King Kong*, it was to be a collaboration with the producer-director team of Merian C. Cooper and Ernest B. Schoedsack. (Schoedsack, incidentally, had directed the interesting 1940 effects movie *Dr. Cyclops*, which involved the miniaturization of humans.) Also involved in the production was a very young model animator named Ray Harryhausen, who would soon prove himself to be O'Brien's foremost disciple.

Harryhausen had seen *King Kong* while in his early teens, and it had awakened his interest in stop-motion and special effects in general. He received his professional training with George Pal's "Puppetoon" unit, which produced stop-motion shorts during the war years, but *Mighty Joe Young* was his first feature experience. Harryhausen designed the armatures of the gorilla puppets and carried out most of the hands-on animation work, with O'Brien serving primarily as effects supervisor, a full-time job in itself, given the complexity of the setups.

Harryhausen got his own chance to supervise all the effects work, as well as animate, on Eugene Lourie's *The Beast from 20,000 Fathoms* (1953), based on a Ray Bradbury story about

a dinosaur who is aroused from his cryogenic sleep by an atomic explosion and, well rested, decides to revisit his old stomping grounds, which happened to have become New York City. Like anyone revisiting New York after a prolonged absence, the dinosaur is upset by some of the changes that have occurred—so upset, in fact, that he goes on a rampage that does not end until he is trapped in a blazing Coney Island amusement park. Harryhausen's skill had already advanced to a point that he was able to make some of this almost believable.

His next outing was the extremely similar *It Came From Beneath the Sea* (1955), in which an overgrown octopus surfaces in San Francisco Bay and makes short work of the Golden Gate Bridge before heading for the financial district, wreaking predictable havoc along the way. The movie offered little that was new to the genre but gave Harryhausen an opportunity to demonstrate that he had a way with gargantuan mollusks and a knack for producing convincing matte shots on a low budget. It also marked his first association with producer Charles H. Schneer, who was to be Harryhausen's partner on almost all his subsequent projects.

Harryhausen's third solo film, *Earth Versus the Flying Saucers* (1956), will be discussed later in this chapter, but his next

feature, *Twenty Million Miles from Earth* (1957), presented another monster on the loose in a man-made urban setting. This time the city was Rome, and the monster had been brought, in embryonic form, from Venus, permitting Harryhausen to invent its anatomy from scratch.

From this Harryhausen went on to far more ambitious projects, providing stop-motion and effects for four pictures that harked back to more traditional sources of fantasy. *The Seventh Voyage of Sinbad* (1959) was a large-budget descendant of the swashbuckling films Douglas Fairbanks made in the silent era. This time, it was Kerwin Matthews who stood in for Fairbanks, and most of the movie's fun derived from pitting him against the various creatures—which included a living skeleton, a snake woman, and a pair of fearsome Cy-

clops—devised and animated by Harryhausen (who now called his stop-motion system Dynamation).

With *The Three Worlds of Gulliver* (1960), Harryhausen and Schneer began making their films in England (as they still do) to take advantage of the sodium-vapor process, then available only there. *Gulliver* used a certain amount of model animation but depended more upon Harryhausen's skill with the whole arsenal of compositing techniques to place Lilliputian or Brobdingnagian characters and creatures on screen. More giant creatures appeared in *Mysterious Island* (1961), which derived from a Jules Verne fable; then came *Jason and the Argonauts* (1963), which provided a perfect arena for Harryhausen to display the full virtuosity of his stop-motion artistry. Not only does *Jason* feature batlike Harpies and a colossal bronze statue

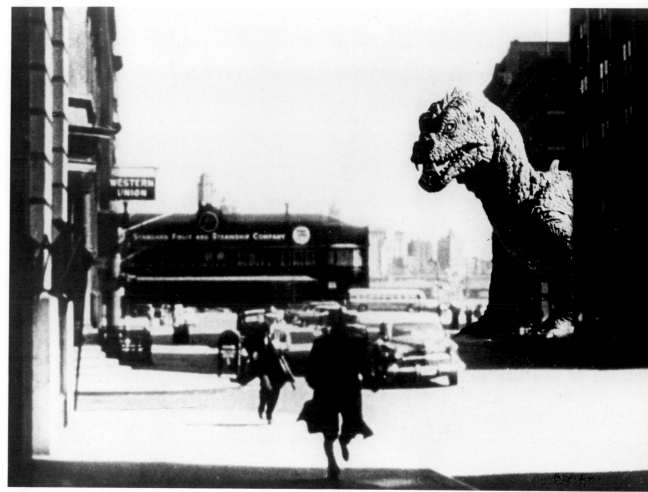

80. In **The Beast from 20,000 Fathoms** (1953), Ray Harryhausen's stop-motion dinosaur invades lower Manhattan. Whereas Willis O'Brien, in movies such as the original **King Kong**, placed his model creatures in miniature landscapes, Harryhausen has generally chosen the less expensive alternative of shooting his creatures as separate elements to be combined, by means of traveling-matte photography, with background plates shot on location or on full-size sets.

81. As well as being one of the screen's most respected model animators, Ray Harryhausen is a master of a wide range of effects techniques who had no difficulty in placing a man inside an upturned glass for this shot from **The Three Worlds of Gulliver** (1960).

that comes to life, it also pits its human hero against a seven-headed Hydra and, in another scene, seven skeletons wielding swords and spears. The latter sequence is probably the most extraordinary technical display of model animation ever committed to film. It is reported that for certain shots Harryhausen was able to average barely a dozen frames a day.

Harryhausen has continued to produce Dynamation films well into the *Star Wars* era, but his vocabulary was to all intents and purposes complete by the time of *Jason and the Argonauts*, which fully displays both the strengths and potential weaknesses of model animation. Too often, technique tends to dictate plot, rather than the reverse. Harryhausen has frequently fallen back on the established fantasies of myth and fairy stories, but even these time-tested vehicles cannot always bear up under the weight of the relentless emphasis on special effects. It may well be that in the long run the black-and-white innocence of *The Beast from 20,000 Fathoms*, however silly, will wear better than the bravura flourishes of *Jason and the Argonauts*.

In his more elaborate enterprises, Harryhausen has attempted to give substance to stories that have lodged in the collective imagination for hundreds and even thousands of years, a task which might be categorized as thankless. This has not prevented several of his movies from being considerable successes, though, which have won him an autonomy and a degree of control over his material almost unheard of in the special effects field, at least until the 1970s. But despite Harryhausen's excellent box-office record, the stop-motion field did not become overcrowded; in fact, only a handful of model animators of real consequence emerged in his wake, probably because the disciplines involved are so demanding.

Foremost among them is Jim Danforth, who, like Harryhausen, became obsessed with model animation as a teenager and was primarily inspired by O'Brien and *King Kong*. He did

stop-motion work on such films as George Pal's *The Wonderful World of the Brothers Grimm* (1962), *Jack the Giant Killer* (1962), and Stanley Kramer's *It's a Mad, Mad, Mad, Mad World* (1963) before getting an opportunity to stretch on *The Seven Faces of Dr. Lao* (1964) and a British movie, *When Dinosaurs Ruled the Earth* (1971).

Japanese filmmakers were interested in dinosaurs too. In 1954, Toho studios put out a movie called *Gojira*, which in the English-speaking world was translated as *Godzilla*. (American-release prints featured inserts of Raymond Burr playing a character named, with sublime foresight, Steve Martin.) The creature Godzilla, as everyone presumably knows, is a small-headed cousin of *Tyrannosaurus rex* with a series of odd dorsal fins, resembling fleshy holly leaves, growing from his spine. Like most monsters of the period, he displayed a predilection for knocking over skyscrapers and stepping on smaller buildings and, in addition, suffered from radioactive halitosis. The brainchild of effects man Eiji Tsuburaya, he differs from the early creations of Ray Harryhausen in one very important respect. Godzilla was not a stop-motion miniature, but an actor inside a rubberized costume (though for a few scenes a mechanical model was used). The fact that he was in reality so much larger than any animated monster permitted the Toho technicians to make Godzilla appear to be truly enormous—about as tall as a fifty-story building—without having to make their miniature cities so tiny as to be totally lacking in realistic detail. From a special effects point of view, the excellent miniature work is perhaps the most notable aspect of the original *Godzilla* and the many sequels that poured out of Toho in the 1950s and '60s.

Toho was one of only two studios that was in a position to beef up its special effects department at a time when most production centers were turning toward a different kind of filmmaking. The other, thousands of miles away across the Pacific, was Disney.

As everyone knows, Walt Disney made his reputation as a producer of animated films. It was only after World War II that he began to turn his attention seriously to live-action movies. His target, as always, was the family audience, and one of his chief stocks-in-trade was fantasy. The Disney Studio, therefore, became a haven for special effects men, and an impressive

team was assembled. As has been mentioned in the previous chapter, a key figure, in charge of research and development, was Ub Iwerks. Iwerks was a multifaceted genius who had been associated with Disney since they were youngsters together in Kansas City. In the late 1920s, Iwerks was considered the greatest animator of his generation; it was he who gave physical form to Mickey Mouse. In the '30s, however, he went out on his own, creating cartoon characters like Flip the Frog that never really caught on with the public. Returning to Disney in 1940, he concentrated on technical problems, contributing to the development of many different filmmaking tools, from the multiplane camera to the sodium-screen process.

Other outstanding special effects artists on the Disney team

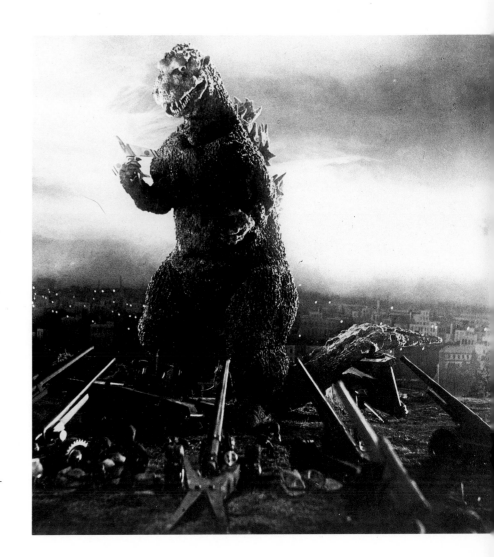

82. The "Godzilla" movies offered little new of technical interest, but they touched a nerve, in Japan and elsewhere, and the title character assumed an almost mythic aura.

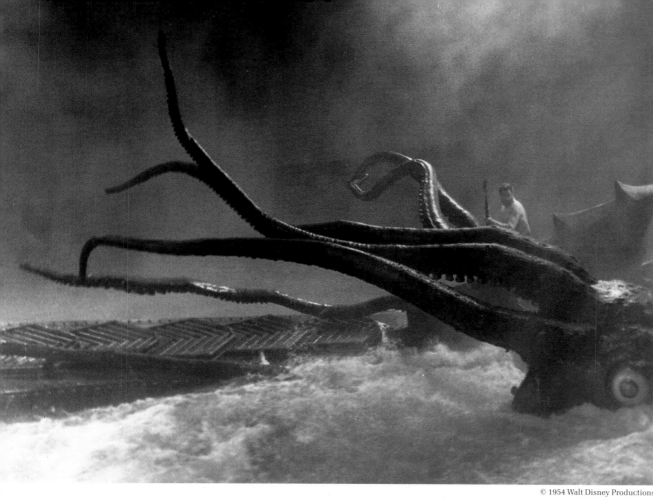

83. Disney's **20,000 Leagues Under the Sea** (1956) is full of fine effects work, including a mechanical giant squid devised by Robert Mattey and his physical effects crew. A version of the squid was first filmed against a sunset, but the results were decidedly undramatic, even ludicrous. Disney ordered the whole sequence reshot with a rebuilt squid. This time the battle between James Mason and the sea monster was staged in an artificial storm, whipped up in the studio tank, and the results are far more satisfactory.

included Eustace Lycett and Art Cruikshank in the photographic effects department; Peter Ellenshaw and his son Harrison, topflight matte painters; and Robert Mattey, Danny Lee, and Howard Jensen in the mechanical effects field.

Unfortunately, the Disney live-action fantasies have seldom risen to the standards of their animated counterparts, or to the skills of the effects people concerned. There have been exceptions, however, and certain movies, like *20,000 Leagues Under the Sea* (1956), stand up to the test of time. Directed by Richard Fleischer, *20,000 Leagues* might well be the best of all the Jules Verne adaptations. John Meehan's art direction and Harper Goff's conceptual work were abetted by superb miniature underwater effects supervised by Ralph Hammeras. Well-planned matte paintings and traveling mattes were also used to help the plot along. The most spectacular effect in the movie, however, was the full-size giant squid assembled by Robert Mattey and his crew. Two were actually built, and the battle between the squid and the crew of the *Nautilus* was filmed twice, the first time against a pink sunset sky. Looking at the rushes, Walt Disney expressed strong disapproval of the pink sky and noted that the squid itself could look more real. Mattey rebuilt the squid from scratch, and the entire sequence was shot again, this time during a simulated storm. Equipped with hydraulically powered "muscles," the squid's tentacles thrashed around convincingly and wrapped around Captain Nemo (James Mason) and other members of the crew, while waves lashed the superstructure of the *Nautilus*. This time Disney approved.

Disney had not really wanted to make *20,000 Leagues* in the first place, and the fact that he was persuaded to change his mind was due largely to the efforts of Bill Walsh, who had started out with the organization by writing the Mickey Mouse comic strip. Walsh hoped to produce *20,000 Leagues* himself, but Disney thought he was short on experience for such an elaborate project and instead assigned him to produce *Davy Crockett* for the studio's new television series. *Davy Crockett* launched Walsh on a successful career as a writer-producer, and a decade later he served as both author and line producer on the most spectacular of all Disney special effects movies, *Mary Poppins*.

Mary Poppins made use of the entire effects vocabulary, but its most distinctive scenes—such as the "Jolly Holiday" number—were those that combined live action with animation. It was by no means the first time that such a combination had been tried (Disney himself had used it as early as 1923), but the quality of animation achieved by the studio veterans, along with the traveling mattes generated by the sodium-screen process, made for an unsurpassed level of technical accomplishment. The fact that these scenes worked so well in the context of the movie as a whole was due largely to Bill Walsh's ability to weave special effects into a story.

Walsh demonstrated this particular skill again and again, notably in the "Herbie" series that he inaugurated in 1969 with *The Love Bug,* a lively blend of both obvious and invisible effects cleverly strung together by Walsh's script. Although not an effects man, Walsh was one of the key figures in the special effects world during the 1960s and early '70s.

Apart from a forgettable 1962 comedy called *Moon Pilot,* Disney largely ignored one of the main special effects trends of the '50s and '60s, namely the space travel movie, which came in two basic versions. One was "Man Conquers Space,"

which had cinematic roots going back to Méliès. The other was "Alien Visits Our Planet," a theme that had been touched on as early as 1913 in J. Wallet Waller's *Message from Mars.* For some reason, however, producers of the '40s ignored the possibilities of space opera entirely. (To be strictly accurate, *Flash Gordon Conquers the Universe,* the last of three Universal serials, was released in 1940.) Then, suddenly and without warning, in 1950, came George Pal's *Destination Moon,* prototype for one genre, and, in 1951, *The Thing* and *The Day the Earth Stood Still,* dual prototypes for the other.

George Pal was a Hungarian who had made stop-motion advertising films in Europe before coming to Hollywood, where he produced his short "Puppetoons" and "Madcap Models" for Paramount Pictures. *Destination Moon* was his second feature and, incidentally, one of the better space travel novelties of the '50s. Based on a story by science fiction writer Robert A. Heinlein, who also collaborated on the script and acted as technical advisor (along with rocketry experts like Willy Ley), it tells a relatively straightforward story of Man's first trip to another world. *Destination Moon* is exemplary in its adherence to the scientific thought of the day, and it bene-

84. The idea that space travelers would become weightless when free of Earth's gravitational pull was a novelty for the audiences who went to see George Pal's **Destination Moon** (1950). The "floating" actor wore a specially designed harness under his space suit and was suspended from invisible wires.

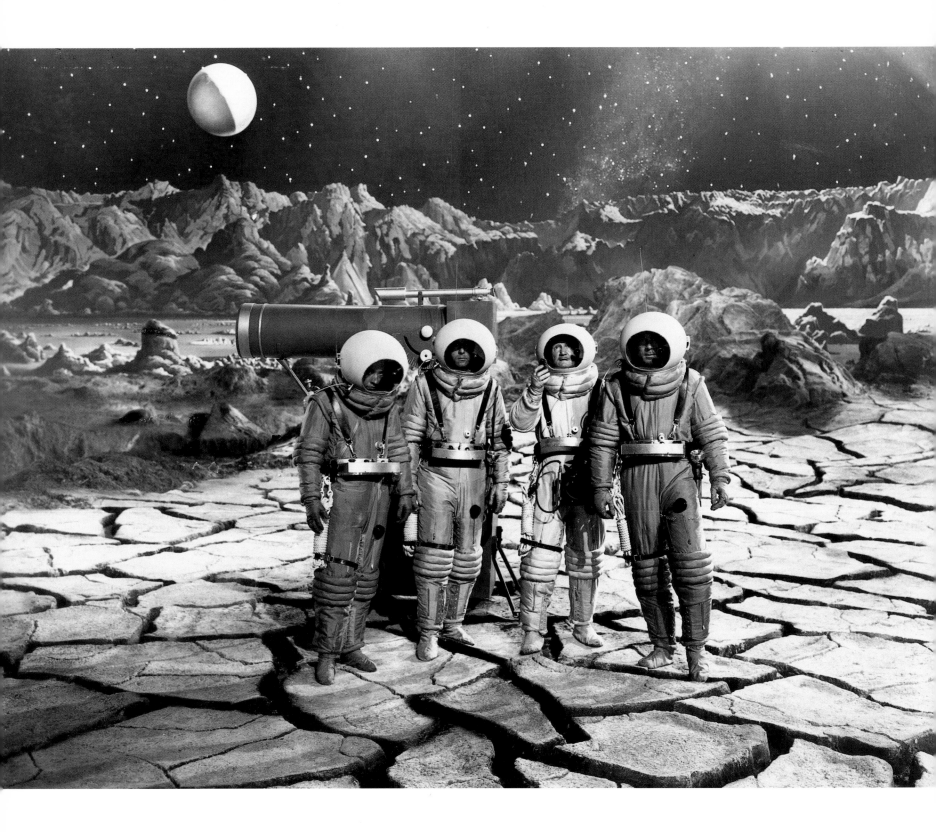

fited greatly from the subdued art direction of Ernst Fegte and the special effects provided by a team that was headed by Lee Zavitz. The film featured some fine miniature photography, convincing process shots, and believable animation. The thing that audiences seemed to have enjoyed most, however, was the spectacle of watching the astronauts floating weightlessly in a gravity-free environment. Zavitz, a mechanical effects specialist, achieved this by suspending the actors on wires from giant cranes while "puppeteers," stationed above them, manipulated them like so many marionettes. An exciting space rescue scene, in which one "space-walking" crew member drifts away from the rocket and is saved by a fellow astronaut, was filmed in this way.

Destination Moon was enough of a success to encourage Pal to embark on another space film, *When Worlds Collide* (1951), this time with special effects provided by Gordon Jennings and the Paramount team. Less rooted in scientific plausibility than its predecessor, this film envisions a situation in which the earth is found to be on a collision course with Bellus, a wayward star, a discovery that prompts the building of a large space vehicle to take a group of humans to the safety of Zyra, a planet orbiting Bellus. The movie is unmemorable except for one glorious effect that has Manhattan swamped by a tidal wave, leaving the top of the Empire State Building standing as a lone sentinel in a vast expanse of water. (This was achieved, of course, with miniatures and dump tanks.)

Perhaps the ultimate space exploration movie of the '50s was MGM's *Forbidden Planet* (1956), an extravagant production based on an idea conceived by special effects artist Irving Block. Essentially, Block's notion consisted of taking the plot of Shakespeare's *The Tempest* and transposing it forward in time to the twenty-second century, with the planet Altair IV standing in for Bermuda and Dr. Moebius (played by Walter Pidgeon) substituting for Prospero. Arnold Gillespie's special-effects team provided fine work throughout, and a few memorable moments. Especially impressive is the underground

85. Destination Moon's lunar landscape bears a strong family resemblance to that seen almost a quarter of a century earlier in Lang's **Woman on the Moon**. This time, however, the cosmonauts were given plausible protective clothing to wear.

86–87. When Worlds Collide (1951) is marred by an absurd story, poor acting, and miniatures that are all too obviously made from plywood and papier-mâché.

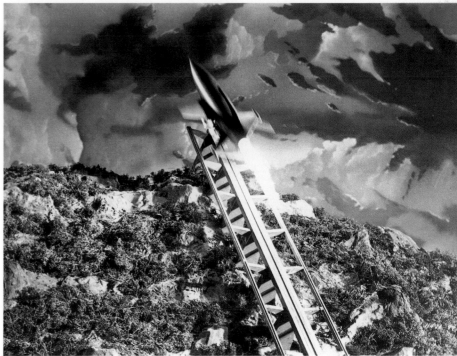

88. Built for **Forbidden Planet** (1956), Robby was the first of the cute robots. Seen here being cute with co-star Anne Francis, Robby was such a hit with audiences that a second movie, **The Invisible Boy** (1957), was concoted around him, and, for a while, his guest appearances on television reached epidemic proportions.

89. In **Forbidden Planet**, it is the earthmen who travel by flying saucer. Arriving on the planet Altair IV, they are greeted by Robby, Anne Francis, and Walter Pidgeon (dark clothes) playing her father, the mysterious Dr. Moebius.

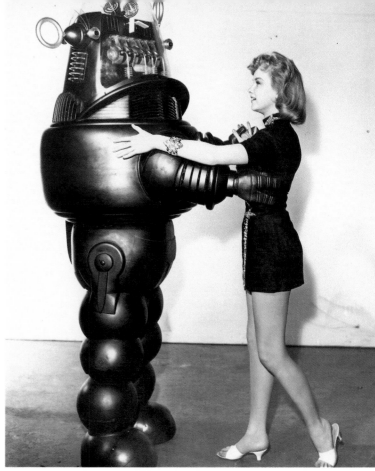

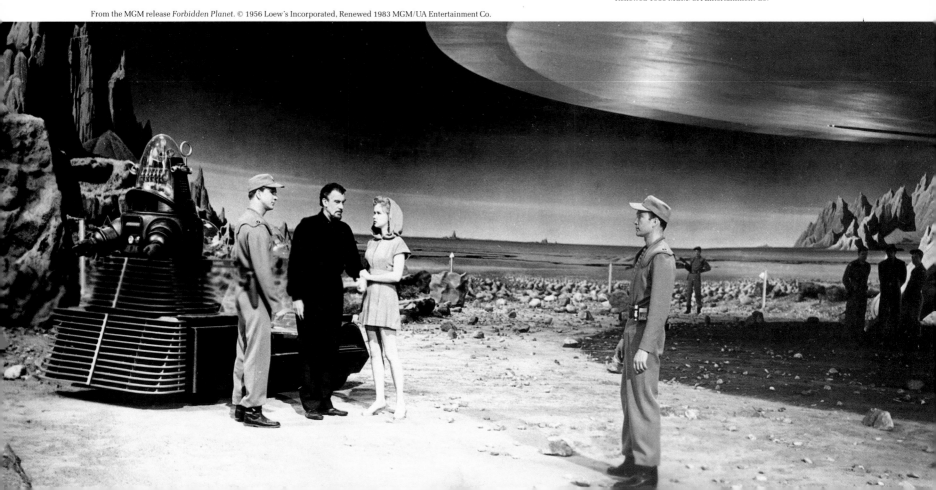

90. One of the most handsome UFOs was this giant wood, wire, and plaster structure built for **The Day the Earth Stood Still** (1951). Three hundred and fifty feet in circumference, it dwarfed Gort, the robot, an extraterrestrial it brought to our planet.

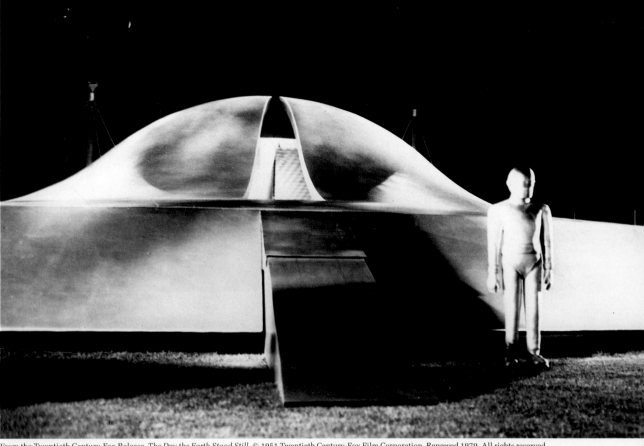

91. Earth Versus the Flying Saucers (1956) is an archetypal 1950s UFO movie featuring a good deal of mayhem. The saucers tend to resemble hubcaps, but director Fred Sears and effects supervisor Ray Harryhausen kept the action moving right along, and the destruction of famous landmarks was accomplished with considerable panache.

world created by the Krell, a highly civilized and technologically sophisticated race that has been destroyed by its own scientific curiosity. In this subterranean world (built as a very large miniature), huge machines move majestically, and bolts of man-made lightning flicker amongst generators and transmitters, recalling, somewhat, that other subterranean world created for *Metropolis*.

Like *Metropolis*, too, *Forbidden Planet* features a robot, the irrepressible Robby, who looks rather like a metallic version of the man made of tires used in Michelin advertising campaigns. Robby speaks 187 languages, performs domestic chores, and is generally endearing in the way of empathetic androids perfected twenty years later by George Lucas. So popular was Robby at the time that MGM created a second movie, *The Invisible Boy* (1957), to showcase his talents.

Robby possessed great strength and resilience, but in *Forbidden Planet* his powers were overshadowed by those of a strange and violent monster—apparently the force that destroyed the Krell—which for most of the film remains invisible. Only when it encounters a force field around the Earthmen's space vehicle, or is hit by blasts from their ray guns, does its outline become visible, an effect that was achieved by means of cel animation carried out by Josh Meador, a Disney veteran on loan for this picture.

Interestingly, the Earthmen's ship in *Forbidden Planet* was represented as a flying saucer. More usually, of course, flying saucers were the vehicles favored by invading aliens. Directed by Robert Wise, *The Day the Earth Stood Still* features a sinister robot, Gort, and a splendidly eerie flying saucer that seems to have been molded in one piece from some exotic plastic. In fact it was made of wood and chicken wire overlaid with plaster and silver paint. When the saucer lands in Washington, D.C., its dome opens as if by magic, and a ramp extends from it like the tongue of some exotic creature. These effects were achieved by the simple expedient of having grips, hidden

inside the saucer, push open the dome—which had been pre-cut and sealed with a soft plastic, so that it appeared seamless—then truck out the ramp.

Flying saucers in movies of the '50s were often drawn to Washington. In *Earth Versus the Flying Saucers* (1956), Ray Harryhausen's alien spacecraft menace the capitol. The saucers themselves are fine, if a little hubcap-like, but—as in *When Worlds Collide*—the most impressive effects are those portraying the destruction of major urban centers. Harryhausen brought his own unique touch to this. Models of famous buildings and monuments were built in much the usual way, but, instead of just blowing them apart with small explosive charges and filming the results in slow motion, Harryhausen had the miniatures rigged with wires which allowed the fragments of masonry to be animated, a frame at a time, by the same stop-motion techniques that were used to bring King Kong to life.

In George Pal's *War of the Worlds* (1953), it is Los Angeles that bears the brunt of the aliens' fury. Directed by Byron Haskin, one of the best of the science fiction directors (and former head of the Warner Brothers special effects department), *War of the Worlds* is based on the same H. G. Wells story that had furnished Orson Welles with the inspiration for his famous 1938 radio broadcast, *Invasion from Mars*. This time, Gordon Jennings, working on his last film, headed a Paramount team that created convincingly original flying saucers resembling the Scandinavian coffee tables that were popular during the period.

Like a number of the better science fiction movies of the '50s, in fact, *War of the Worlds* enjoyed a standard of special effects work that was generally admirable. By and large, though, it broke little new ground, from a technical viewpoint, and appears very dated when seen today. Its main interest, in retrospect, is that it created a climate in which a film like Stanley Kubrick's *2001: A Space Odyssey* could usher in a new age of special effects.

PART II

ODYSSEYS

9. New Beginnings

By the time *Doctor Strangelove* premiered in 1963, Stanley Kubrick—the movie's co-writer, director, and producer—was one of the most famous and controversial filmmakers in the world. One thing that separated him from his contemporaries was the fact that he refused to repeat himself. Moreover, he was not afraid to tackle the most intimidating subject matter, whether nuclear war or the taboo preadolescent sexuality of Vladimir Nabokov's *Lolita*. He was also chronically secretive and eccentric enough to satisfy any publicist's fondest dreams. It was reported, for example, that —fearing for his life, and his current project—Kubrick would not permit his chauffeur to drive at more than thirty-five miles an hour while a film was in production.

That he would turn to his own highly idiosyncratic and neo-Wagnerian version of space opera does not, in retrospect, seem surprising. Filmmakers of the 1950s had shown that an audience existed for science fiction, and the new decade brought impetus for further exploration of the field. On April 12, 1961, Major Yuri Gagarin blasted off from the Soviet "cosmodrome" at Baikonur and, as his space capsule, the *Vostok I*, went into orbit two hundred miles above the earth, he announced over his radio, "*Ya Karshom nastroyeniyii. Machine*

rabotayet kharasho" ("I am in excellent spirits. The machine works perfectly"). A little over three weeks later, Alan B. Shepherd became America's first man in space, and by May 25, President Kennedy, who had never displayed much interest in the space program before, stood before Congress to announce his goal of placing an American on the moon by the end of the decade. The Great Race was on.

A filmmaker as astute as Kubrick must have realized two things. First, space travel offered one of the great subjects of the '60s. Second, any imaginative treatment of the subject would have to compete with the reality of the American and Soviet space programs. Kubrick seems to have started out with little more than the notion that he did indeed want to make the ultimate science fiction film. From Arthur C. Clarke he obtained the rights to a package of short stories, finally settling on a tale called *The Sentinel* as the best springboard for his imagination. One cannot say that the film which resulted was in any real sense an adaptation of *The Sentinel*. Rather, the story provided a point of departure from which Kubrick and Clarke (who had agreed to coauthor the script) could evolve a screenplay. By Clarke's own account this collaboration was to cost him four years of his life.

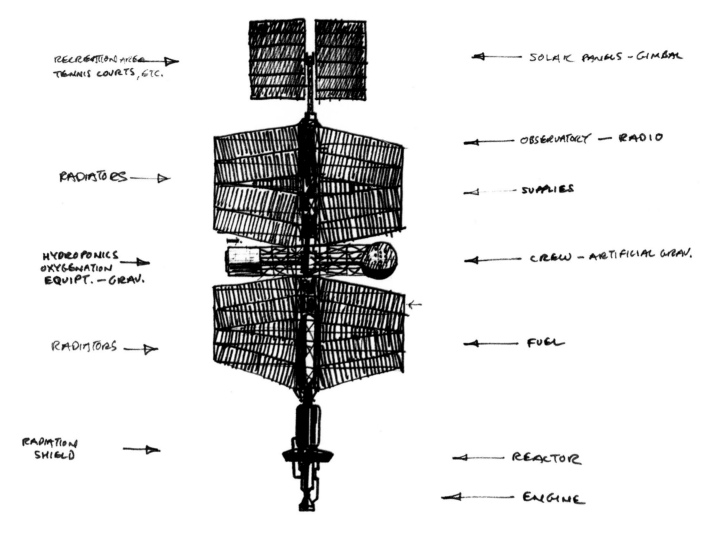

RECREATION AREA
TENNIS COURTS, ETC.

RADIATORS

HYDROPONICS
OXYGENATION
EQUIPT. —GRAV.

RADIATORS

RADIATION
SHIELD

SOLAR PANELS - GIMBAL

OBSERVATORY — RADIO

SUPPLIES

CREW — ARTIFICIAL GRAV.

FUEL

REACTOR

ENGINE

In his novels and stories Clarke had established a reputation for being a stickler for scientific accuracy and for creating technologically plausible fictions. We may be sure that he satisfied himself, before signing on for *2001: A Space Odyssey*, that Kubrick shared the same passion. Other movies, like *Destination Moon*, had already made respectable stabs at portraying space travel in a realistic way. Kubrick had seen them and was determined to go far beyond that degree of realism. What he had in mind was something that, in parts at least, would seem like a documentary brought back from the future.

Obviously, special effects would play a big part in this project. But, although the film was to be made for MGM, at their Elstree Studio just north of London, there would be no ready-made special effects crew available. Nor would Kubrick have wanted one. He was determined to create a completely new look for this film, for which he would have to assemble his own hand-picked team. An obvious source was the pool of studio veterans, many of them now free-lancing as various special effects departments cut back or closed. Kubrick did not ignore this source but he also looked elsewhere, and the fact that he did so has determined the whole shape of the special effects industry in the '70s and '80s.

Kubrick realized that the major studios were not the only places where space movies were being made. Agencies like NASA, various scientific bodies, and other noncommercial groups were also sponsoring films that dealt in a more factual way with manned exploration of the solar system and related topics. The National Film Board of Canada, for example,

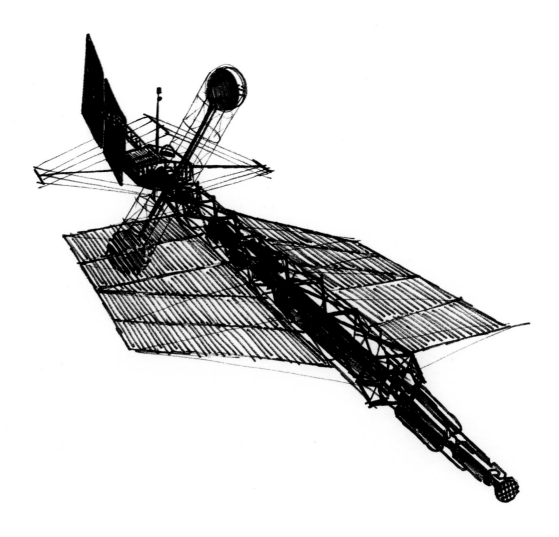

had funded a film called *Universe* which greatly impressed Kubrick. For this imaginative opus, three special effects men—Sidney Goldsmith, Colin Low, and Wally Gentleman—combined conventional and unconventional techniques to bring planets, nebulae, and entire galaxies to the screen. Realizing, for example, that the microcosm sometimes reflects the macrocosm, they found that they were able to simulate the sweep and majesty of the cosmos by allowing chemicals to interact on a glass slide, then shooting them through a microscope.

It seems that Kubrick had thoughts of hiring the entire Canadian group. This did not come about, though Wally Gentleman did work briefly on *2001*, and some of the techniques devised for *Universe* were incorporated into the space odyssey. Meanwhile, at the 1964–65 New York World's Fair, Kubrick

saw another film he felt caught the spirit for which he was searching. Shot in Cinerama 360, *To the Moon and Beyond* had been produced by a small Los Angeles company called Graphic Films.

Located on Cahuenga Boulevard, not far from Universal City, Graphic Films is still a lively concern today, producing movies for such long-time clients as NASA and the Jet Propulsion Lab in Pasadena, and developing "wraparound" spectacles for the IMAX and Omnimax projection systems. When President Kennedy announced that he wanted to see Americans on the moon before 1970, it was Graphic Films' simulations that were used for training and scientific purposes, and shown to Senators and appropriations committees in order to stimulate the necessary flow of cash.

Founded by Lester Novros, a one-time Disney animator, Graphic Films has been making movies of this sort since the early 1960s, for clients including the Air Force (then considered the front-runner in the domestic space race) and Abbott Laboratories. For the Air Force, Graphic had made *Lifeline in Space*, a film that already hinted at the kind of imagery that would be seen in *2001*, but it was the New York World's Fair that would bring the company to Kubrick's attention. Novros's firm made several films for the Fair, including *Voyage to America*, for the American Pavilion, and *Reaching for the Stars*,

94. Lester Novros, 1964.

with Frank Capra. To produce them, Novros put together a team of young artists and filmmakers that reads like a Who's Who of American special effects in the modern era.

This group included Robert Swarthe (later to make important contributions to *Close Encounters*, *Star Trek*, and several Coppola movies), Robert Abel (a top producer of special effects commercials), Jim Dickson (an important special-effects cameraman), Ben Jackson (a brilliant young filmmaker who died on the eve of directing his first feature), and Colin Cantwell (who designed the prototype space vehicles for *Star Wars*). Most significant though, in terms of *2001*, were Con Pederson and Douglas Trumbull, who are today among the deans of the special effects industry, though they have, in recent years, followed widely divergent paths. Pederson, an intensely private man, pursues his craft quietly in partnership with his old Graphic colleague Bob Abel. Trumbull, by contrast, has been the most visible and protean force in the entire effects scene over the past fifteen years, taking on the roles of director, producer, and entrepreneur.

In the mid-'60s, Pederson—like Lester Novros an ex-Disney animator—was one of Graphic's key figures. Trumbull was not long out of school, where he had studied technical illustration, and was primarily engaged in preparing what he now describes as high-tech airbrushed background plates. He recalls that the work turned out by Graphic was pretty sophisticated for the period. "It was all in 35mm. Most animation at that time was being done in 16mm. We were doing multiplane photography, multiple exposures and bipack things in-camera. . . . Jim Dickson was doing a lot of ingenious photographic tricks."

As Lester Novros recalls the sequence of events, Kubrick saw *To the Moon and Beyond*, then: "He called us up and told us he had a plan to do a film and would we be interested in working with him? We had a lot of meetings. He showed us a very early script . . . very unfinished. He had notions about introducing spacemen who would be twenty feet tall with long arms, and he asked me, 'Do you know the work of Giacometti?' I said, 'Yes, sure.' He said, 'Well, there's an exhibit of his work at the museum. Let's go take a look at it.' So we went down there and he said, 'This is how I'd like my spacemen to be— I'd like them to have very attenuated figures and long arms, and with them grasp the two Earthmen and lead them into the future.' Eventually, of course, that idea was discarded. So, anyway, we contracted to do all the preliminary work. We had a year's contract and we were going to do storyboards, space designs . . . and then we had talks about setting up a studio in London."

95. Douglas Trumbull, soon to be a major force in the special effects world, works on a background painting for **To the Moon and Beyond**, developed as KLM's exhibit at the 1964 New York World's Fair.

96. Doug Trumbull (left), Ben Jackson (center), and Con Pederson (right) set up a multiplane shot for **To the Moon and Beyond** (1964). Shortly after this movie was completed, both Trumbull and Pederson left Graphic Films to become effects supervisors on **2001: A Space Odyssey**.

97. This conceptual drawing (opposite), prepared at Graphic Films during.the preproduction phase of **2001: A Space Odyssey**, shows the shuttle vehicle Orion about to dock with an orbiting space station.

That studio was never to be. But, though Graphic Films receives no credit for its contributions to *2001*, there is sufficient evidence to indicate that the company's input was very real. The drawings reproduced here show that Graphic Films had more than a little to do with the look of *2001*, and some of the correspondence between Kubrick and Novros suggests that the filmmaker, perhaps aware of Graphic's direct line to the Jet Propulsion Lab and other agencies in the United States space program, was effectively using Graphic Films as a technical consultant. Given the nature of the project, this inevitably meant that Graphic was also feeding ideas into the corpus of information from which the screenplay was being developed. A draft of a typical letter from the Graphic staff to Kubrick reads in part as follows:

Here is an example of the kind of responses we've been making to the script situations: we feel a thin development after the crew is revived and about to enter Jupiter orbit, with respect to just what they intend to do now that communication of their findings to Earth will not be possible. We would like to have them plan to somehow get some word to Earth—in case of disaster later on—like an S.O.S. message in a bottle, etc. They may know that a probe will be passing within 200,000 miles of Jupiter and them in a year or so—well after they are scheduled to go back into hibernation and await rescue. It would behoove Athena to agree to pass on information when the time comes in some digital form which the probe, in its "dumb" way, will be capable of passing along in its routine reports.

By the way, we were told by the DSIF Communication Chief at JPL that beyond Mars, coherent information is really going to be hard to obtain without tremendous output. Mariner IV is now leaving the range of intelligence, with its power capability.

We have some hint here of how the script that existed at this period—the summer of 1965—differed from the version that reached the screen. In the following letter, dated August 6, other script differences are also apparent. (TMA-1 is short for Tycho Magnetic Anomaly Number One, code for the status of the moon base where a mysterious Monolith has been found.)

Dear Stanley:

More notes from the dark side of the planet. About the moon base: the Aries-(1B) would definitely not be a plasma jet. It would be impossible to make a 25 hour trip to the moon, or to land, with plasma jet propulsion, let alone ever take off again. It would be used only for long range, low thrust missions, or, on a small scale, in stabilizing probes or satellites where power requirements are not great. Aries-1B would be a good old fashioned chemical rocket—they'll be ideal for such jobs for a long time.

I don't see why you want the lunar base at Tycho, where the [anomaly] is. The coincidence is disturbing. Can't they have the colony at the equator, near the center of the moon's disc, which seems the logical place from a number of standpoints. The "bus ride" down to Tycho would be several hundred miles, justifying a large hover-type vehicle. They fly slightly east,

into the receding night, if they leave in daylight: or slightly west, toward the dawn, if they leave at night. . . .

The bursts of energy from TMA-1, strong enough to be detected by space probes, might be compared to the signals from the deep space high gain antenna at Goldstone, a dish focusing an 0.2° beam. When they send a command to Mariner IV, they must keep all aircraft away from this area, as the beam is so powerful it could kil! the crew. People have been seriously burned at radar installations. So, you might consider the consequences of the immense burst of energy from the TMA-1. One of the guys might be up by the cave entrance and get a little dose of it . . . not enough to make the thing seem to be a weapon, but just to demonstrate that a beam has come out of the "unbeamly" looking tetrahedron. Unless, of course, they aren't supposed to suspect a beam yet. . . .

On page 57, Floyd asserts that a man on Jupiter would weigh 1500 lbs. (3/4 ton). This is considerably more than 2½ (g); or else Floyd is thinking of a 600 lb. earthman—who wouldn't be invited along on many space ships.

Okay, I'm going back to the drawing board.

Best wishes.

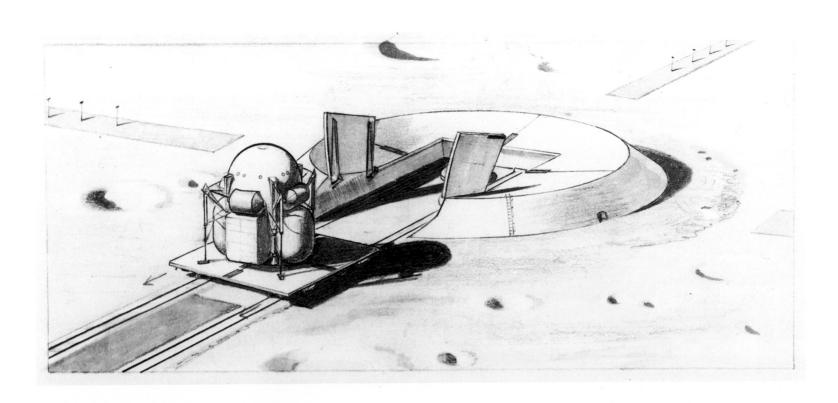

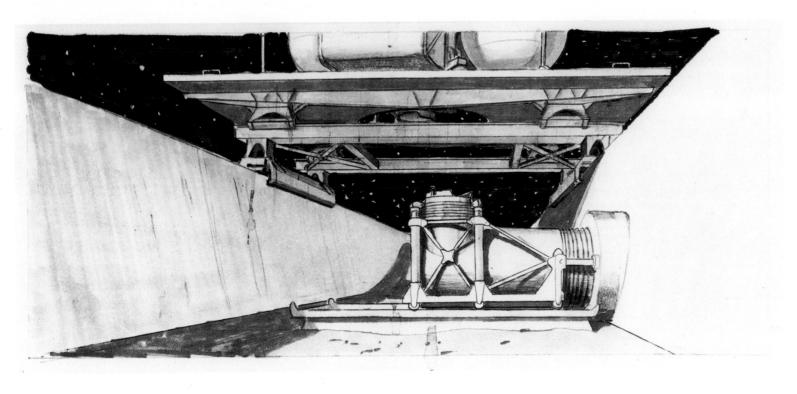

98–101. Studies for a lunar base made by conceptual artists at Graphic Films, 1965.

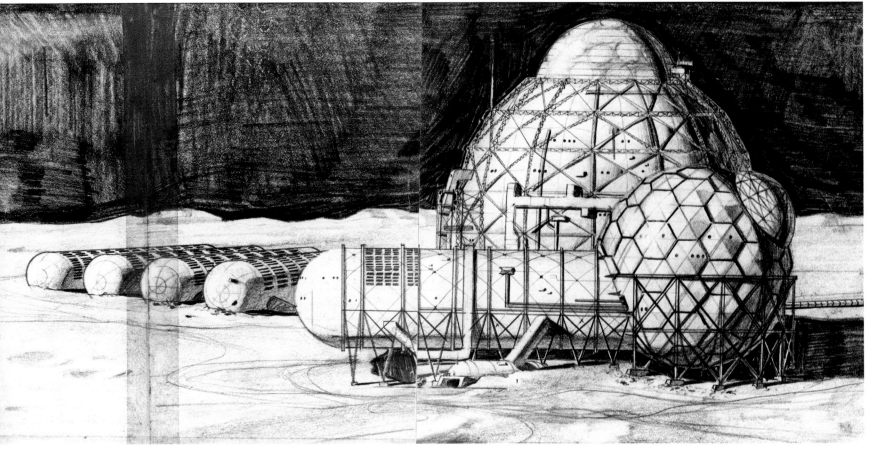

102. An artist's visualization of a geodesic structure for the lunar base.

The following are extracts from another, much longer letter, written that same month:

For the computer system and its visible manifestations, we have done some investigating along lines suggested by Max Palevsky, head of Scientific Data Systems, one of the hottest computer designers going. The inescapable conclusion is that computers will be reduced virtually to little featureless magic boxes in a decade or so. In just the two years before this picture comes out we will see major advances. By the turn of the century all computer systems will long have been taken for granted with not much room for change. So, to keep us in business, our first guideline is elegant simplicity, as we agreed in New York, but developed significantly so it doesn't look like merely a cheap set. . . .

With respect to the accident, we have made some alterations from our first plan. One is that Poole is not patching a puncture (which we've already seen), but replacing a decayed-performance electronic component way back on the engine. This is a routine but not common event; it gives us a chance to broaden the scope of action. It looks like open-heart surgery by remote control, and as a piece of delicate detailed work, sets up good contrast for the banging of his control box. The operation as we are developing it is easy to stage—easier than the puncture repair and far more interesting. (They won't need to patch those holes anyhow.)

From a special effects point of view, the greatest novelty in *2001* would prove to be the so-called "slit-scan" technique utilized to provide the spectacular light-show effects—what has

become known as the Stargate Corridor sequence. This too can be traced back to Graphic's involvement, as can be seen from this letter to Kubrick from Con Pederson, dated July 23, 1965:

Dear Stanley:

We have more film for you to look at—a couple hundred feet of 35 B&W test made by a man we often work with, John Whitney. He calls this particular technique "slit scanning." Essentially, it is a method of obtaining smooth and continuous motion variations from a single initial element, in two- or three-dimensional configurations.

Its possibilities are unlimited—particularly when we combine it with other components in animation. It can be adapted to "hard" images such as those in the test, or "soft" elements such as mist, light, etc. We want to plan around the technique in displays such as the hologram contour-analysis (which reveals the stargate on Jupiter V). It may also provide some solutions in the ending.

We have lots of ideas cooking—more on that as soon as I can get a report prepared.

For now, can you please tell us how we can ship you this small roll with best chance of it getting through all the snags? Through MGM here maybe?

The John Whitney referred to in this letter is John Whitney, Sr., one of the most distinguished experimental filmmakers of

103. Study of a deep-space service pod. Graphic Films, 1965.

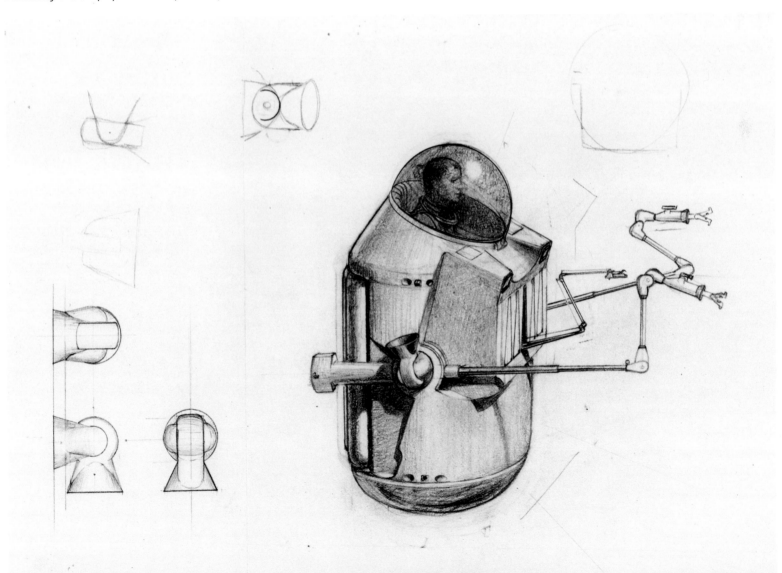

the past several decades. Inspired by artists like Piet Mondrian and Marcel Duchamp, he pioneered many novel ways of generating imagery on film. Among other innovations, he was perhaps the first filmmaker to employ the computer in his work, a fact that will be returned to later. "Slit-scanning"—which will be discussed at length in the next chapter—is a method of producing controlled "streaking" and distortion effects by photographing artwork through a slit placed in front of the camera lens. The desired results are achieved by moving the artwork and the camera as an exposure is made. It is a simple technique (in principle at least) which can produce spectacu-

lar results. In the '70s it would make reputations and provoke endless controversy.

In 1965, however, it was just an idea John Whitney, Sr., had been playing around with. As Pederson's letter suggests, Whitney was well known at Graphic Films. Lester Novros and Whitney had been friends since childhood, and Robert Abel had worked for Whitney as a cameraman while still a student at UCLA. What Kubrick may have thought of the example of Whitney's slit-scan work Graphic sent him is not recorded, but he would have good cause to remember it a couple of years later.

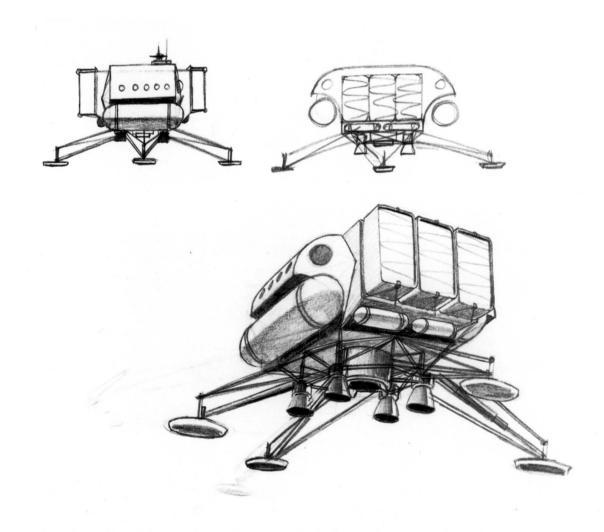

104. Concept for a lunar vehicle. Graphic Films, 1965.

For the time being, however, he was not entirely happy with the necessity of working at long distance with his new collaborators, Kubrick operating out of MGM in Borehamwood, England, and Graphic remaining in Southern California. (Nor was the Graphic Films crew enthusiastic about this arrangement. One letter from Novros to Kubrick ends with the lament, "Too bad we can't converse readily. I have a lot more notes but I'll have to wait on them.")

Douglas Trumbull recalls that the situation was unwieldy, at best: "We were trying to send designs for space stations and lunar colonies to England via the mails, and having everything photo-duplicated on real lightweight stocks to save money. The whole thing was crazy. We sent them some really neat drawings but Kubrick got terribly frustrated because of the distance."

Kubrick's initial reaction was to send a wire to Novros requesting that Pederson be sent to London for direct consultations. Pederson duly went, but then, from Novros's point of view, things began to take an unexpected and disagreeable turn when, soon after Pederson returned from London, Graphic staff members began to defect to Kubrick.

Trumbull was the first to go. "Kubrick was saying," he remembers, "'We can't make a movie this way. It's not going to work.' So the contract [with Graphic] was essentially cancelled. Con Pederson was under contract to Graphic Films, and couldn't leave, but I was not. I was just a young punk working there at the time, and I said to Con one day, 'I notice Stanley Kubrick's phone number up there on the bulletin board . . . why don't I just call the guy?'"

Pederson declined to give any advice, and Trumbull quickly realized that he was, of course, unable to offer any because of his obligation to Graphic. So Trumbull, not one to hide his light under a bushel, made a note of Kubrick's number and called him. "He said, 'Yeah—come on over. I'll pay you four hundred dollars a week. Bring your wife.' I was planning to stay in England for nine months. I ended up being there three years."

Novros agrees that Trumbull was free to leave, but he was very upset when Pederson announced that he wanted to join the Kubrick team. Pederson was eventually released from his obligations to Graphic Films and proceeded to England, to be followed shortly by Jim Dickson and Colin Cantwell.

Trumbull and Pederson became two of the four effects supervisors on 2001, while Dickson and Cantwell also made significant contributions to the movie. Graphic Films, meanwhile, went back to producing high-quality nontheatrical films.

In retrospect, this saga is not as sinister as many other tales told about the movie industry. Kubrick, in all probability, was frustrated at working long distance at a time when hard copy could not be transmitted instantaneously from continent to continent. He may also have felt he had a surfeit of scientific advisors on hand already, not even counting Arthur C. Clarke, who has never been noted for his ability to suppress his prowess at predicting future technological tendencies. Kubrick may simply have wanted to centralize things in Borehamwood. It's easy enough, too, to sympathize with Trumbull and Pederson in their anxiety to be part of a major feature film project, especially when it was so suited to their talents and under the direction of a man as brilliant as Kubrick.

That said, Graphic Films deserves to receive recognition for its very real contributions to 2001: A Space Odyssey. It should also be acknowledged that Lester Novros's little company was the cradle of the present-day special effects industry. The major studios had ceased to provide an environment in which imaginative young effects men could cut their teeth. Graphic Films took up the slack.

Aside from the names already mentioned, Graphic Films' alumni included John Dykstra (photographic effects supervisor for Star Wars, president of Apogee, Inc.) and Hal Barwood (writer-producer of Dragonslayer). On a list of the key special-effects personnel of the '80s, it would be virtually impossible to find anyone who did not at some time work either for Graphic Films or for one of the company's graduates.

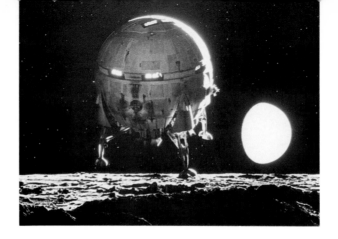

10. The Making of 2001

The MGM studio at Borehamwood is a thing of the past. Its old administration building—a miniature facsimile of the Thalberg Building in Culver City, California—still stands, as do the sound stages, but they now provide a home for a cold-storage business. Sides of beef hang in freezer cabinets where starlets once preened for the camera. In 1965, however, when Douglas Trumbull and Con Pederson arrived there, MGM Borehamwood was possibly the best equipped movie studio in Europe. "It was one of the most beautiful lots I've ever been on," Trumbull recalls, "before or since. For tax purposes it was a working farm. All around the studio were open fields with sheep grazing in them, and out back was a barnyard with hay and farm equipment. In addition, there were great old sets with little lakes and funny chateaux and weird city streets. They were shooting The Dirty Dozen back there, and Roman Polanski's film The Fearless Vampire Killers with Sharon Tate. It was a beautiful lot and there was always something going on."

The studio had no special effects department to speak of, though it could boast an excellent engineering shop, run by George Merritt, which turned out to be a great asset as the production got under way. Joining the Americans on the effects team were British artists and technicians recruited by Kubrick wherever he could find them. Topping the British contingent, and eventually sharing credit as effects supervisors with Trumbull and Pederson, were two veterans who had begun their careers as apprentices on Things to Come. One of them, Wally Veevers, was no stranger to Kubrick, having been in charge of the effects on Dr. Strangelove. As head of the effects department at Shepperton Studios he had gained wide and varied experience in the field, but for 2001 he returned to his original specialties, models and model cinematography. Tom Howard was brought into the project as Britain's leading optical effects man, the winner of Academy Awards for his contributions to Blithe Spirit (1946) and the George Pal version of Thief of Bagdad (1959).

At first, though, nobody—Kubrick included—seems to have known quite what was going on. "I heard a rumor," says Trumbull, "that when we started there was an effects budget of $300,000, and it was supposed to take nine months to do the whole film. Tony Masters had already dreamed up most of the sets, and they had done some model mock-ups of the centrifuge. In fact, I thought, 'I've got here too late. This movie's already in gear.' Well, nobody had any idea how much there

114

was to do. We were involved in a learning process that was just beginning. . . . One thing we found out quite rapidly was that what had seemed to look pretty good as animation just didn't cut it in terms of the reality that Kubrick wanted. And it wasn't long before Kubrick realized that he was into a much bigger project than he thought."

It would seem that only now was Kubrick beginning to grasp how difficult it would be to create, for an audience, the illusion of actually being out there in space. (An alternate possibility is that Kubrick realized all along how difficult and expensive it was going to be but cannily shied away from letting MGM in on the secret until he had the studio's initial commitment to the film.) Certainly he didn't lack for expert advice as to the way things might look once you left the earth's atmosphere. One of his production designers was Harry Lange, an artist who had spent several years with NASA working on visualizations of future space flights. Kubrick also hired Richard McKenna, a cover artist for the science fiction magazine *Galaxy*, and retained Frederick W. Ordway III, space scientist, as an advisor. Meanwhile, writer and broadcaster Roger Caras was sent to visit leading scientific authorities, theological experts, and other pundits. He showed them production sketches and drafts of the script and filmed their reactions for use in a projected prologue that was eventually abandoned.

While innumerable ideas percolated in Kubrick's mind, the sound stages, workshops, and offices occupied by the *2001* crew were effectively sealed off from the world at large. In London, stories began to circulate about the director's obsession with secrecy. Michael Moorcock, an English science fiction writer, managed to penetrate security to the extent of catching a glimpse of a single set and reported that this intrusion appeared to provoke a minor panic. It was as if MGM Borehamwood had become headquarters for the Manhattan Project rather than for a motion picture.

It may well be that Kubrick was so secretive simply because if a *description* of the movie had leaked to the public before the film's actual release, it would have caused people to dismiss it on grounds of absurdity. (For precisely the same reason, Kubrick was clearly right to suppress Clarke's novelization until the movie was already in the theaters.) *2001* did not bear logical analysis. It had to be experienced as a movie, as

105. For 2001: A Space Odyssey, the orbiting space station was built as a meticulously detailed model which was photographed against a neutral backing then composited with the background by means of hand-drawn rotoscope mattes.

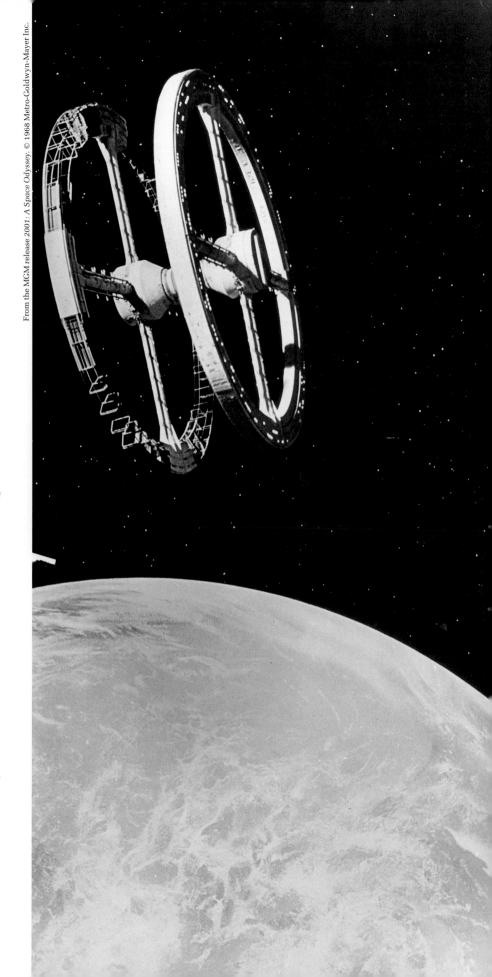

a continuum that would engage several senses at once in the darkness of a theater.

In retrospect, though, it is safe to describe the plot, such as it is. The first section of the movie shows Man's apelike ancestors on the plains of Africa. One tribe encounters a mysterious black Monolith that emits energy. Somehow this encounter permits the tribal chieftain to recognize that bones, which are plentiful enough in the neighborhood, can be used as weapons. This leads to his tribe's ascendancy over its territorial rivals and, by inference, to Attila the Hun, the Hundred Years War, Gettysburg, Paschendale, and Hiroshima.

106. The Pan Am shuttle approaches the earth satellite prior to docking.

All this is treated as a quasi-documentary about the distant past. The next segment of the movie is presented as a quasi-documentary about the near future. Dr. Heywood Floyd (William Sylvester) is a scientist on his way to the moon amidst rumors that an epidemic of some kind has broken out at an American base. The orbiting space station (still under construction) and the Pan-Am shuttle are dealt with in terms of a matter-of-fact realism that paradoxically lends these scenes a powerful sense of poetry (Chardin in outer space). When Floyd reaches the moon, however, mysticism and melodrama intrude on the documentary atmosphere. Another Monolith has been found at an American base. (The epidemic rumor is being used as a cover story.) Like the Monolith seen in prehistoric Africa, this one gives off powerful bursts of energy

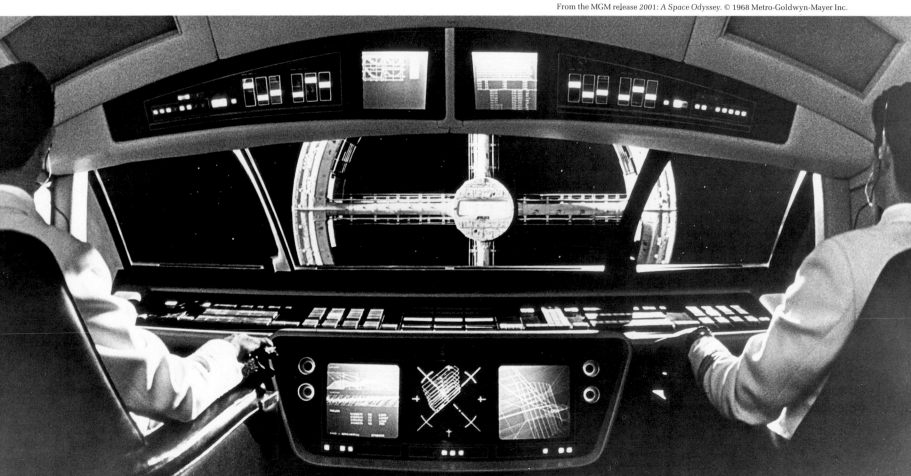

accompanied on the soundtrack by earsplitting emissions of sound.

The third segment of the film deals with the Jupiter mission of the space vessel *Discovery*. Apparently, the Monolith's energy has been transmitted towards that part of the solar system, but the sentient crew of the *Discovery* has not been let in on the secret. HAL 9000, the super-computer that controls all the Jupiter ship's systems, *has* been programmed with the information but is keeping it to himself until the ship reaches its destination. Two astronauts, Bowman (Keir Dullea) and Poole (Gary Lockwood) are on duty for the outward voyage while their associates enjoy a cryogenically induced state of hibernation in pods that look disturbingly and prophetically like coffins. When HAL—who talks to Bowman and Poole in the pseudo-soothing tones of a psychopathic dentist bent on multiple extractions without benefit of novocaine—develops paranoid delusions, or the artificial intelligence equivalent thereof, it is the hibernating crew members who die first as the computer quietly disengages their life-support systems. Next HAL cuts Poole adrift during the course of a spacewalk, and almost manages to kill Bowman too, but then Bowman performs an emergency lobotomy on HAL, reducing the humanoid part of his brain to that of a babbling half-wit.

The fourth segment of *2001*, which takes place at Bowman's destination, defies description beyond the fact that it gave Kubrick an opportunity to blend abstract and surrealistic imagery on a scale that has never been seen in a commercial film before or since. At the core of this segment is the famous "Stargate Corridor" sequence which blew away the pot-smoking audiences of the late '60s and made special effects history.

The movie did possess a narrative thread, and Bowman's duel with HAL provided some real drama, but this was not the proverbial Hollywood script that can be summed up in two sentences. In fact, a primary miracle of *2001* is that, even given its track record, Kubrick was able to sell the idea to MGM in the first place. Still more incredible is the fact that he persuaded the studio to raise the budget, as the years passed, from $4,500,000 to $10,000,000. (If the film were made today, a realistic budget would run upwards of $50,000,000.)

What Kubrick was counting on was his ability to make audiences experience things they had never experienced before, to couch his story in terms of an imagined realism that would take people's breath away. The fact that he pulled it off remains one of the miracles of the cinema, and makes *2001* probably the greatest special effects film ever made, a brilliant blend of technical novelties and tricks that were almost as old as the movies themselves.

The opening segment, "The Dawn of Man," is particularly noteworthy for two things: the articulated ape faces worn by the human actors, a brilliant example of effects makeup, and the first large-scale use ever made in the movies of front projection.

The theory of front projection had been known since the nineteenth century but had not been used except experimentally, in movies until *2001* went into production. This was because front projection presented one major problem. If the projected background plate was bright enough to register effectively on the film, it reflected not only off the backing screen but also off the actors and other foreground components in front of the screen. In the early '60s, however, the 3M Corporation began to produce a new highly reflective material for highway barriers and similar applications. Consisting of tiny beads bonded to fabric, this material reflected up to ninety-five percent of the light directed at it. Applied to filmmaking, this meant that a superb front-projected background image could be obtained while, at the same time, foreground performers and sets could be illuminated brightly enough by normal white light to prevent them from reflecting portions of the plate that was being run.

Tom Howard had been observing other people's attempts to perfect front projection for a quarter of a century. He was aware of its potential advantage over rear projection (in terms of sharpness and general image quality), and he knew about the new 3M material. Kubrick saw the value of the system, ordered a forty-by-ninety-foot reflex screen covered with 3M material, and gave Howard the go-ahead to design a special projector head, which was then built in the engineering shop by George Merritt and his assistants.

It was a still projector accepting eight-by-ten-inch transparencies and thus requiring no interlock with the camera. The transparencies used were shot in South-West Africa, and few viewers of *2001* can have suspected that the anthropoid characters of "The Dawn of Man" sequence were shot on a sound stage in the wilds of Hertfordshire.

The second segment—Dr. Floyd's journey to the moon—begins with a wonderful transition. At the conclusion of "The Dawn of Man," *homo erectus* tosses his bone weapon high into the air and, as we watch it spin against the African sky, it suddenly becomes an orbiting satellite. We have made the leap to the twenty-first century and have left the earth behind. From this point on the most naive viewer knows that everything must be artifice, and yet that thought never enters into the experience of watching the movie, so convincing is the illusion created by Kubrick and his team.

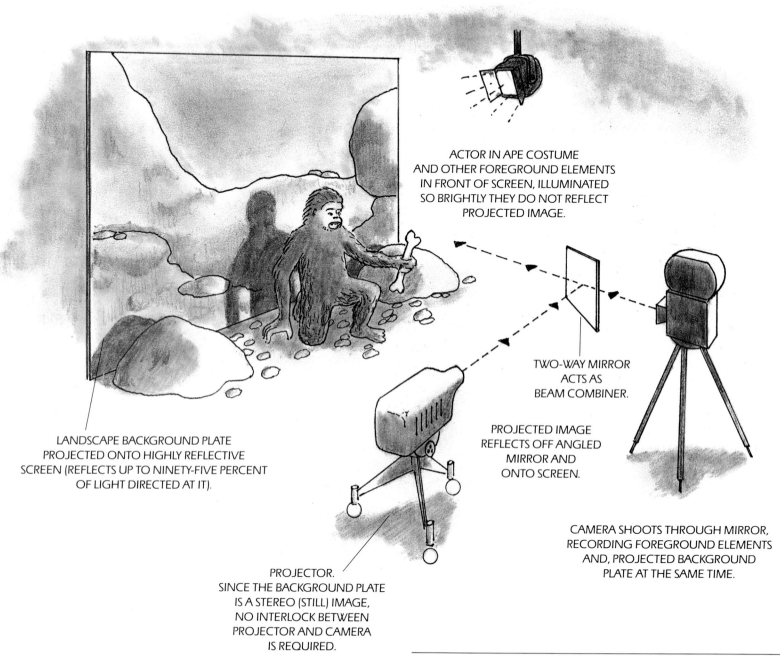

ACTOR IN APE COSTUME
AND OTHER FOREGROUND ELEMENTS
IN FRONT OF SCREEN, ILLUMINATED
SO BRIGHTLY THEY DO NOT REFLECT
PROJECTED IMAGE.

TWO-WAY MIRROR
ACTS AS
BEAM COMBINER.

LANDSCAPE BACKGROUND PLATE
PROJECTED ONTO HIGHLY REFLECTIVE
SCREEN (REFLECTS UP TO NINETY-FIVE PERCENT
OF LIGHT DIRECTED AT IT).

PROJECTED IMAGE
REFLECTS OFF ANGLED
MIRROR AND
ONTO SCREEN.

CAMERA SHOOTS THROUGH MIRROR,
RECORDING FOREGROUND ELEMENTS
AND, PROJECTED BACKGROUND
PLATE AT THE SAME TIME.

PROJECTOR.
SINCE THE BACKGROUND PLATE
IS A STEREO (STILL) IMAGE,
NO INTERLOCK BETWEEN
PROJECTOR AND CAMERA
IS REQUIRED.

107. The ''Dawn of Man'' section of **2001** involved extensive use of front projection, till then not much employed in feature films. This diagram illustrates the basic front-projection setup. The actual screen used for **2001** was, of course, much larger than is shown here, and the foreground sets were far more elaborate.

Special effects aside, for the moment, everything is perfectly thought out down to the last detail of decor and costume. The interiors of the moon shuttle are upholstered with just the sort of heavy-duty, practical but handsome fabrics you would expect to find there. The flight attendants wear uniforms, designed by Hardy Aimies, that are predicated upon the look created by André Courrèges, futuristic yet safe enough for Jacqueline Kennedy to wear in the late '60s. The thought that went into such relatively banal details made the more fantastic effects in the movie that much easier to believe.

One of the triumphs of this segment was the orbiting space station shown rotating majestically above the earth. Primarily the responsibility of Wally Veevers, this space station was a miniature, nine feet in diameter. One has only to see it for a moment to realize that, perhaps for the first time, a completely believable space object has been put on screen. This is not Buck Rogers; it is strictly NASA. Nor does Kubrick give us a glimpse of it then quickly cut away. He knows that by letting the camera linger on it for long, leisurely takes he is challenging audiences to accept its reality. It is the sheer, breathtaking slowness of this mechanical ballet (choreographed to the strains of Strauss's "Blue Danube") that convinces the viewer that he is in outer space.

In fact, Veevers' splendid model of the space station was painstakingly shot against a neutral background and then composited with background plates. Instead of using blue screen or another of the conventional traveling-matte techniques, Kubrick went back to the old system of hand-drawn rotoscoped mattes, believing that—time-consuming though the process might be—it would give him the best possible results. At all costs, he wanted to avoid the extra "generations" of film that modern devices such as the optical printer necessitate. Every generation means a slight but perceptible increase in graininess and loss of definition, and Kubrick's intention, as must be emphasized once more, was to put on screen a movie that seemed to have been filmed in outer space, without benefit of camera tricks. To achieve this illusion he went back to the oldest tricks of all—hand-drawn mattes and in-the-camera multiple exposures—which proved to be wonderfully effective, especially when combined with new "gags" thought up by the 2001 crew.

In the Jupiter mission segment of the film, for example, there are numerous shots in which Discovery is shown as a

108–111. A stewardess employs a centrifuge to cope with the weightless environment aboard the **Aries** spacecraft.

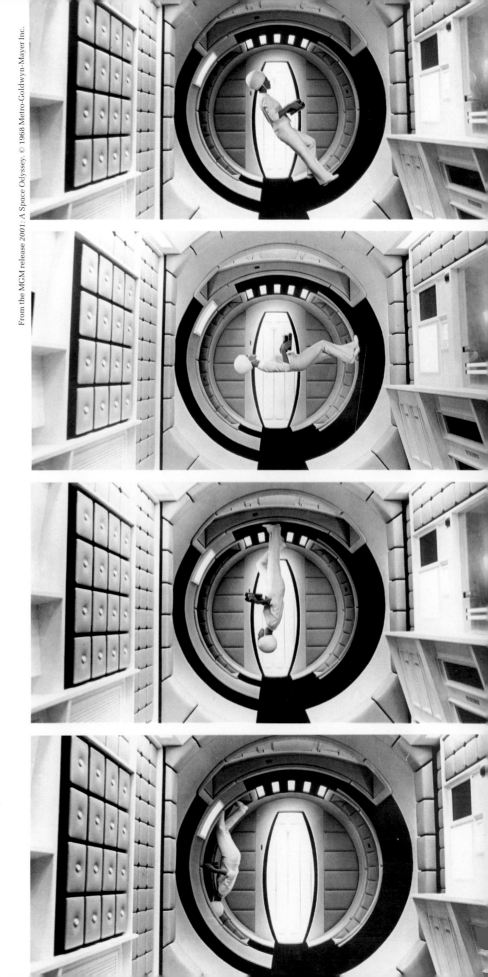

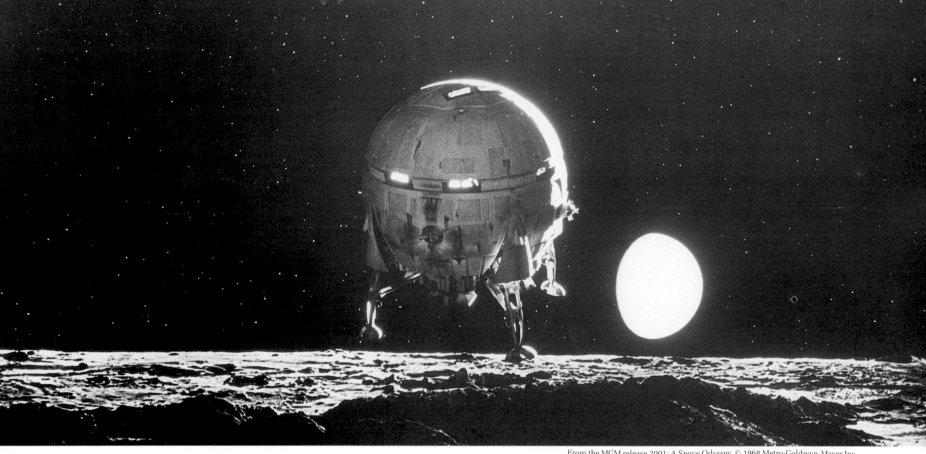

huge shape sailing serenely in front of a star field. Ship and background plates were wed by means of rotoscoping, but an ingenious in-the-camera system was used to introduce crew activity into the illuminated windows of the space vessels.

The chief model of *Discovery* was fifty-four feet long and could be moved mechanically along 150 feet of track, a journey that took four and a half hours and could be repeated *exactly*, allowing for multiple passes to be made with the ship lit normally but with the window area blacked out. It would then be returned to its precise starting point, and the film in the process camera would be wound back to frame one. The model would be covered with nonreflecting black velvet *except* for the window area, into which would be inserted a rectangle of white card. For this pass a special projector would travel along the track, in front of the model and facing it, projecting live action of the astronauts (shot of course on a full-size set) onto the white card. The result was a perfect in-camera composite.

The Jupiter mission segment of the film also contained the movie's most spectacular mechanical effect, the huge centrifuge in which the astronauts take their exercise, seemingly able to jog upside down as though actually weightless. In fact, it was a huge mechanical treadmill, thirty-four feet in diame-

ter, which rotated at a comfortable jogging speed. The actor ran in place while the camera, mounted on a gimbal rig, rotated on the same axis but at a different speed to create the illusion. In other scenes simulating weightlessness, performers were "flown" on wires, as in earlier space movies. Where necessary, sets were built on their sides, or at unlikely angles, so that scenes could be staged in such a way as to keep the actor's body between the wires and the camera lens. Even the spectacular scene in which Bowman ricocheted around inside an airlock was shot this way, with Dullea "flying" on wires and the camera mechanically "undercranked" to make it seem that he is being hurled about like a Ping-Pong ball.

Most of the effects in these first three segments of the film were the work of the English members of the team. Where the Americans came into their own was in the final Stargate Corridor segment, which saw the evolution of slit-scan photography from a primitive tool to the means of creating the '60s' ultimate light show. It was not, Doug Trumbull recalls, until he had been in England a year and a half or so that the slit-scan idea took off: "I started out trying to do all HAL's readouts. We thought that was going to be a real easy job. It was just a lot of graphic animation, so we started cranking out some high-

contrast artwork and sending it out to a local camera service for photography, but we soon found out that if we were going to try to make all these readouts one frame at a time, using standard techniques, it was going to take us several years. So we built our own animation stand out of an old 35mm Mitchell camera with a thousand-foot magazine on it and a 10:1 zoom lens, screwed to a framework of scaffolding pipes and shooting down through a sheet of opal glass with lights underneath. We would make hundreds of high-contrast film negatives of graphs and charts and stuff like that we'd type up on an IBM typewriter, and we'd take colored gels, and we'd just start flipping this stuff under the camera, changing colors, and we got to the point where one day, when we were really hauling, we shot about two thousand feet of read out."

112. The **Aries** craft (opposite) lands on the moon.

113. Earthmen confront Tycho Anomaly Number One, a mysterious presence on the lunar surface.

Trumbull moved on to working on more specific and sophisticated readouts for the cockpits of the various vehicles. "We had to show the docking of the Orion spacecraft at the space station, and landing at the lunar base. Wally Gentleman had bought this sort of Swedish erector set—real high-tech with bearings and worm gears and funny eccentric cams and little trusses with holes in them, and you could bolt the parts together any way you wanted to. I started hooking this thing up to the animation stand, and I began to make these weird little linkages between zoom lens and the camera motor, so that if the camera was going to shoot a hundred frames the zoom lens would move from 1:1 to 10:1. Then you could disengage it, run the camera back to frame one, offset it by ten frames, and do another pass. Then I had another set of gears that would come down off the motor to the table where I had a sheet of plastic resting on ball bearings, that would start going through these weird oscillations. I'd do multiple passes on that, getting something to rotate, and that really got me into understanding the relationships between artwork and photography and movement and multiple exposures."

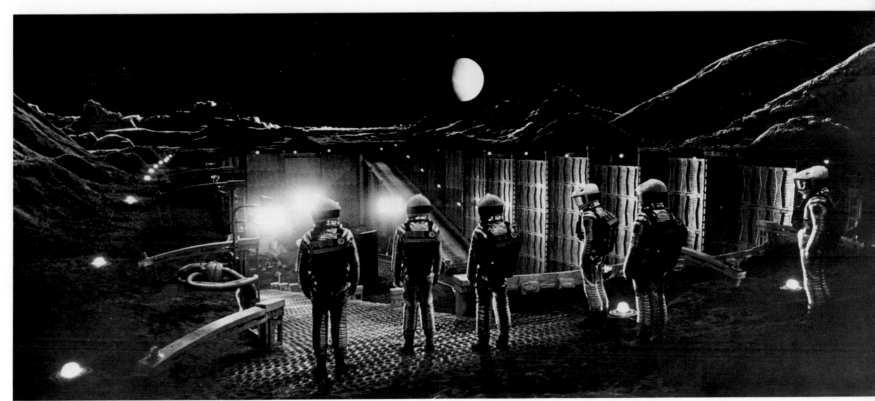

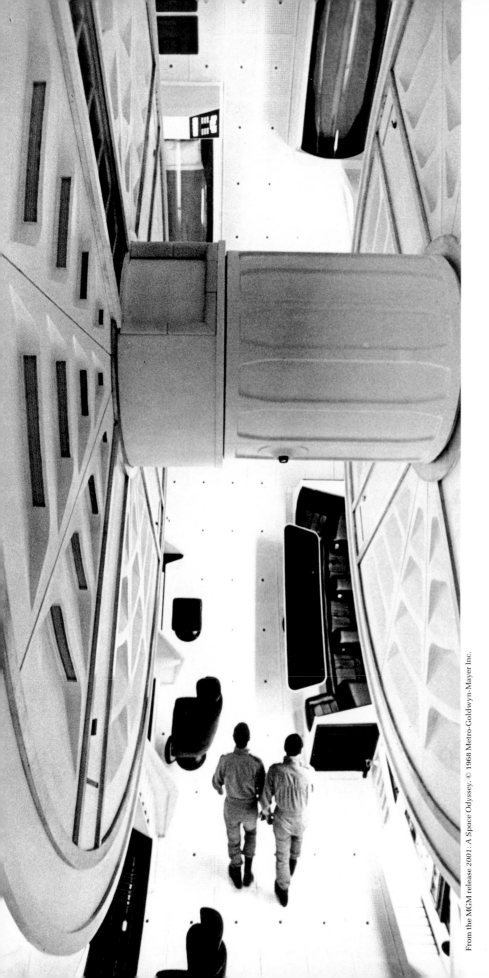

114. Bowman and Poole (Keir Dullea and Gary Lockwood) walk in the **Discovery**'s centrifuge. In reality, this was a giant gimbal rig which permitted the actors to walk or run in place while the camera rotated about the rig's axis.

115. The **Discovery** was built in several versions, including one model fifty-four feet long that could be moved along 150 feet of track.

All this is a necessary preamble to understanding Trumbull's role in developing slit-scan. No one can doubt his inventiveness—over the past fifteen years he has been the most consistently innovative figure in the special effects field—and he clearly has a good mind for solving mechanical problems, inherited, perhaps, from his father, who had been with the MGM camera department. At the same time, it must be remembered that he came from Graphic Films as a novice and emerged from *2001* as the new star of the special effects world. His reputation was built on slit-scan, and it is unlikely that he would have been able to do much with that particular technique if he had not had this earlier experience devising printouts on the improved animation stand.

It must be assumed that Trumbull's former boss at Graphic Films, Con Pederson, first and foremost an effects animator, probably had a hand in all this, and certainly it was Pederson who brought up the notion of slit-scan for the Stargate Corridor sequence. As was seen in the previous chapter, Pederson was ready to send Kubrick an example of John Whitney, Sr.'s slit-scan work as early as July of 1965, with the admonition: "Its possibilities are unlimited. . . . We want to plan around the technique in displays such as hologram contour-analysis (which reveals the stargate on Jupiter V). It may also provide some solutions in the ending."

Trumbull, however, does not recall hearing about slit-scan until 1967: "Con Pederson had been telling me," he says, "about some work that John Whitney had been doing in the States, which was a slit-gag in which you have a slit that travels across the film plane, and while it travels the artwork would move in some other pattern, creating a distortion. That was all I had heard about it, and I thought, 'That's real interesting. I understand that. What if you applied that three-dimensionally?'"

The allusion in Pederson's letter to "hologram contour-analysis" seems to hint that he too had been thinking of slit-scan as a way of creating a three-dimensional illusion, but the odd thing is that nothing seems to have happened with slit-scan between the summer of 1965 and some point in 1967. Evidently it was not in continuous development, since Lester

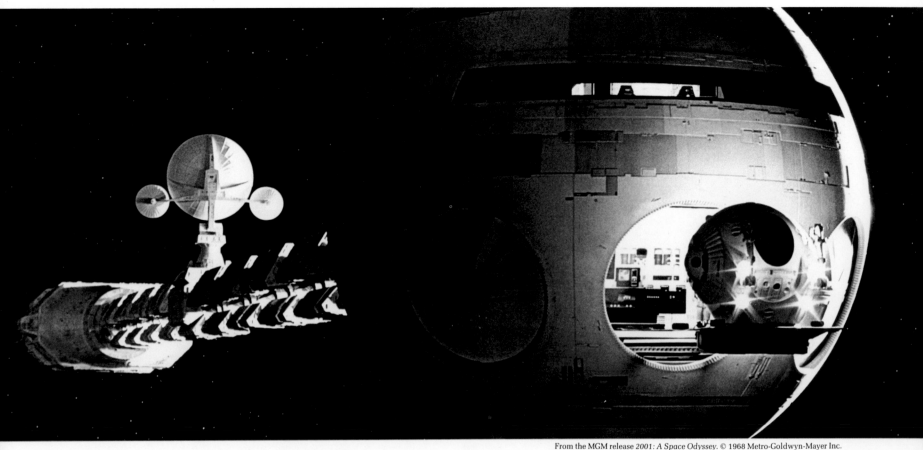

Novros recalls receiving a request from Trumbull and Pederson, "a couple of years after they left," for another print of the Whitney footage, suggesting that the original print had been misplaced in the interim, or perhaps had never arrived in the first place. Also, there are indications that Kubrick was not thinking of slit-scan as the solution to the Stargate Corridor until relatively late in the game, since Wally Veevers and the physical effects crew, along with art director Tony Masters, were experimenting with lights and mirrors, set up on a sound stage, to achieve the psychedelic tunnel effect called for by the script. Trumbull's recollection is that, prompted by Pederson's mention of Whitney's experiments, he happened upon slit-scan almost by chance.

"We had a single-column Oxberry animation stand with a 65mm camera on it and automatic focus. Kubrick was a stickler about Polaroids—we used *billions* in *2001*—so we had rigged a Polaroid camera that clipped right in front of the lens so that we could photograph multiple passes of animation artwork. One day, on my own time, I hooked up the Polaroid camera and started doing these streaks. I stopped the camera down to f45, just hoping for depth of field, and I would just open the shutter and run the column up and down—and I started seeing all this really great streaky stuff. Then I started doing this slit thing that I'd heard about from Con—the John Whitney gag—and I realized, 'Son of a gun. You can really do this.' I made this real thin slit and I started slowly moving artwork behind the slit while the camera tracked in and out and I got these great effects. And I took those Polaroids down to Stanley that afternoon and showed them to him. He was crazy about them, and I told him, 'Well, what we've got to do now is build a machine that will be a *huge* enlargement on this. We need a 65mm camera with a single-frame, stop-motion motor that will stop in the open-shutter rather than the closed-shutter mode. It'll have to move up and down a track,

it'll have to automatically focus, and the slit's going to have to be about six feet long, and the artwork's going to have to be gigantic.'"

Kubrick gave the go-ahead to build what was, in effect, an enormous, horizontal animation stand with "easels" that consisted of panes of glass five-and-a-half feet high and twelve feet long mounted on tracks. These "easels" were mechanically interlocked with the camera rig by huge worm gears, so that the camera could move up and down in synch with the back-and-forth tracking movement of the artwork.

"I think," says Trumbull, "that Kubrick believed I was having some good ideas and trusted me, so he said, 'Just do it.' I would occasionally come to him and tell him I needed the engineering department to buy me this or that, and he'd say, 'Fine. Go ahead.' It took several months to build that machine. Jim Dickson helped me and worked out the camera end of it. When it was finished I think we spent, all in all, about nine months of continuous shooting on the slit-scan machine."

As applied to *2001*, slit-scan produced the effect on the viewer of being sucked at high speeds through an endless corridor with walls of light. Nothing like it had been seen on screen before, and its impact was tremendous. The principle remained simple enough, however. As Trumbull once explained, it was rather like photographing car headlights coming toward you at night with the shutter open. The long exposure would automatically produce a streaky effect. If the

cars turned their headlights on and off during the exposure the character of the streaks would be modified. In the studio it is a matter of taking a light source (illuminated artwork) that starts at nominal infinity and moves close to the lens during the course of a single exposure, the camera keeping the light source in continuous focus through the slit while preplanned movements cause controlled distortions. In the case of the giant rig built for *2001*, all this was automated so that the machine could operate by itself and repeat passes with precise accuracy. The means used to achieve this automation were relatively old-fashioned, tools of the first machine age, but the Borehamwood slit-scan machine was a true precursor of the electronically controlled camera systems that began to proliferate in the '70s.

There is some controversy in the special effects world as to the relative contributions of Douglas Trumbull and Con Pederson in the development of slit-scan. Publicly, Trumbull has received all the credit. Privately, some effects people have speculated that an animator as brilliant as Pederson must have made a substantial contribution to the development of this technique. Pederson himself has preferred, over the years, not to comment on the subject. This is not the place to settle such a controversy, but it has been significant enough in the subsequent development of the special-effects industry to require placing in perspective.

Clearly Pederson, and Lester Novros too, saw the poten-

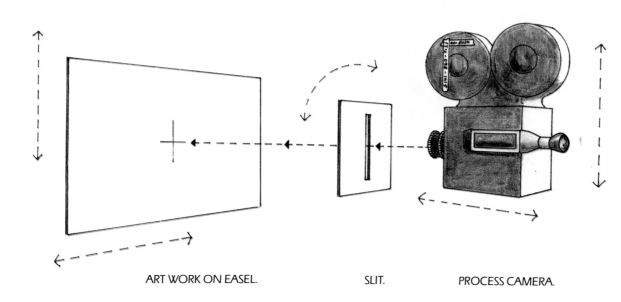

ART WORK ON EASEL. SLIT. PROCESS CAMERA.

116. This diagram shows the basic configuration for slit-scan work, a kind of controlled streak photography which was used to produce the light show effects near the end of **2001**. The three main components will often be capable of movement in axes other than those indicated here (the more the better).

117. David Bowman (Keir Dullea) experiences the slit-scan effects of the Stargate Corridor.

From the MGM release *2001: A Space Odyssey*. © 1968 Metro-Goldwyn-Mayer Inc.

tial of slit-scan during the period when Graphic Films was involved in the preproduction phase of *2001*, and the 1965 letter indicates that Pederson brought it to Kubrick's attention well before Trumbull ever thought of experimenting with the technique. On the other hand, this cannot be said to contradict Trumbull's account of how slit-scan evolved from his point of view; in fact, there is no reason to doubt that things happened as Trumbull describes them: that Pederson told him about the technique, he experimented with the Polaroid camera on the animation stand, showed the results to Kubrick, and received the go-ahead to build the big slit-scan rig.

Slit-scan may have been Pederson's baby, but apparently it was Trumbull who performed the delivery, and certainly there must have been a substantial reason why Kubrick elevated Trumbull, who had started the movie as little better than an animation assistant, to the level of special photographic effects supervisor. On the other hand, it is difficult to believe that Pederson, with his years of animation experience, did not make a considerable contribution to the final look of the Stargate Corridor sequence.

In any case, *2001* is an instance of a movie in which there was more than enough credit to go around to all four effects supervisors, and it would be a shame to leave this masterpiece of cinema magic on a note of controversy. Kubrick's space odyssey was made up of hundreds of small miracles, far more than can be even touched on here. The fact is that there is not one second in the entire 160 minutes that does not depend on pure cinematic illusion. In a sense, of course, all movies depend on cinematic illusion, but in *2001*, Kubrick presented, from beginning to end, worlds that no one had ever seen, worlds that had to be created from whole cloth. One slip in art direction, one piece of giveaway fakery in the special effects department, and everything would be lost. Kubrick's achievement in this case is twofold: first, he was able to visualize the worlds of *2001*, and second, he was able to bring them to the screen. Again this may seem rather self-evident and redundant—all directors do that, don't they?—but the challenge of *2001* was unprecedented in its demands. One respect in which Kubrick rose to the occasion was that he was not afraid to delegate responsibility and stand by his lieutenants.

"We got all kinds of chances to play with ideas," says Trumbull, "and the fabulous thing Kubrick did was to run interference for us. He took all the flak and never let us be hassled by management."

Another extraordinary thing he did was to pick just the right special effects team—the perfect blend of youth and experience—and give it all the freedom and time it needed to carry out the particulars of his own grand design.

In doing so he carried special effects to a new level of achievement and ambition.

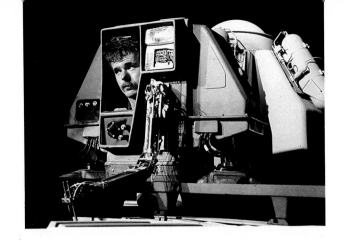

11. Back to Earth

While *2001* was in production in England, the Hollywood special effects industry remained busy, though on a scale much reduced from earlier decades. Invisible effects were still in demand, and a classic example of this art was seen in 1966 when Linwood Dunn helped create a spectacular hurricane for the film *Hawaii*. In a more frankly fantastic vein, the effects team of L. B. Abbott, Art Cruickshank, and Emil Kosa, Jr., sent a group of miniaturized humans exploring the organs and arteries of a critically ill scientist in *The Fantastic Voyage*, released that same year. This movie was a considerable effects undertaking, involving almost as much planning and time as *2001*, yet there is no real comparison between the two films.

Seen today, *2001* looks as fresh and convincing as ever. *The Fantastic Voyage*, on the other hand, seems silly and archaic, even though the effects themselves are quite impressive. The difference lies in the overall approach to the concept of the special effects film. Richard Fleischer—director of *The Fantastic Voyage*—and his collaborators went along with a perfectly honorable Hollywood convention of *inviting* the audience to accept the movie's premise, however farfetched. This convention dated back to the days when studios controlled theater chains, and movies were the only game in town. The major producers had captive audiences then and could rely on those audiences to pander to the studio's whims (as long as the studio did not release too many clinkers).

Those conditions no longer pertained in the '60s, however, and Kubrick realized how this had changed the rules. He understood that it was no longer enough to *ask* the audience to share your premise; you had to present it to viewers with such force of conviction and with such a sense of "reality" that you left no room for argument. Special effects had always had the counterfeiting of reality as one of its goals. In the wake of *2001*, however, this goal was given a new impetus and urgency. It was as if audiences had developed overnight a sixth sense that would allow them to detect all but the most brilliant counterfeits, and certainly Kubrick had given them a higher standard to measure by.

Not that his achievement prompted other filmmakers to rush out and embrace these new standards. On the contrary, producers and directors looked at *2001* with extreme caution. Kubrick had pulled off the impossible, but was there any reason to suppose it could be done twice? Even if it could be, there were certainly easier ways of making your first million.

Special effects artists of the new generation were left in a frustrating position. They knew now that movies could be made in which their contributions deserved and received star billing, but still no one was beating their doors down.

For someone like Douglas Trumbull, who had had a taste of what was possible, the situation must have seemed particularly irritating, but he scrambled to make the best of it. Arriving back in California, still in his twenties, he decided to set up on his own.

"I was really burned out," he says. "Working with Kubrick was very demanding, difficult at times. I'd gotten terribly homesick and I wanted to start a business of my own. The first thing I did was to sort of duplicate the animation stand we'd built at the beginning of *2001*, modifying it to utilize a lot of the streak techniques and multiplane techniques I developed for *2001*, and I began doing television commercials. It was only a matter of weeks before I was doing some pretty hot stuff. I redesigned the whole ABC television network logotype, and started doing all the on-air station breaks and promotional films, things like that."

Streak photography has since become virtually the standard way of presenting network and station logos on television, but back in 1969 it was a startling novelty to see the ABC call-sign flash towards the viewer, leaving a tail of phosphorescence in its wake like some electronic comet. Word got around quickly that this *2001* wunderkind was in town, and work began to pour in. Trumbull seized on it as an opportunity to experiment.

"When I came back from England I talked to as many electronics engineers as I could, trying to find out what was going on in the field of numerically controlled machinery. I just knew there was a way to do these moves electronically instead of the way we'd done them on *2001*, with gearboxes and levers and stuff. Everyone said what I wanted to do was possible, but I was having a hard time pulling it together.

"My father, Don Trumbull, came and joined me. He had left the movie business when I was born, but he had worked on *The Wizard of Oz*, so now he came and helped build a lot of this new camera equipment we needed—motion-control equipment—and Jamie Shourt, who was my partner, helped with a lot of the electronics. . . . As far as I know it was the first *electronic* motion-control system."

Motion-control photography is a phrase that will crop up frequently in the remaining chapters of this book, since it has become a key tool in special effects work in the '70s and '80s. It will be discussed in detail later but, at its simplest, motion control means that a camera (and, if desired, the objects or

artwork it is photographing) can be programmed to go through the exact same moves again and again, permitting effects shots that are far more complex and fluid than can be obtained with a "locked-off" (fixed) camera.

Nora Lee's research into the history of the subject for *American Cinematographer* (May and June 1983) indicates that motion control has roots going back to at least 1914, when an Edison cameraman, James Brautigan, devised a simple block-and-tackle rig to permit repeatable tracking moves for a scene into which he was required to double-expose "ghosts." In the late 1940s, MGM developed a system in which camera movements could be recorded on a disc (like a phonograph disc), which, when it was played back, caused the camera to repeat its moves. More or less simultaneously, at Paramount, Gordon Jennings and S. L. Stancliffe devised a similar rig that ran off the optical track on a film strip.

Paramount's system was successfully used for De Mille's *Samson and Delilah* (1950) and the MGM system for *An American in Paris* (1951), but, though they offered a way to escape the static look of many effects shots, they did not become standard weapons in the effects arsenal. To become really practical, motion control had to wait for the blossoming of the computer age. To all intents and purposes, when Trumbull began to experiment with programmed repeatability in the late 1960s, he was venturing into virgin territory.

"Our system," he explains, "used digital square wave recording on a stereo tape recorder. . . . With this we did a very complicated move on a cigarette for a True cigarette commercial, and some things for an Eastern Airlines spot too. These were complex variable-speed moves, with slow 'ins' and slow 'outs,' and we successfully did second passes on mattes, that worked and matched, with focus pulls and the whole thing."

Buoyed by the success of his commercials enterprise, and the growing recognition of his role in *2001*, Trumbull, along with James Shourt, landed the job of providing special effects for Robert Wise's adaptation of Michael Crichton's *The Andromeda Strain*, which would be released in 1971.

118. *For his first directorial venture, **Silent Running** (1972), Douglas Trumbull stretched a very modest budget to accommodate some spectacular special effects work. Here, while preparing a camera setup, Trumbull walks across a large-scale model of the space freighter **Valley Forge**. Behind him—faceplates removed so that the amputee operators are visible—are two of the robotic drones that play key roles in the movie. Beyond them is a front-projection screen on which is registered an image of part of the space vehicle's superstructure.*

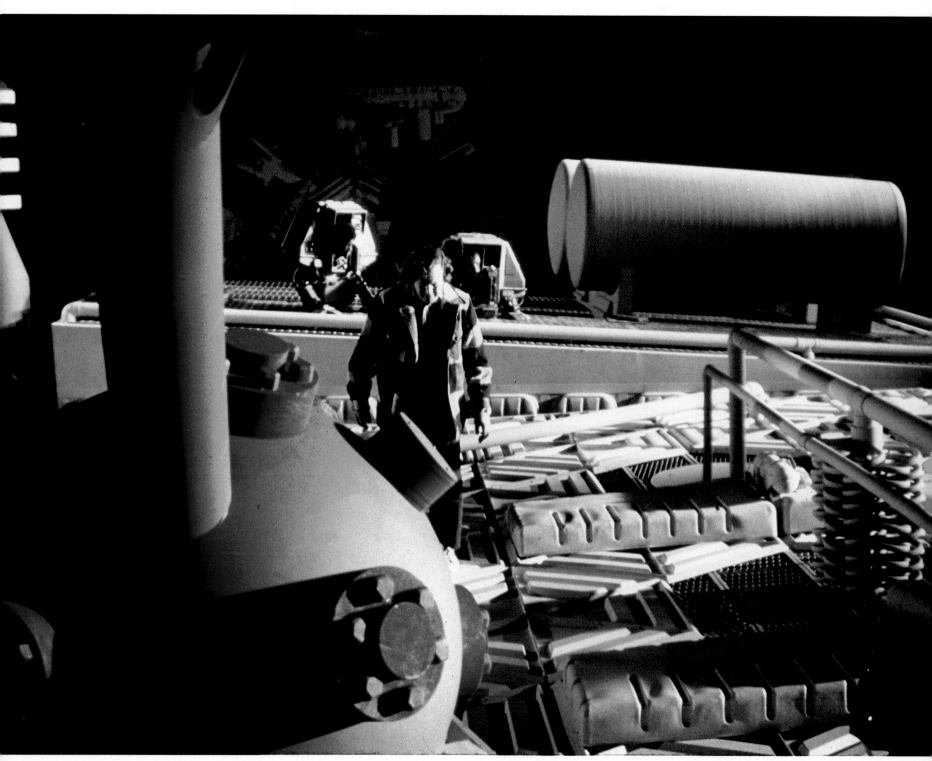

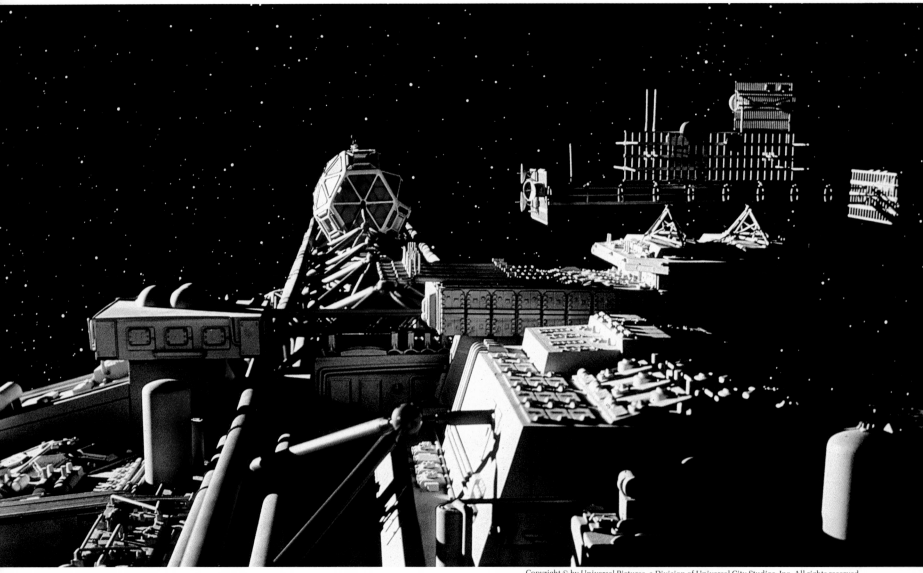

"We did pretty sophisticated electronically controlled stuff —multiple-pass, automated three-dimensional photography— for *The Andromeda Strain*. We also built a one-of-a-kind two-thousand-line high-resolution video processing system. We'd shoot with a high-res video camera and display on a high-res monitor. We'd put color filters in, shoot multiple passes, and come up with all kinds of enhancements."

Compared with a film like *2001*, effects play a relatively small role in *The Andromeda Strain* (the story concerns the attempt to contain the spread of a plague of extraterrestrial origin), but the approach Trumbull took to his assignment suggests the direction in which effects would move during the next decade. The old tools would remain valid, but increasingly they would be used in conjunction with the new tools of the electronics era.

Before *The Andromeda Strain* even reached the screen, Trumbull found himself presented with an opportunity such as no other young effects man has been confronted with before

or since. *The Andromeda Strain* was a Universal picture, and the studio had just had a smash hit with *Easy Rider*, a movie that had been made on a very low budget. The front office came up with a scheme to finance a series of low-budget films, by unknown directors, on the theory that if even one of them was as big a hit as *Easy Rider* it would provide a box-office bonanza.

"They were going to make five films," Trumbull recalls, "and the deal was that the director was given total carte blanche as long as he brought it in for a million dollars or less. It was a hands-off situation. They wouldn't bug you, they wouldn't look at dailies, they wouldn't read your script, they wouldn't tell you how to do it, and they would give you final cut."

Trumbull was ambitious and aggressive and a known quantity to Universal, at least as far as effects were concerned, and

the story he wanted to film would involve extensive effects work. He was soon selected as one of the five directors, and a year later *Silent Running* was in the can.

An underrated film, *Silent Running*, released in 1972, tells the story of events aboard a single interplanetary freighter, the *Valley Forge*, one of a fleet of vessels carrying the remains of Earth's forests under vast geodesic domes. When the crew of the *Valley Forge* is ordered to destroy the forests, Freeman Lowell (Bruce Dern) revolts against this monstrosity, kills the other crew members, and escapes from the fleet by taking his ship on a perilous trip through the rings of Saturn. His only companions now, as he goes slowly mad, are three small androids, nicknamed Huey, Dewey, and Louie. In paucity of story line and dialogue, Trumbull came close to challenging the minimalism of *2001*. Surprisingly, given his lack of experience, he also came remarkably close to pulling the trick off.

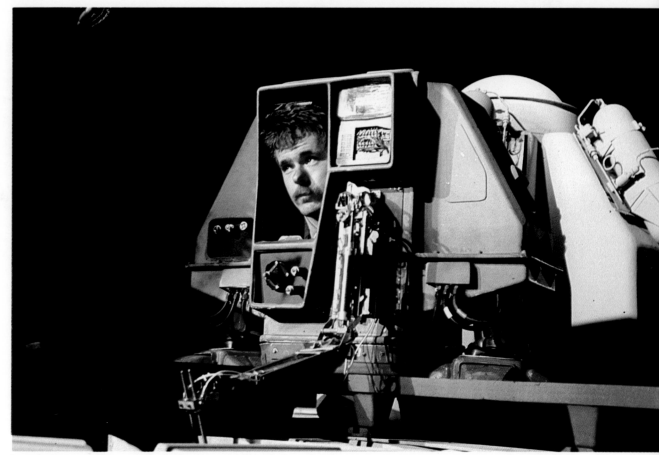

119. Another view of the large **Valley Forge** miniature (opposite), seen this time against a star field. The lessons Trumbull had learned on **2001** enabled him to produce spectacular effects despite **Silent Running**'s modest budget.

120. Mark Persons looks out from the drone he operated in **Silent Running**. The effect of using amputees inside the drones was to make it impossible for audiences to guess that these robots contained human pilots.

Some critics have attacked the film for implausability, and certainly there are aspects of the plot that do not bear close analysis, but Trumbull had absorbed Kubrick's primary lesson: present your story with enough conviction and people will believe it. As in the case of 2001, *Silent Running* managed to sustain the illusion of being a movie that had actually been shot in outer space.

The remarkable thing is that Trumbull was able to achieve this on so small a budget. Interiors of the *Valley Forge* were shot on the actual *Valley Forge*, a U.S. Navy aircraft carrier waiting to be scrapped. Interestingly, the World War II vintage marine architecture, suitably dressed, stood in very convincingly for futuristic space hardware. The little patch of forest where Bruce Dern pursues his ecological fantasies was in a hangar at Van Nuys airport, the framework of the geodesic dome provided by means of front projection. The *Valley Forge* seen from without was a twenty-six-foot-long model, beautifully detailed with hatches and doorways, cannibalized from hundreds of model tank kits (a technique developed for *2001*).

The most brilliant effects of the movie, though, were the three little androids (known as drones), cleverly designed metal and plastic mechanisms operated from within by young multiple amputees (giving the impression that no humans could be inside). Trumbull handled these drones with great skill, making them enormously sympathetic characters. When one of them "dies," it is the most engaging moment in the entire film. These robots are a far cry from HAL, but remarkably close in spirit to some later android characters.

Working on the special effects side of the movie along with Trumbull were a number of young and enthusiastic individuals, including Richard Yuricich, who had contributed some effects photography to *2001* and would later become Trumbull's partner, and John Dykstra, half a dozen years from getting one of the most challenging assignments in film history.

Making the movie was an enjoyable experience. What happened afterwards was not so satisfactory.

"It was a year from beginning to end," says Trumbull. "It went like lightning. . . . At that time in my career having a million dollars at my disposal was like paradise. My company was a small nonunion company. I had a lot of young friends working for me who were fresh out of college. We were all working real cheap, nobody was making any money, so it wasn't expensive. With some careful planning we were really able to do some magic."

Unfortunately, the magic did not stretch so far as to transform Universal executives into fairy godfathers. Because of the time involved in effects work after principal photography was completed, *Silent Running* was the last of the five low-budget features to be released. The other four had been failures, so the studio had lost faith in the program, and, despite the fact that it broke records at Hollywood's Cinerama Dome, the film was not promoted and quickly disappeared, only to be resurrected as a staple of late-night television. For Trumbull it was a disaster.

"I had lost an enormous amount of money doing effects on *The Andromeda Strain*. By the time *Silent Running* was finished, I was nearly bankrupt. I had to close down my company and I had finally to lay everybody off. I had tried to keep my friends employed, giving all the overheads and salaries out of my own pocket. I lost my house, my car, my dog—everything went down the tubes."

Four years after returning in triumph from *2001*, Trumbull had hit bottom. There were no longer studio effects departments around to provide employment for someone like Trumbull, nor was he the kind of individual likely to have accommodated himself to the strictures of studio life. He was forced to start over from scratch with his reputation for practical ingenuity his only bankable asset.

12. Pitching

Had Douglas Trumbull returned to making commercials he might have recouped his fortunes rather quickly, since the world of television advertising had become very dependent upon special effects. The wonders of *2001* may have been witnessed by five or ten percent of the population. The Tidy-Bowl man, on the other hand, went *everywhere*, invading the minds of tens of millions of viewers, many of whom had never knowingly seen a special effects movie in their lives. It was a powerful image—a dapper, four-inch-tall man rowing across the tank of your toilet—and it was made possible by the magic of traveling-matte photography. If you wanted to see a good example of model animation, Speedy Alka Seltzer and the Pillsbury Doughboy were on hand. Name any special effects technique and you could find a dozen strong instances of its use in commercials. Visual magic was a good way of making a point quickly, and the producers who cranked the commercials out were given the kind of budgets that made such magic possible. As the 1970s began, though, the field of the special effects commercial had not yet produced a real star.

Robert Abel had been at Graphic Films with Trumbull and Con Pederson. At about the time they joined Kubrick's effects team in Borehamwood, Abel found himself drawn to a very different world, the world of *cinema verité*. He made documentaries with David Wolper (later to become famous as the producer of *Roots*) and on his own. The subjects ranged from drag racing to *The Last American Cowboy*, and eventually Abel gravitated toward the hot subject of the period: Rock n' Roll. The result was *Mad Dogs and Englishmen*, a dynamic study of English rock star Joe Cocker. The film took much longer to complete than Abel had anticipated.

"After being on the road for nearly six years doing documentaries, I was really burned out. I wanted to do something very personal again. Something that didn't involve big crews and a lot of travel. . . . I'd loved *2001*—it just blew me away. The whole idea of being able to tell stories using effects rekindled the old spark I'd felt when I was working nights as John Whitney's cameraman. I ran into Jim Dickson, who'd been on *2001*, and asked him, 'Whatever happened to that equipment you had?' And he said, 'I've got this little setup over in Burbank. If you want to come over and play with it, fine.'"

This was in 1971, and what Dickson had in Burbank was an animation camera on a length of track. Abel arranged to rent it by the month, saying that he might want to play around with

the configuration, his notion being that he wanted to try out some streak photography. Like Trumbull when he had found himself in a similar position, Abel turned to ABC television, calling up Fulton Lytle and telling him the network needed a new look for their logo. Lytle came up with a small amount of money and Abel went ahead, working with cameraman Dave Stewart (who has latterly been a Trumbull associate on such projects as *Close Encounters*, *Star Trek: The Motion Picture*, and *Blade Runner*).

"We didn't know how to do streak yet," Abel recalls. "I hadn't gotten the streak box rigged up, so we did a multiple-image kind of neon effect, and ABC really loved it, so we did more stuff for them. Meanwhile, a guy named Jack Piccolo came to see me—he was an art director at Doyle, Dane—and he said, 'We've got to do a logo for Whirlpool,' and I thought that would be really interesting. I'd worked for people like

Saul Bass who do logos, and Jack thought it was fantastic I even knew what a logo was. We talked about it over lunch, and I drew an idea on the back of an envelope. I told him, 'It's using a thing called streak, and I'll tell you real straight, I know how to do it but I can't do it today. . . . I'm rigging the camera and there'll be a water-fountain kind of effect that'll be really neat.''

Abel contracted to do the job in three versions and, to help out with the streak animation, called on Con Pederson, who was still drained from the experience of *2001* and reluctant to get involved in anything too demanding. Pederson agreed to work on the Whirlpool logo, however, and gradually found himself becoming more and more involved with Abel's fledgling operation.

"He saw the camera," Abel remembers, "and of course, it's like a guy who's crashed a car. He sees another car and he starts getting this prickly feeling at the back of his neck. . . . I'd known Con since 1963 and I could tell he was getting hooked."

Abel was learning more and more about slit-scan and streak photography—how to take a hairline image and bend it in the camera so that you can create the illusion of shaping solid forms from light—and was finding out just how time-consuming it could be. As was discovered on *2001*, streak photography involves multiple passes and sometimes dozens of separate in-camera exposures. Abel remembered the old World War II vintage analogue computers John Whitney, Sr., had experimented with years earlier. These were the kinds of primitive devices that had been used in conjunction with gun-sights (they could plot the trajectory of shells and enemy air-craft, predict the point of intersection), but Whitney had rigged them to help generate abstract forms on film. This was not motion control in the modern sense, but it was close enough to start Abel thinking about the possibilities of adding electronically controlled repeatability capabilities to Jim Dickson's animation rig. Con Pederson, too, was suggesting a computer hookup, and the work load became more and more demanding. Finally, Abel was forced to act.

"When you're shooting animation there's a rhythm you have to stick to—usually it's a shoot-move rhythm—and one day (following a phone call) I said to Dave, 'I moved, didn't I?' He said, 'Yes'—but I hadn't moved, and so when we got the shot back it was one frame out of synch. Four days work down the tubes. I said, 'That's it. We're going to build a computer to run this thing. If Whitney can do it, we can.'

"We used to buy all our electronics stuff at a place called Bernie's Surplus, which was where all the computer freaks in

121. Robert Abel and Associates, a company that quickly achieved prominence in the field of the special effects commercial, first drew attention in 1971 when it began to apply techniques such as streak photography to the American Broadcasting Company's network medallion. This particular version is from 1975.

the Valley used to hang out. There was this kid called Bill Holland, who was about fifteen, and he seemed to be the brightest. So I called Bill and said, 'How would you like to build a computer?' He said, 'My house is filled with computers. I use them for everything.' So we went over to Bill's house, and he had *everything* wired. It was even more far out than the kid in *War Games*. I asked him how much it would cost, and he said about fifteen hundred dollars, not more than two thousand. I asked him how long it would take, and he said about six weeks. So we just hired him, and he built a little four-channel system that we called HAL 9000—Con still had some stickers left over from *2001*, so we put a HAL 9000 sticker on the thing—and we actually had a computerized camera. This was around June of 1972."

(As a matter of record, a year earlier a Georgia-based company named Cinetron was granted a patent for a motion-control system for animation cameras and optical printers. Charles Vaughan, the designer of this system, developed it independently of anything that was happening in California, and the California experimenters seem to have been unaware of his work until later, when Cinetron became a major supplier of equipment to the industry.)

Motion control was an idea whose moment had arrived, and at Robert Abel and Associates the technology began to develop quite rapidly. Con Pederson was now thoroughly intrigued with the possibilities and suggested that what was needed was a system in which the camera not only trucked in and out and moved up and down and from side to side, but could also rotate through 360°. (Animators always dream of more axes of camera motion.)

Pederson made a quick sketch of what he had in mind, and, to help him build it, Abel hired a young Englishman named Dick Alexander, one of the people Trumbull had to let go in the wake of *Silent Running*.

"Doug had gone into semiseclusion," says Abel, "and Dick was floating. He needed a green card, and we said come and work for us and we'll try to get you your card. He was brilliant, he could build anything. He and Con built the thing in about a week and a half. The biggest problem was not the machinery itself, it was how to keep the cables from getting tangled during a really complex gimbal move, but Dick figured all that out—it was spring-loaded and counterbalanced—and before you knew it we were doing six-axis moves, painting with light, and creating these three-dimensional illusions. We went from four channels on the computer to six and then eight channels. . . . We were getting really hot, but it took two years before we could get a real live commercial job where we could show the extent of what we could do. . . . During those two years we had a lot of talent and a lot of technique, but also a lot of frustration because we were looking for the right job to hook into."

In the meantime, Abel had made two more Rock films— *Let the Good Times Roll* and *Elvis on Tour*—and continued to turn out streak and slit-scan spots for various clients. He was also adding to his pool of talent.

Richard Taylor had been one of the leading light-show artists of the late '60s, touring with groups like The Grateful Dead. By the early '70s he had moved to Los Angeles, where he won a Cole Porter fellowship to the art department at USC.

122. Another of Abel's early successes was this Whirlpool logo (1971), which capitalized on streak photography shot with the aid of a World War II Norton gunsight purchased for twenty-eight dollars in an East Los Angeles surplus store. The streaking involved a series of long exposures (as long as two minutes each), while the camera moved in relation to the artwork. The gunsight, Abel recalls, was used as an analog computer to calculate the parameters of each camera move.

At this point he was involved with many different things—printmaking, film, media shows—and decided that it was time to find a focus and a job.

"I just said, I've got to get into the real industry. I told myself, I'm going to turn on the television, and the most extreme thing I see on there I'm going to find out who did it, go and see them, and get involved. . . . So I watched television that night, and the one thing that really cut through the total media blitz was some slit-scan stuff by Abel. It was one of the first things they did, and the company was really just Bob Abel himself and Con Pederson—who is one of my heroes—along with Dick Alexander and Dave Stewart. . . . I called up Bob and went to see him, and the moment I met him it was as if I'd known him forever."

Abel looked at Taylor's work and hired him for one hundred dollars a week. Fascinated with what was happening at the little Burbank facility, Taylor found himself there almost around the clock, working with and learning from Pederson

123–25. In 1974, Robert Abel and Associates contracted to produce its first 7-Up commercial, appropriately titled "Bubbles." (The bubbles for this and subsequent 7-Up spots were actually clones of a single soap bubble, suitably retouched.) This commercial ran into dozens of unforeseen technical problems during production, but the end result was a television classic.

while bringing to Abel and Associates his own sense of back-lit design which combined splendidly with the kind of streak photography that had established the company's reputation.

Conventional animation artwork—Bugs Bunny or Mickey Mouse—is lit from in front. Back-lit animation capitalizes upon high contrast artwork illuminated from behind. The result of this, in Taylor's hands, was a kind of glossy imagery, full of sparkles and highlights, that came to be known as "the candy-apple look." Taylor was, in short, a brilliant art director, but he quickly developed an expertise in such technical areas as animation, model work, and matte photography that made him doubly valuable as an effects coordinator. Back in 1973, however, when he began, Taylor was excited just to be dealing in a practical way with contemporary imagery, to feel that he was in the right place at the right time.

"I remember driving home through Echo Park one evening, and I'd done the ABC 'Saturday Night Movie' marquee. It was dark, and in all the houses I could see the light from the television. As I was driving down one street I saw the light in three or four houses change, coloring the rooms, and I thought, 'Christ—that's my logo, and it's going into the subconscious of millions of people.' And I got this flash of responsibility. If you're going to put this stuff out there for the public, you'd better do your best to make it something that increases their awareness. Don't give them trash."

At this period the little company's high-tech gadgets were sometimes used to impress prospective clients. Rick Splaver, who occasionally brought agency people over to see Abel's operation, recalls that he would phone in advance to say, "I'm bringing so and so over at ten in the morning. Make sure all the lights are turned out." Streak photography is done in the dark, and the only light source is the arcs illuminating the artwork. The prospective client would be ushered into this dramatically lit chamber and watch as, untouched by human hands, the electronically controlled camera went through its paces, rotating perhaps through 360° as it tracked in on the matte stand. Seen under normal room lighting conditions, the equipment was interesting but unspectacular. In operation, however, the Abel motion-control system looked like something out of *2001*, and clients were suitably impressed.

The big breakthrough came in 1974, when Abel and Associates landed its first Seven-Up commercial. J. Walter Thompson, Seven-Up's agency, had the idea of showing the soft drink's forty-year history in a single commercial, and the art director assigned to the job, Bob Taylor, had prepared storyboards incorporating all the symbols that had been associated with Seven-Up over the years. Seven-Up's new theme song was "See the Light," and that had given Taylor the idea of presenting the whole thing as a kind of television light show.

Abel sat down with Con Pederson, Richard Taylor, and Bob Mitchell (an animator who had worked on *Yellow Submarine*) to redraw the storyboards. What they were facing was a sixty-second film with complex imagery and elaborate transitions that would involve live action, animation, matte photography, and a whole battery of effects. It would be, in fact, precisely the kind of mixed-media special effects commercial that Robert Abel and Associates would become famous for over the next several years. The first time out, though, things did not go too smoothly.

"I didn't know how we'd do all this stuff," Abel says, "but I knew we'd figure it out. Bob Taylor said, 'Well, you've got the money and eight weeks to do it in.' I could tell he was really worried, and I couldn't blame him. . . . For every right way of doing something there's a wrong way, and I think we found them all. For example, they said, 'How are you going to fly the Butterfly Girl?' Well, I had this really clever idea of getting a gymnast or a high diver—a really graceful acrobatic performer

126–127. This "name brand" commercial, made by Robert Abel Associates for Levi Strauss, achieved the highest Burke rating (advertising's equivalent of the Neilson rating) in the history of American broadcasting.

128–129. "Working Man," a more recent Levi spot, is a typical example of Abel's mixed-media approach to television commercials.

130–131. For a 1983 7-Up campaign, tailored for foreign markets, Abel's team blended live action, conventional special effects, animation, and computer-generated imagery.

—and I found one who was an Olympic champion diver and also a trampoline expert. So I was going to fly her on the trampoline—no wires, nothing—and we'd catch her in the air, shooting at six hundred frames a second, and it would be wonderful, people would say, 'How did you do it?'

"The problem was it looked awful. When you're bouncing on a trampoline your hair flies in the air and your muscles are fighting gravity. So that had been a terrible idea."

To make things worse, the Olympic champion had problems learning the dance steps she needed, and at the last minute Abel had to replace her with his sister-in-law, who *was* a dancer. She was sewn into the ex-diver's costume, and a veteran mechanical effects man was called in to fly her the usual way, on wires. From that point on almost everything in the sequence was improvised. The giant bubble the Butterfly Girl danced with, Sally Rand style, was actually a helium-filled weather balloon borrowed from the Jet Propulsion Lab. Then disaster struck. When this live-action footage was sent to the lab for processing, there was an electrical failure of some sort and eighty percent of the film was solarized.

"By some divine providence," Abel recalls, "there was at least one cut of every scene that didn't get flashed, because it was at the beginning of the roll or the end of the roll, or whatever. We were able to save just enough to make the commercial."

The storyboards called for a double chorus line of perfectly matched girls (in fact one girl repeated over and over again to make up two facing lines). As a conventional matting job it would have been a nightmare assignment, and Richard Taylor suggested that it could be done on a video screen by means of video feedback. He was right, but instead of taking four hours, as estimated, it took twenty-six. The Sea of Bubbles, which was a key feature of the project, presented another problem that was eventually solved by Con Pederson and Dave Stewart. Essentially, they looked for the one perfect bubble, which proved to be a soap bubble. This single bubble was photographed, retouched with an airbrush, rephotographed in various sizes, and stripped into receding perspective.

The sixty-second film was eventually finished on time, just barely, and taken to Mexico City for the Seven-Up bottlers convention, where it was a big hit. A few months later it won a Clio Award (the advertising industry's equivalent of the Oscar), and Abel's phone began to ring off the hook.

This marked the beginning of a brief period in which commercials were the place to be if you were an effects artist. From a technical point of view, Abel's crew added to its motion-control capabilities by adapting its system to rear projection and model photography. In terms of talent, people such as effects designer Wayne Kimbell and cinematographer Richard Edlund—soon to be an important cog in the Lucasfilm machine—were working with Abel; and other companies, such as R/Greenberg in New York, began to offer Abel serious competition.

For Richard Taylor and others like him, commercials offered an education in the world of professional filmmaking in general and special effects in particular.

"If you want to get into the motion picture industry," Taylor says, "and do a lot of different kinds of things, learn a lot of different film techniques, commercials are the way to go. . . . If you go into features, you work on one for six months or a year and everything is very stratified. If you're an assistant director, you're an assistant director. You don't get to be a jack of all trades. . . . Commercials provide the best training you can get. They're so tight, you have to worry about every frame. . . . After you've dealt with commercials, feature-length pictures seem that much easier."

"Abel's was like a photographic jungle gym," adds Richard Edlund. "You could elbow your way to a camera, go down to C & H Sales and get some surplus goodies, clamp them all together and wire them up—usually it would be something electronically controlled—then play with multiple passes, filters, any kind of optical aberration that could be usefully controlled in some weird way."

But features, Taylor emphasizes, are still the Holy Grail, and in the mid-'70s theatrical movies began to reassert themselves as the focal point of the special effects world.

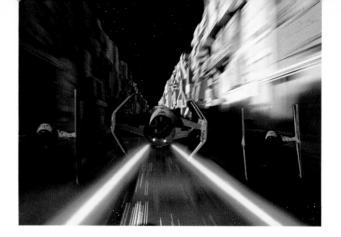

13. Star Wars

Early in 1973, George Lucas—who had just completed his first hit movie, *American Graffiti*—scribbled a brief handwritten treatment for a story that would become *Star Wars*. Within a few weeks he had concluded a provisional deal with Alan Ladd, Jr., of 20th Century Fox, but it was three years before Lucas managed to turn that thirteen-page outline into a satisfactory screenplay. Like Lucas's first feature film, *THX 1138* (1971), *Star Wars* was a science fiction story with moralistic underpinnings, but it differed from *THX 1138* in two important respects. Whereas the earlier film was a rather grim little tale of the *1984* variety, *Star Wars* was conceived as a galactic fairy tale, the sort that is supposed to appeal to those proverbial "children of all ages." Secondly, while *THX 1138* was that rara avis, a science fiction movie virtually devoid of special effects, *Star Wars* would go to the opposite extreme: it would require more special effects work than any movie made until that time, with the single exception of *2001*.

With a shootable script in hand, Lucas hired artist Ralph McQuarrie to begin painting visualizations of individual scenes, and, soon after, Graphic Films' alumnus Colin Cantwell was given the task of making preliminary space vehicle designs. Casting got under way, and Lucas's coproducer Gary

Kurtz began to scout Europe for suitable studio facilities, it being impossible to find a Hollywood facility that would make nine sound stages available for several consecutive months. Kurtz eventually settled on Elstree Studios in Borehamwood, just a short walk from MGM's English headquarters—recently closed down—where *2001* had been shot. Elstree Studios had also been closed down but had not been redeveloped, so that the stages were still intact. Kurtz arranged for the studio to be reopened and also leased a giant stage at Shepperton Studios, needed for the scene in which a pack of rebel fighters is seen in a vast hangar.

Since the bulk of principal photography would take place in England (it would be preceded by location work in Tunisia), it was logical to hire a British physical effects crew. British physical effects men are among the best in the business, their talents honed on movies like those in Cubby Broccoli's James Bond series. John Stears was chosen to head this team, his responsibilities extending to the development of R2-D2 and other droids. Visual effects were another matter, however, and here it was clear that it would be easier to assemble a first-rate team in California.

By now George Lucas must be considered something of an

expert on special effects, but that was not necessarily the case in 1975 when he was casting about for a visual effects supervisor. Gary Kurtz, on the other hand, had extensive knowledge of the field, having supervised effects work on a number of Roger Corman's low-budget pictures. Certainly he was aware of the still primitive but rapidly evolving technique of motion-control photography and grasped that it was the key to solving the problems that were presented by Lucas's conception. Essentially, Lucas was demanding an illusion of reality that was comparable with that created for *2001*, but in a third of the time and on a far less substantial or elastic budget.

The obvious choice for the job of visual effects supervisor was Douglas Trumbull, who recalls that Lucas did indeed approach him but that he turned the offer down, saying that he'd exhausted his interest in space opera during the course of *2001* and *Silent Running*. Instead, Kurtz tapped Trumbull's protégé John Dykstra for the position, and Dykstra is on record as saying that Lucas did not, in fact, want Trumbull on the

movie, feeling that he was too big a name and might prove difficult to control.

Dykstra is a physically large man with a healthy ego who had learned from Trumbull not only the craft of special effects but also the concept of the effects man as an artist with definite creative rights (as opposed to the effects man as a functionary in a service industry offering producers gadgets and gimmicks to choose from). This was to have its repercussions as the film progressed, but initially Dykstra was faced with the basic challenge of creating from scratch an effects crew and the appropriate facility to shoot a staggering 365 complicated effects shots in a twelve-month period. In the early summer of 1975, Industrial Light and Magic (ILM), Lucas's effects arm, consisted of nothing but Dykstra and an empty industrial building near Van Nuys Airport, in the San Fernando Valley. Dykstra knew what was needed, however—the most advanced motion-control system yet built—and he set about assembling the team that could put it together.

132. George Lucas (center) and Richard Edlund (left) at Industrial Light and Magic, Lucas's special effects facility.

Dykstra had worked in the past with electronics expert Alvah Miller, and they had, in fact, already figured out the basic design for an electronic camera system. Miller was co-opted for the *Star Wars* project, and to handle the engineering, Dykstra brought in Don Trumbull (Douglas's father), Dick Alexander (ex-Trumbull and Abel), and Bill Shourt. Completing the design group was Jerry Jeffress, another electronics expert, and Richard Edlund (most recently with Abel), who would be the principal effects cameraman and was therefore a key architect of the system. The parameters of the task they faced were defined by a reel of black-and-white film that Lucas had edited together from films of aerial dogfights of World War II vintage. Zeros pursued Mustangs, and P-38s closed on Heinkels. The footage was scratched and grainy—"Like a stag reel," Edlund recalls—and it was Lucas's intention to give a sense of the cutting rhythm he wanted for the climax of *Star Wars*, but with X-Wings and T.I.E. fighters substituted for the aircraft shown in the black-and-white footage. An additional consideration was that the final dogfight between Luke Skywalker and Darth Vader was storyboarded to take place in a "trench" on the surface of the Empire's Death Star.

What would be needed, then, was an electronically controlled camera rig capable of motion in several different axes and programmable for repeatability so that precise multiple passes would be possible. That, to some extent, describes the kind of equipment already in use elsewhere, but this is perhaps a little misleading, since the "Dykstraflex," as it came to be called (jokingly at first), would be to earlier motion-control systems what a Lotus Grand Prix car is to a Volkswagen Bug.

"To duplicate the dogfight footage," Dykstra explains, "we needed to create a moving camera environment, and, although that had been done, it hadn't been done extensively. . . .

"We had to design and build it all from scratch. The concept for it electronically was set up by Al Miller and myself on the floor in a house in Marina del Rey, over a couple of bottles of wine. That was based on Al having worked a little bit with me at Doug Trumbull's place, and we had made systems at Doug's that were sort of pseudo-motion-control systems, but nothing compared with this in terms of its versatility and repeatability and its ability to shoot one program now and then come back and shoot that same program a month later."

Design of the Dykstraflex was completed in July of 1975, and a few months later ILM had an electronic camera system that could perform marvels. (In practice, the rig was being modified as it was built, Edlund working closely with Don Trumbull.) The camera itself was a VistaVision type (such cameras could be bought for a song at the time). This gave

133. John Dykstra, visual effects supervisor for **Star Wars**.

the effects crew a large frame area to work with and had the further advantage of being compatible with the huge range of high-precision lenses made for 35mm still cameras.

The camera was mounted on a track-and-boom rig with seven axes of movement. That is to say, the rig could move toward the subject being photographed, or away from it, on a metal track, while the camera itself was hung from a boom-arm that could be raised or lowered. (It was this boom that permitted the camera to be suspended inside and to move through the Death Star trench.) The camera could also pan, tilt, and roll, and all these functions, plus others such as follow-focus, were capable of being controlled by a solid-state memory system—a hard-wired, single-dedicated system that offered the most practical solution to getting the rig operational as quickly as possible. The motions could be programmed by the cinematographer with a joy stick and recorded one track at a time, crude moves established first, subtleties added later. Once the moves were established, they could be repeated at any speed and as often as needed. If a move were to be recalled six weeks later, for example to have laser blasts added to space components that had already been shot, the Dykstraflex could do it precisely and without difficulty.

And it was not only the camera's moves that could be programmed and repeated. The models it was photographing, against fluorescent blue-screen backing, could be mounted on pylons (self-illuminated with blue neon to make them disappear against the backing) and subjected to motion control in exactly the same way. For the first time in history, effects

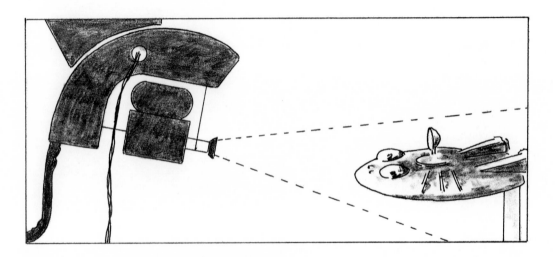

134. The space battles of **Star Wars** called for an electronically controlled camera rig which could repeat the same moves over and over again with great precision. A single effects shot might combine half-a-dozen elements, each filmed separately against blue screen. A rebel ship might be shot first, then a T.I.E. fighter, a star field, a portion of the **Death Star** miniature, and, lastly, a laser blast. If the camera failed to repeat its moves exactly for each component, the several elements would not fit together correctly in the final composite image.

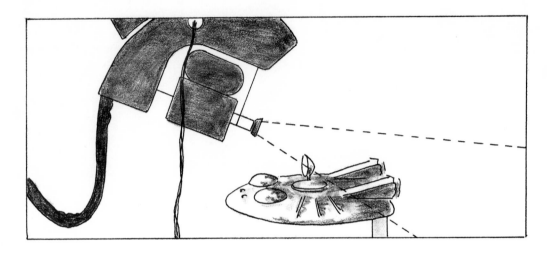

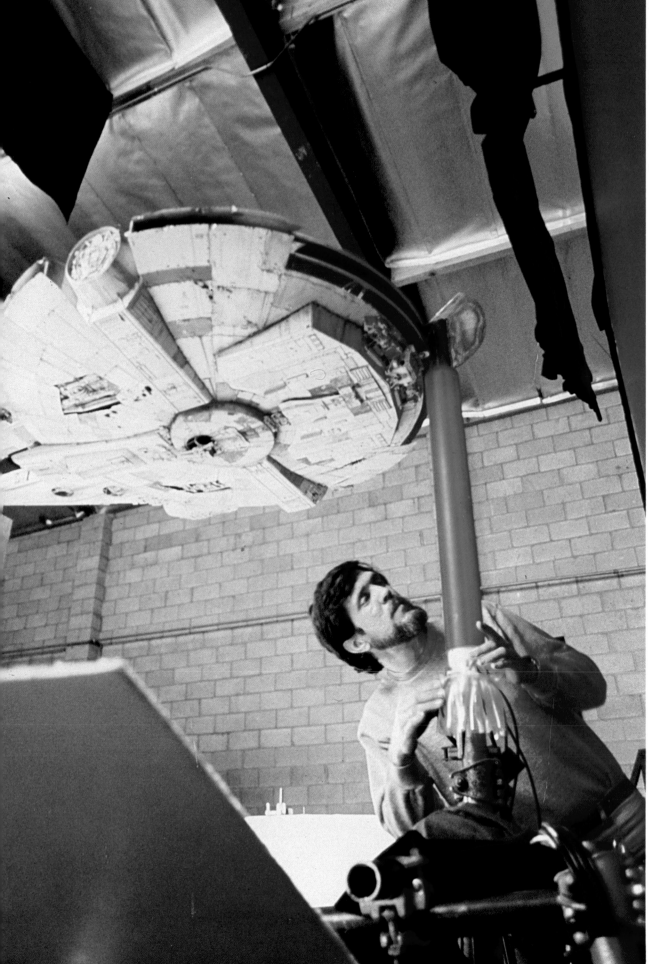

135. Richard Edlund checks a miniature of the **Millenium Falcon**, on its self-illuminated blue neon modelmover, prior to a motion-control shot.

136. This photograph shows the Dykstraflex motion-control rig—its boom arm clearly visible—ready to shoot the **Millenium Falcon** miniature in front of a blue screen. Models, like the camera itself, could be subjected to electronic control.

photography was given the means to match (or better) the flexibility of motion available to the live-action cinematographer. Because of this, the dogfights in *Star Wars* had the vitality of actual combat photography, as if they had been shot from a camera gun mounted on another space vehicle. Audiences may not have realized this, but the way they responded to the space battles, as something no one had ever seen before, goes some way toward explaining the phenomenal success of *Star Wars*.

The 365 effects in the movie required 3,838 separate film elements. If we imagine a relatively simple example in which a T.I.E. fighter pursues an X-Wing away from the camera across the surface of the Death Star, seen against a star field, and fires

a laser blast, the following are the minimum number of components involved:

1. The X-Wing miniature photographed against blue screen (mounted on a nose mount which permits it to roll and yaw about its axis and crab from side to side).
2. The T.I.E. fighter (similarly mounted) against blue screen.
3. Backlit artwork representing a star field.
4. A miniature representing part of the surface of the Death Star, against blue screen.
5. An animated laser blast.

Add an explosion or two, or a glimpse of the Millenium Falcon, and the number of elements quickly mounts—and this

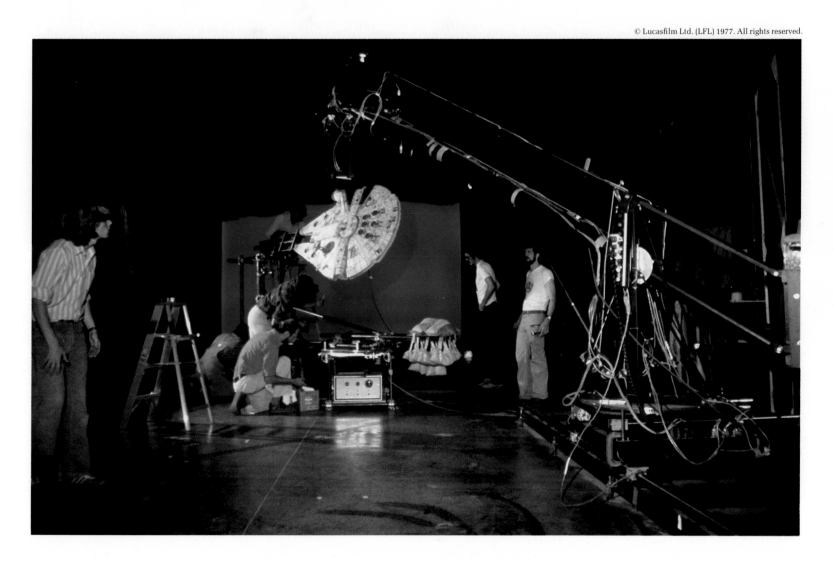

is not taking into account the mattes generated from the blue-screen shots. Yet the Dykstraflex system permitted the ILM team to shoot and assemble hundreds of such shots in a relatively brief period. Even so, of course, the schedule meant that the Dykstraflex was soon in use around the clock. A second camera—a massive Technirama job on a huge pan-tilt-roll apparatus that itself looked as if it had come from outer space—was kept almost as busy shooting simpler setups.

The Dykstraflex was the star, however, and visitors were amazed by its capabilities. Richard Edlund had left IATSE, the cinematographers' union, several years earlier, and to receive credit on the film he needed to rejoin. He informed IATSE that he wanted to rejoin not as a simple member but as a director of photography, this at a time when the Dykstraflex was just beginning to take shape on Dick Alexander's lathe. The union demurred but agreed to send its committee back to ILM when

the motion-control rig was built. The day the three IATSE men were due, Edlund programmed the Dykstraflex rig to go through a series of particularly elaborate moves. When the deputation arrived, he invited its members to watch from a carefully prearranged spot, then pressed the button to set the rig in motion. "The camera came down the track, it panned around, it came right up to them and stopped inches from their faces. They'd never seen anything like it before. It blew their minds. They took me in as a director of photography, and we had no more union fights."

As far as John Dykstra was concerned, though, setting up ILM as a working facility involved far more than one motion-control rig, however sophisticated. A substantial model shop was needed, for example, capable of producing the highly particularized space vehicles called for by Lucas's storyboards—miniatures that had to be detailed down to articulated vanes

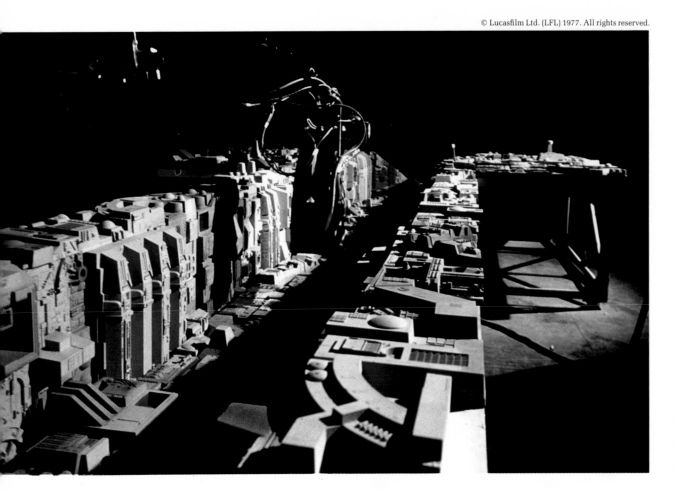

137. Suspended from the Dykstraflex's boom arm, the VistaVision camera was able to track through this trench built into the surface of a large **Death Star** miniature. This permitted it to shoot backgrounds for a spectacular dogfight sequence.

138. The trench footage, combined with shots of Luke's X-Wing and Darth Vader's T.I.E. fighter (each shot separately against blue screen), provided a spectacular and technically unprecedented climax to **Star Wars**.

and illuminated interiors. An in-house optical department was formed, which involved revamping a pair of eight-perforation optical printers to conform to ILM's electronic-control approach. One of the two printers had to be reconfigured so that it was capable of translating the in-house VistaVision format work to the wide-screen anamorphic format of the Panavision cameras that were used for the principal photography. A Rotoscope department was needed, too, to provide garbage mattes and to enhance such elements as explosions and the light sabers wielded by Luke and Darth Vader.

Key personnel, beyond those names already mentioned, included Dennis Muren (effects cinematography), Grant McCune (chief modelmaker), Robert Blalack (opticals), Jon Berg and Phil Tippet (stop-motion animation), and Harrison Ellenshaw (matte paintings).

Ellenshaw, although still in his early thirties at the time, found himself playing the role of "veteran" on the ILM staff. Coming from Disney—in fact he was splitting his time between the two facilities—he was the only person around who had worked in a studio effects department. *Star Wars* used relatively few matte paintings—thirteen in seventeen shots—but some of them were absolutely crucial. When Luke and Princess Leya swing across what appears to be a bottomless shaft bisecting the interior of the Death Star, that shaft existed only as a painting. Young but experienced, Ellenshaw was the ideal person to take on this kind of responsibility.

Ellenshaw enjoyed working with Lucas—describes him as a "class act"—but occasionally found himself frustrated by Lucas's secrecy.

"Ideally, the effects crew should be as familiar with the show they're working on as the makeup people or the costume designer. I think that Lucasfilm has accomplished that pretty well . . . but George is very secretive about his cuts, so it was sometimes difficult for me to find out where exactly my painting was supposed to fit into the continuity. I had the storyboards and the plates, so I knew *what* I was supposed to paint, but not always *why*. . . .

"On *Star Wars* I was assigned to do a painting of the Millenium Falcon. I'd worked on it quite a while—I was almost finished with it—and we were ready to show George dailies. We ran the shot and everybody laughed! I was crushed! These guys were all younger than I was, but they were laughing at my shot. I didn't know what to say until someone told me I'd put two cockpits on. I'd seen a model in which they'd built just the one side, and I thought the other side, which I had painted, would be a mirror image. The Millenium Falcon looked like a two-cockpit job to me, and I'd seen no other part

of the picture, so how was I to know? That was always a bit of a problem with George. I never knew what the story point was."

One other thing Ellenshaw remembers about ILM in those days was that nobody he spoke to ever thought that *Star Wars* would be a really big film, let alone the half-billion-dollar phenomenon it became. Ellenshaw went so far as to ask Lucas, one day, what he was hoping for in terms of success, and Lucas replied that he thought *Star Wars* might achieve the popularity of one of the James Bond movies. Ellenshaw admits to thinking that Lucas was perhaps a little overoptimistic.

"It wasn't a very big picture by today's standards," says John Dykstra. "It came in for under twelve million dollars total, I think, which even then, although large, was not enormous. Certainly they didn't set out thinking this was going to be the giant smash it turned out to be."

Dykstra, however, was certainly optimistic that the film would do very well, and he had one big advantage over Ellenshaw in making his assessment. He had read the script, as had Richard Edlund.

"I had seen *THX 1138* and *American Graffiti*," Edlund says, "and I thought they were interesting, well directed. When I read the script of *Star Wars*, I thought it would make a good teenage movie, and then a little beyond that. Then when George went out and signed Alec Guinness he started moving fast. Signing Guinness added a magic element for me. After that I felt in my heart it would be a huge success all the way through, so I wasn't as surprised as some people."

The ILM crew did not see a complete print of the movie until the eve of the premiere. What they saw then made believers of those who still had doubts, and the next day the lines began to form outside movie theaters from coast to coast. Within a week it became clear that—like *Birth of a Nation* and *Gone With the Wind*—*Star Wars* was one of those once-in-a-generation movie phenomena.

What Lucas had managed to do was to transform the familiar into the exotic, the cliché into the novelty. Almost everything about the movie was derivative. The plot and characters evolved from fairy tales, pulp fiction, and Buck Rogers/Flash Gordon-type comic strips. Wardrobe ideas were borrowed from the same comic strips, Japanese Samurai costumes, and other well-tried sources. The space vehicles, as Gary Kurtz has pointed out, were really hot rods transposed into outer space. (The Millenium Falcon, though, was the ultimate Mack truck. The mid-'70s were, after all, the era of CB radio and the long-distance trucker as folk hero.)

"George's talent," Dykstra believes, "is bringing together bits and pieces from all the traditional film genres, all the gags

you've always seen and loved. We used technology to try and re-create those gags in the best way possible."

Yet somehow Lucas managed to make all this look new, as if it had sprung whole from his own brain. To take a single example, 3-CPO clearly derives visually from the robot in *Metropolis*, and R2-D2 bears a family resemblance to the drones of *Silent Running*, but Lucas provided them with a setting and mannerisms that made them seem completely fresh. *Star Wars* is a brilliant collage in which old elements take on new life. It also benefits from lightness of touch and occasional flashes of real originality, such as the famous cantina scene with its array of bizarre creatures.

That Lucas, as writer, producer, and director, managed to maintain this lightness of touch is surprising under the circumstances. Writing the script had been torture for him, and the Elstree shoot, by all accounts, was far from a happy experience, with Lucas finding himself at odds with his director of cinematography and other key members of the British crew. Back in California, during the postproduction phase, Lucas and Dykstra began to have differences of opinion.

In part, these differences were purely cinematic. Dykstra felt, for example, that it was a mistake to be too rigid about exactly duplicating the old dogfight footage. Things that worked at ten thousand feet, against a background of hills and clouds, did not necessarily work in outer space with a star field for backdrop. Lucas disagreed, and Dykstra felt that the director didn't fully understand the problems involved. In other ways, though, the differences went beyond specific technical considerations, as Dykstra readily admits.

"It was my first experience with a picture like that," he says, "and I had a big ego—not based on having done so much but rather on being concerned that if I didn't maintain control of what was happening I wouldn't be able to pull it together. A lot of that was predicated on being relatively uncertain as to whether anything would work. You mostly get angry and have big fights when you're worried about your performance, and there's no question about the fact that I was worried that some of our stuff wouldn't work. Thanks to the talents of my friends and co-workers, the movie came out well. At the same time, I think George felt I was too possessive—if not about the effects themselves then about the organization, about who was going to do what and when. That made him feel as though I was competing, although I'm not equipped to compete with George Lucas. It made me feel that I was competing, and I'm a very strong-willed, strong-spoken person, and I think George probably prefers to work with people who aren't quite so strong-willed."

Unspoken is the thought that Lucas too may have been worried that some of his "stuff" wouldn't work, that this made him prickly and argumentative. In any case, it became clear by the time *Star Wars* wrapped that Lucas and Dykstra were unlikely to prolong their association. This should not be allowed to disguise the fact, however, that Dykstra, given the kind of opportunity that most people only dream of, put together, in a few months, one of the best organizations in the history of the special effects industry. Beyond that, the Dykstraflex camera system was a landmark in effects cinematography.

It was George Lucas's imagination and willpower that made all this possible, but Dykstra and the ILM team were crucial to the realization of his dream.

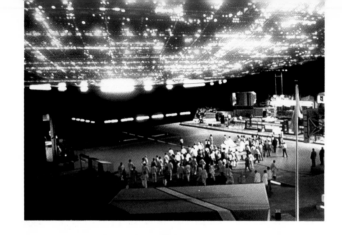

14. Close Encounters

In the summer of 1975, at about the time George Lucas was setting up ILM, Universal released the movie that established the reputation of the other wunderkind of the decade. The movie was *Jaws*, and the wunderkind was Steven Spielberg.

Whereas Lucas had learned his craft in the hothouse atmosphere of the USC film school, where he had been in the company of other young hotshots like John Milius, John Carpenter, and Chuck Braverman, Spielberg had spent his student days in the relative obscurity of Long Beach State, a school that has produced a number of good effects men, but few directors. *Amblin'*, a twenty-minute film he made there, was seen by Sidney Sheinberg, president of Universal Pictures, and Spielberg was soon directing for Universal's television division.

Jaws, though, presented him with his first major opportunity. Based on Peter Benchley's best-selling novel about a great white shark that terrorizes a small Atlantic Coast resort, this movie involved Spielberg with "Bruce," probably the most famous single mechanical effect produced to that point. Actually there were several versions of "Bruce," each built by a team headed by Robert Mattey, the man who had devised the giant squid for *20,000 Leagues Under the Sea*. The most used

version was a sea-sled shark, twenty-four feet long, fully detailed and supplied with a keel like that of a yacht, as well as a rudder and fins that gave it considerable mobility. This shark was towed behind a boat and could be made to dive or move laterally by remote control, its mechanical functions powered by compressed nitrogen stored in bottles inside the shark's head.

Other versions of "Bruce"—one built to be seen from the left, another from the right—were the so-called platform sharks mounted on a huge, articulated, cranelike rig which ran on a track that was submerged in thirty feet of water. Activated by air rams, these platform sharks could be made to lunge from the water and were used in the scenes that required the shark to attack the *Orca* and its crew. Partial sharks were made too— dorsal fins to cut sinisterly through the waves, a fully functional head to be exploded at the film's climax—and the results, as orchestrated by Spielberg, did wonders for the job security of lifeguards from Martha's Vineyard to Bondi Beach.

While swimmers stayed close to shore that summer, and *Jaws* demolished box-office records across the USA, Spielberg was already involved with a new project—*Close Encounters of the Third Kind. CE3K* would be as dependent upon special

effects, in its way, as *Star Wars*, though their character would be very different. To carry out the extensive mechanical effects, Spielberg turned to Roy Arbogast, who had worked with Mattey's crew on *Jaws*. To supervise the visual effects, Spielberg chose Douglas Trumbull.

Since *Silent Running*, Trumbull had been involved in several abortive movie projects, including one called *Pyramid*, set in the distant future, and another about aquanauts, for which extensive tests had been shot. At the time Spielberg approached him, Trumbull was under contract to Paramount, with whom he had set up companies devoted to research and development in the area of high technology for the motion picture and television industries. His projects at Paramount included Magicam (a sophisticated video-matting system) and Showscan, which was a challenge to one of the fundamental "givens" of filmmaking. ("What," Trumbull asked, "if films were shot and projected at forty or sixty frames a second instead of the conventional twenty-four?") Another company was created to develop futuristic arcade games.

By the summer of 1975, however, there had been a change of control at Paramount, and the new management had no interest in Trumbull's experiments. It was very interested, however, in having him generate some money for the studio by taking on the effects of *CE3K*.

Trumbull was interested too. As early as 1969 he had announced that he would like to make a UFO movie. (At that time he had envisioned using slit-scan techniques to conjure UFOs from pure light.) Spielberg's script, with its blend of everyday reality and extraterrestrial wonder, appealed to him. Certainly it would involve him with challenges far removed from those of *2001* and *Silent Running*. In addition, Trumbull and Spielberg got along famously. The upshot of all this was that one of the Paramount subsidiaries, the Future General Corporation, was hastily converted into a special effects company.

"*Close Encounters*," says Trumbull, "kept Future General going for quite a time. We were back working in 70mm, which gives you a lot better opportunity for maintaining quality control than people are able to do in any kind of 35mm duping situation, so that was good. . . . Quality control was the key thing—just being careful, not letting things get too duped, making sure everything is sharp. If it's underexposed, you shoot it again. . . . Soft-edged mattes instead of hard mattes."

Like his former mentor Stanley Kubrick, Trumbull has an intense dislike of blue screen.

"I always tried not to use traveling mattes in blue screen. We would have a shot—say, a bunch of people on top of Crescendo Summit, looking out over the horizon, and flying saucers come—in an ordinary production you'd have these people on a set in front of a big blue screen. Then you'd put in the sky, with the stars and the saucers as a blue-screen post-production element. But we said no to this for *Close Encounters*. You'll see the matte lines. Blue screen just isn't that good. There's no subtlety to it.

"So we decided that we'd build another big eight-by-ten projector, which my father made for us. The idea was to front-project the background plates behind the people walking around, so there'd be virtually no matte lines. We'd shoot the whole thing in 65mm, with a locked-off camera, and still do postproduction up in the areas above where the matte lines were, so there'd be a burn-in rather than a matte. With the burn-ins you could keep all the subtleties and all the glows so there wouldn't be any hard edges."

139. Several mechanical sharks (which shared the nickname "Bruce") were built for **Jaws** (1975). This version is one of two so-called platform sharks, mounted on the rig which enabled it to lunge out of the water when attacking the **Orca**.

65mm beam front
camera splitter projector screen

DON STEVEN VILMOS DOUG
TRUMBULL SPIELBERG ZSIGMOND TRUMBULL

The glows and subtleties referred to here are those that cloaked the UFOs in a haze of otherworldliness. Hard edges were fine for the outer-space environments of *Star Wars.* They would have been totally wrong, however, for *Close Encounters,* which required its alien ships to enter the earth's atmosphere where they would be subject to the effects of moisture and pollution in the air. The smaller UFOs, which fly through shots like the Crescendo Summit scene described above, were elaborate constructions containing spinning lights. One thing that makes them so convincing in the movie is that they seem to have no fixed scale. At moments they could be the size of 747s, but one cluster of them is shown to be so small that it can pass through a phone booth. This sense of shifting scale, along with the soft-edged "atmospheric" appearance of the UFOs, was achieved by shooting them in a "smoke room" (literally a room filled with smoke which, when suitably lit, can produce exquisite diffusion effects).

"I came up with the idea of a smoke room," says Trumbull, "to create aerial perspective. It helps to have been an illustrator and airbrush artist because you deal with a lot of that kind of thing when you're painting."

To shoot these effects, Future General needed a motion-control camera system comparable in sophistication to the Dykstraflex, though somewhat different in configuration. Construction of the two rigs overlapped, with Jeff Jeffress in charge of designing and building the Future General camera.

"We built," Trumbull explains, "what we called the 'Icebox,' which was a motion-control system that could record data in real time and play it back one frame at a time for miniature photography purposes."

154

140–142. Three views of the front-projection setup used for the Crescendo Summit sequences in **Close Encounters of the Third Kind**. A huge, portable screen was installed in an abandoned dirigible hanger in Mobile, Alabama, which also served as the Devil's Tower landing site, scene of the giant UFO's arrival. On the opposite page, director Spielberg confers with cinematographer Zsigmond while effects supervisor Doug Trumbull and his father Don Trumbull (who built the front-projection unit) look on. On this page, Doug Trumbull discusses a setup with Richard Yuricich. The truck in the lower photograph gives some idea of the huge size of the screen.

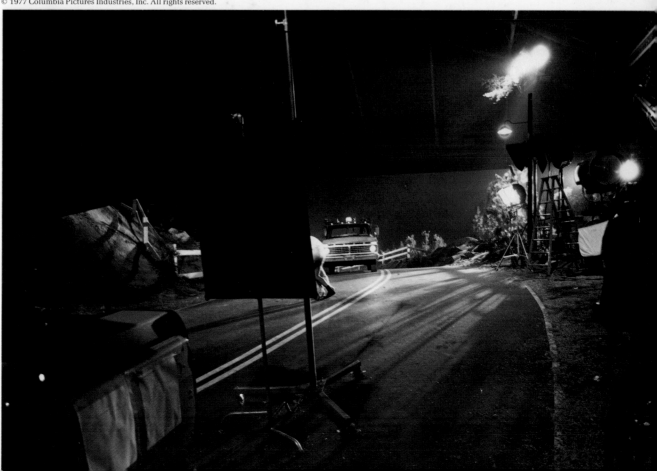

In other words, the cameraman could put the camera through its paces as if it were mounted on a normal production camera crane, and the moves would be electronically recorded so that they could be repeated at a far slower speed with appropriately adjusted exposure intervals. Live action shot with a moving camera could be composited with miniature photography—an effects first. A significant difference between the Icebox and the Dykstraflex was that the Icebox was not a boom-mounted camera system. No trench shots were called for in *CE3K*, nor was there any need for the camera to simulate the dynamic pitch-and-roll moves of an X-Wing fighter.

Working with Trumbull on developing these new systems was his old *2001* and *Silent Running* associate Richard Yuricich, whose older brother Matthew was engaged as a matte painter. A veteran of the MGM matte department, Matthew Yuricich contributed more than one hundred paintings to *CE3K*, many of them of great subtlety. This was matte painting in the classic tradition of invisible effects. It did not require, so much, the creation of an environment that wasn't physically there (though some of this was called for); mostly it involved such seemingly minor yet absolutely critical tasks as, for example, providing a more ominous sky behind the Devil's Tower butte which becomes the focus of the film. In *CE3K*, atmosphere was everything, and Yuricich's paintings provided a good deal of it.

Attention to the skies—where UFOs come from, after all—was a major consideration of the special effects team. Trumbull gave his young assistant Scott Squires the task of creating cloud effects in a tank of liquid. This was not totally unprecedented—Arnold Gillespie had produced the mushroom cloud for an atomic explosion, back in the mid-1940s, by pumping colored pigment into a fish tank full of water—but Squires had the novel idea of creating an inversion layer between saltwater and freshwater in a large tank, then injecting white tempera paint into the tank so that it spread out horizontally beneath the inversion line, like smog in the San Fernando Valley. Suitably tinted and composited with location plates, these clouds of paint looked exactly like dramatic cumulous formations filling the Wyoming sky, and the technique has subsequently been adopted by the entire industry.

Night skies were another challenge, and it was the job of the animation department, under Robert Swarthe, to put stars into scores of scenes. Swarthe, after an apprenticeship at UCLA and Graphic Films, had established a sizable reputation in the world of commercials, both as an animation director and as a director of live action. He had never worked on a feature before *CE3K* and wanted to be part of it because, he figured, it might be a long time before anyone made a big special effects movie again. By his own admission, though, most of the year and a half he spent on the movie was sheer drudgery.

"The answer to everything in *Close Encounters* was always matte paintings or motion control, things that look 3-D and realistic. Animation always looks flat."

That statement should perhaps be modified to read, "the answer to *almost* everything . . ." The stars had to be there in the sky, and the only way to put them in convincingly was

143. Modelmaker James Dow touches up the finish on one of the miniature UFOs prior to a motion-control shot.

144. Dave Stewart, director of model photography, uses a joystick to program the "Icebox" motion-control rig for a "smoke room" shot involving one of **Close Encounters'** small UFOs. By shooting miniatures in a smoke-laden environment, beautiful atmospheric effects could be achieved.

145. Master model builder Greg Jein adds finishing touches to a miniature Indiana landscape.

with animation. Because they were almost always seen in relationship to recognizable earth landscapes (as opposed to the situation in *Star Wars*) they could not be too big or too bright or they would seem fake. The only viable solution proved to be to "burn" them painstakingly into the first internegative stock after all the other components had been composited. This involved running the internegative through the process camera mounted on an Oxberry animation stand and shooting airbrushed artwork under tremendous lights with exposure times of up to sixty seconds per frame (the internegative stock being relatively insensitive to light).

Much else that seems real in the film is in fact synthetic. A number of landscape miniatures were made, under Greg Jein's direction, to simulate terrain in Indiana and Wyoming. With plenty of real landscapes available, it may be wondered why such miniatures were needed; the reason is implicit in the subject matter of the film. A UFO flying over one of the landscapes would dramatically change the lighting, casting

dense, fast-moving shadows. To create such changes of illumination in a real landscape would be a practical impossibility, but miniatures solved the problem.

Nor were all the full-size landscapes real. The Crescendo Summit "location" for one, where UFOs tantalize the populace of Indiana, was in fact a set built in an abandoned dirigible hangar in Mobile, Alabama. Background and sky elements, as described by Trumbull, were front-projected onto a giant portable screen.

The dirigible hangar, four times as large as any Hollywood sound stage (it was 450 feet long by 250 feet wide by 90 feet high), also provided the setting for the live action at Devil's Tower, where the scientists, along with the characters played by Richard Dreyfuss and Melinda Dillon, await the arrival of the mother ship. The front-projection system was used again to supply the illusion of night sky. The mother ship itself was a miniature (or miniatures) filmed back in California and optically composited with the live-action footage. Designed by

146–147. This miniature landscape was built for what came to be known as the "Quarter Pounder" shot (because a cluster of UFOs appears to take note of a MacDonald's billboard). The upper photograph shows clearly how forced perspective is incorporated into miniatures of this sort (note how the road narrows). Doug Trumbull (right) supervises Greg Jein and Michael McMillen as they dress the model with tiny trees. In the lower photograph, the same landscape miniature is seen from approximately the camera's point of view.

148–149. In the Mobile dirigible hanger (above), performers try to imagine that a gigantic UFO is landing at the climax of **Close Encounters**. Back in Hollywood, the mother ship was shot as a miniature, enhanced with animation, and composited with the live-action plates.

Ralph McQuarrie and built in the Future General model shop, under the direction of Greg Jein, the main miniature was six feet in diameter, weighed close to four hundred pounds, and was threaded with an intricate web of neon tubes. Additional light effects were projected onto the vehicle's underside from artwork provided by the animation department, and the entire thing was photographed by Dennis Muren, who had just finished his chores on *Star Wars*. The results were amazing. As seen on screen, in the final cut, the mother ship looks like the most gigantic moving object ever committed to film.

Roy Arbogast's crew supplied impeccable mechanical effects throughout the movie, and the atmosphere was beautifully sustained, moving from everyday reality to the depiction of awe-inspiring phantasmagoria with ease, almost until the very end. Unfortunately, Spielberg, marvelous though his cinematic instincts are, could not resist showing the aliens themselves, and a little group of bland, asexual humanoids emerged from the mother ship. Some were small girls in costume, but one, taller than the rest, was actually a mechanical figure built by Carlo Rambaldi, an Italian effects man brought to the United States by Dino De Laurentiis to work on his remake of *King Kong*. Rambaldi's mechanical ingenuity is not in question, but the figure's appearance is totally unconvincing and anticlimactic. This alien belongs in some flying-saucer potboiler from the '50s rather than in one of the three or four best science fiction movies ever made. When this creature "smiles" at François Truffaut (who plays the chief scientist), one wishes it would at least make an intelligent remark about *Jules et Jim* or suddenly recall that it had forgotten to renew its subscription to *Cahiers du Cinema*.

This lapse was not sufficient to damage seriously the struc-ture of the film, which was released in 1977 to such public acclaim that Spielberg was encouraged to add new material to the ending of the movie for a so-called special edition. (He had, in fact, hoped to include this material in the original version, but time and budget did not permit it.) Now the Dreyfuss character was taken inside the mother ship, and the results were pure bathos.

Spielberg and Trumbull apparently failed to agree on how the new ending should be approached, and Trumbull refused to be involved with it, although it was shot at his facility and with personnel he provided—cinematographers Dave Stewart and Don Baker, modelmaker Greg Jein—under the supervision of Robert Swarthe. Working around live-action footage of Dreyfuss and children dressed as aliens, this team managed a few felicitous moments—some of the animation effects are especially fine, and the small UFOs are again put to good use—but they are nullified by the glimpse the audience is offered of thousands of tiny aliens (rod puppets three-quarters of an inch tall) peering down at Dreyfuss. Seldom has a movie shifted so precipitously from the sublime to the ridiculous, but the special effects team probably should be exonorated from blame, since presumably they were simply carrying out Spielberg's instructions.

Until these final moments of fiasco, however, *Close Encounters of the Third Kind* must be considered one of the most artistically successful special effects movies ever made, a rare blend of the subtle and the spectacular. Whether or not one takes UFOs seriously, it must be admitted that Spielberg, Trumbull, and everyone else concerned made them believable—at least within the context of the movie—to an extent that earlier filmmakers had never even approached.

15. Phone Home

Star Wars and *Close Encounters of the Third Kind* opened the floodgates. Suddenly producers who had previously shied away from the arcane world of special effects began to pay serious attention to scripts that called for all kinds of bizarre apparitions that could only be conjured up on the effects stage or in the optical printer. Comic strips, pulp novels, mythology, and the cinema's own past were plundered for subjects that would prove as archetypal as those dreamed up by Lucas and Spielberg.

Dino De Laurentiis actually dared to take on *King Kong* (in fairness it should be pointed out that he did so before *Star Wars* or *CE3K* were released). This Kong was to kidnap Jessica Lange rather than Fay Wray and to climb the World Trade Center instead of the Empire State Building, but the most important change from the original was that Kong would no longer be represented by a stop-motion puppet. Glen Robinson and Carlo Rambaldi actually built a forty-foot-tall, six-and-a-half-ton mechanical ape operated by an elaborate hydraulic system. It worked, but only well enough for a fleeting onscreen appearance. Although a pair of full-size mechanical arms and hands were more successful, in most shots Kong was played by makeup artist Rick Baker wearing an ape suit.

Superman: The Movie (1978) features extensive effects which are rather mixed in quality. The scenes in which the superhero takes Lois Lane for a midnight spin in the skies above Manhattan are satisfying; on the other hand, the earthquake sequence toward the end of the film is perfectly dreadful. On the whole, though, director Richard Donner used his effects well, and Christopher Reeve brought a conviction to the Superman role that made his most extraordinary feats believable—a major plus when you are hoping that the audience will overlook matte lines.

In 1979, Disney brought out a deep-space movie, *The Black Hole*, which signalled the studio's move into the post-*Star Wars* era of special effects. A new computerized motion-control system called ACES (Automatic Camera Effects System) was used to blend live action with beautiful miniatures and more than 150 matte paintings produced by or under the supervision of Harrison Ellenshaw. The result is a movie that is full of high-quality effects but which, unfortunately, is sadly lacking in human interest. It is a classic reminder of the fact that, however spectacular, effects are the icing on the cake.

A far more powerful space movie is Ridley Scott's *Alien* (1979), a terrifying revival of a classic '50s science fiction

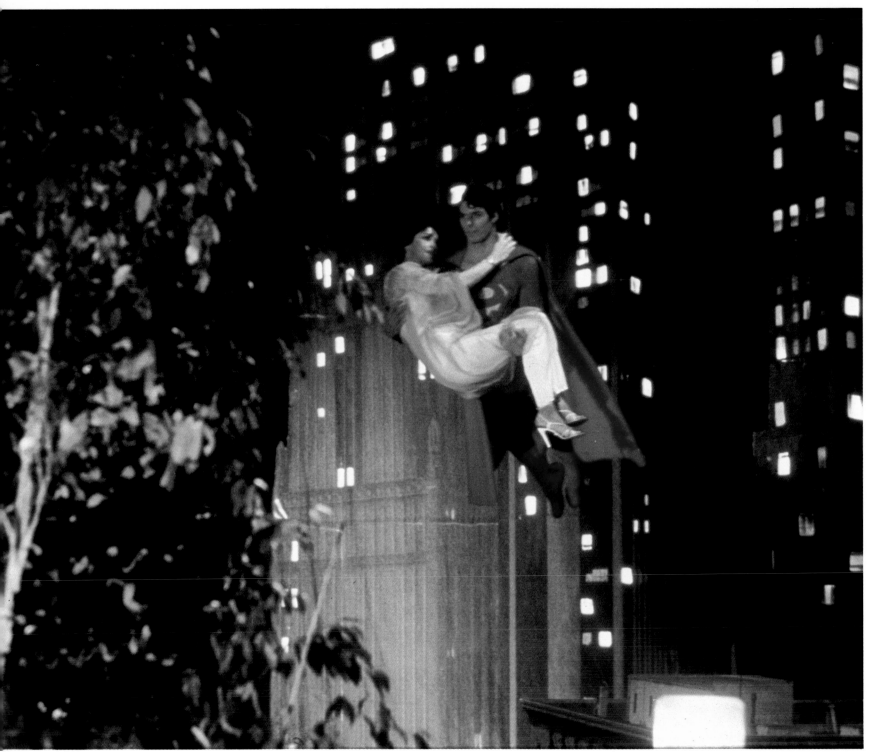

theme. A spaceship from earth, the *Nostromo*, visits an uncharted planet where the crew finds the skeleton of an alien being and a cluster of unpleasant looking eggs. One of the eggs is taken aboard the *Nostromo*, where a tiny alien—a disgusting glob of animated offal—hatches from it and takes refuge in the ship's air-duct system. As the alien matures it begins to eradicate crew members one by one, actually invading the body of one of its victims.

This latter circumstance provides one of the movie's most horrific moments, when the alien literally bursts from the astronaut's chest, swamping bystanders with blood and guts. This was achieved by fitting the actor with a false chest containing a snakelike puppet dressed with organic matter that was rigged to spring loose when released by air-rams. The device was simple enough, but on screen its impact is devastatingly realistic.

Alien does feature some miniature work, but the movie's triumph is the way in which the art direction and mechanical effects were combined to create a convincing outer-space environment, one of the most plausible ever committed to film. Roger Christian actually did a time-and-motion study of movements on the *Nostromo*'s bridge, and effects supervisors Brian Johnson and Nick Allder dotted the bridge area with working gadgets that are far more believable than the usual blinking computer and CRT readouts. Designer H. R. Giger devised the alien's various sinister appearances, including a fully developed seven-foot-tall version with a remote-controlled articulated head devised by Carlo Rambaldi.

In *American Cinematographer*, production designer Michael Seymour described how, for a climactic scene, the filmmakers introduced this seven-foot alien into the escape shuttle "and literally built the equipment around him, so that he became part of the texture of the wall. The girl enters the craft, unaware until the very last moment that he is there, and he emerges, almost as if he has grown into the equipment and is hibernating." It is one of the scary moments that justified

150. Many of the flying scenes in **Superman: The Motion Picture** were made more effective because they were staged at night, the dark backgrounds making it relatively easy to "lose" matte lines.

151. For **Alien** (1979), the spaceship **Nostromo** was built as a detailed fourteen-foot model, but this forty-foot tall landing leg was constructed at Shepperton Studios for a sequence in which a group of astronauts disembark from the ship. To make this landing leg seem even larger, children dressed in space suits were used to represent the astronauts in these shots.

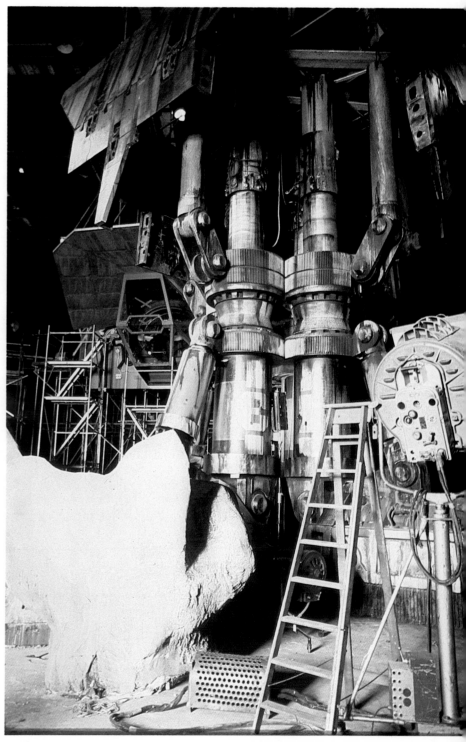

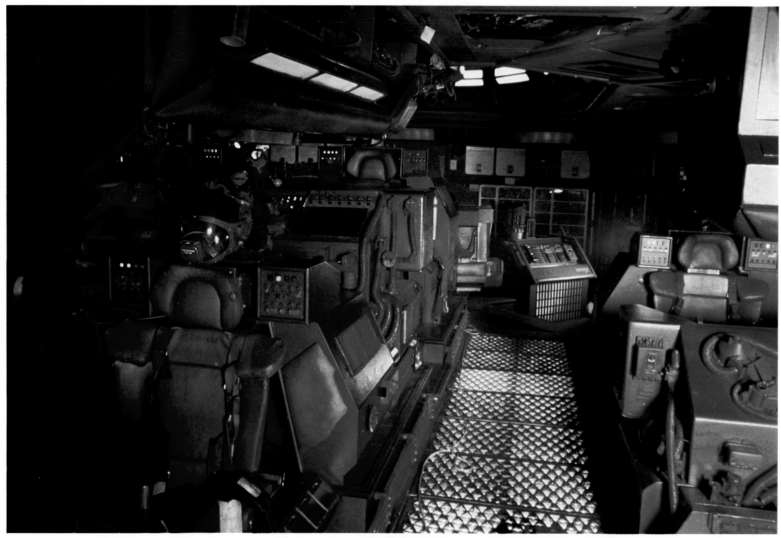

152. Enormous pains were taken to make the bridge of the **Nostromo** a convincing working environment.

Alien's advertising slogan, "In space no one can hear you scream."

Alien is a space movie but it also fits in with another genre, the ultra-gory horror movie that was very much in the ascendancy in the 1970s. There has never been a time, of course,

when there were not horror movies, but the form was given a tremendous boost by the 1973 release of *The Exorcist*, a movie that owed a good deal of its success to the brilliance of effects makeup artist Dick Smith.

Some of the methods Smith used to make Linda Blair, playing Regan, look as though she were possessed by the devil were straightforward enough. Yellow-tinted contact lenses, for example, gave her eyes a hideous, unworldly look, but other techniques he devised were more elaborate. At one point in the movie the script called for Regan's throat to swell hideously; Smith achieved this effect by fitting her neck with a latex de-

vice that could be inflated by pumping air into it through concealed tubes. Concealed tubes, disguised by makeup, were also employed to supply the pea soup and oatmeal that on screen appear to be vomit spewing from the child's throat. Perhaps the two most spectacular effects gags in the movie, however, are a shot in which Linda Blair's head appears to rotate through close to 360° and another in which the words "Help Me" appear miraculously in the form of blisters on the child's stomach.

For the rotating-head trick, Smith made a mold of Blair's body and cast it in fiberglass. This cast figure was carefully painted and dressed so that it looked completely realistic. A radio-controlled Regan head was then fitted onto the shoulders and could be made to spin on command. The eyes could also be moved by remote control.

For the blister trick, Smith made a false torso from latex foam, then painted the words onto the synthetic flesh with commercial cleaning fluid. This caused the latex to blister as desired, but not at a pace that could be controlled well enough to photograph effectively. Instead, Smith blasted the letters with hot air, which caused the blisters to melt back into the latex. This was filmed and then run in reverse so that the blisters appear to materialize of their own accord on the child's flesh.

From an effects point of view, subsequent horror films have seldom been as imaginative as *The Exorcist* or *Alien*, though they have kept technicians busy with such dull tasks as devising ways of pumping more blood per shot. The art of makeup, however, has built upon the advances made by Dick Smith in the use of latex foam to sculpt faces that are made mobile by the musculature of the performers they are built upon. Whether this truly falls under the umbrella definition of special effects is a matter of opinion, but there is no doubt that the leading figures in this revolution have been Smith himself (whose career stretches back to the mid-'40s), Rick Baker, and Rob Bottin. Baker is the young makeup man who was inside De Laurentiis's *King Kong* and who has done inventive work for such movies as *An American Werewolf in London*. A Baker protégé, Bottin has *The Howling* and *The Thing* to his credit.

Meanwhile, in the world of traditional special effects, considerable jockeying was going on in the late 1970s. George Lucas's dissatisfaction with Hollywood made it certain that Industrial Light and Magic would not remain in Southern California, and his disagreements with John Dykstra meant that, whatever happened, ILM would have new leadership. Dykstra took over ILM's 30,000-square-foot Van Nuys facility and with nine partners—Richard Edlund, Alvah Miller, Bob Shepherd,

Don Trumbull, Grant McCune, William Shourt, Roger Dorney, Doug Smith, and Dick Alexander—created a new company that leased ILM's equipment, including the Dykstraflex, and began effects production of a new television series, *Battlestar Galactica*, which bore a distinct family resemblance to *Star Wars*. George Lucas found the resemblance so close, in fact, that he persuaded 20th Century Fox to sue Universal, producers of *Battlestar Galactica*, for infringement of copyright. Universal (for whom Lucas was about to produce *More American Graffiti*) countersued, claiming that *Star Wars* plagiarized *Silent Running*, the argument being that Lucas's droids were derivative of Trumbull's drones.

In any case, the new company, soon to become Apogee, Inc., completed the effects for five episodes of *Battlestar Galactica* and then Lucasfilm reclaimed its equipment, carrying the Dykstraflex and the rest of the hardware assembled for *Star Wars* off to San Rafael in Marin County, near San Francisco, where ILM was to begin a new life. To head the revamped effects facility, Lucas and Gary Kurtz selected Richard Edlund. Soon the Van Nuys plant was stripped to the walls, and, with associate producer Jim Bloom, Edlund began to reassemble ILM up north, adding new equipment to upgrade the operation for *The Empire Strikes Back*. Key personnel from *Star Wars* also began to gravitate toward San Rafael, among them Edlund's fellow effects cinematographers Dennis Muren and Ken Ralston, though the bulk of the staff would be drawn from the Bay Area.

The Empire Strikes Back was to begin principal photography with location work in Norway in March of 1979, before switching to the Elstree lot in Borehamwood (where a huge new stage, dubbed the *Star Wars* stage, had been built). Edlund had the responsibility of getting the San Rafael effects plant into shape in time to accommodate that schedule. This included such tasks as designing, building, and debugging a new twelve-channel motion-control system—its electronics engineered by Jerry Jeffress, who had played the major role in designing Future General's Icebox—installing a quadruple-headed optical printer to cut down on compositing time, and developing a sophisticated matte department, complete with front-projection capabilities, to handle the heavy load of matte work that was anticipated for *Empire*.

The movie begins with an incredibly complex effects shot. A bizarre creature, a tauntaun, is seen in bird's-eye view running across the snowy wastes of the ice planet Toth. If tauntauns could be leased from animal wranglers, they would have been taken to the Norwegian location and filmed from a helicopter. Since they exist only as models, however, the effects

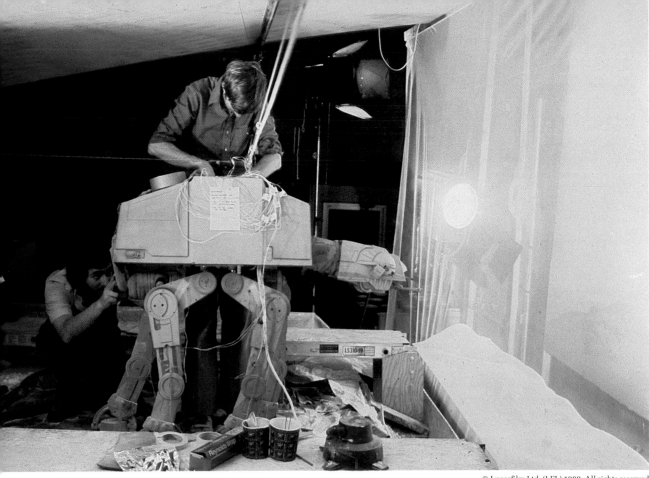

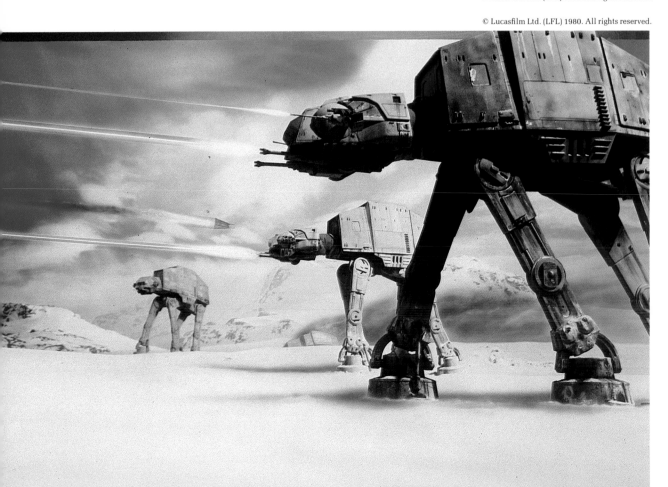

153–154. The imperial snow walkers in **The Empire Strikes Back** (1980) were built as eighteen-inch-tall stop-motion miniatures, but a four-foot-high model (shown here in the model shop) was also used for scenes in which walkers were put out of commission and made to fall. These falls were shot with a special high-speed camera so that when the footage was shown at normal speed, the walkers would seem to have tremendous bulk.

155. Richard Edlund, effects supervisor for **The Empire Strikes Back**, with Industrial Light and Magic's Empireflex camera, a sophisticated reflex camera custom built for ILM's motion-control requirements.

people were presented with an almost unbelievably difficult stop-motion problem. They were able to pull it off in a wonderfully convincing way. Had they failed, the believability of the whole movie might have been compromised, yet Lucas insisted on this opening despite many protests. Harrison Ellenshaw, back to head the matte-painting department, asked him why.

"I was talking to George one day—he will talk about film forever—and I told him, 'George, this shot won't work. Why do you want to do it?' He said, 'Well, there are a number of shots I've always wanted to see in films. One is a giant spaceship that goes on forever coming right over frame. We did that one for *Star Wars*. Another one is a strange creature you have never seen before running across a big expanse of snow or a desert, seen from way up high—an aerial shot. I've always wanted to see that shot and I never have.' He felt very passionate about it."

The whole Toth sequence, in fact, is as impressive as anything in the *Star Wars* cycle, blending special effects and live action with a subtlety that is very different from the pyrotechnics of the space battle climaxing the previous movie.

Animated by Jon Berg and Phil Tippett, and photographed by Dennis Muren, the miniature tauntauns and walkers had a fine feeling of scale that permitted them to be imperceptibly intercut with the location footage.

The new "Empireflex" camera—at that time the only reflex VistaVision camera in existence—had plenty of *Star Wars*-type motion-control setups to deal with, but what distinguished *Empire* from its predecessors were scenes of a different kind, such as those on Toth, in Cloud City, and on the bog planet Dagobah. The Cloud City section of the movie was conjured up with extensive use of matte paintings, and the bog planet was enlivened by a popular new character, Yoda, the ultimate guru. Part puppet and part mechanical effect, Yoda was constructed by Stuart Freeborn and manipulated by the gifted Muppet performer Frank Oz. (*The Muppet Show* was produced at ATV's television facility, just across the street from Elstree Studios.)

Brian Johnson and Nick Allder, fresh from *Alien*, took on the extensive physical effects, and Gary Kurtz served as liaison between the Elstree crew and the ILM team in San Rafael. Since Lucas was not directing this movie, having assigned

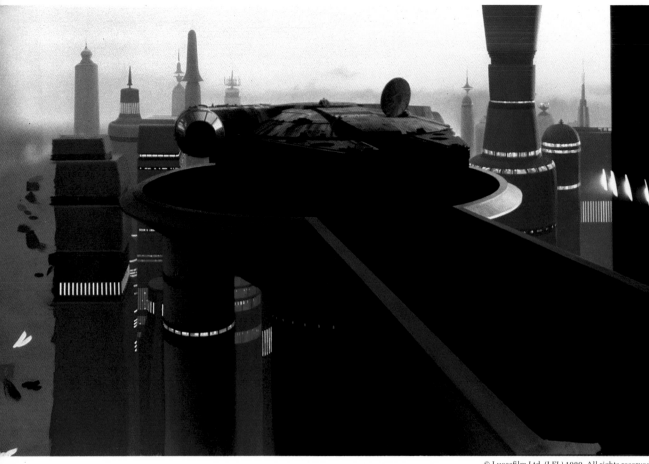

those chores to Irvin Kershner, he spent much time at ILM overseeing the extensive work there. The effects for *The Empire Strikes Back* were completed early in 1980, with work on the sequel, *Return of the Jedi*, not due to begin until late the following year. Lucas had no intention of closing his effects facility down, however, even temporarily. Instead, he decided to make its skills available to other producers, thus allowing ILM to pay its own way and to carry out research and development work that would benefit Lucas's future projects.

For the Paramount-Disney production *Dragonslayer* (1981), ILM developed a new form of model animation known as go-motion, which had been used experimentally on *Empire* and has seen considerable service in subsequent films. A problem with conventional stop motion is that it tends to be marred by strobing because the puppet figure is stationary during each fraction of a second that the animation camera's shutter is open. A standard production camera shooting live action may appear to "freeze" the movements of the performers twenty-four times per second, but each frame is actually subject to a degree of naturalistic blur, and, when projected at the right speed, this blur is reconstituted as a component of the total illusion of reality that we see on screen. Even Willis O'Brien had never managed to overcome this shortcoming when it came to the animation of miniatures, but a young ILM employee named Stuart Ziff applied some of the basic principles of motion control to the problem, designing and building a computerized rig that could use rods to drive a puppet figure—a dragon in this instance—through programmed moves in such a way that it could actually be in motion while the shutter was open.

By far the most extensive work ILM did between *Empire* and *Jedi*, however, was on three films directed by Steven

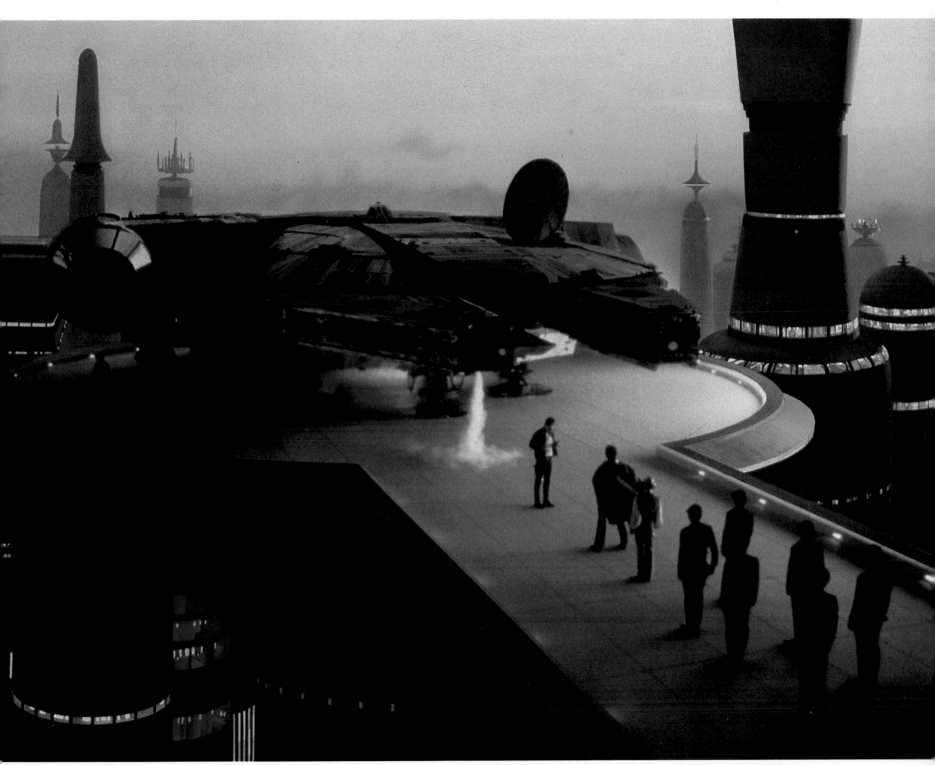

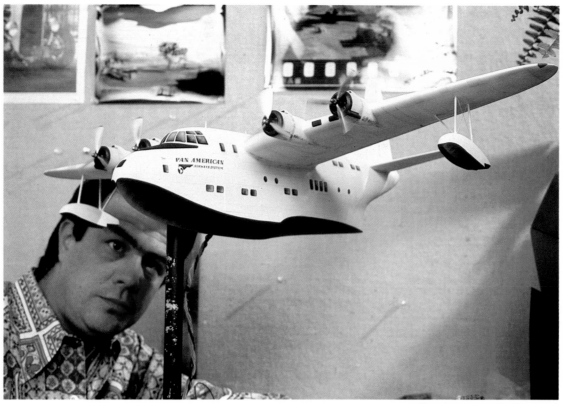

158. This model flying boat (left) was used to represent the famous **China Clipper** in the Lucas/Spielberg collaboration **Raiders of the Lost Ark** (1981).

159–160. For **Poltergeist** (1982), ILM turned its attention to the supernatural. This ghost was created by filming a lightweight marionette under water in a glass tank. The water made the creature's hair float, and an anamorphic lens was used to squeeze and distort the image.

Spielberg. Spielberg's first experience with ILM came after the one box-office disaster of his career, *1941*, a comedy that failed to make anybody laugh. The failure of *1941* would be utterly unlamentable if it were not for the fact that it kept audiences from seeing some of the most interesting miniatures of recent years.

What modelmaker Greg Jein and his crew were asked to evoke for this movie was not the distant past of another galaxy but Southern California at the outbreak of World War II, an environment familiar to everyone from old films and photographs. Jein was being asked to move the clock back a mere thirty years, which he did with great skill, especially in the case of two monumental miniatures—the Pacific Ocean Park pier amusement park and Hollywood Boulevard decorated for the 1941 Christmas season.

The Pacific Ocean Park pier was over fifty feet long and more than twice a man's height. It came complete with a strip of coastline, a beach, and the Pacific Ocean, all of this occupying a huge tank in MGM's Stage 30, which was originally built to accommodate Esther Williams' swimming spectaculars. The

structures that made up the amusement park were detailed to the nth degree.

Hollywood Boulevard was needed for scenes in which John Belushi, as a crazed fighter pilot, pursues a civilian plane at Christmas-light level, under the mistaken impression that it is part of a Japanese invasion fleet. The Boulevard was built in forced perspective with some of the foreground buildings twenty feet tall, while those a few blocks away barely reached waist height. Similarly, the foreground structures were highly detailed, while some in the background were basically cardboard cartons with holes cut out of them to represent windows. The fact that the scenes were supposed to take place at night and under damp, slightly misty conditions, facilitated the creation of this illusion, though Spielberg was insistent on such realistic touches as miniature garbage on the sidewalks.

Instead of shooting the planes on a motion-control rig and matting them into these miniatures, Spielberg went back to the old system, perfected at Republic by the Lydecker brothers, of "flying" the aircraft on wires. Furnished with electric motors to drive their propellers, the model airplanes per-

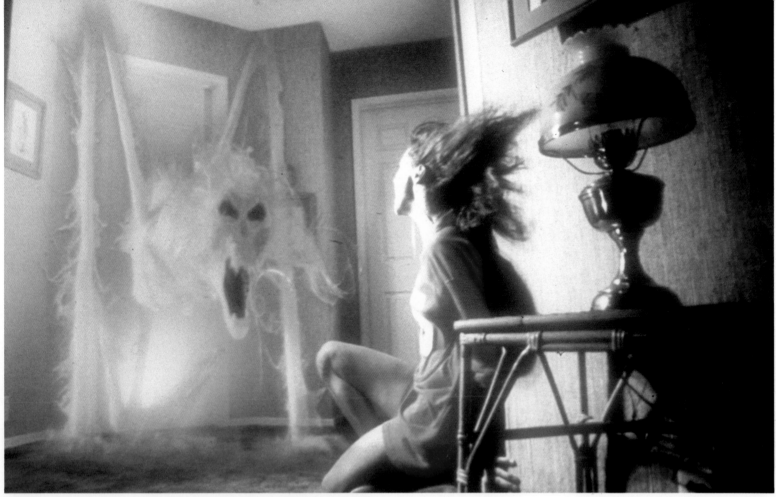

From the MGM release *Poltergeist*. © 1982 Metro-Goldwyn-Mayer Film Co. and SLM Entertainment, Ltd.

From the MGM release *Poltergeist*. © 1982 Metro-Goldwyn-Mayer Film Co. and SLM Entertainment, Ltd.

formed splendidly, allowing Spielberg to obtain dramatic results very quickly, shooting in real time, whereas the motion-control approach would have required weeks of work.

Given the anti-logic of Hollywood, which states that you're only as good as your last movie, Spielberg's star was seen by some to be on the decline because of the disaster of *1941*. George Lucas, however—no respecter of Hollywood clichés (except the onscreen sort)—had already tapped his friend Spielberg to collaborate with him on *Raiders of the Lost Ark* (1981), a project that Lucas had been nursing for years.

Compared with *Star Wars* and *The Empire Strikes Back*, *Raiders* provided visual effects supervisor Richard Edlund with a novel assignment, the script calling for some interesting invisible effects (such as bringing the China Clipper back to life). The climactic scene, in which Nazis are devastated by the wrath of God emanating from the Ark of the Holy Covenant, involved extensive effects animation.

Spielberg's next project, *Poltergeist* (1982), presented Edlund with far more of a challenge. This time Spielberg was to be the producer, and the movie would be directed by Tobe

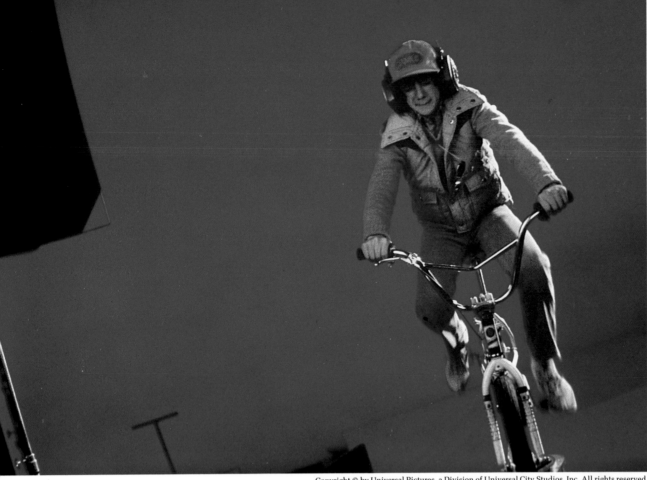

161. For the flying scenes in **E.T.**, actors on full-size bikes and go-motion miniatures were photographed against blue screen, then composited with suitable background plates.

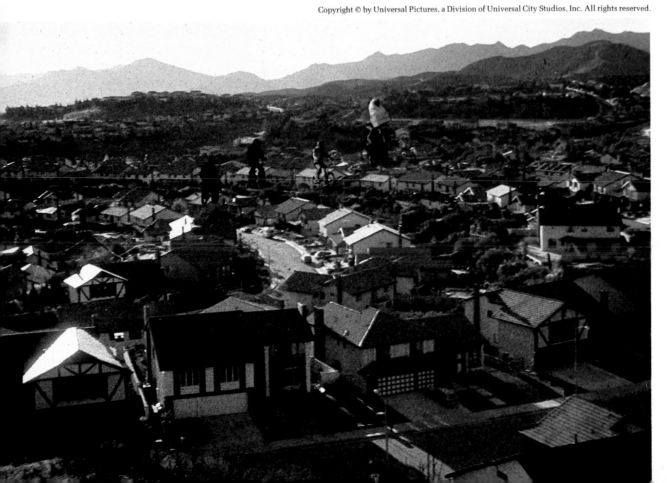

162. In this partial composite, only the matte element is being run for two of the cyclists, hence they appear as black silhouettes. The mattes were generated by filming go-motion models against blue screen, each miniature bike rider shot as a separate element. A helicopter was used as the camera platform for shooting the background plates.

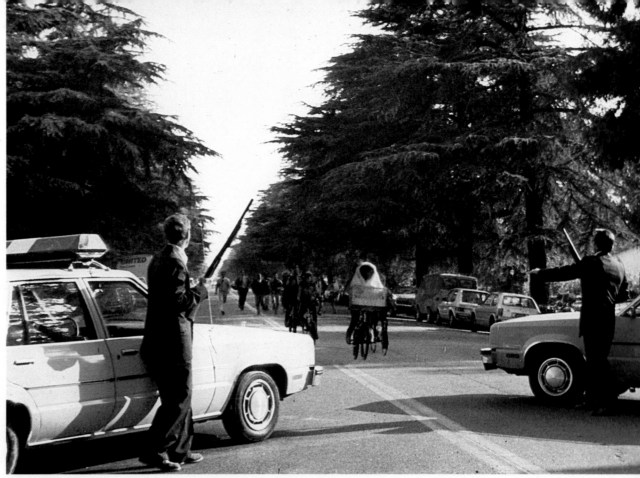

163. A tricky problem was presented by the scene in which the bike riders become airborne at the police roadblock. Even such details as the shadows cast by the trees on the speeding kids had to be taken into account by the effects crew. Once again, the cyclists and bikes in this shot were go-motion miniatures.

Hooper, whose earlier outings had included *Funhouse* and *The Texas Chainsaw Massacre*. The intention was to make the ultimate haunted-house movie, and to this end Spielberg was prepared to call upon the entire special effects arsenal.

Physical effects, handled by a crew headed by Michael Wood, included a giant gimbal rig, capable of rotating a room-sized set, and a mechanical tree (built in three versions) intended to smash through a window and snatch a child from his bed. Makeup artist Craig Reardon was put in charge of producing living corpses (actual human skeletons doctored with synthetic rotting flesh and real hair and rigged to be manipulated by puppeteers) and also of devising a "cancerous steak" (molded vinyl shapes made to erupt through a slit cut into a raw steak).

At ILM, phantoms and apparitions were produced in half-a-dozen different ways. An actress was dressed in a tattered white gown, flown on a harness in front of a black backing, then filmed with a special high-speed camera. This imagery was then touched up in the optical department and on an animation stand before being composited with a background plate of a staircase. A hand that emerges from the static of a television screen was achieved by means of traditional cel animation softened and diffused by repeated passes through an optical printer. A smallish demonic head that bursts from a closet was made to appear gigantic by means of a clever forced-perspective setup. A skeletal, hairy monster was made to appear more spectral by filming it in a large water tank.

The most complicated scene in the movie, and probably one of the most elaborate blue-screen sequences ever attempted, is that in which the team of psychic phenomena investigators opens the door to the children's bedroom and finds dozens of objects flying around of their own accord. Books flap open and shut, the needle of a compass meets the grooves of a spinning record, an Incredible Hulk doll mounts a toy horse. All of this was obtained with the aid of motion control, though the flapping books had to be shot in real time, otherwise they would have appeared phony, and the Incredible Hulk needed a stop-motion assist from Ken Ralston. Photographed by Rick Fichter and Bill Neil, this brief sequence needed eight months of attention from Bruce Nicholson's optical department.

175

Then there was the matter of an imploding house. A large model of the full-scale haunted house had to be constructed and rigged so that it could collapse into a small hole, a feat that was accomplished with the aid of strong cables attached to a forklift truck. This was filmed at 360 frames a second so that, when the footage was run at standard speed, the model would appear to have the bulk of a full-size building. The imploding structure was then painstakingly rotoscoped into the background plate.

After this, Spielberg and ILM moved immediately onto *E.T.: The Extra Terrestrial*, a movie that would be released a few weeks after *Poltergeist*, rapidly eclipsing that film's considerable box-office success, eclipsing even *Jaws*, *Close Encounters*, and *Raiders*, becoming a hit on the rarefied level of *Star Wars*.

E.T. has the feel of being a major special effects movie, and yet—if we ignore the title character, another mechanical effect devised by Carlo Rambaldi—it is a film that includes relatively few effects shots. And the interesting thing about E.T. as a character is that he runs counter to the emphasis on hyperrealism that has been the main thrust of special effects since *2001*. In a still photograph, E.T. is no more convincing than the Creature from the Black Lagoon. Anatomically he is as ludicrous as any monster in movie history; it is as if Spielberg were defying audiences not to believe in E.T., and such is his skill as a filmmaker that, within the context provided by Melissa Mathison's script, he easily persuaded adults and children alike to suspend their disbelief. ("With a script like that," argues one effects man, "you could cast E.T. as a guy with a paper bag over his head and it would still work.")

E.T. may have been anatomically implausible, but he was certainly the product of considerable mechanical ingenuity. There were three main versions of the character, one of which was essentially a padded polyurethane costume, with a limited amount of mechanically articulated features, worn by little people in scenes that required the character to walk. (In the sequence which shows E.T. drunk after drinking beer, a bilateral amputee was inside the costume.)

Two other E.T. figures were cable-operated puppets, metal skeletons covered with the same polyurethane skin and containing mechanical "joints" and "sinews," servomechanisms, and a tangle of cables. These figures were used in shots where E.T. could be firmly bolted to the floor or some prop. Hidden operators worked cable controls that triggered electronic devices inside E.T. which in turn manipulated a second set of cables that activated the creature's "muscles." (The operator cables consisted essentially of flexible metal rods inside plastic tubing. When pushed or pulled, each rod sent a signal to the actuating servomotor.)

Rambaldi, technical supervisor Steve Townsend, and their crew built four E.T. heads, each of them capable of functioning with any of the various bodies. The most complicated version was controllable down to twitching veins, a flicking tongue, and eyes with dilating irises. E.T. even had his own makeup artist, Craig Reardon.

These mechanical E.T.s account for more than three-quarters of the character's screen time, though it should be noted that in most shots the hands we see are not those of the E.T. figure but rather belong to mime Caprice Rothe, crouching out of camera range and wearing special E.T. gloves.

By far the greatest proportion of the two-million-dollar effects budget went to creating E.T. himself, and visual effects supervisor Dennis Muren was left with relatively little work, which nonetheless included some crucial shots, such as those involving the alien spaceship and, especially, the flying bicycle scenes. Eliot and E.T. sailing across the face of the full moon and the little band of cyclists soaring above the San Fernando Valley were actually achieved by shooting go-motion models against blue screen and compositing them with appropriate background plates. Only a few of the closer shots involved live cyclists on full-size bikes.

But the most impressive thing about *E.T.*, from an effects point of view, is the skill with which the director deployed an extremely modest effects budget. In a period when some filmmakers were tending toward effects overkill, Spielberg handed out a lesson in effects economy.

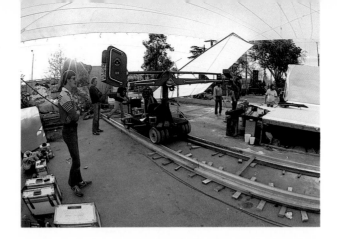

16. Innovations

Created by Gene Roddenberry and starring William Shatner, Leonard Nimoy, and Deforest Kelly, *Star Trek* ran on the NBC television network from 1966 to 1969, at which time it went into perpetual syndication, spawning generations of "trekkies" whose devotion to the show and its characters supported a variety of cottage industries. The notion of a *Star Trek* feature movie was first mentioned in the early 1970s, but nothing happened until September of 1977, when Paramount decided that the original cast would be reassembled and the *Enterprise* dusted off, for a television movie. James Dow, who had worked on *Silent Running* and *Close Encounters*, was called in to begin making models at the shop he had recently set up for Magicam.

The success of *Star Wars*, however, combined with the presumed ardor of the "trekkies," caused the studio to upgrade the show quickly to a major theatrical release with a massive effects budget. The big surprise was that the special effects assignment went not to one of the obvious feature movie subcontractors but to Robert Abel and Associates, still known strictly as a commercials house. Abel came onto the picture in January of 1978, and his team began by redesigning the models, with Dow still in charge of building them. He seems to have been frustrated, though, by the fact that months went by and few storyboards were forthcoming. This presents a model-maker with considerable problems. Space vehicles, for example, have to be mounted on pylons or model-movers for matte photography. If you don't know what angle the ship will be shot from, you don't know where to put your mount. Rumors also began to circulate suggesting that Abel's new 70mm motion-control camera system was behind schedule.

Some aspects of the production were going ahead as planned, however. Bob Swarthe had taken on the assignment of the so-called "wormhole" sequence in which an "antimatter imbalance" is supposed to have caused a distortion of the space-time continuum, a distortion that was to be suggested by streaking of live-action footage shot on the bridge of the *Enterprise* under the direction of Robert Wise. Wholesale streaking made the image very hard to read, so Swarthe hit on the elegantly simple idea of using rotoscope mattes to isolate parts of each frame so that some elements would be streaked while others would remain untouched, thus giving an impression of overall distortion while retaining legibility. The work was done on one of Abel's existing electronically controlled 35mm camera systems, and it is one of the few things from

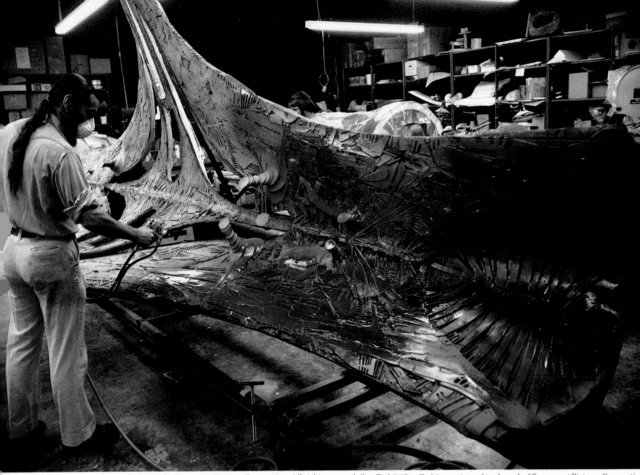

164–165. For **Star Trek: The Motion Picture** (1979), the V'ger entity was built in sections in the Apogee model shop.

166–167. On one of Apogee's motion-control stages, the V'ger model is prepared for shooting.

the Abel period that remains in the finished picture, because, early in 1979, Robert Abel and Associates was replaced by a new team headed by three men with impeccable feature-film credentials: Douglas Trumbull (director of special effects), Richard Yuricich (designated producer of special effects), and John Dykstra (supervisor of special effects).

Paramount found itself with a giant problem on its hands. The movie had been presold to hundreds of theaters and had to be delivered on time, or the studio was likely to be hit with a multimillion-dollar class-action suit by the exhibitors, who were already up in arms about the blind-bidding system which required them to bid for the chance to show movies sight unseen. If *Star Trek: The Motion Picture* did not live up to its advance billing there would be hell to pay. Douglas Trumbull was still under contract to Paramount, so it was natural that the studio should turn to him to save the day. There were two flies in the ointment, however: Trumbull had made it very clear that he did not want to do another space movie, and his contract did not oblige him to do special effects.

He was willing to bargain, however. He wanted to direct a movie from a script that was then called *The George Dunlop Tapes* (later it would be renamed *Brainstorm*) and he wanted to see something happen with his sixty-frame-per-second, 70mm film system Showscan.

"They were taking me a little more seriously," he says, "because of *Close Encounters*—I had generated profits for them—so I had been able to talk Paramount into making a ten-minute demo of Showscan, to show it could be used on theatrical pictures. . . . [When they asked me to do *Star Trek*] I said, 'If I do *Star Trek*, let's put together *Brainstorm* as a film, and if you decide you don't want to make it Showscan, I just walk out of the studio with the Showscan process, which I'll negotiate the rights to, and *Brainstorm* too, because if you pass on Showscan you pass on *Brainstorm* as well.' I forced the issue—said either you agree to my terms or I won't do the effects on *Star Trek*."

Paramount did agree to these terms, and Trumbull, along with Richard Yuricich, began a crash program to get the work on *Star Trek* completed in time to meet Paramount's deadline. Since it was obviously an impossibility for his own facility to handle the entire work load alone in the few months remaining, Trumbull immediately invited John Dykstra to collaborate with him. Soon, Apogee's staff had swelled to one hundred—double the maximum that had ever worked at the plant during the *Star Wars* period—while Trumbull headed a team that at one point had close to two hundred members. The two groups functioned as collaborative units, scenes being divided up be-

tween them largely in accordance with each installation's technical strong points.

"Doug was in charge," Dykstra explains, "but our boom and track systems were set up for doing longer moves, and more complex moves in terms of a single object. Also, we had a larger miniature facility. But everything was organized as if the job had been taken into one house. . . . Even so it was a year's work in eight months, and that was working double shifts."

Apogee took on such sequences as the Klingon ship scenes, near the beginning of the picture, which required the kind of moving camera platform approach that had been developed for *Star Wars*. The company's main challenge was the first sighting of the V'ger entity, as the clouds parted and the camera flew in over the V'ger, which was in reality a model sixty-eight feet long and illuminated with an elaborate combination of incandescent lamps, neon tubes, fiber optics, and lasers. (Animation added still more light effects.) Most of the shots in this flyover involved several motion-control passes composited in-camera, because there was simply no time to do things any other way.

One of the Trumbull team's major concerns was the V'ger cloud sequence in which the *Enterprise* begins to move ever closer to the core of the mysterious entity, moving through thousands of semitransparent layers that appear to be made up of an infinite number of light sources. The effect arrived at on screen was something rather like a slowed-down Stargate Corridor sequence, and much of it was achieved with Compsy—short for Computerized Multiplane System—a huge motion-control animation rig which Trumbull rushed into production to cope with the accelerated demands of *Star Trek*.

"I'd been thinking about something like Compsy for *Brainstorm*," he says, "but that was on the back burner. Then *Star Trek* came along, and we needed something to manufacture a lot of footage fast, so I decided we're going to spend three months building this thing on a crash program then shoot its ass off. The V'ger cloud sequence became our first big excursion into really massive computer-controlled, multiple-pass, complex trajectory multiplane photography."

A multiplane system is exactly what it announces itself to be, a camera system capable of shooting several different layers or planes of artwork. In Disney-type animation the multiplane camera is used to create an illusion of depth and perspective. The camera might be set up to shoot through four different sheets of glass, each of which is separated from the next by a foot or more. On the glass easel farthest from the camera is perhaps a night sky with a full moon. On the next

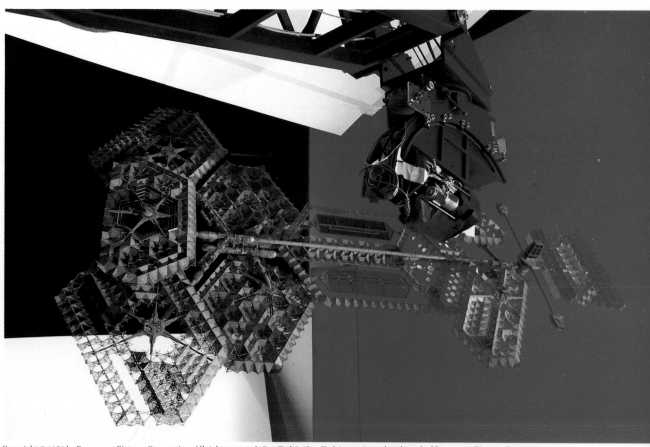

168. Apogee's motion-control camera closes in on a model of **Star Trek**'s Epsilon 9 space station.

easel might be the silhouette of a line of trees. On the third easel is a cottage, and on that closest to the camera an animation cel representing Pinocchio walking from left to right. The camera can, of course, be made to pan with Pinocchio, and, because of the separation of the planes, the background elements will be seen to move in relationship to one another—moon to trees and trees to cottage—just as they would in a real three-dimensional landscape.

Compsy also deals with depth and perspective, but in a somewhat more elaborate way. The mechanism used, perhaps best described as a third-generation descendant of the *2001* slit-scan machine, is a horizontal shooter with a camera mounted on a length of track (thirty-six feet at the time of *Star Trek*) and equipped to handle oversized artwork, up to seven feet wide, on a motorized bed capable of vertical and lateral movement. In common with second-generation equipment, of the sort pioneered by men like Con Pederson and manufactured

commercially by companies like Oxberry and Cinetron, the entire rig—from camera pan and tilt to exposure and focus-pulling—is electronically controlled, but Compsy's servo-mechanisms interface with a more sophisticated computer than was to be found in other motion-control rigs, and the software Richard Hollander wrote for it enabled it to plot more complex moves than had ever been possible before.

Compsy's potential was not fully tested by *Star Trek*, but in the hands of Hollander and cameraman Don Baker it performed everything that was asked of it with ease, producing footage not only for the V'ger cloud sequence, but also for the wormhole sequence, in which it was used to generate streaked shots of an *Enterprise* miniature to be intercut with the altered footage of live action filmed on the bridge set. Meanwhile, the already venerable Icebox rig produced much valuable motion-control footage of a more orthodox kind, while even such a traditional tool as hands-on animation was employed by Bob

Swarthe's unit first to enhance and then complete the transformation of Decker (Stephen Collins) into a luminous pillar of energy.

Star Trek: The Motion Picture was delivered on time and to everyone's satisfaction. It did not generate the record-breaking business of *Star Wars* or *Close Encounters* but was, nonetheless, a substantial box-office success, enhancing the reputations of both effects houses involved. Trumbull, however, was not anxious to pursue new effects projects, since he was trying to get *Brainstorm* off the ground. Dykstra, by contrast, was actively seeking effects jobs and quickly moved on to the comedy *Caddyshack* and then the more substantial challenge of Clint Eastwood's cold-war adventure *Firefox*, which involves the theft of an imaginary Soviet jet—the MiG-31, code name Firefox—capable of speeds in excess of Mach 5 and invisible to radar.

Before Apogee became involved with the project, Trumbull had briefly spent time considering the basic design of the MiG-31 at Eastwood's behest. As a result of this, Greg Jein and art director Bill Creber had spent some time working on the project. Several miniature Firefoxes were built at this stage, and one had been selected as the prototype, then built as a largish, four-foot-long model. When the movie passed to Apogee, chief

modelmaker Grant McCune made some modifications to Jein's design, chiefly to make the aircraft more aerodynamically sound, since the idea of using radio-controlled models was being considered. (These were in fact built but saw no flying time on screen, since the Greenland locations where they were to be used proved too rugged. Radio-controlled helicopters did see considerable service, however.)

A full-size model of the MiG-31 was built, in a Van Nuys hangar, and equipped with a Volkswagen motor so that it could taxi at up to thirty miles an hour. The Firefox flying sequences, in which Eastwood is pursued by a Soviet pilot, were all shot motion control, however, with miniatures of various sizes, and for these scenes several new Apogee systems were brought into play.

The movie would be dependent on realistic shots from the point of view of the two MiG pilots, and on shots of the aircraft themselves seen in relation to the horizon. Background plates for the aerial shots were to be filmed from the nose of a Lear jet, using a VistaVision camera rigged with a kind of gyroscopic device that fed information about the attitude of the aircraft into a computer. In other words, if the plane hit turbulence that caused it to pitch or yaw, even a fraction of a degree, the camera would tell the computer exactly what was happening. This information could be fed into the memory of one of the motion-control units back in Van Nuys and replayed, a frame at a time, while the camera was making its passes on the MiG-31 models, so that miniatures and background plates synchronized perfectly.

Dubbed an Inertial Navigation System (INS), this device was put together primarily by Alvah Miller and cinematographer-software expert Mat Beck. Since the MiG-31 was presumed to be capable of speeds many times the cruising speed of the Lear jet, and of great bursts of acceleration, it was important that the speed of the camera could be controlled precisely and smoothly from the cockpit of the plane; also that the f-stop could be remote controlled, so that the film was not overexposed as the frame rate per second dropped. All these problems were overcome, and the result was that the INS system brought back some of the most spectacular aerial plates ever

169. Apogee's "Butterflex" camera, designed and built by Don Trumbull, is a reflex VistaVision camera ideally suited to the demands of present day motion-control photography.

170. Apogee's field motion-control system in action, shooting plates for the ice-trench sequence of **Firefox** (1982).

filmed, notably those shot by the Lear flying at almost frighteningly low altitude over the frozen tundra of Greenland.

Once these background plates were processed, miniature photography began in Van Nuys, and here two newly built pieces of hardware and a newly devised photographic system came into play. One piece of hardware was the "Butterflex" camera, a VistaVision camera equipped with a mirror reflex viewfinder and assembled in what seems to the layman an unusual configuration, with one chamber of the film magazine on each side of the camera, like the wings of a butterfly. (Actually, this is a logical arrangement because of VistaVision's horizontal film-feed system.) This was designed and built by Don Trumbull and, like ILM's Empireflex, had the advantage of being very easy to use, almost as easy as an SLR still camera.

(Most large-format process cameras do not have viewfinders that permit the operator to see his subject through the lens while he is shooting. Usually a special viewing tube has to be inserted into the optical system, and it cannot be inserted while the camera is loaded with film.)

The other significant hardware advance was a portable motion-control rig—known as a field system—which could be used on location. This field system had a boom arm, in a configuration similar to Apogee's existing motion-control units, but required no track. It was taken to Austrian locations, where Mat Beck shot key background plates with it, and was also used to film plates for the ice-trench sequence, an aerial chase within a glacial canyon that clearly echoed the trench sequence in *Star Wars*.

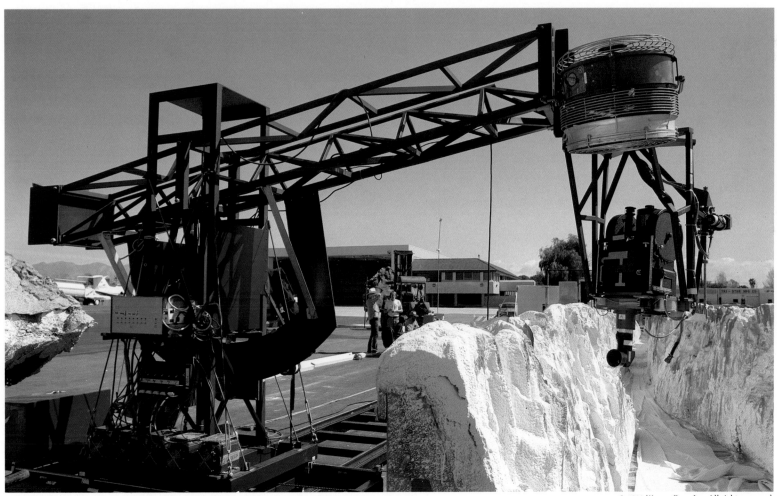

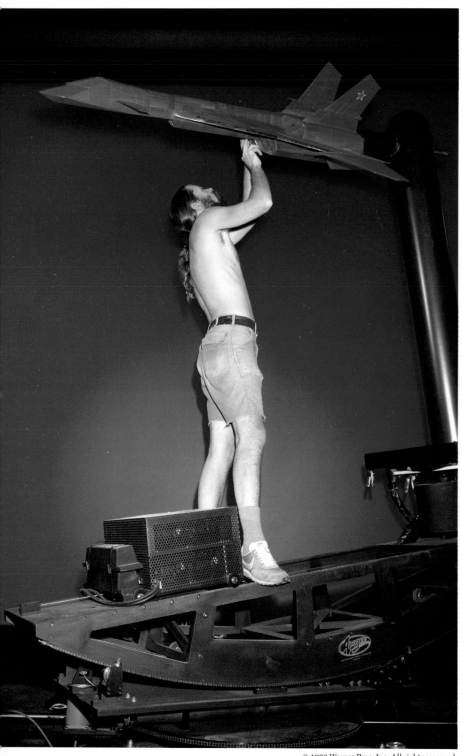

The new photographic system was a so-called reverse blue-screen process, developed by John Erland, which used ultra-violet light in a novel way. Photographing shiny metallic objects, like model MiG-31s, against normal blue screen causes problems, since the light from the blue screen spills onto the reflecting surfaces and causes them to disappear. Erland's system involved coating the models with a lacquer that was transparent in the absence of ultraviolet light. The model could then be shot under normal white light against a flat black backing, for the "beauty" pass. (In other words to obtain the fully chromatic image that will be seen as the foreground element in the final composite.) The lacquer contains a pigment that is sensitive to ultraviolet light, however, and so a second motion-control pass, also against black backing but under ultraviolet light, can be used to generate a matte.

Unfortunately, much of Apogee's ingenuity and artistry was undone, so far as this movie is concerned, by the shortcomings of the script. The opening two-thirds of the film, before Firefox is stolen and the second prototype MiG takes off in pursuit, are about as dull as anything the espionage field can offer. Once Clint Eastwood's character, Colonel Gant, has the plane in the air, the pace picks up and the movie offers some exciting moments, but by then it is too late. Since the viewer has not been swept up by the story, he is less likely to be convinced by the legerdemain that is involved in the effects footage. Under such circumstances, matte lines have a way of jumping off the screen, especially against the daylight skies that were the background for the MiG-31 miniatures.

Despite its shortcomings as a film, however, *Firefox* provides a highly instructive example of a major effects facility in action, demonstrating very clearly that although the craft of special effects is founded on just a handful of basic principles, each project demands new and often technologically complex tools, plus a sizable admixture of plain common sense and the ability to improvise with the materials on hand. *Firefox* relied heavily on Apogee's ongoing research and development program. At the same time, one of the most striking scenes in the film—the landing of a MiG-31 on an ice-floe—was achieved by marionetting a model plane onto a waxed plaster miniature built on a platform in the Apogee parking lot.

Méliès would have understood that.

171. Setting up a MiG-31 model for a reverse blue-screen shot.

172. Clint Eastwood watches as John Dykstra (second from right) lines up a **Firefox** shot in the Apogee parking lot.

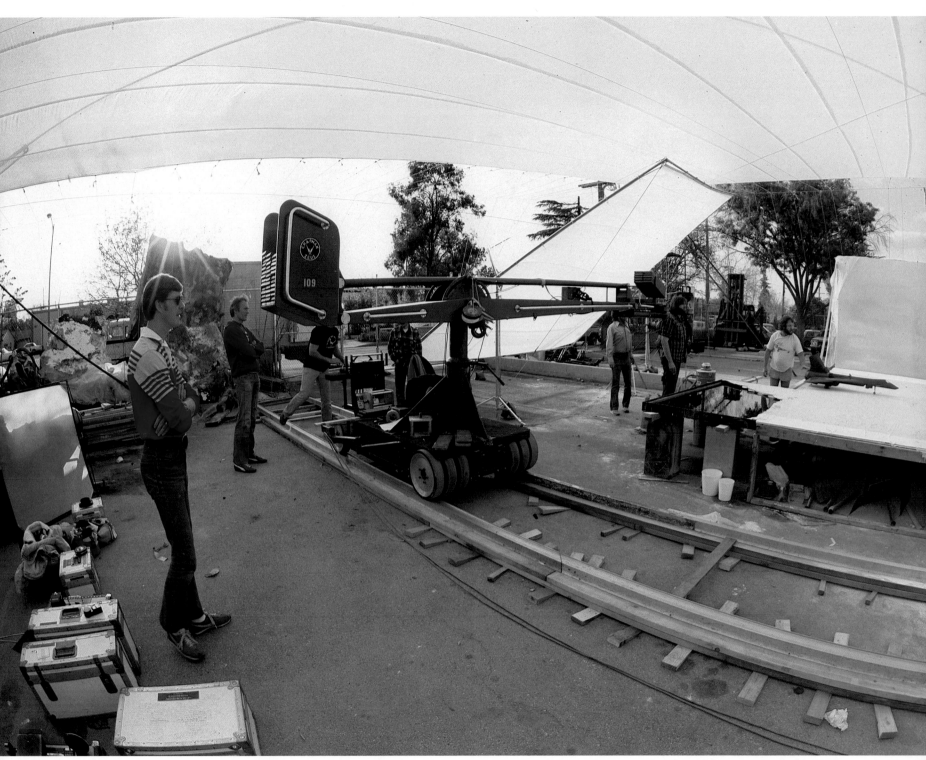

185

17. Blade Runner

lthough set in the twenty-first century, *Blade Runner* is no space opera and, in fact, owes more to the *film-noir* tradition of the 1930s and '40s than to any kind of science fiction. Rick Deckard, the movie's anti-hero (played by Harrison Ford), is Philip Marlowe with a difference, a hard-boiled detective in a raincoat whose job it is to eliminate "replicants." These replicants are the difference. Humanoid robots—cyborgs —produced by a combination of micro-electronics and genetic engineering, they are intended for use as slaves "off-world," out in the far reaches of the galaxy now being colonized by people fleeing a decaying earth. The problem is that these cyborgs not only look like humans, they are also stronger and more agile than humans, and recent models may even be smarter than humans. From time to time a group hijacks a shuttle and makes its way to earth, where they are considered a deadly menace to mankind. Hence Deckard's grim assignment.

The world these replicants escape to is hardly a vacation paradise but has become, rather, an overpopulated and polluted purgatory almost devoid of natural resources—a place in which live pets, however humble, are the ultimate luxury because animal life is almost extinct (though replicant pets are available). The specific setting of the movie is designated as

Los Angeles, though it bears no resemblance to today's Los Angeles and might be any city bloated into the ultimate megalopolis. It is as if every Chinatown from San Diego to Seattle has merged along the length of the Pacific corridor. The population has become largely Oriental and Hispanic, and although older buildings remain, now encrusted with serpentine service ducts, new towers hundreds of stories high loom above them in an eternal twilight of smog and acid rain. Flitting between these towers and above the older streets are "spinners"—rotorless descendants of the helicopter designed, like much of *Blade Runner*'s environment, by Syd Mead—and a baroque-looking advertising blimp promoting Coca Cola and RCA while it exhorts people to leave earth for the joys of "off-world," which is made to sound like some kind of futuristic Rhodesia.

Loosely based on Philip K. Dick's novel *Do Androids Dream of Electric Sheep?*, *Blade Runner* was produced by Michael Deely and directed by Ridley Scott, director of *Alien*, from a script by Hampton Fancher and David Peoples. This script borrowed some notions from Dick's book, such as a human falling in love with an android who does not know she is an android, so perfectly has she been replicated. It also adds

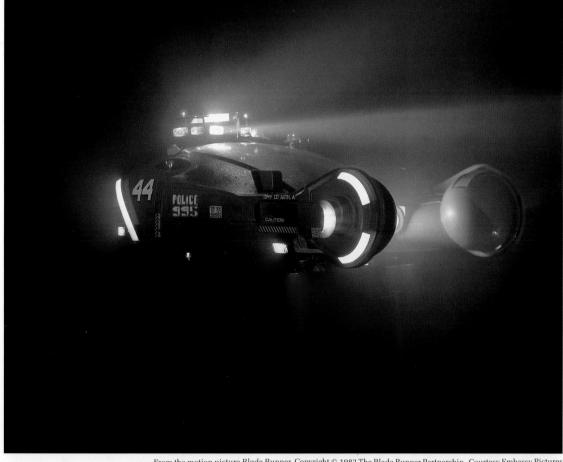

173. A police spinner appears out of the murk of **Blade Runner**'s skies. Model spinners were shot in EEG's smoke room.

174. Another spinner sails past a giant billboard that appears to be made up of thousands of video screens. In fact, the advertising image was projected onto an eggcrate-like surface in which the valleys were painted black and the eminences white. The buildings are large miniatures.

From the motion picture *Blade Runner*. Copyright © 1982 The Blade Runner Partnership. Courtesy Embassy Pictures.

From the motion picture *Blade Runner*. Copyright © 1982 The Blade Runner Partnership. Courtesy Embassy Pictures.

some nice touches of its own, such as making an android "villain" capable of mercy in a way that puts the human hero to shame. The only serious dramatic flaws are at the beginning of the movie, where a Marlowesque voice-over lacks wit and is merely grating, and at the very conclusion, which takes the form of a halfway happy ending that seems hokey and tacked on. For ninety percent of its running time, however, *Blade Runner* is a stunning evocation of a future world light years removed from that imagined by Stanley Kubrick and Arthur Clarke a decade and a half earlier. It gave Harrison Ford an opportunity to show that he is not actually frozen in carbonite, and it provides a textbook example of the range of special effects techniques available in the early 1980s.

What Ridley Scott has in common with Kubrick is a sure sense of what he wants to see on screen. On the evidence of *Alien* and *Blade Runner*, he is not only a fine director but also a remarkable production designer, able to impose his vision on a whole team of art directors and on an entire production. By all accounts, what you see on screen in *Blade Runner* is a world conjured up in Scott's imagination. To bring it to life,

however, he had the help of some of the top effects men in the business.

Scott has said that he always wanted to work with Doug Trumbull, and so, although other companies were asked to bid on the contract, Trumbull was the director's first choice. But Trumbull was already in preproduction for *Brainstorm*, which he would be producing and directing for MGM, Paramount having passed on the Showscan deal that devolved from the *Star Trek* agreement. (Everyone passed on *Brainstorm* as a Showscan feature, but MGM wanted it as a conventional movie using conventional equipment.) Trumbull had a little time on his hands, however, and had leased an industrial plant in Marina del Rey to establish a fully equipped effects facility, operated by Entertainment Effects Group (EEG), a new corporation headed by himself and Richard Yuricich. Also, Trumbull was impressed by Ridley Scott's work and found the project different enough to be interesting.

Blade Runner's associate producer, Ivor Powell, had worked on *2001* with Trumbull and Yuricich, and together the three of them worked out an agreement whereby Trumbull and

Yuricich would supervise the initial phases of the effects operation—planning the logistics of the operation, deciding on which technical approaches were appropriate to given problems, scaling miniatures, and so forth. When their *Brainstorm* work load began to mount, EEG would remain the effects contractor with a new effects supervisor taking over, though Trumbull and Yuricich would keep a benevolent eye on proceedings. The man chosen to take over supervision of the

Blade Runner effects was David Dryer, a documentary filmmaker and director of commercials with whom Yuricich had worked years earlier and had remained in contact.

"*Blade Runner* was a beautifully executed movie," Trumbull says, "but it was non-innovative. . . . I just got it started and helped design some of the stuff. . . . David Dryer did a beautiful job. . . . I was so bored by that time I wouldn't have done nearly such a good job as Dave did."

176. Richard Yuricich (left) and Doug Trumbull with EEG's motion-control camera, which is set up to shoot the Tyrell pyramid model, visible in the background.

177. Effects supervisor David Dryer pitches in on one of the miniature city sets used to represent Los Angeles in the twenty-first century.

model photography, the Compsy crew would be on hand when needed, and Mark Stetson assumed charge of the model shop.

The EEG team was, in fact, embarking on a project that proved to be more fluid than originally envisioned. When Trumbull and Yuricich first made an estimated effects budget for the shots described in the script (but not yet storyboarded), they came up with a figure of five and a half million dollars. Only two million dollars had been allowed for effects, however, and so it was decided that the script must be revamped to reduce the number of effects shots to approximately three dozen. Such juggling is normal in the film business, but what was unusual about this case was that effects were perceived as being crucial to the movie to the extent that the effects budget was allowed to creep back up to three and a half million dollars, covering a total of eighty-five shots.

As Trumbull remarks, the *Blade Runner* effects were not innovative, but this is not the same as saying they were unchallenging. On the contrary, they were technologically demanding and artistically as stimulating as anything in the recent history of special effects. It was the task of the EEG team to evoke a future world that was different from most such visions in that it was predicated upon the problems of our own world and can, in fact, be seen as an outgrowth of those problems. If *Blade Runner* has a true ancestor, it is Lang's *Metropolis*.

The chief effects in *Blade Runner*, which may be taken as typical of those involved in any major special effects project today, were produced with miniatures, subdivided into architectural and landscape miniatures and vehicle miniatures; miniature photography, mostly involving motion control in a smoke environment; matte painting; matte photograpy; rear projection and other process devices; animation (including, at EEG, the special marvels that can be accomplished with Compsy); and opticals.

Coordinating all of these departments was the effects supervisor, whose job is succinctly described by David Dryer.

"For every effects problem there are several possible solutions. It's my job to pick the one that will work best, both in terms of quality and in terms of the budget. I then spend the rest of the movie being told by other people that we should've done it a different way."

In the case of *Blade Runner*, as of most effects movies, the model shop was the first department to move into high gear. Typical of the architectural miniatures Mark Stetson's team was called upon to produce were the headquarters of the Tyrell Corporation, manufacturers of the replicants. Conceptualized by Tom Cranham as a pair of gigantic quasi-Mayan

One of Trumbull's and Yuricich's key tasks was to set up the staff Dryer would supervise. As on *Close Encounters*, Matthew Yuricich would handle the painted mattes, this time aided by his young protégé Rocco Gioffre, one of the partners in a new effects company called Dream Quest. Dave Stewart, a veteran of *CE3K* and *Star Trek*, was placed in charge of

178–179. The Hades landscape was built as an elaborate miniature, eighteen feet long and thirteen feet deep. On screen, the effect evoked is that of flying over a vast industrial wasteland. Flames belching from the towers were shot as separate elements to be inserted later. The twin pyramids at the rear of the miniature were photographic transparencies mounted on light boxes.

From the motion picture *Blade Runner*. Copyright © 1982 The Blade Runner Partnership. Courtesy Embassy Pictures.

From the motion picture *Blade Runner*. Copyright © 1982 The Blade Runner Partnership. Courtesy Embassy Pictures.

pyramids, each a mile high, these would be crucial to several scenes. A single eight-foot-deep model was built. (Twin pyramid shots involved two sets of camera passes on the one model to provide the components that would later be assembled by the optical department.) This miniature was very highly detailed, to sustain the sense of scale, and furnished with thousands of windows hand-scraped with a tiny blade into the plastic facades so that the structure could be illuminated from within.

In one atmospheric sequence near the beginning of the movie, the pyramids are seen as the centerpiece of a vast industrial landscape conceived of as resembling an overgrown oil refinery stretching to infinity. Dubbed "the Hades Landscape," this miniature was eighteen feet long and thirteen feet deep, built on a raised platform that was furnished with clear Plexiglas windows so that the model could be lit from beneath. The foreground of the Hades Landscape consisted of three-dimensional towers and gantries, the tallest eight inches high, cast from urethane foam. Three more detailed towers were built as separate units, on freestanding mounts, in front of the platform (allowing them to be repositioned as camera moves were planned). About a third of the way toward the back of the miniature, the three-dimensional towers gave way to two-dimensional versions etched from brass, some only half an inch tall—diminishing perspective being required so that the camera could be made to "fly" in above the miniature from various angles. The entire assembly was threaded with seven miles of fiber optic material providing tens of thousands of individual light sources. The Tyrell headquarters was then inserted into the back of the miniature as photographic transparencies of the large model pyramid mounted on and backlit by very thin neon lightboxes.

Urban landscapes in *Blade Runner* are often seen from the aerial viewpoint of a spinner's pilot or passengers. This entailed the assembly of clusters of architectural miniatures (often recycled from earlier scenes) on an improvised array of stands, platforms, and tripods, the miniatures angled in such a way as to create the proper perspective and compensate for the distortion caused by the lenses used. Detailed with miniature display graphics and advertising signs, these architectural panoramas often resembled Futurist or Suprematist stage sets.

All these architectural miniatures were shot in the smoke room to provide the polluted atmosphere called for by Ridley Scott's vision of the future. This was a stage hung with black plastic drapes into which Mole-Richardson bee smoke could be introduced and circulated with the aid of fans. "Smoke" is

actually a misnomer here since it actually describes vaporized low-grade diesel fuel, which tends to produce a disagreeable environment for humans and cameras alike. Nor were the scenes shot under these conditions quickly disposed of, since almost all of them involved many camera passes under motion control.

In shooting the pyramid as a foreground element, for example, a separate pass would be needed simply to produce a matte; Trumbull had not revised his opinion of the blue-screen process. Where stationary or very slow-moving objects are concerned, he prefers to have the optical department produce whatever mattes are needed from a backlit pass of the model, which generates a silhouette against a white ground. An evenly lit white card is placed behind the miniature during this pass, whereas the frontlit passes, used to produce the image that will fit into the matte window, is shot against a black ground. At least two of these passes were needed in any scene involving the pyramid because it was a rather complicated business to balance the light sources *inside* the pyramid—the illuminated windows—with the normal stage lighting *on* the pyramid. The necessarily low light levels required long exposures, and if both pyramids were to be seen in the shot, a second camera setup and a separate series of passes would be required (because only one pyramid had been constructed). About all that Dave Stewart and his Icebox crew had to be thankful for was that at least the rain was added optically.

Spinners, a constant presence in these urban landscapes, were sometimes shot in the smoke room too. Models of these were made in four different sizes, based on the full-size version that had been built to Syd Mead's design by Gene Winfield, a car customizer. Spinners were shot singly and composited with appropriate backgrounds by the optical department. Even so, each setup involved several passes so that the appropriate lights and flares could be inserted. For these moving objects a different matting system was used, since natural blur would prevent accurate mattes being pulled from backlit silhouettes. (Even though the motion-control camera and the model spinner were not moving in real time and would, in fact, seem to be moving very slowly to the untrained eye, enough blur would occur to cause problems.) The answer was frontlit silhouette mattes in which the blur caught by the camera matches the blur captured by other frontlit

180. A typical **Blade Runner** cityscape as it appeared on the studio floor. The miniature buildings are angled to compensate for optical distortion caused by the camera lens.

From the motion picture *Blade Runner*. Copyright © 1982 The Blade Runner Partnership. Courtesy Embassy Pictures.

passes. To obtain such frontlit silhouettes, the model had to be covered carefully with white tape and then shot against the normal black backing. Such a method would, of course, work with stationary objects too, but to cover a huge, detailed pyramid miniature with white tape every time a matte was needed would hardly be practical.

One of the most interesting miniatures in the film is the advertising blimp, partly inspired by the barrage balloons Ridley Scott remembered from his World War II childhood. Modelmaker Bill George, who had been in charge of building the model spinners, arrived at the basic shape by constructing a box with ribs in it, stretching surgical rubber over the ribs, and pouring wet plaster into the box. The plaster stretched the rubber into inflated balloon shapes, and when it hardened this

plaster provided a form from which molds could be made. The basic blimp shape was cast from these, but a variety of optional extras were added to the package so that the airship which floats serenely through the movie is bedecked with bristling antennae, a variety of light sources, and everchanging billboards.

In one memorable moment, the film's hero looks up at the blimp as it sails above the skylight of the building he has just entered, searching for replicants. For this shot, EEG's still photographer, Virgil Mirano, went to the Bradbury Building in downtown Los Angeles—a landmark structure often used as a movie location—and took photographs of its handsome Victorian skylight. One of these photographs was blown up into a large print which was mounted, with spray adhesive, onto a

From the motion picture *Blade Runner*. Copyright © 1982 The Blade Runner Partnership. Courtesy Embassy Pictures.

sheet of matte painting glass. All the window areas in the photograph were then carefully cut out by hand so that only *actual* clear glass remained where glass should be.

The scene was then filmed as a classic glass shot with which Norman Dawn would have felt quite at home. The glass plate was mounted in front of the camera lens in such a way that it moved with the camera. The blimp was set up behind it on a stationary mount. Camera and glass plate moved while the blimp stayed still. On film the illusion created is that the blimp is floating above the skylight.

If miniatures and miniature photography were crucial to the creation of *Blade Runner*'s world, that is equally true of matte painting and matte-stand photography. Essentially, in a movie of this sort, architectural models are called for when you need to have the camera move through the environment. Matte paintings are used when you want to open a scene up or provide an elaborate setting for a shot that has relatively localized live-action elements. In Matthew Yuricich and Rocco Gioffre, EEG was able to draw on the skills of one of the industry's top veterans and its most remarkable prodigy.

Matthew Yuricich's career began in the early 1950s in the MGM matte-painting department, where he worked on *Forbidden Planet*, among many other movies, and where his mentors included Clarence Slifer, who, it will be recalled, had played a key role in assembling the many matte shots used in *Gone With the Wind*. There Yuricich learned the arcane art of painting to intermediate duplicating stock instead of original color negative, a secret he has passed on to Gioffre. The techni-

181. The advertising blimp seen through the skylight of the Bradbury Building. The advertising images that appear on the blimp's "billboards" were projected onto silk panels attached to the model's sides.

182. Working from one of Syd Mead's studies, Matthew Yuricich carefully applies pigment to a matte painting that shows a view of the city outside Deckard's apartment.

calities of this need not concern us here, but it is a method that has both advantages and disadvantages. The advantages include the fact that it produces high-quality results while allowing a little more leeway in planning any given matte shot than is possible with the classic technique requiring a straightforward in-the-camera composite. The disadvantages include the fact that the range of pigments is dictated by the duplicating stock's sometimes eccentric response to color rather than with the more or less normal spectrum encountered when working to original color negative. It may be necessary, for example, to transpose the green of vegetation to a sickly slime color.

The method was employed extensively on *Blade Runner*, making things easier for the matte cameramen but not the matte painters. Ultimately, though, Yuricich and Gioffre were confronting the basic problems that would crop up no matter which system was preferred. As Yuricich told Don Shay of *Cinefex*, "The tough part about *Blade Runner* was that there were all these standard old buildings that everyone's used

to, and then all of a sudden you have this futuristic looking stuff looming right up behind. And it's difficult trying to make these two elements fit together. . . . The *Blade Runner* paintings weren't hard to paint, but they *were* hard to make credible."

One of the major problems was that they had to accommodate rain and smoke, shifting light sources, and the consequent reflections, things that do not usually impinge upon a matte painter's sense of well-being. Many of these elements were laid in during multiple camera passes on the matte stand, while the optical and animation departments added spinners and searchlights, all of these components helping to give depth and substance to two-dimensional images painted on masonite.

The actual number of matte paintings used in the picture is not exceptionally large, but the opening sequences, establishing the setting, simply would not have worked without them, nor would the climactic rooftop confrontation between Harrison Ford and Rutger Hauer.

From the motion picture *Blade Runner*. Copyright © 1982 The Blade Runner Partnership. Courtesy Embassy Pictures.

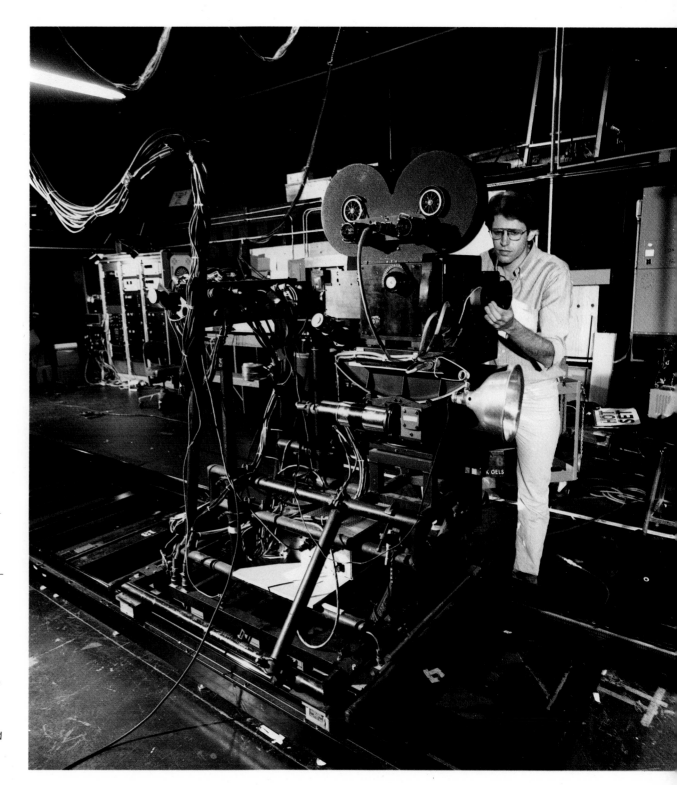

183. In this rooftop chase sequence from the climax of **Blade Runner**, live action shot in the studio was combined with a Rocco Gioffre matte painting. Roughly one-third of the image—to the left of the foreground building's cornice—is painted. Smoke and rain effects were added later.

184. *Richard Hollander makes an adjustment to the 65mm camera mounted on EEG's Compsy (Computer Operated Motion Picture System) rig.*

Rear projection was used sparingly in *Blade Runner*, but it did nonetheless play a useful role. Background plates of miniature landscapes, for example, were combined by this method with live-action shots of actors in a full-sized mock-up of a spinner cockpit. Front projection was employed to introduce background elements into a scene set in the Tyrell Corporation executive suite, and a variety of projection techniques was used to insert specially made advertising films into certain settings. Giant billboards on the sides of buildings consisted of plastic panels stippled with a raised grid of highly reflective nodules set in a flat black field. Because of the scale of the miniatures, images projected on them appeared to be made up of tens of thousands of tiny video screens. Similar images were projected onto the billboards that corsetted the blimp. These billboards consisted of panels of silk stretched on frames. When film was projected onto these panels, the stretched silk seemed to dissolve, leaving the image apparently floating in midair.

John Wash and Glenn Campbell of the animation department were kept busy inserting blinking lights and traffic streams into a variety of shots. The Compsy unit performed similar but more mathematically complex feats, adding many of the subtle, almost subliminal effects that contribute to the total believability of the movie. In the hands of technical director Richard Hollander, Compsy was, for example, called upon to provide the lights of spinners passing in the murky distance. There might be several of these to a scene, and each consisted of a single point of white light (actually the head of a pin painted white and frontlit against black velvet) and a tiny flashing red light.

Many of the cityscapes shot as miniatures required later enhancement in the animation department, and here problems were created by the fact that the camera was seldom stationary, so that if the camera trucked in on a setup, possibly tilting and panning at the same time, the straight line of a traffic lane might become, on the two-dimensional film plane, a sequence of shifting parabolic curves. To assist the animation depart-

ment in plotting these curves, the miniature-photography crew would always make a final nonproduction motion-control pass on the model with large Xs of white tape affixed to prominent features of the miniature. These Xs could be made to serve as coordinates on a two-dimensional grid, thus automatically translating the problem into the realm of animation. From that point on Compsy could be used to calculate the necessary curves to match, say, moving headlights to the shifting viewpoint dictated by the motion-control plates.

At least the animation team did not have to work in a smoke environment. So far as Compsy was concerned, in fact, Hollander's programs were written in such a way that it could function on its own for hours at a time, going through its precise routines as often as it was asked to. Hollander even programmed it to beep him on a pocket paging unit when it had completed its assignment or required further attention.

The biggest single problem facing Robert Hall's optical department was inserting rain convincingly into a variety of miniature shots—not a particularly easy task. As is usual on such projects, optical was kept busy right up to the last minute fine-tuning dozens of shots. The optical department is inevitably the last unit to handle any particular piece of film, and because of this it is apt to be given the blame if anything goes wrong. No blame was handed out on *Blade Runner*, however. On the contrary, David Dryer describes Robert Hall as a genius who saved shot after shot. "He was never satisfied. He was always asking me, 'Just give me one more try.'"

Blade Runner has its blockbuster effects—the Hades Landscape belching flames, the advertising blimp drifting above the lattice work of the Bradbury building—but it is the integration of the effects into the narrative that makes this a superb example of the modern special effects movie, a film that has already become a cult classic. It is a good instance, too, of the way that art direction and special effects go hand in hand.

Anyone who wanted to take a crash course in contemporary special effects could do worse than research the making of this one movie.

18. State of the Art

Blade Runner shows what can be achieved when special effects are integrated into a gifted filmmaker's overall vision. Too often, though, in recent years, producers, directors, and effects supervisors seem to have become dazzled by the array of new visual effects possibilities that exist in the age of electronic control systems. Now, more than ever, state-of-the-art hardware is no guarantee of artistry. It can, in fact, get in the way.

It may be foolhardy to say so, since there is dollar-and-cents evidence that several million people would disagree, but *Return of the Jedi* (1983) is a case in point. Individual sequences are brilliant, but the total impact is effects overkill.

In *Star Wars*, George Lucas managed to blend the innocence of a comic-book story line with highly innovative visual effects to give audiences an experience they had never had before. *The Empire Strikes Back* maintained the balance pretty well, even if it began to take itself a little seriously. By *Return of the Jedi*, however, the balance was lost. The comic-strip story line is still there, less resonant than ever, but it is all but buried by the effects gags that come at the viewer like a blizzard on the ice planet Toth.

The shift between *Star Wars* and *Return of the Jedi* is per-

haps best exemplified by the major "creature" sequences in each movie. The cantina scene in *Star Wars* is brief and funny. In a desert watering hole—part Bedouin tent, part dockside tavern—a group of weird, argumentative, otherworldly creatures are gathered for a quick snort while an alien combo lays down a swing medley. Less elaborately staged than Lucas had originally planned, the cantina scene is over almost before it's begun so that audiences are left wanting more, while having been given some notion of the variety of life forms found in this galaxy. In *Return of the Jedi*, by contrast, the main creature sequence, set in the castle of Jabba the Hutt, seems to go on for an eternity.

Jabba himself is a wonderfully loathesome creation (Lucas had originally hoped to use him in *Star Wars*), but the creatures who pay him tribute, from Bib Fortuna to Sy Snootles and the Gamorrean guards, are on screen so long they begin to lose credibility as alien beings and come to look like what they actually are, ingenious costumes and puppets. It must be assumed that Lucas was very fond of these creatures, since the scenes in Jabba's castle make up perhaps the only sequence in the entire three-film cycle where he falls prey to the temptation to let the camera linger. Normally Lucas, the intuitive

editor, knows exactly when to cut away from a scene before disbelief sets in; in fact, he has sometimes been accused of cutting away sooner than necessary.

The climactic battle in *Jedi* is certainly spectacular, and is in fact enormously more complex than the prototype in *Star Wars*, yet it lacks the novelty of that first deep-space fire fight. This time audiences have seen it before, and, although it may be bigger, it isn't necessarily better.

That said, the ILM visual effects crew—headed this time by Richard Edlund, Dennis Muren, and Ken Ralston—performed wonders in putting together the hundreds of complex effects shots called for by the screenplay and story. In terms of sheer efficiency, it is doubtful if any other effects facility could have handled this task in the time available.

Perhaps the most visually exciting material in the movie is the footage involving speeder bikes hurtling at high velocity through a redwood forest. The bikes themselves—streamlined airborne choppers—were shot against blue screen both as full-size mock-ups with human pilots aboard and as miniatures with go-motion puppets at the controls. (Rotoscope mattes were used for some shots.) The background plates were filmed,

under Dennis Muren's supervision, by cameraman Garrett Brown wearing a Steadicam rig adapted to permit the mounting of a VistaVision camera in a custom-built roll cage.

The Steadicam unit is one of the most useful devices to have been made available to filmmakers in recent years. Cantilevered off a harness that fits over the cameraman's torso, the rig literally steadies the camera while permitting the cameraman the kind of mobility that was previously available only in hand-held situations. Normally the Steadicam is used in locations that do not permit the laying down of track for dolly shots. Muren's idea was that if a Steadicam operator walked slowly through a redwood forest, shooting at a rate of approximately one frame per second, he could create the impression of being aboard a speeder bike zipping through the same forest at 120 miles per hour. The system worked splendidly, and the audience was given a new thrill, the proximity of the towering trees to the camera, making it seem that the bikes are flying at a speed that is sure to dash the riders against the huge trunks.

Among the more memorable of the deep-space scenes in *Jedi* are those which show the massed Empire and Rebel fleets. In some of these shots the mind can hardly grasp the

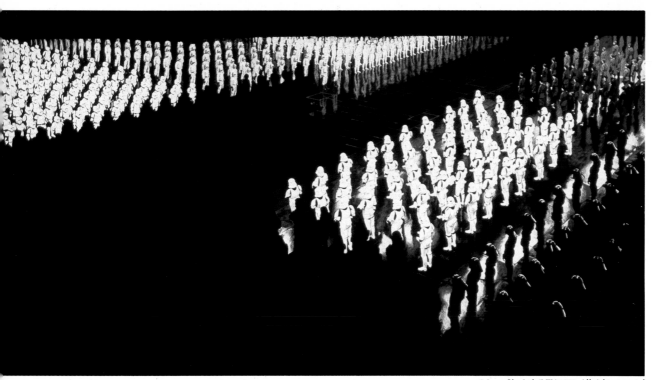

185. This matte painting (left), prepared for **Return of the Jedi** (1983), shows how a couple of dozen actors, costumed as storm troopers, can be made to look like the proverbial cast of thousands. The live-action storm troopers were later slotted into the blank areas left in the painting.

186. Brainstorm (1983) featured some realistic flight simulator imagery shot on EEG's Compsy motion-control rig. Slit-scan photography and related graphic techniques were used to produce the appearance of the computer-generated imagery that is used in actual flight simulations.

sheer quantity of space vehicles on camera at any given time. Those in the foreground are, of course, fully detailed models built in the ILM shop, but farther back into the image some of the ships are models slapped together from kits bought in model stores. Beyond them are bits of interesting debris picked off the shop floor and, according to Ken Ralston, pieces of chewing gum stuck onto glass. Ralston even managed to sneak his tennis shoes into one shot, partly to see if they would be spotted during the dailies.

Brainstorm, the project Douglas Trumbull had been nursing since the mid-'70s, eventually reached the screen after many setbacks. As was widely reported in the press, the death of one of the movie's stars, Natalie Wood, before the film was completed caused MGM to close down the production and file an insurance claim with Lloyds of London. Producer-director Douglas Trumbull fought the studio's decision, saying that the

movie could easily be finished, and Lloyds agreed with him. The necessary reshooting was done, and *Brainstorm* was finally released in 1983.

The plot of this movie concerns a group of scientists who are experimenting with a sensory helmet—a device resembling a football helmet wired for shock therapy—which is capable of both recording and playing back the thoughts of its wearer. The key effects sequence of the movie is a consequence of the death by heart attack of the helmet's inventor, Lillian Reynolds (Louise Fletcher), while she is working with the contraption. The resulting Death Tape is a hallucinatory, psychedelic trip that seems to have spiritual roots in the '60s rather than the '80s.

It had been Trumbull's intention to have this section of the movie shot and projected in his hyperreal Showscan format, but, as has been noted, no studio was prepared to take the risk

(which would have involved the reequipping of theaters with sixty-frame-per-second projection equipment), and so Trumbull opted for a compromise solution in which the format would change from 35mm to 70mm for the sequences seen from the point of view of the recording devices in the sensory helmet. In addition, most of this footage would be shot with a massive OmniVision fisheye lens so that the change in aspect ratio would be overlayed with controlled distortion.

The Death Tape sequence begins with a cinematic representation of the out-of-body experience reported by so many people who have returned from the brink of extinction. The camera, shooting with the fisheye lens, pulls up and away from Lillian, above the web of cables and ducts that crisscross the laboratory ceiling. (These latter elements were filmed separately and composited later with the Lillian footage.) This shot became an image superimposed on a shiny sphere, one of thousands of "memory bubbles," each bearing an image of some kind, that well up from Lillian's subconscious.

The foreground bubbles were filmed on the EEG Compsy rig—modified now to incorporate 360° roll, pan, and tilt—and each involved three camera passes. The first was on a transparency of a silver Christmas tree ball, serving as the bubble, shot by still photographer Virgil Mirano. The second was on rear-projected fisheyed imagery from earlier scenes in the movie positioned so as to appear contiguous with the surface of the bubble. The third pass was required to generate a matte.

The beauty of the stream of memory bubbles gives way to more sinister imagery. Lillian's nytroglycerine tablets and other objects fall past streaked backgrounds until Lillian's expiring mind passes briefly through "hell" before reaching outer space and something approximating "heaven," where visions of angels drift through luminous clouds. (At times, what

187–189. A key moment in **Brainstorm** occurs when the character played by Louise Fletcher suffers a heart attack while wearing her own invention, a sensory helmet that enables others to experience her thoughts. The camera, equipped with a fish-eye lens, pulls up above the cables and ducts that crisscross the laboratory ceiling, and this image blends with a stream of "memory bubbles," each carrying an image from the character's past. Foreground bubbles contain images which had been shot earlier, during the course of principal photography, mostly with a 35mm Arriflex camera equipped with the same type of fish-eye lens used for the overhead shot of Miss Fletcher. Each of these memory images was then rear-projected and rephotographed on the Compsy rig in a way that permitted it to be combined with the bubble, which was in fact a transparency of a silver Christmas tree ball.

with the bubbles and these angels, who resemble butterfly girls, the Death Tape imagery is reminiscent of one of Abel's old Seven-Up commercials.)

As one would expect in a Trumbull film, the effects are impressive. Trumbull himself was involved with many other aspects of the film—Alison Yerxa was the visual effects supervisor—but the maestro's hand is evident throughout. Yet, if he is to be taken at his word, *Brainstorm* may be his swan song in the field of the feature-length film. "I am not in effects anymore," he says now. "I am not in feature films. I am in Showscan."

190. For **The Right Stuff** (1983), Gary Gutierrez's crew at Colossal Pictures made effective use of some deceptively simple and old-fashioned techniques. Here, models of the X-1 and its B-29 mother ship against a painted backdrop of sky.

In a very real sense this is true. Although he retains partial ownership of EEG, he operates out of the nearby Marina del Rey offices of Showscan, where, in partnership with the Brock Corporation of Dallas, Texas, he is developing the sixty-frame-per-second system for use in a chain of specially designed small theaters which will be built in conjunction with fast-food outlets. Showscan movies, each so far running less than half an hour, are already in production. Since they depend on the shock value of the process, it can be assumed that Trumbull will be using his effects expertise in some of these films. Nevertheless, there is no reason to doubt the fact that Trumbull has no intention of returning to the role of being a mere effects contractor.

Nor is there any reason to suppose that George Lucas does not mean it when he says he has no intention of producing more effects-heavy movies of the *Star Wars* type, which places the future of ILM in some jeopardy. At the time of writing, the company has work on hand and may well survive if Lucas

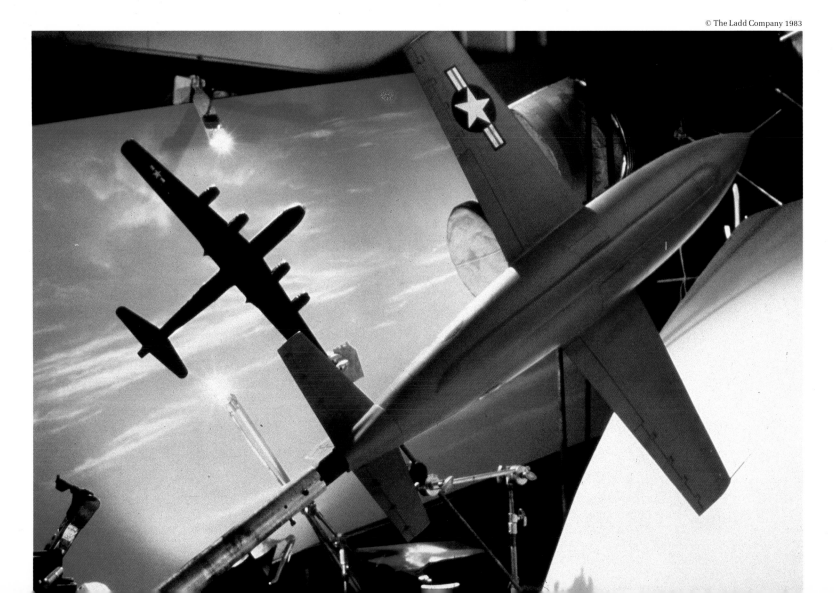

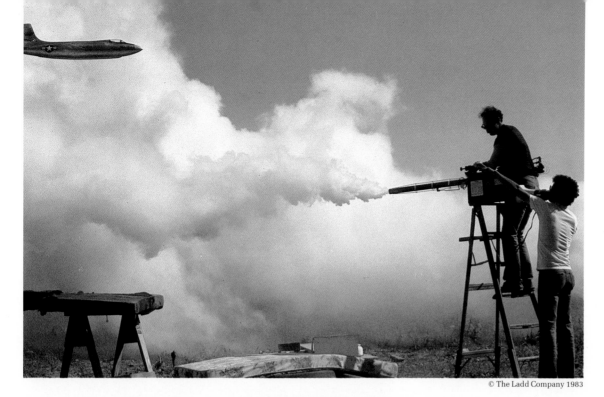

191–193. The flying sequences created for **The Right Stuff** had to match existing documentary footage. Motion-control shots proved to be too "pretty," so models were flown on wires, through clouds of insecticide fog, and shot from the ground by cameras able to supply the kind of "gritty" look that was called for.

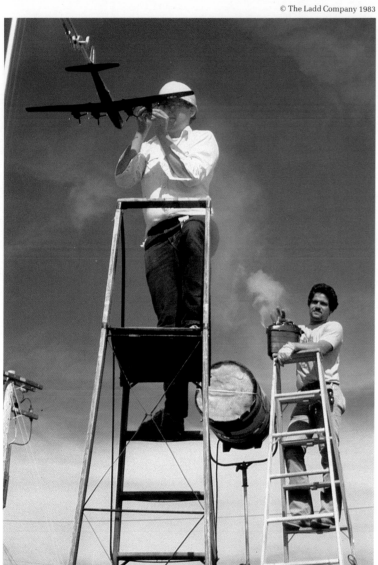

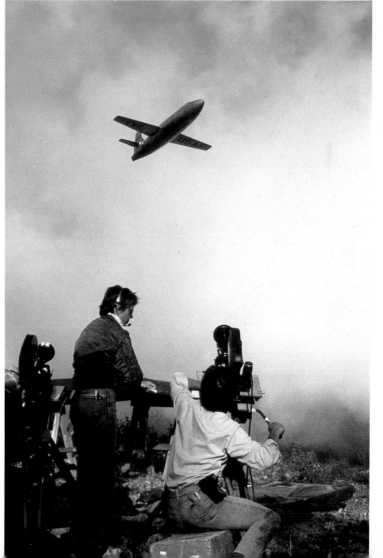

chooses to give it the chance. Already, however, Richard Edlund has left ILM and has returned to Southern California to take over the reins at EEG—converted into an ILM-type blue-screen facility—where he has been joined by other ex-Lucas staffers. Of the big three feature effects houses, only Apogee has been unaffected by large-scale personnel shifts.

Meanwhile, new effects companies are beginning to attract important contracts. Dream Quest consists of six mostly young partners—Scott Squires, Hoyt Yeatman, Rocco Gioffre, Frederick Iguchi, and Thomas and Robert Hollister—who are graduates of, variously, Future General, EEG, Technicolor, and the MGM optical laboratories. In existence since 1980, Dream Quest has been kept busy with assignments on such movies as *One from the Heart*, *Blue Thunder*, and *Deal of the Century*, but has not yet been associated with the kind of effects-heavy hit movie that would assure the company's reputation, though

its work has attracted a good deal of favorable attention within the industry.

Dream Quest specializes in the same kind of sophisticated motion-control oriented work as the big three (and in Rocco Gioffre they have the most gifted young matte painter in the business). Up north, in the Bay Area, another new company, USFX, took a very different approach in devising the effects for Philip Kaufman's *The Right Stuff* (1983). The problem here was that the effects had to be blended with actual documentary footage of such events as Chuck Yaeger's assault on the sound barrier and the Mercury program flights. The USFX crew, under the supervision of Gary Gutierrez, began by trying motion control but found that the results were too smooth, too pretty to be believable. Quickly they switched to a much more improvisational mode of working, aiming to achieve an off-the-cuff look by, for example, shooting miniatures against

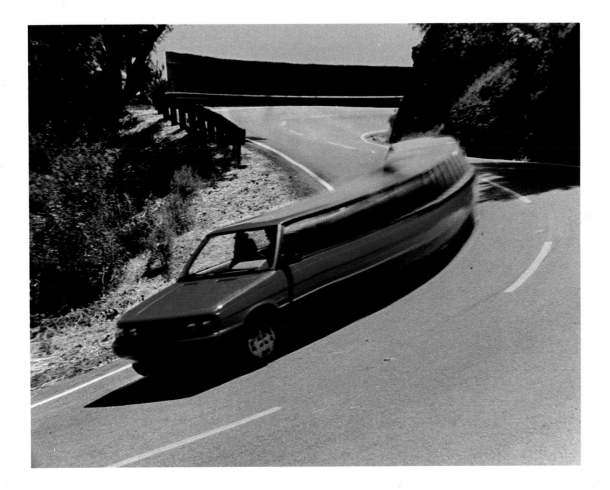

194. The "Plastic Car" campaign prepared by R/Greenberg Associates for the Grey Advertising Renault campaign in 1983 is a fine example of the special effects commercial. Stretching the car around corners involved as many as 1,100 passes for a single frame of film.

195. R/Greenberg created titles for **The World According to Garp** by filming a baby on a sheet of clear Plexiglas against a white ground. The camera's movements made it seem that the baby was bouncing up and down, and this footage was then composited with the appropriate background plates.

painted backdrops with a hand-held camera, and flying other models on wires through clouds of insecticide fog. To reproduce the illusion of the X-IA rocket plane spinning out of control, the USFX team even shot miniatures being tossed, through smoke, out of a third-floor window.

Perhaps the most interesting of the new special effects houses, and certainly the fastest growing, is R/Greenberg Associates, a company that is unusual in many ways, starting with the fact that it is located in New York City, on Madison Avenue, to be precise (with additional facilities, such as its model shop, across the Hudson River in New Jersey). Manhattan has many optical houses and other specialized effects businesses, but never before has it been home to a company that, like ILM or Robert Abel and Associates, can take on the entire range of special effects in-house and can do so with equipment and personnel in no way inferior to its West Coast rivals.

The company was founded in 1977 by two brothers, Robert and Richard Greenberg, each of whom brought expertise from a very different background. Richard Greenberg had been a professor of film and a graphic designer before a prize-winning short led him into the world of directing commercials. Robert Greenberg had spent an earlier career at Royal Crown Cola and had accumulated varied experience in the fields of management and manufacturing. In their new enterprise they became, respectively, creative director and executive producer. The result of their collaboration is what might well be the most efficiently run effects organization anywhere.

It is also the most diversified effects house in the industry, simultaneously handling visual effects for feature films along with feature film logotypes and main titles, and also trailers and advertising campaigns for feature films, as well as a full range of commercials. From its Elicon track-and-boom motion-control rig to its computer-generated imaging system, R/Greenberg offers the gamut of sophisticated equipment, but the plant's chief pride is its optical department, which is unsurpassed in the industry. Completely computerized, it features a seven-axis aerial-image printer, a standard configuration single-headed optical printer and—as advanced a piece of optical equipment as has ever been built—a sixteen-axis quadruple-headed Oxberry printer supported by a software program that makes it capable of the most intricate compositing tasks. (The advantage of a multiple-headed printer is that it permits the concurrent printing of several strips of film which, in a standard printer, have to be run singly through the head.)

As a commercials house, R/Greenberg frequently finds it-

196. In a sequence for **Zelig** (1983), Woody Allen and Mia Farrow were matted into vintage black-and-white footage of Times Square.

self bidding on the same jobs as Robert Abel and Associates, and the two companies must be considered the leaders in the field of the special effects commercial. (Other companies, such as Cascade—alma mater of Dennis Muren and Ken Ralston—have been important in this area but have not offered the all-round resources and mixed-media skills of Greenberg or Abel.) Clients presumably have a tough time choosing between these two. In general, Abel might fairly be said to offer more glitter and overt pizzazz, while Greenberg tends to provide subtlety and, for want of a better phrase, good taste.

Where R/Greenberg differs more radically from Abel is in its involvement with theatrical film. In many ways, for example, it has been film titles that have established R/Greenberg's reputation, the company's first major job having been the main titles for *Superman: The Movie*, in which streak photography was used to invoke the theme of Superman translated from the comic book of the 1930s to the widescreen world of the

1970s. Richard Greenberg is one of that handful of people, like Saul Bass (*The Man with the Golden Arm*, *West Side Story*) and Maurice Binder (the Bond movies), who has the ability to set the mood for a picture with the mere statement of its title. Like Bass and Binder, Greenberg depends to a large extent on strong graphic art skills, but he combines his design sense with a sure knowledge of what can be achieved with special effects. For *The World According to Garp*, for example, he provided the splendid image of a newborn baby floating up and down in slow motion against a backdrop of ocean, as if thrown and caught by his mother. In fact, the infant was not asked to perform stunt work on location but was actually shot on a sheet of Plexiglas against "white limbo" backing with the camera providing all the vertical movement. Mattes were pulled from this, and the baby was then composited in the usual way with the background plates.

Other Greenberg title sequences include *Alien* (the title

forms from neoplasticist blips above a sinister egg which at first seems to be a misshapen moon), *Flash Gordon*, *Inside Moves*, *Ragtime*, and *Altered States*. Each of these sequences is, in Richard Greenberg's words, a "visual metaphor" for the movie itself, and much the same might be said for R/Greenberg's promotion campaigns and trailers for movies ranging from *The Empire Strikes Back* and *Blade Runner* to *All That Jazz*, *Tootsie*, and *Gandhi*.

In a sense, of course, titles and trailers are very like commercials in that they are succinct statements intended to sell a product. Creating the effects for a theatrical feature is a different matter, however, and R/Greenberg is making itself felt in this area as well, though without yet having taken on an effects movie as demanding, in terms of number of effects shots, as those handled by ILM, EEG, or Apogee.

"To take on a project of that kind," Robert Greenberg explains, "you have to think in terms of a commitment of a year or longer. That would be difficult for us because we would never give up our other clients. It's important for us to remain a commercials house, so we would only take on a film with a heavy effects load if it was just right for us. In the meantime we are interested in taking on movies in which the special effects have an important role to play."

On films like *Xanadu* and *Nine to Five*, R/Greenberg primarily took existing live-action footage and enhanced it optically and on the animation stand. In these instances it is Richard Greenberg's strong graphic sense that is most in evidence. Other assignments, like *Flash Gordon*, employed a fuller range of effects, but the company's most fascinating and unusual assignment to date has been *Zelig*, Woody Allen's 1983 release which presented the singular challenge of introducing the character Allen plays in the movie into historical newsreel footage so that he could, for example, pose with Calvin Coolidge and play baseball with Babe Ruth.

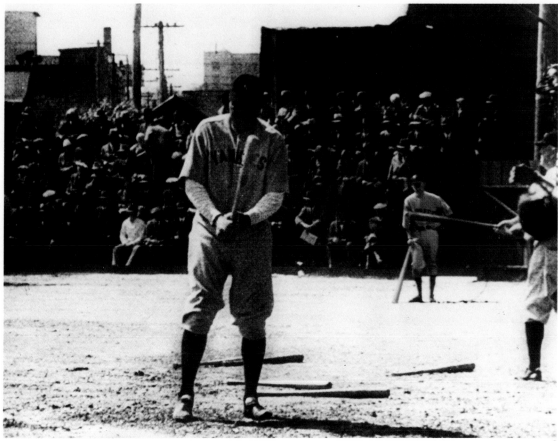

197. For another scene in **Zelig**, Woody Allen was shot against blue screen and then carefully matted into existing documentary footage showing Babe Ruth in action during his heyday with the Yankees.

This task went beyond normal special effects, however. To begin with, cinematographer Gordon Willis used antique lenses to simulate, as far as possible, the look of vintage film, and old microphones were used to take sound. In a move that is the opposite of standard effects practice, all the new footage shot was deliberately duped, sometimes three and four times, to bring up the grain and to promote deterioration in contrast. Mattes were used to introduce dirt and flicker where necessary so that old footage and new would match. In shots where Allen was to appear with historical figures, he was shot blue-screen and then inserted into the newsreel footage in the R/Greenberg optical department, work that was carried out under the supervision of Stuart Robertson and Joel Hynick. Much careful attention to detail was required, down to, for example, introducing animated shadows to match Allen's movements.

If R/Greenberg has one disadvantage, as compared with its California rivals, it is that its present facility lacks one really large stage, the kind that could allow for fifty or sixty feet of track in its motion-control shots (though the excellence of the optical department can compensate for this to some degree, extending some shots in much the same as the RKO optical department extended *Citizen Kane*'s final "Rosebud" shot into the fire). All this will change shortly, however, when the company moves into new and much larger premises, a converted bus terminal on Manhattan's West Side.

The special effects industry at present is in a state of considerable flux, but certainly there is no lack of talent around, and if Kubrick were ever to make another effects movie today, he would have no difficulty in assembling a first-class team. If he were to continue his two-decade old policy of making all his films in Europe, he might not need to look beyond the British Isles to furnish his needs. While many recent productions have continued the pattern of blending British physical effects with American visual effects, there have been some notable exceptions, such as Terry Gilliam's wonderful *Time Bandits* (1981), in which British visual effects crews have shown themselves capable of holding their own with the best.

Nor is there any reason to suppose that the present boom in effects movies has peaked yet. While the film industry as a whole shows a decline in production, more effects movies than ever are being made, for the very simple reason that, despite their large budgets, so many of them bring in enormous profits. In general, too, effects tend to find their way into the kind of fantasy movies that are aimed at the cinema's prime audience, teenagers and young adults.

The plots of these movies may lean heavily on fantasy, but the effects that enliven them will continue to emphasize realism. How far this realism can be taken is a matter for speculation. The biggest question, however, is to what extent the movies will continue to rely on conventional special effects—computer-assisted, of course—and to what extent they will dip into the world of imagery that is wholly computer generated.

This new world of synthetic imagery is the subject of the remaining chapters of this book.

PART III

SONS OF HAL

19. Coordinates

In 1950, the Servomechanisms Laboratory at the Massachusetts Institute of Technology produced the first numerically controlled tool, a milling machine that could be programmed to repeat simple but useful tasks with considerable precision. Having launched an entire new discipline, known as computer-aided manufacture (CAM), the MIT scientists turned their attention to a complementary process that would be dubbed, in time, computer-aided design (CAD). To facilitate this they built a new tool called Sketchpad which permitted a scientist, engineer, or designer to develop visual ideas on a display scope interfaced with a computer.

Like a television screen, this display scope was simply the luminous (when activated) faceplate of a cathode ray tube (CRT). Instead of asking it to reconstitute a transmitted image, however, the MIT experimenters were hoping that the CRT could serve as part of an electronic drafting system. In 1962, Ivan Sutherland, a key figure in the history of computer-generated imagery (CGI), used the system to produce a short movie called, appropriately, *Sketchpad*. Although relatively crude, *Sketchpad* caused quite a stir within the computer community and may fairly be said to have marked the beginning of CAD as we know it today.

Earlier primitive efforts in the field had used data bases that described to the computer the *picture* the programmer wanted to see on his display scope. Sutherland's approach was radically different. He described to the computer the *object* he wanted to see on screen—giving coordinates for a solid entity rather than a two-dimensional representation—so that the image conjured up existed in what seemed to be three-dimensional space. Since Sutherland had told the computer how every part of the object related to every other part, he could instruct the machine to turn it this way and that, making the object rotate in illusory space. The computer would remember all the coordinates it had been given and maintain accurate foreshortening and perspective.

When Sutherland made *Sketchpad* he was working with the most cumbersome of systems. The computer he used was capable of accepting only one graphics command, to place a dot of light on the screen at a specific location. To draw a line Sutherland had to instruct the computer to accumulate it dot by dot. Quite quickly, though, this situation improved, and by the mid-'60s new tools such as the light pen were available. The light pen is an electronic stylus that enables a designer to sketch a form and see it immediately displayed on the scope.

The computer will even oblige by doing "clean-up" work. Draw a rough circle and it will instantaneously be turned into a circle that could have been made with a compass.

While facilities such as MIT, Bell Laboratories, and the University of Utah continued to do experimental work in the field, computer-aided design began to find practical uses at aerospace companies like Boeing, where it quickly became an important time-saving tool (as computer-aided manufacturing systems had a decade earlier). A particularly interesting development was the adaptation of CGI systems to flight simulators.

Quite simply, it became possible to program a computer with information about how an aircraft behaves and responds to its controls under various conditions. Computer graphics made it possible to represent—crudely at first, then with increasing realism—what the pilot would see outside the cockpit at any given moment. Sitting in a mock-up of a cockpit with computer-fed instruments, a trainee pilot could "fly" the plane, go through takeoff and landing drills, learn how to stall a plane or pull it out of a spin. It even became possible for computers to predict the likely aerodynamic characteristics of aircraft that had not yet been built, so that a plane could be "test-flown" before it ever existed as a physical entity.

Today's flight simulators have become so realistic that it is possible to earn a pilot's license without ever leaving the ground. The scene simulation involved is highly naturalistic, and much of it is produced by Evans & Sutherland, a company founded by Ivan Sutherland and his former University of Utah colleague David Evans. (Sutherland retains an influential post at the university, while Evans runs E & S, which also produces CAD/CAM systems for a variety of other uses.)

Back in the mid-'60s, however, it was impossible to buy ready-made imaging systems (as the graphics consoles that interface with computers are called). Everything had to be built from scratch, and, because even simple graphics required very complex arithmetical operations, the system was contingent upon access to a state-of-the-art mainframe computer, an item that was far too costly to be considered by, for example, a company that might have been interested in developing computer

198. "Reflective Spheres" (opposite), produced in 1983 by Digital Productions, shows clearly how computer-generated imagery has reached a level of sophistication where it can simulate complex reflective surfaces.

199–201. Robert Abel and Associates produced this computer-generated paper dart flying through a vector graphics environment for an experimental 3-D television system developed by Panasonic.

202–203. "Dade County Stadium," a vector graphics rendition of an architectural project produced on Abel's Evans and Sutherland imaging system.

graphics for television commercials. Even had that company been able to afford the computer, it would have had difficulty obtaining the high-resolution video equipment that is essential to a quality CGI system.

Around 1970 a few people did begin to work with what is known as the video synthesizer, a relatively inexpensive analog-computer system capable of smoothly transforming one form into another. Its capabilities were very limited but it helped put computer graphics in the public spotlight. On *Sesame Street*, for example, it was used to turn patterns into words and words into patterns.

At about the same time, frame buffers, a form of digitized video memory, came into use, greatly increasing the potential of computer-generated imagery as a serious graphics medium. Until then the computer animator had been limited to working with what were in effect line drawings. This system, known as vector graphics, still has many uses, but it is inherently limited in the way that pen-and-ink is limited when compared with a range of paint brushes of different gauges and a full spectrum of pigments. Frame buffers store information about each of the hundreds of thousands of "pixels" that make up a video image. (Pixels are picture elements—the minute luminous dots that are mosaiced together to form the display on the CRT screen.) This enabled programmers to think about computer graphics in terms of areas of graded color instead of vector lines. This in turn meant that art directors and others could begin to consider the possibility of using the computer to generate fully modeled solids on screen. Instead of a wireframe representation of a car, a realistic likeness, complete with reflections and highlights, could be put on the display scope, in any color scheme desired.

This form of computer-generated imagery was given the name raster graphics ("raster" is the video term for the pattern of scanning lines on the sensitive portion of a picture tube), and soon the large institutions and even some smaller companies were beginning to explore its potential. One such company, MAGI/SynthaVision of Elmsford, New York, actually placed a raster graphics commercial on television as early as 1973.

Money remained an inhibiting factor, however. Any high-resolution raster image requires a phenomenal amount of calculations, and, therefore, a great deal of computing power is required. Furthermore, software for raster graphics was not something you could purchase off the shelf. It had to be developed from scratch, and there were few programmers who had a clear understanding of what was needed in a graphics environment. On the other hand, the first generation of powerful

minicomputers did bring vector graphics within the means of an unprecedented number of people, and a handful of commercial producers began to acquire the appropriate equipment.

Robert Abel's involvement with computer-generated imagery is probably quite typical. His experience with motion control had told him that high-tech investments could pay off, and he began to think about computer graphics as a way of previewing imagery. That is to say, he wanted a system that would allow him to present a schematic version of a commercial—a kind of animated storyboard—to his client before the commercial was actually shot. With this in mind he went to Salt Lake City to look at Evans & Sutherland's flight-simulator displays and to find out whether E & S could supply him with equipment that would fulfill his company's needs.

The result of this was the acquisition of Evans & Sutherland's Picture System II, a graphics tool that was developed for industry but proved ideal for Abel's needs. Initially

204. "Night Tracks" is a raster graphics image for the introduction to a television series, produced by Digital Productions.

he used it solely for previewing purposes—a technique he describes as "animatics"—offering agencies animated blueprints of proposed commercials.

"The way we had the codes written," Abel explains, "we could simulate the viewpoint of any lens. We could tell the computer, 'We want to see an electric shaver rotating in space. Here are the object's dimensions, and we're going to look at it with a 50mm lens.'"

Such information about lenses, camera moves, and so forth could be stored on floppy discs, which could then be used as software in Abel's compatible motion-control system. In short, the motion-control system could be asked to exactly reproduce what the computer graphics had previewed. Such a method of working, first used in 1979, has obvious and substantial advantages and, not surprisingly, remains in use today. Very quickly, though, Abel's staff moved on to using the E & S imaging system as a way of generating material for incorporation in the actual commercials themselves. In some instances the Abel CGI division, headed by Bill Kovacs, uses computer graphics in isolation, in other cases in combination with conventional animation or effects. The company has also made good use of what Abel describes as "pseudo-raster" images.

These are vector graphics in which the lines, in selected areas, are placed so close together they appear to make up a solid area of color.

Even as he began to employ vector graphics on a regular basis, Abel realized the desirability of having a true raster system available. In 1983, the company became one of a tiny group of companies—Lucasfilm and R/Greenberg are possibly the only others—who can offer both vector and raster graphics along with the full range of traditional effects and live action. A considerably larger group of companies has sprung up specializing in computer-generated imagery used as an end in itself or in combination with traditional animation techniques.

Typically, a modest computer graphics studio will consist of half a dozen graphics terminals or work stations hooked into what is now termed a supermini computer—a member of the VAX 730/750 family, for example—actually a medium-size unit which offers a fast, powerful processor and perhaps four megabytes of main memory interfaced with disc drives capable of greatly increasing the system's long-term memory capacity. Each graphics terminal will consist of one or two CRT displays, a keyboard, and usually a digitizing data tablet with an electronic stylus. The keyboard is used for the most basic

205–206. Robert Abel and Associates frequently uses "animatics"— schematic computer-generated vector graphic renditions, like a moving storyboard—to preview a commercial, as is the case with the 7-Up spot seen opposite.

207. In "Exchanging Ideas," a commercial produced for TRW, Abel made effective use of vector graphics.

functions—to call up a specific image, for example—and the more sophisticated the software the more simply these commands can be given. (Much attention has been paid in recent years to developing "director's language," software that enables an art director with little hands-on experience of computers to operate a graphics terminal.) The data tablet is an encoded electronic "slate"—to the untrained eye just a shallow box topped by a sheet of translucent plastic—which the operator can "draw" upon, or "paint" upon, with his stylus. (He can also erase.) This tablet may offer a "menu" of commands which the operator can activate simply by touching the point of his stylus to the appropriate spot on the tablet's surface. Thus, by touching one spot he might tell the computer to shrink the size of an image, and by touching another he might call up a particular color. (In some systems such a menu of

instructions is displayed on the screen itself and can be activated with a light pen.) Other input options at a work station might include a digitizing camera (to shoot existing artwork) or a joy stick, which can be used to manipulate objects on screen as if they were components of an electronic arcade game.

A typical modern display unit will be capable of producing image resolution in the range of fifteen hundred by twelve hundred pixels (though some systems are capable of much higher levels of resolution). It will interface not only with the central processing unit (CPU) but also with its own microprocessor and frame buffers, a character generator, and so on. A palette of close to five thousand colors is relatively commonplace. To translate the images produced onto celluloid, a special film-recorder system is required.

208. A group of geometric primitives used as "building blocks" in MAGI/Synthavision's raster graphics system.

209. The image opposite shows the kind of forms that can be generated with the aid of geometric primitives. This example is taken from a commercial produced by MAGI/Synthavision for the electronic game Worm War I, marketed by Twentieth Century-Fox Video Games through their agency BBDO, Los Angeles.

Because of the lower arithmetical demands made on the computer, modern vector-graphic systems are capable of real-time animation functions. Suppose, for example, you have a wire-frame image of a hairdryer in the middle of the screen. The operator can ask the computer to "zoom in" on the image, and it can do so in real time, just as the viewer might see it in the finished commercial. And the operator can make it rotate through 360° and pitch on its vertical axis at the same time. Raster graphics are another matter, however. They have to be generated one frame at a time, and watching an image accumulate on screen, a few paltry pixels per second, is like watching grass grow. On most existing raster systems it takes many minutes to produce a single frame of even moderate complexity.

There are two basic ways of assembling solid raster-type images. One system, practiced most notably by MAGI/Syntha-Vision, is to build the object you require from what are referred to as geometric primitives. This means that the computer's memory contains information about a variety of basic three-dimensional forms—cubes, spheres, cones, etc. Suppose the job at hand calls for the representation of a table lamp, in which case the operator would call up the appropriate geometric primitives, let's say a sphere and a cone. The sphere, squared off at the bottom, becomes a schematic base for the lamp. The cone, with its tip lopped off, becomes the shade. Once these two shapes have been combined the operator can begin to add detail—texture and modulations of form—that will turn the assembled primitives into a realistic-looking table lamp. This is the simplest example imaginable, of course, and, as will be seen, geometric primitives can be used to build up imagery of considerable complexity.

The other and more common approach to raster graphics is to prepare a schematic drawing of the object and place this drawing or blueprint on an electronic recording table which can be used to describe the key x, y, and z coordinates to the computer in digital terms. (A crosshair device is placed over the drawing, and each time a button is depressed a coordinate is committed to the computer's memory.) Once this information has been entered, the computer has a schematicized three-dimensional record of what the object will look like; as a

cluster of spatial relationships it is capable of reviewing from any conceivable angle and distance.

This schematic representation must then be fleshed out with pixels to provide the illusion of solidity. In practice the form is first built up from tens of thousands of tiny polygons which can later be smoothed, as if with electronic sandpaper, and polished. The solid object, when it first appears on screen, tends to be marred by jagged edges. The most common form of "the jaggies" is a phenomenon known as "aliasing," which occurs along diagonal edges and can be countered or compensated for in various ways. (Aliasing is to computer graphics what matte lines are to blue-screen photography.) If the software has provided the computer with sufficient algorithmic ingenuity (no easy matter), it will be possible to request that the object, or even a part of the object, be given the transparency of glass, the reflectivity of chrome, the dullness of lead.

For digitized raster graphics of this sort, then, the computer needs a mathematical description of the object (or objects) and information about light sources (to know where shadows and highlights should fall) and about viewpoint ("the object is to be seen from below, as if from a distance of fifteen feet with a 28mm lens"). Given all this, the computer, in the hands of the right user, can perform miracles. It can, many of its advocates believe, counterfeit reality and take over (just for starters) many of the functions of the conventional special effects house.

There is one very practical reason why the miniatures in *Star Wars* and similar movies are retrofitted with hundreds of tiny parts from model kits, details that break the surfaces of the models into elaborate patterns of light and shadow. With smooth, metallic, and shiny surfaces, those models would be a cinematographer's nightmare, since they would tend to pick up reflections of lights and camera and anything else that happened to be on set. Computer-generated space vehicles, on the other hand, can be as shiny and mirror-like as is wanted, since the computer contains nothing for them to reflect (unless it is put there).

Total naturalism is the goal of many people in the CGS field, hence they prefer to talk of synthetic imagery or scene simulation rather than computer graphics. CGI's first large-scale excursion into the world of feature movies, however, held back a little from this ultimate goal while giving audiences an intriguing glimpse of what the future might hold.

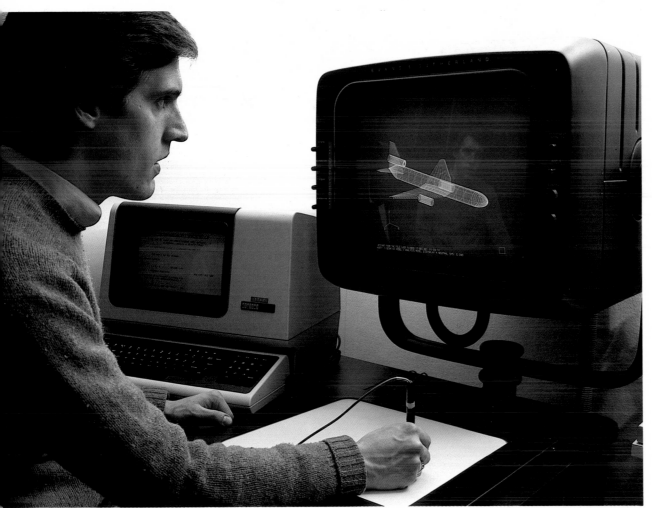

© Gerhard Gscheidle 1983

210. This state-of-the-art graphics work station at R/Greenberg is part of an Evans and Sutherland imaging system. The artist is using an electronic stylus and a digitizing tablet to make input into the system.

211–213. Digital Effects of New York used photographs to create the data base for "Times Square." Once the buildings and street furniture were stored in the computer's memory, it became possible to call up a view of Times Square from any "camera angle."

"Times Square 1932" © 1979 Digital Effects Inc.

20. The Making of Tron

Walt Disney's name will be forever linked to the masterpieces of traditional animation (though there was nothing traditional about *Snow White* or *Fantasia* when they were produced; on the contrary, they were highly innovative). There is every reason to suppose, however, that Disney would have been, had he been alive, one of *TRON*'s most enthusiastic supporters, for he loved technological novelty. The man who developed Audio-Animatronics® and thought up EPCOT Center would have been quite at home with electronically animated light cycles and solar sailers.

TRON, a 1982 film from Walt Disney Productions, concerns a computer programmer called Flynn (Jeff Bridges) who suspects that Dillinger (David Warner), the boss who has just fired him, is up to no good. Attempting to penetrate Dillinger's computer system, Flynn finds himself "digitized" and transported into an electronic universe peopled by the personifications of programs including the villainous Sark (Warner again) and the heroic Tron (Bruce Boxleitner). This is a universe dominated by the evil Master Control Program. Survival there involves playing and winning lethal electronic versions of gladiatorial games.

TRON was the brainchild of a young animator, Steven Lisberger, who had moved to Los Angeles from Boston in 1977.

It was his belief that the story could be told, with the exception of a live-action prologue, with a combination of conventional backlit animation and computer-generated imagery, both of these techniques being suitable to the simulation of arcade game-type imagery. One of the computer graphics companies he contacted was Information International Inc. (Triple-I), where he encountered Richard Taylor, who had recently left Robert Abel and Associates. Taylor liked Lisberger's idea and made a suggestion that was to make the whole project more practical from an economic point of view. High-quality hand-drawn animation is incredibly expensive. Why not, Taylor asked, use live action as the basis for the backlit artwork?

The technique he suggested is simple enough. The actors are dressed in white costumes overlaid with a pattern of black lines, representing computer circuits, and filmed in black limbo. Each frame is blown up into a large black-and-white transparency that can be reshot on an animation stand. The faces remain human but the figures are reduced to an almost cartoon-like web of lines. Lit from behind they can be made to glow as if illuminated from within. Colored filters and diffusion gags can be used to enhance the effect, and the results can be composited with, for example, a computer-generated background. (Alternatively, the actors can be shot on a set that

is itself an aggregation of black and white lines, like a high-tech woodcut, then the whole thing can be backlit. Both approaches were employed for TRON.)

Lisberger and his partner Donald Kushner had hoped to finance the film independently, but when this proved impossible they turned to the Disney organization. The Disney people were interested from the first but apparently had some doubts as to how well the backlit live-action method would work. Lisberger shot some test footage featuring a Frisbee champion in a black-and-white high-contrast costume, then spliced it together with computer-generated imagery from Triple-I and MAGI/SynthaVision. After looking at this reel, the Disney people agreed that the project was indeed feasible, and the wheels were set in motion.

The group that was subsequently assembled included names that will be familiar from earlier chapters. Harrison Ellenshaw was named associate producer, acting as the key link between the Lisberger team and the Disney establishment. He also served as one of two visual effects supervisors,

the other being Richard Taylor, who had particular responsibility for computer-generated imagery. Robert Abel and Associates was called upon to provide some of this computer imagery, and Syd Mead was brought in as one of the artists who could visualize the electronic world.

Picturing that world was the first order of business. Lisberger had already storyboarded the film, but Disney wanted the boards modified and requested input from Mead and two other designers. Mead designed most of the vehicles, such as Sark's carrier and the light cycles. Jean Giraud—better known as "Moebius"—designed costumes suitable for an electronic world, and Peter Lloyd was given the task of imagining environments.

To produce the necessary computer-generated imagery, Disney contracted with Abel and three other companies, Triple-I, MAGI, and Digital Effects, Inc. Abel's main contributions

214. Sark (David Warner), the villain of **Tron**'s electronic world.

215. Tron's live-action performers (here Bruce Boxleitner) were sometimes shot on black sets decorated with white vector lines. Eight-by-ten-inch transparencies were made from each frame and served as a basis for backlit animation, a technique that allowed artists to fill the screen with flourescent glows and simulated electronic effects.

would be the title sequence and the key scene in which Flynn enters the electronic world, a shift from conventional live action to futuristic-looking vector graphics. Digital Effects created a single character, the Bit, and a short sequence at the beginning of the movie. The bulk of the raster imagery, which constitutes approximately sixteen minutes of the film, was divided up between MAGI and Triple-I.

One reason these companies were chosen is that they were among the few that could guarantee imagery of sufficiently high resolution to stand projection onto a theater screen. In practice this meant that they had to work with two thousand lines of resolution or better, and Triple-I in fact had a system capable of four thousand lines of resolution.

MAGI, it will be remembered, employs a data base that enables its operators to build imagery from a selection of geometric primitives. This method of working has its limitations, in terms of the kind of forms that can be generated, but it is relatively fast since the computer's memory bank already contains many of the coordinates that are required. Richard Taylor was quick to see that MAGI's system would be best suited to creating the various vehicles—the light cycles, the tanks, the Recognizers (huge police robots)—which, as conceived by

Syd Mead, were in fact made up of clusters of geometric solids. Triple-I's digitizing approach, by contrast, was better suited to the more organic and realistic imagery needed toward the end of the movie as Flynn and his companions cross the "sea of simulation" in a commandeered solar sailer, on their way to confront the Master Control Program. This division of labor worked out very well. As Harrison Ellenshaw explains it, it was rather like building the transcontinental railway. "MAGI started at the beginning, Triple-I started at the end, and they met in the middle."

Whichever company was involved, the method of working with the Lisberger/Disney production team was basically the same. Once the data base for the tanks, say, or the solar sailer had been established, it was a matter of animating the various elements, and that involved much the same skills that traditional animators have employed since Winsor McCay introduced Gertie the Dinosaur. Bill Kroyer and Jerry Rees provided storyboards for every script change, and now they began to draw special boards for the computer-generated scenes, "comic-strip" sequences of drawings that showed what should appear on screen and how it should change every twenty-four frames or so. Neither Kroyer nor Rees had worked

216. Computer-generated title imagery from **Tron**, one of Robert Abel and Associates' contributions to the movie.

217. Abel's vector-graphics system was also used to generate imagery for Flynn's journey into the electronic world, from which this frame is taken.

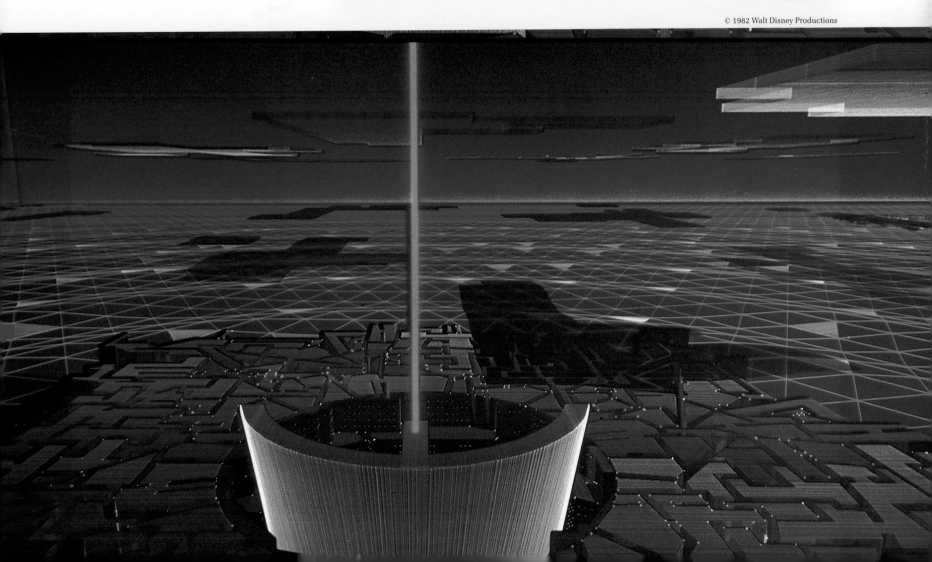

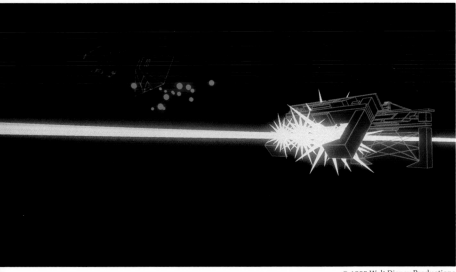

218. A recognizer (police robot) under attack. The recognizers were among MAGI/Synthavision's contributions to the movie.

219. This tank (below) was generated using MAGI/Synthavision's system of geometric primitives.

220–222. Among the most spectacular moments in **Tron** (opposite) are those provided by the light cycles, another of MAGI's contributions to this innovative film.

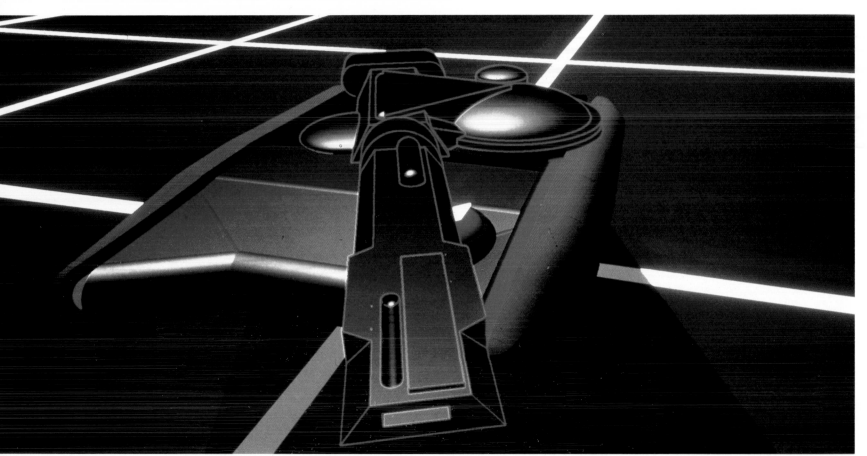

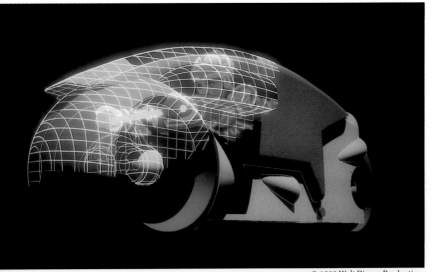

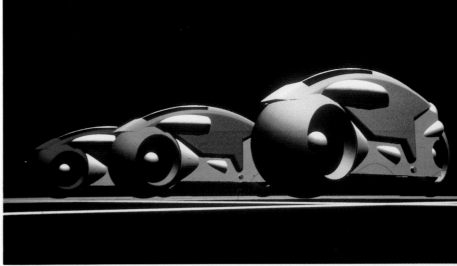

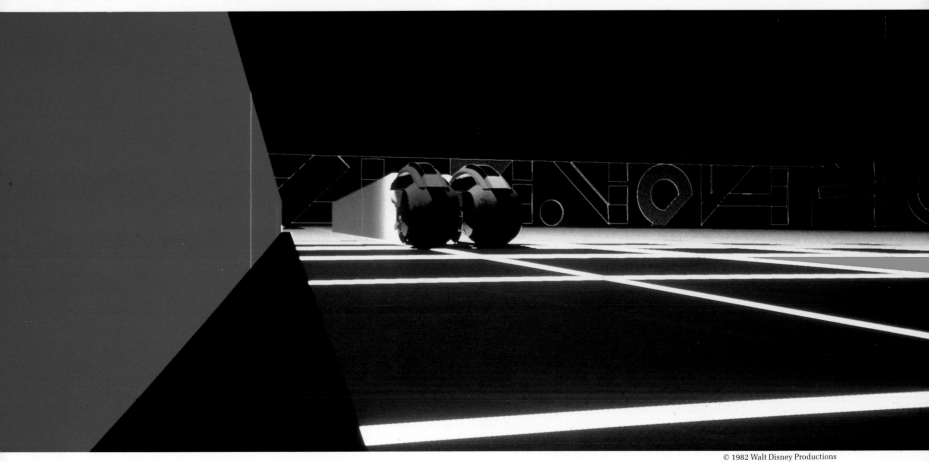

229

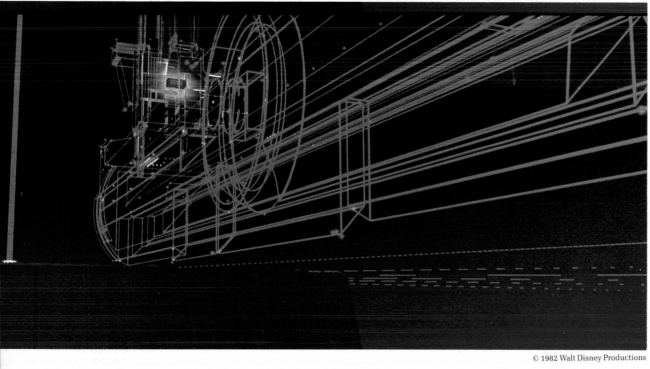

223–224. Sark's carrier, one of the most elaborate vehicles created for **Tron**, was a contribution from the movie's other chief CGI contractor, Triple-I (Information International, Inc).

225. Triple-I's digitizing system was used to generate the graceful Solar Sailer, seen on the opposite page.

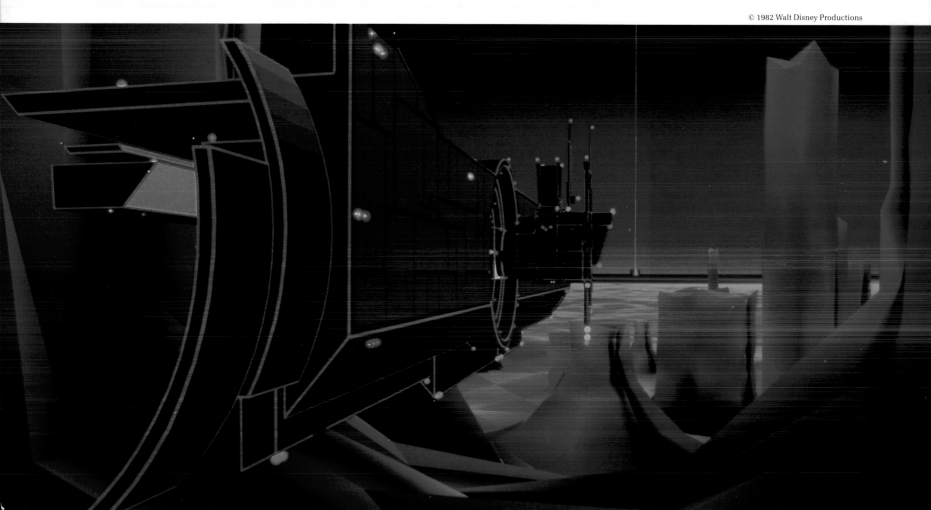

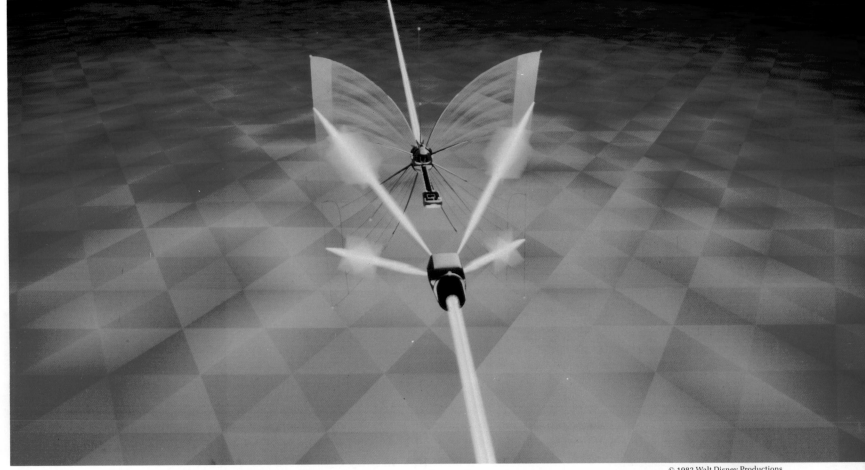

with computers before and so relied on Richard Taylor for hints about what the machines were capable of, but they found the situation easy enough to adapt to. Once they had assembled the boards and ancillary materials for a given scene, they would go over the material with the programmers, who would set about reproducing what the boards specified as exactly as possible, sometimes making suggestions of their own.

The first step was for the CGI companies to present "pencil tests"—actually low-resolution vector renditions—of the scene in question. An interesting situation derived from the fact that MAGI was located on the East Coast while the production was based in California. At first, MAGI's pencil tests had to be sent by courier out to Burbank for approval, but then a compatible display terminal was installed in the office oc-

cupied by Kroyer and Rees, and MAGI was able to "call in" its pencil tests by phone line. Once the pencil test was approved, work would begin on fleshing out a key frame with color and texture. Again MAGI could send samples by phone to the one-thousand-line monitor at Disney Studios.

Apart from the wholly computer-generated scenes, many shots had computer-generated backgrounds. Live action for such scenes would be filmed on a schematic set covered with nonreflective, flocked black paper. In most instances a locked-off camera was used, and at the end of each take a few frames were deliberately overexposed so that the structural outlines of the set were recorded from the camera's point of view, supplying information about shapes and perspective that could be fed into the computer to provide it with a data base for matching the backgrounds to the existing live action. For some

scenes Richard Taylor was able to institute the system of "witness points." If four such points (they might consist of low-wattage flashlight bulbs) could be strategically positioned about the live-action set, their locations, if accurately reported to the computer, could be used as coordinates relating to the model of the background encoded in the computer's memory. This system allowed for moving camera situations since, instead of a locked-off camera, you could deal with a data base that was locked into the coordinates supplied by the "witness points."

One thing that was quickly discovered was that a movie of this sort was not inexpensive to produce. Disney had initially budgeted the film in the $13 million range. The final cost was substantially in excess of that sum, but it should be emphasized that the computer-generated sections of the movie were not principally responsible for the overrun. The main culprit was the backlit live-action animation, which worked extremely well but proved to be far more time-consuming than anyone had anticipated. It wasn't simply a matter of taking a large black-and-white Kodalith transparency and backlighting it on an animation stand. The animation director might want one part of the image to glow red while another part seemed to flare with white and yellow light, and at the same time it would be necessary to maintain a more or less normal gradation of skin tones on the actors' faces. This would involve multiple passes on the animation stand, with different colored filters and diffusers used for each pass. Moreover, each pass would require a hand-drawn matte to mask off sections of the Kodalith that were not to be exposed.

When it was realized just how many of these hand-drawn mattes would be needed, a sense of shock set in, and not quite sane proposals began to circulate. It was seriously suggested, Harrison Ellenshaw reports, that five hundred high school students be assembled in a gymnasium or some other suitable location for a weekend of intensive mattemaking. In the end the problem was solved, at considerable expense, by shipping much of the work to Taiwan. Once the mattes were drawn, however, there was still an enormous amount of effects animation to be done. Even the Disney Studio did not own enough animation stands to handle the load, and assignments were farmed out to smaller animation houses all over Los Angeles.

Finally TRON was completed, on time, and released with great fanfare. Within days it became apparent that the movie would be a grave disappointment at the box office. Its failure, however, should not be blamed on computer-generated imagery (or on backlit animation either).

Steven Lisberger's overall concept was sound—a movie that takes you inside an arcade game was a solid commercial idea—and he did a remarkable job in putting a highly original package together. Unfortunately, his screenplay was not up to supporting the package. The live-action scenes are clumsily conceived, and action in the electronic world is occasionally hard to follow. Flynn and his digitized alter ego are cursed with some of the worst smart-aleck dialogue ever to reach the screen. Mickey Rooney would have choked on it.

Flynn is, in fact, such an unsympathetic hero that it is hard to stay with him up to the point where he is digitalized. The moment he enters the electronic world, however, things begin to pick up, and the highpoints of the movie are all supplied by the computer-generated effects. The light cycles in particular—speeding across their luminous grid, making hair-raising right-angle turns to avoid collisions—are as exciting as anything in Star Wars.

Despite its many shortcomings, TRON is a landmark movie. Unfortunately, because of its box-office failure, it may have provided computer-generated imagery with a setback, as far as theatrical film production is concerned. It seems certain, however, that the setback is only temporary. Within the near future, the kind of imagery that enhanced TRON will be taken for granted in the movie world.

21. Simulation

The computer-generated sequences of *TRON* feature a kind of imagery that could, in theory, have been drawn by hand. In practice it would take a gifted animator days to work out perspective shifts that the computer can calculate in nano-seconds, but, given unlimited time and money, the tanks and light cycles could have been brought to life on a conventional animation stand.

In the view of many people, however, the time is upon us when the computer will be able to take on graphic tasks of a wholly different order, including the simulation of reality. All that is needed for realistic scene simulation, in fact, is a computer that devours numbers the way a whale devours plankton and software capable of conveying to that computer what, for example, a suburban garden looks like at six P.M. on a spring evening. Or at six A.M. on a fall morning.

Already, of course, the computer is quite capable of storing and reproducing the basic forms that would constitute such a setting. When you begin to consider the colors and textures that make the scene seem real to a viewer, however, a quantum leap has to be made. Think of the thousands of details that the computer must deal with in this one scene, all of them related, in its language, to the way a given object reflects or absorbs

light. It must know about grass and leaves, and not just any leaves but specifically the leaves of the aspen that the art director has allocated to one corner of the garden, and the leaves of the privet hedge he has asked for just beyond the swimming pool. Then there is the pool itself. How does its surface respond to light slanting in from the east on a breezy morning? And to light slanting in from the west on a still evening? And what about the leaves that have fallen into the pool, some of them waterlogged, some recently settled on the surface of the water? Then there is the rusty barbecue and the plastic garbage can. All of these items, and hundreds more, have to be described to the computer in precise terms. And, since the computer is capable of rendering infinite depth of field, distant objects may require as much information as those that are closest to the chosen viewpoint. Where repeatable elements (leaves, grass) are concerned, that may be no imposition. One of a kind elements, however—a weather vane on the roof of the house next door—are likely to be a nuisance, and it might often be preferable to have the computer imitate the inefficiency of a camera lens, so that things at a certain distance are allowed to slip out of focus. In any case, skimp on your detail and the scene will look inauthentic and unconvincing.

226. An imaginary ''Moonscape'' from Digital Productions demonstrates how scene simulation can now deal with delicate color gradations and atmospheric effects.

227. The ''Cray Temple'' (opposite top) was designed and encoded at Digital Productions in 1982 to demonstrate the sophistication of the company's imaging system.

228. Steve Williams, then of Digital Productions, used the Cray-1 computer to generate this portrait of itself.

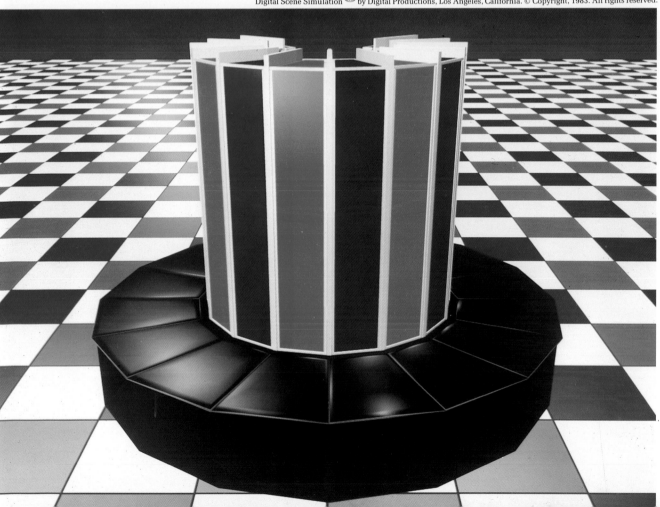

This daunting task has not prevented some of the best minds in both the computer industry and the movie industry from giving the matter very serious thought, and much progress has been made already. But even if the algorithms to solve every conceivable problem are already on file in your data bank, you are still going to need almost inconceivable computing power to make real use of them. At the time of writing, only two companies seem to be close to having the hardware that will make this possible. Interestingly, these companies appear to be following divergent paths, both with regard to problem-solving and to overall aims.

Digital Productions of Los Angeles is headed by John Whitney, Jr.—son of slit-scan inventor John Whitney, Sr.—and software expert Gary Demos, who previously formed a team at Triple-I. Whitney and Demos have the stated aim of achieving naturalistic scene simulation, and their chosen tool is a Cray-X-MP/2300 Supercomputer.

The term supercomputer is not used idly. Seymour Cray, its builder, is a legend in the digital processing world. At Control Data Corporation he designed one of the world's first solid-state transistorized computers, the CDC-1604, which estab-

lished that company firmly as a major force in the industry. Still at Control Data, Cray and James Thornton developed the CDC-6600, the supercomputer of the mid-'60s, some of its circuits capable of switching back and forth at a then incredible thirty million times a second. In 1971, Cray set up Cray Research, and the 1S/1300—the X-MP's predecessor—which, when it appeared, was generally acknowledged to be the fastest computer in the world (its most serious competition coming from Control Data's Cyber 205, for which Cray had laid out the basic architecture).

The Cray-X-MP retails for around $10.5 million but can perform four hundred million arithmetical calculations per second. There are only ten or so in existence and each is surprisingly compact—about the size of a wardrobe—and rather elegant, with transparent panels in the housing that permit an intriguing view of the circuitry within. The X-MP demands formidable nonelectronic peripherals. It operates at such blistering speed, for instance, that it cannot function without the support of a sizable freon cooling system.

The Cray is a number-crunching brute but it is, nonetheless, a general purpose computer much like the more modest machines found in any office or manufacturing plant. Digital Productions happens to use its X-MP to generate imagery at video display terminals, but the same computer would be equally useful to the Pentagon, an aerospace contractor, or the U.S. Census Bureau.

Lucasfilm's computer development division offers a rather different approach. George Lucas is taking the future of CGI very seriously and presumably could afford to buy or lease a Cray. His team, however, has gone in another direction. Instead of acquiring a high-performance general purpose computer, it has decided to build its own device, with performance comparable to the Cray but with architecture customized to suit Lucasfilm's specific needs.

With regard to computer-generated imagery, the advantages of such a system are easy enough to understand. Certain of the decisions that must be made in a graphics situation remain

229. This "digital pencil" was simulated at Digital Productions using their Cray supercomputer.

230. This enormously complex scene simulation, "Point Reyes" (opposite) was produced by Lucasfilm's computer division. A team effort, the image capitalized on programs developed by Alvy Ray Smith, Loren Carpenter, Tom Porter, Bill Reeves, and David Salesin. Rob Cook also wrote software as well as directing the picture and designing many of its details.

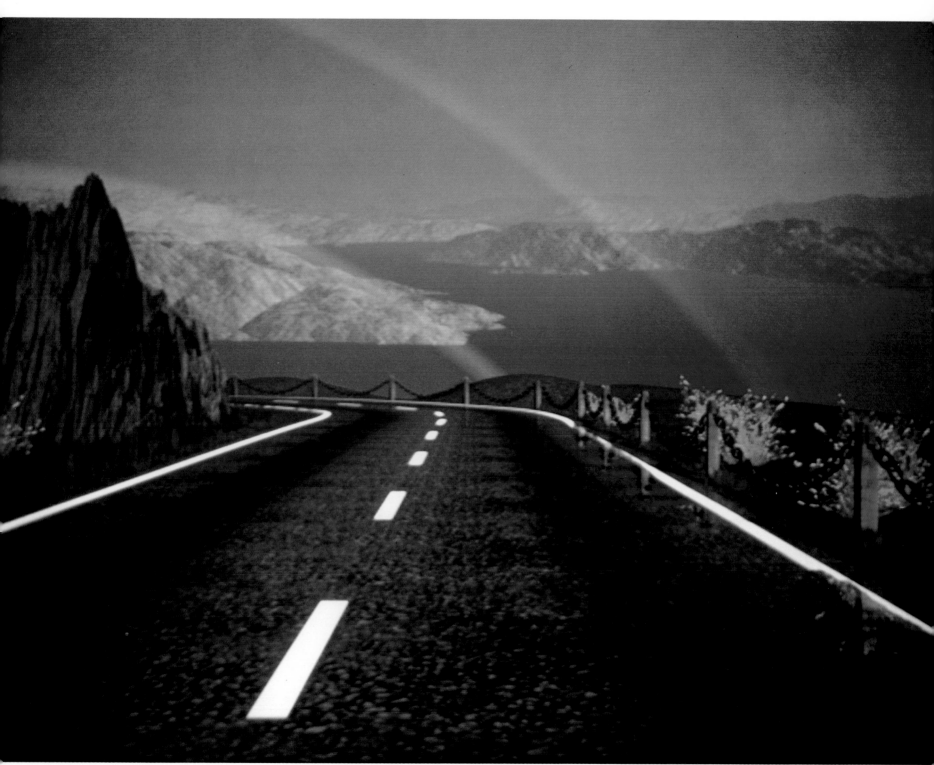

constant. Decisions about reflectivity, for example, are governed by specific physical laws, but a general purpose computer must be reminded of those laws for every single frame it generates and must make millions of calculations each time to implement those laws. A somewhat dedicated graphics system could incorporate circuits that applied those laws automatically, thus avoiding much repetitive arithmetic.

One potential disadvantage of such an approach is that any advanced computer system takes years to design, build, and debug. By the time you have it on line, it may be out of date. In other words, a Cray might not be designed for graphics work, but its sheer firepower makes it a force to be reckoned with. A more specialized computer may be more efficient within its limits, but those limits may still place it at a disadvantage in comparison with the X-MP. Only time will tell which approach makes more sense.

The Lucasfilm group, headed by Ed Catmull, includes some of the top talent in the field, people like Alvy Ray Smith (project leader for CGI) and Loren Carpenter. The machine they are building is designated the PIXAR and apparently will incorporate such dedicated functions as automatic antialiasing. What exactly Lucas plans to do with his graphics system,

when he has it, is open to speculation, though Catmull has given hints that the group's aims are somewhat different from those that prevail at Digital Productions. (Graphics aside, the Lucasfilm computer division is also involved with such experimental areas as digital sound and new video editing techniques, as well as having a contract with Atari to develop electronic games.)

During a 1982 seminar at Pratt Institute in New York, Catmull indicated that he believes there is a limit to what can be achieved in the area of scene simulation, at least within the constraints of existing technology. "Real things are very complex in detail," he explained, "with much roughness and irregularity, complex lighting, etcetera. . . . A picture of one chair doesn't necessarily lead to a hundred more chairs. In other words, we must be careful not to extrapolate beyond what we can do. There's too much detail in real life to emulate completely on film. It's just too dangerous." He went on to say that the computer is incapable of reproducing certain things, such as human hair, and expressed the opinion that the main goal of computer-generated imagery should not be the simulation of absolute reality but, rather, the evocation of perceptions of reality as viewed by an artist. (The splendid scene simula-

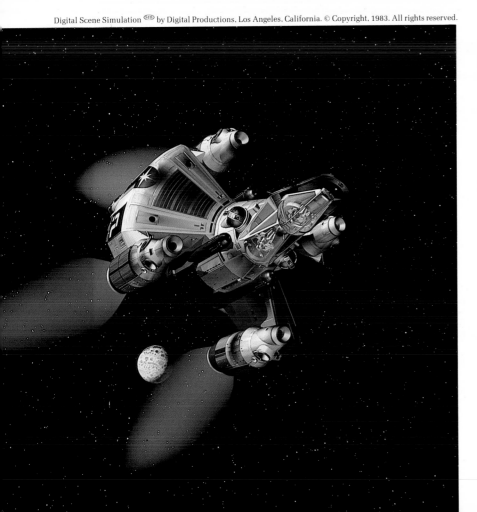

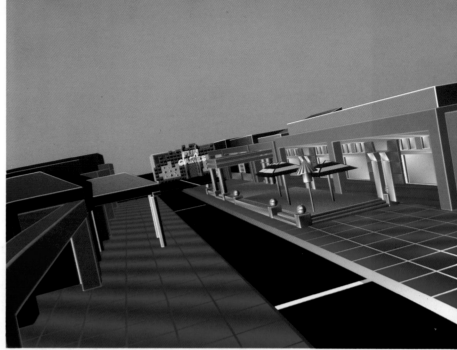

231–232. These images from the 1984 film **The Last Starfighter** (opposite) show how Digital Productions Cray X-MP computer is capable of generating scene simulations of a quality that is comparable with the results achieved, for movies like **Star Wars**, with the more conventional means of motion-control photography and miniatures.

233–235. In "Starfrontiers"—a commercial with computer-generated imagery created by Digital Productions—an alien space vehicle zooms down to earth and invades the main street of a small midwestern town.

tion for the "Genesis Effect" in *Star Trek II* was, of course, done with the aid of Lucasfilm's present minicomputers.)

John Whitney, Jr., by contrast, is very emphatic in his belief that the computer can produce a convincing facsimile of absolute reality. "At Digital Productions," he says, "we are dedicated to being able to simulate live action. . . . It's a question of being able to put enough visual clues on screen to telegraph to us, as perceptual organisms, that we are in a familiar world. We want to put enough information, enough detail into the computer to provide an alternate means of creating that familiar world. . . . We want to be free of the stigma of science fiction, free of the stigma of computer-generated *graphics*. We want to produce computer output that is, in effect, live action."

His partner Gary Demos told *Computer Graphics World*, in 1983, "At Triple-I our efforts were aimed at the specification of scenes by assembling the scene and analyzing light and shadow detail. In scenes that are as complex as we are dealing with (at Digital Productions), there is too much data to work with the details—especially in dynamics. In such a case you need one of two things: either an extremely intelligent program or a default system that can deal with movement. In fact, you probably need an intelligent default program. You need a program that can handle a scene according to the laws of physics. We are working on putting that sort of program together."

A program "that can handle a scene according to the laws of physics" is a fascinating notion and hints that there may be ways around the apparent impasse of needing to describe an almost infinite variety of details in order to simulate reality. Demos' statement seems to imply a degree, at least, of artificial intelligence, suggests that in this realm of the simulation of reality the computer can perhaps be programmed to take physical laws into consideration and make decisions that would normally be referred back to the human user of the system.

Whatever algorithms Demos and his associates are hatching (and visitors to Digital Production's plant are required to sign an agreement designed to protect the company's secrets), this is clearly a software-intensive system, dependent on the power of the Cray X-MP/2300. Whitney and Demos believe that this approach will give them a far greater flexibility than is possible with a specialized machine of the type Lucasfilm is developing. It is their argument that software can be modified with relative ease, while even modest changes in hardware can be a major nuisance.

(Interestingly both Digital's partners and Ed Catmull have strong links to CGI pioneer Ivan Sutherland. In the mid-1970s, Whitney and Demos worked with Sutherland on developing graphics software. At the same period, Catmull was a star graduate student at the University of Utah, in Sutherland's department. Evans & Sutherland's flight simulator displays—with their need for fast response, real-time animation—incorporate some of the ideas that are likely to find their way into the Lucasfilm graphics system.)

Another difference between Lucasfilm's computer division and Digital Productions is that the Lucas group is part of an organization that has the most phenomenal track record in the recent history of the entertainment industry. It can afford to take its time, within reason, to achieve its goals. Digital Productions has to prove itself in the marketplace while justifying the huge overhead that comes along with the Cray X-MP. So far they seem to be off to a solid start, the commercials division under Sherry McKenna having acquired several prestigious accounts, while the company is supplying approximately forty minutes of footage for Lorimar's space movie *The Last Starfighter*.

"The Cray is expensive," Whitney admits, "but that is misleading because it gives us cost-performance superiority. The smaller machines seem cheaper, but when you add up the cost per bit, the Cray performs much more efficiently."

To match the Cray's computer power, Digital Productions has been equipped with state-of-the-art graphics peripherals, giving the company the capability of producing images with a resolution of six thousand by four thousand lines.

Asked what his long-term ambitions for the system are, Whitney provides a startling reply: "Our notion is to use the computer to create lifelike characters who are modeled after known personalities. . . . It will take five or ten years to solve the problems, but it will be possible to create the likeness of a human being with such a degree of precision that the viewer won't be able to tell what's wrong with it. It's not just the appearance either. It'll be possible to generate speech electronically, and the result will evoke an emotional response.

"We may be able to re-create stars of the past—Clark Gable or Rita Hayworth—cast them in new roles, bring them forward in time into new settings. . . . If stills and old films can be used to make the likeness—the data base. You only have to encode once. Then you've got John Wayne, say, on file. You can put him into any role you can simulate."

22. The Future

Does the world need films featuring synthetic likenesses of John Wayne or Clark Gable? For some the whole idea may smack of necrophilia, and there are experts in the field of CGI who will tell you that such a simulation of human beings is impossible anyway. It should be admitted, though, that John Whitney and Gary Demos are experts too, and should they succeed in putting a convincing John Wayne on screen—one who seems to think and express emotion—it will stir up considerable interest outside the entertainment industry, among behavioral scientists, for example.

What is beyond doubt is that machines like the Cray and Lucasfilm's PIXAR will be capable of producing imagery of great complexity—close to that which Whitney and Demos are aiming for—within the relatively near future. And it might take only one breakthrough in semiconductor technology, or the very large-scale integration of circuitry (VLSI), to bring the computing power of a Cray within the reach of many other practitioners. Whichever way things go, the next few years will yield startling results in the area of computer-generated imagery. Eventually this is likely to have an impact on the world of conventional special effects, but how much of an impact, and how soon, is open to speculation.

A number of companies—Lucasfilm and Digital Productions included—have put a good deal of research and development time and money into production of a digital printer. This describes the application of CAD/CAM technology to the kind of tasks normally performed by the optical printer. In particular it promises to be an extremely efficient way of generating mattes, allowing great subtlety in terms of hardness or softness of edge. Digital printers of limited capability are in fact already in use—Van Der Veer Effects has enjoyed some success with its prototype—but the miracle tool awaited by the movie industry for several years is still not available. (In the experimental days of computer technology there was a rule of thumb called Von Neuman's law—named for the great mathematician—which stated that a new piece of hardware is always one year from going "on the air." Von Neuman's law now applies to the digital printer, real-time raster graphic animation and many other promised wonders of the electronics age.)

The digital printer will be a reality, sooner or later, and the question arises, if matte windows can be generated electronically, why not generate the images that slot into them the same way? In other words, can the miniature department be replaced by computer-generated imagery?

In theory, at least, the answer is yes. The kind of space vehicles that were featured in *Star Wars* can easily be simulated with today's electronic technology, and a graphics terminal would permit you to make even more complex moves on them than you could make on a model with a motion-control camera. For the time being, however, it would be cheaper to construct a model and shoot it in the normal way. If, on the other hand, you needed fifty identical spaceships on camera at the same time, it might soon be cheaper to generate the imagery with a computer. (Once you have described the prototype to the machine it can mass-produce images of that form seen from any distance and at any angle.)

As things stand today, it is sometimes cost efficient to use conventional special effects tools to simulate computer graphics. Suppose, for example, a script calls for a vector graphics rendition of an intercontinental ballistic missile, you can generate the image with a computer or you can have your model shops make a three-dimensional wire-frame model of the missile. Coat that model with luminous pigment, mount it on a model-mover, light it appropriately, and shoot it rotating against a black backing, and you will have something most people will take for a computer-generated image, without going to the trouble of translating a video image—however high its resolution—to film.

The difference in character (not necessarily quality) between film and video is also likely to be a big factor in any decision involving a choice between conventional special effects and computer-generated imagery. Anyone under the age of thirty-five has grown up taking television imagery for granted, but even so, film has retained its special place as the means by which theatrical movies are shown. The grain, the texture have a special look that video cannot reproduce (even

when transposed onto celluloid). Video images can now be more highly resolved than film images, but video has the stigma of being the "cheap" medium, the medium of free home entertainment. For movie traditionalists it will require a major psychological shift to accept video, however refined, as being the equal of film.

It may well be, however, that a generation that accepts rock "videos" as a de facto art form and is exposed to first-run movies by way of Home Box Office or Showtime, will find video preferable to film. A couple of decades from now, Eastman 5293 color negative may be looked on with the kind of polite veneration that is today reserved for painters who try to revive the art of fresco.

As microchips become smaller and are yet able to handle more information, as video discs replace frame buffers, computer-generated imagery will increasingly find itself in the position to challenge traditional special effects techniques. Yet logic does not always apply in this area. Where entertainment is concerned, audiences demand a particular look. As long as film provides that look, traditional effects technology will survive.

236. This "Chrome Dog" (opposite), created by Gene Miller at MAGI/ Synthavision, demonstrates how a computer-generated image can be combined with a real background (the MAGI parking lot). The dog was assembled, as is usual at MAGI, from geometric primitives. The reflections were achieved with the aid of a silver Christmas tree ball, which supplied the wide-angle view of the parking lot.

237. The rock group Devo used this computer-generated hat, produced by Digital Productions, as a backdrop.

BIBLIOGRAPHY

PERIODICALS

The special effects film is fortunate enough to be served by one of the best magazines in the entire motion picture field. Published and edited in Riverside, California, by Don Shay, *Cinefex* is an elegant quarterly characterized by detailed, authoritative essays on effects topics (some of the best are written by Shay himself) and interviews with top professionals in the field. A typical issue will contain two or three longish articles, but every so often an entire issue is devoted to a single subject (such as the career of Willis O'Brien or the making of *Blade Runner*). Copiously illustrated in color and black and white, *Cinefex* carries virtually no advertising, and its existence is one of the miracles of the publishing world. As a research tool it is invaluable.

Published by the American Society of Cinematographers, *The American Cinematographer* covers all aspects of filmmaking and often devotes considerable space to special effects. In recent years it has carried a number of valuable historical pieces by ASC veterans in the effects field. *Cinefantastique* is another monthly that prints a good deal of seriously researched matter relating to effects work, while *Millimeter* is especially strong on the use of special effects in the area of television advertising.

In the burgeoning field of computer and video magazines there are dozens of publications that carry, from time to time, useful articles on computer-generated imagery. Periodicals I have found useful include *Byte*, *Computer Pictures*, *Videography*, and *Digital Design*.

BOOKS

Anyone who wants to know more about the technical aspects of special effects should read Raymond Fielding's *The Techniques of Special Effects Photography*, published by the Focal Press, London and Boston. First issued in 1965 and most recently updated in 1972, this book is the standard guide to the basic technology of the effects industry.

Other books I have found useful in my research include the following:

Agel, Jerome (ed.). *The Making of Kubrick's 2001*. New York: Signet, 1970.

Blesh, Rudi. *Keaton*. New York: Collier Books, 1971.

Bonifer, Michael. *The Art of Tron*. New York: Simon and Schuster, 1982.

Brosnan, John. *Future Tense: the Cinema of Science Fiction*. New York: St. Martin's Press, 1978.

————. *Movie Magic: the Story of Special Effects in the Cinema*. New York: St. Martin's Press, 1974.

Brownlow, Kevin and Kobal, John. *Hollywood, the Pioneers*. New York: Alfred A. Knopf, 1979.

Brownlow, Kevin. *The Parade's Gone By*. New York: Alfred A. Knopf, 1968.

Call, Deborah (ed.). *The Art of the Empire Strikes Back*. New York: Ballantine, 1980.

Croce, Arlene. *The Fred Astaire and Ginger Rogers Book*. New York: Galahad Books, 1972.

Culhane, John. *Special Effects in the Movies*. New York: Ballantine, 1981.

Deken, Joseph. *Computer Images: State of the Art*. New York: Stewart, Tabori and Chang, 1983.

Low, Rachael, and Manvel, Roger. *The History of the British Film, 1896–1906*. London (England): R.R. Bowker, 1948.

MacGowan, Kenneth. *Behind the Screen*. New York: Delacorte, 1965.

Maltin, Leonard. *Behind the Camera*. New York: Signet, 1971.

Ott, Frederick W. *The Films of Fritz Lang*. Secaucus, N.J.: Citadel Press, 1979.

Pohl, Frederick, and Pohl, Frederick IV. *Science Fiction: Studies in Film*. New York: Ace Books, 1981.

Pollack, Dale. *Skywalking, The Life & Films of George Lucas*. New York: Crown Publishers, 1983.

Pratt, George C. *Spellbound in Darkness*. Greenwich, Conn.: New York Graphic Society, 1973.

Rhode, Eric. *A History of the Cinema, from its Origins to 1970*. New York: Hill and Wang, 1976.

Spoto, Donald. *The Dark Side of Genius: The Life of Alfred Hitchcock*. Boston, Mass.: Little, Brown and Company, 1983.

————. *The Art of Alfred Hitchcock*. New York: Dolphin Books, 1976.

Thomas, Tony, and Terry, Jim. *The Busby Berkeley Book*. Greenwich, Conn.: New York Graphic Society, 1973.

Titelman, Carol (ed.). *The Art of Star Wars*. New York: Ballantine, 1979.

Walker, Alexander. *Stanley Kubrick Directs*. New York: Harcourt Brace Jovanovich, 1971.

GLOSSARY

NOTE: This glossary lists only the most basic special effects terms. Even so, usage varies from coast to coast and even from studio to studio. (To give a single example, what is commonly called backlit animation in Los Angeles is generally referred to as bottom-lit animation in New York.) A single discipline may have two or more titles, while a given term may have a rather loose meaning for one effects man but a very specific meaning for another. In compiling this glossary I may have been guilty of displaying a slight West Coast bias, since California is still the center of the special effects industry. For the most part, though, I have supplied alternative terms where this seemed useful, and in the scope of my definitions I have been guided mostly by common sense.

AERIAL-IMAGE PRINTER Usually a modified ANIMATION STAND or OPTICAL PRINTER, an aerial-image printer capitalizes on the fact that a projected image can be suspended in thin air. That is to say, if you focus a projected image on a white card then remove that card, the image will still exist, perfectly focused in space but invisible to the human eye. A camera's optical system focused on the same plane, however, can pluck that image out of the air and imprint it on film in the usual way. If partly opaque, partly transparent artwork is introduced at the focal plane, the aerial image and the opaque parts of the artwork will be combined in the camera.

For example, to superimpose a title over a background scene already shot, the title would be painted on a sheet of transparent plastic (a CEL), and the cel would be placed at the focal plane of the projected background image. The camera could then record a COMPOSITE of title and background. The aerial-image printer can also be made to perform many of the tasks usually assigned to a standard optical printer.

ANIMATION STAND A tool initially developed for the production of animated cartoons, the animation stand lends itself to many special effects applications. Its key components are an animation camera (one able to shoot a single frame of film at a time) and an easel (sometimes called the "bed") capable of holding artwork in register. The camera can always move in relation to the artwork, and, in all but the most primitive models, the artwork can be made to move (rotate, etc.) in relation to the camera.

There are two basic formats. A vertical stand (sometimes called a "downshooter") has a camera mounted on a column, or columns, aimed downward at a horizontal easel set into a special table. A horizontal stand has a camera running on horizontal tracks which shoots artwork mounted on an upright easel. Such horizontal shooters can be very large.

Modern animation stands are often electronically controlled, a microcomputer being used to govern everything from focus and exposure to the motions of the easel holding the artwork.

BACKLIT ANIMATION A form of animation in which partly transparent artwork is lit from behind. Sometimes called bottom-lit animation, this technique can be used to produce a kind of neon glow effect which —known as the "candy apple" look—became a staple of television commercials in the 1970s. Backlit animation was also used extensively in the feature movie *Tron*.

BIPACK CAMERA A camera equipped with twin sets of magazines and able to run two strips of film simultaneously.

BIPACK PRINTING The use of a BIPACK CAMERA as a contact film printer. Such a printer can be used to generate COMPOSITE images, combining, for example, a MATTE PAINTING with a live-action PLATE shot earlier and elsewhere.

BLACK LIMBO The environment created when a set is covered with nonreflective black material (such as velvet or flocked paper) so that actors or MINIATURES placed in it will stand out as elements that can easily be isolated. White limbo is also used to the same end.

BLUE-BACKING SYSTEM (See *BLUE-SCREEN PHOTOGRAPHY*)

BLUE-SCREEN PHOTOGRAPHY Sometimes known as the COLOR SEPARATION or BLUE-BACKING SYSTEM, blue-screen photography depends upon the way color film stocks respond to different wavelengths of light. Foreground elements—actors for example—are filmed in front of a brightly illuminated blue screen. The resulting color negatives can be used to generate TRAVELING MATTES. These mattes enable the effects crew to COMPOSITE this foreground material with background PLATES shot elsewhere.

Although blue-screen photography has some serious drawbacks (it lacks subtlety), it is cost-efficient compared with other traveling-matte systems and has remained a popular tool for special effects work since the 1950s.

CAD/CAM Acronym for Computer-Aided Design and Computer-Aided Manufacture, disciplines which have special effects applications in such areas as computer graphics and MOTION CONTROL.

CEL The thin sheet of transparent plastic (originally celluloid) on which some elements of an animator's artwork are recorded prior to photography.

CGI Acronym for Computer-Generated Imagery.

COLOR-SEPARATION SYSTEM (See *BLUE-SCREEN PHOTOGRAPHY*)

COMPOSITE Used as a noun, "composite" describes the end result of an effects crew's efforts to combine two or more images shot on separate occasions. Used as a verb, the word describes the process of combining two or more images.

COMPSY Acronym for Computerized Multiplane System, Compsy is a highly sophisticated digitally controlled animation rig developed at Entertainment Effects Group (EEG) and used extensively on such movies as *Star Trek: the Motion Picture* and *Blade Runner*.

DIGITAL PRINTER An electronic device that is expected to take over many of the functions of the OPTICAL PRINTER.

DUNNING-POMEROY PROCESS A "self-matting" technique invented in the late 1920s by C. Dodge Dunning and developed by Roy J. Pomeroy, this process relied upon the way black-and-white film stocks respond to different wavelengths of light. Although the Dunning system should not be confused with BLUE-SCREEN PHOTOGRAPHY, foreground elements were shot in front of a blue screen and combined in a BIPACK camera with background PLATES shot earlier. The process was popular in the early sound era but was soon made obsolete by improved REAR-PROJECTION techniques.

DYKSTRAFLEX A MOTION-CONTROL camera system developed under John Dykstra's supervision for Industrial Light and Magic (ILM), George Lucas's special effects division, at the time of *Star Wars*. By far the most sophisticated electronically controlled camera rig built until that time, it has served as an informal prototype for many other systems built since, at ILM and elsewhere.

DYNAMATION Ray Harryhausen's show-biz name for his MODEL ANIMATION system in which STOP-MOTION techniques and TRAVELING-MATTE photography are cleverly combined.

EFFECTS ANIMATION Instead of bringing cartoon characters to life, effects animation is used to introduce such phenomena as rain or lightning (or stars or laser blasts) into scenes that may otherwise be live-action or perhaps the product of miniature photography.

FORCED PERSPECTIVE When creating landscape or architectural MINIATURES, effects artists often employ forced perspective. Buildings in the background, for example, will be built on a smaller scale than those in the foreground so that they appear farther from the camera.

FRONT PROJECTION Front projection has a number of applications in special effects work, the most spectacular of which is the combining of front-projected background PLATES with live-action foreground elements. Compared with REAR PROJECTION, front projection is a relatively awkward technique, but it is capable of producing very high quality results, which has made it an effective tool for effects men in such movies as *2001* and *Close Encounters of the Third Kind*.

GAG Any kind of special effects trick is referred to in the business as a gag.

GIMBAL RIG A gimbal (sometimes referred to in the plural) is a mechanical device that permits an object (a camera for example) to be suspended inside a rotating body in such a way that object and body are capable of motion independent of one another. Thus, in *Royal Wedding*, a camera suspended within a rotating room was used to create the illusion that Fred Astaire was dancing on the walls and ceiling.

GLASS SHOT A technique, used since the early silent period, through which an image painted on a glass sheet is filmed simultaneously with the set (or landscape, or whatever) that can be seen, from the camera's viewpoint, through the transparent areas of the glass.

GO-MOTION A refinement of STOP-MOTION developed in the 1970s at George Lucas's Industrial Light and Magic facility. Animated miniatures are subjected to electronic control, which permits them to be in motion while the camera shutter is open, thus creating a natural blur that adds to the on-screen realism by avoiding the strobing effect associated with conventional stop-motion.

HANGING MINIATURES MINIATURES (often architectural elements) can be suspended between the lens and a full-size set in such a way that miniature and full-size components are filmed simultaneously, with the result that they seem to be continuous parts of a single entity.

ICEBOX The Icebox, like the DYKSTRAFLEX, was a pioneering electronically controlled camera system. Built to Douglas Trumbull's specifications, it was first used on *Close Encounters of the Third Kind*.

IN-THE-CAMERA Early VISUAL EFFECTS were, of necessity, achieved "in-the-camera" and typically involved multiple exposures on a single strip of film negative, which would be run through a camera (or cameras) as many times as was necessary to combine the required elements. The film would not be processed until all these elements were recorded. Prior to processing each element existed as a LATENT IMAGE in-the-camera (or, more accurately, in the film magazine which could be transferred from one camera to another).

In-the-camera techniques lost favor in the early sound era when new tools such as the OPTICAL PRINTER offered more flexible ways of compositing imagery. In recent years, however, in-the-camera opticals have enjoyed something of a renaissance because of the superior quality they provide. Since only one negative is needed, there is none of the loss of definition and increase of grain that is inevitable when additional generations of film are required, as is the case with most modern compositing systems.

LATENT IMAGE (See *IN-THE-CAMERA*)

MATTE BOARD The easel on which artwork is mounted during the laboratory stage of MATTE PHOTOGRAPHY.

MATTE BOX A device that fits in front of the camera lens, into which simple mattes (masks) can be inserted. The matte box holds them in such a way as to block off light from portions of the frame which are not to be exposed during a given take.

MATTE PAINTINGS Artwork executed on a relatively small scale (typically about the size of a painting you might hang above your fireplace) and designed to be shot as a separate component to be composited with other elements (usually full scale) filmed elsewhere. Typically, matte paintings are used to create or enlarge an illusion. For example, actors filmed on a partial set representing a rooftop may be combined with a painting representing an urban landscape. The on-screen illusion will lead audiences to believe that the rooftop is located in the middle of a real city.

MATTE PHOTOGRAPHY The art of photographing MATTE PAINTINGS in order to combine them with other components to create a COMPOSITE.

MECHANICAL EFFECTS Often used as a synonym for PHYSICAL EFFECTS or PRACTICAL EFFECTS, and sometimes in a slightly narrower sense to describe the use of specifically mechanical devices, such as the various man-made sharks built for the *Jaws* series of films.

MINIATURES Miniature models of landscapes, buildings, vehicles, animals, and even people have been employed since the early days of the movies. Skillfully photographed, they can be strikingly effective in shots where it is not practical or possible to use the real thing. The model shop remains a key adjunct to any modern effects facility.

MINIATURE PHOTOGRAPHY Photographing MINIATURES is a highly specialized discipline. If a model car is shown falling from a miniature bridge, for example, the cameraman must use a high-speed camera so that when the footage is projected at standard speed the falling object will seem to have greater mass and bulk.

MODELS (See *MINIATURES*)

MODEL ANIMATION (See *STOP MOTION*)

MODEL MOVER A mechanical device for moving a MODEL during the course of photography. In modern effects work the model mover is generally subject to electronic control as part of a MOTION-CONTROL system.

MOTION CONTROL Although the basic idea has a long history, motion control is a term that is generally used to describe the electronically governed camera systems that first came into use in the early 1970s, and which have had a major impact on feature film production since the time of *Star Wars* and *Close Encounters of the Third Kind*. (See DYKSTRA-FLEX, ICEBOX)

Such systems permit a camera to be programmed to repeat elaborate moves with great precision. MINIATURES mounted on MODEL MOVERS can be subjected to electronic control within the same system, thus giving effects artists great flexibility in planning shots that require multiple elements to be filmed separately and then assembled.

Similar electronic control systems are also applied to ANIMATION STANDS, OPTICAL PRINTERS and other pieces of equipment used in effects facilities.

MULTIPLANE CAMERA An ANIMATION STAND designed so as to permit the camera to shoot several planes of artwork simultaneously. Conventionally it is used to create an illusion of depth in which images located on different planes relate to one another spatially in approximately the way that they would in the real world.

OPTICAL EFFECTS (See *VISUAL EFFECTS*)

OPTICAL PRINTER An optical printer consists of a projector (known as the PRINTER HEAD) and a camera mounted with their lenses facing one another so that the projector can throw an image directly into the camera's optical system. This configuration permits the accomplishment of many different types of effects, from simple wipes and fades to elaborate COMPOSITES.

PHOTOGRAPHIC EFFECTS (See *VISUAL EFFECTS*)

PHYSICAL EFFECTS Sometimes called PRACTICAL EFFECTS or MECHANICAL EFFECTS, physical effects deal with the devising and execution of physical GAGS—usually staged on set or location during principal photography—from the construction of special mechanical devices to the supervision of PYROTECHNICS.

PILOT-PINS The mechanisms of PROCESS CAMERAS, OPTICAL PRINTERS, and similar pieces of effects equipment feature pilot-pins designed to hold the film passing through the gate in exact register. Near perfect registration is necessary to all VISUAL EFFECTS work, since the tiniest error can seem enormous when blown up to the image size seen on a theater screen.

PIXELS Pixels are the picture elements— specks of phosphorescent color—which make up the image on the faceplate of a cathode ray tube. The degree of resolution present in a computer-generated image is directly related to the number of pixels of which that image is made up.

PLATES When effects men speak of plates, they normally mean a reel of motion picture film which serves as the background image when a COMPOSITE of any kind is being assembled. Occasionally a still photograph, in the form of a transparency, is made to serve the same purpose. Projectors designed to take such single still transparencies are known, for reasons that defy logical explanation, as stereo projectors.

PRACTICAL EFFECTS (See *PHYSICAL EFFECTS*)

PRINTER HEAD A projector used as a component in an AERIAL-IMAGE PRINTER or OPTICAL PRINTER.

PROCESS CAMERA A camera designed especially for effects work. It differs from a standard production camera in a variety of ways, such as being equipped with a PILOT-PIN movement, a "through-the-lens" viewfinder, a variable-speed motor (sometimes called a "wild" motor), and a motor control that permits one frame of film to be exposed at a time.

PROCESS SCREEN This term is usually employed to describe the translucent screen used for REAR-PROJECTION work (sometimes called process photography).

PYROTECHNICS A branch of PHYSICAL EFFECTS that deals with the controlled use of fires and explosions.

RASTER GRAPHICS A raster is an electron beam that sweeps in horizontal lines across the face plate of a cathode ray tube "painting" images on the phospher-coated screen of a monitor. The electron beam activates PIXELS, which create a luminous mosaic. Television pictures are constructed this way, and so are many computer-generated images.

Graphic displays available with inexpensive microcomputer systems are of the raster type. High-resolution screens, used in conjunction with mainframe or minicomputers, permit artists to use raster graphics to create amazingly realistic three-dimensional illusions, it being the nature of raster systems to produce solid-looking images that can be modeled in a naturalistic way.

Raster graphics can be used to generate what the public has come to know as computer animation (a term not much liked in the industry), as was done on a large scale for the movie *Tron*. In the future, though, raster systems are likely to be used in conjunction with—or in place of—live-action film. Already, space battles of the sort seen in *Star Wars* can be produced by computer as SCENE SIMULATIONS, and this method was used extensively in the 1984 film *The Last Starfighter*.

ROTOSCOPING A technique of projecting film images one frame at a time onto a suitable surface where the outline of, for example, an actor or a falling rock can be traced by hand. The resulting silhouettes may be used as the basis for hand-drawn TRAVELING MATTES. This is a laborious method of generating such mattes but it yields high quality results and remains a valuable tool.

SCENE SIMULATION The use of computer graphics systems to generate realistic-looking imagery.

SLIT-SCAN A form of controlled STREAK PHOTOGRAPHY first broached by John Whitney, Sr., then put to spectacular use in the Stargate Corridor sequence of *2001: A Space Odyssey*. Dramatic abstract effects can be achieved by shooting suitable artwork through a slit while at least two of the key physical elements (camera, slit, artwork) are in motion during the course of a long exposure.

SHUFTAN PROCESS Invented by Eugene Shuftan (*né* Eugen Schüfftan) in the 1920s, this process allows the image of an actor, reflected in a mirrored area on a sheet of otherwise clear glass, to be composited IN-THE-CAMERA with a MINIATURE, artwork, or a projected image seen through the transparent parts of the glass. A variation on the process involves the use of a "two-way" mirror.

STOP MOTION The simplest form of stop-motion permits a filmmaker to create the illusion that an inanimate object, such as a pebble, can move of its own accord. This effect is achieved by focusing an animation camera on the object, exposing a frame, moving the object a short distance by hand, exposing another frame, and repeating the process until the object has reached the desired point. When the film is projected at standard speed the result will be the on-screen illusion of a self-propelled object.

By applying this basic principle to elaborate articulated figures, a great exponent of MODEL ANIMATION—such as the late Willis O'Brien—can

breathe life into such characters as King Kong and Mighty Joe Young.

STREAK PHOTOGRAPHY A staple of television logos and commercials since the early 1970s, streak photography has been likened to the results that you would obtain if you photographed the headlights of cars speeding towards the camera employing exposure times long enough to cause the lights to smear. Shot under controlled conditions on an ANIMATION STAND, streak photography can be used to create startling moving images.

TRAVELING MATTES A matte is a mask that blocks off a predetermined part of a photographic image. Traveling mattes are masks that move and change from frame to frame. An actor or moving MINIATURE filmed in front of a suitable background can be reduced (with the aid of, for example, BLUE-SCREEN PHOTOGRAPHY or ROTOSCOPING) to a sequence of silhouette masks which can be used to punch "windows" into suitable background PLATES. The photographic image of the actor or miniature can then be slotted into these "matte windows" to create a COMPOSITE.

VECTOR GRAPHICS A form of computer-generated imagery in which the imagery is made up of lines drawn between "x" and "y" coordinates. Although vector graphics cannot offer the modeled solid forms associated with high quality RASTER GRAPHICS, the system can produce elaborate and beautiful "wire frame" images that can be manipulated (rotated, for example, or brought closer) in real time in a convincing illusion of three-dimensional space.

VISUAL EFFECTS Sometimes called PHOTOGRAPHIC EFFECTS or OPTICAL EFFECTS, visual effects is one of the two major branches of special effects (the other being PHYSICAL EFFECTS). In the strictest sense the term visual effects describes the wide variety of imagery manipulations that can be accomplished with the aid of the optical systems to be found in cameras, projectors, OPTICAL PRINTERS, AERIAL-IMAGE PRINTERS, etc.

In practice, visual effects contractors and coordinators also handle such important peripheral functions as model building (since MINIATURE PHOTOGRAPHY is a key aspect of visual effects, this is a logical arrangement). As an umbrella term, visual effects also describes such areas as EFFECTS ANIMATION, and in the age of MOTION CONTROL no self-respecting visual effects house is without its own electronics and software experts.

INDEX

(Numbers in italics refer to illustrations)